# Napoleonic Art:
# Nationalism and the Spirit of Rebellion in France (1815–1848)

Barbara Ann Day-Hickman

DELAWARE

Newark: University of Delaware Press
London: Associated University Presses

Associated University Presses
440 Forsgate Drive
Cranbury, NJ 08512

Associated University Presses
16 Barter Street
London WC1A 2AH, England

Associated University Presses
P.O. Box 338, Port Credit
Mississauga, Ontario
Canada L5G 4L8

The paper used in this publication meets the requirements
of the American National Standard for Permanence of Paper
for Printed Library Materials Z39.48–1984.

**Library of Congress Cataloging-in-Publication Data**

Day-Hickman, Barbara Ann, 1942–
    Napoleonic art, nationalism, and the spirit of rebellion in France
: 1815–1848 / Barbara Ann Day-Hickman.
        p.    cm.
    Includes bibliographical references and index.
    ISBN 0-87413-615-6 (alk. paper)
    1. Politics in art.   2. Napoleon I, Emperor of the French,
1769–1821—Portraits.   3. Printed ephemera—France—History—19th
century.   4. Popular culture—France—History—19th century.
5. Nationlism and art—France—History—19th century.   I. Title.
NE962.P64D38   1999
769.944'09'034—dc21                                    97-35761
                                                        CIP

*To the memory of my father*
*John Broderick*
*The Son of a printer*
*Who never doubted my dream*
*Of being a writer*

# Contents

# Acknowledgments

I WOULD LIKE TO EXPRESS MY SINCERE APPRECIATION to Mlle Simone Lossignol, who over the years so generously shared her knowledge and passion for French popular art. A special debt of gratitude to Mlle Lossignol and her sister, Madame Jeannine Noyelle, for graciously offering their hospitality during summers of long, unrelenting research in Paris. Gratitude is also due to colleagues and friends in France, who supported this project with their continuing solicitude. I would particularly like to acknowledge professors Maurice Agulhon, André Burguière, Geneviève Bollème, and Roger Chartier, whose seminars and consultations inspired and deepened my understanding of French politics and culture. My appreciation extends as well to members of my French "family," Christine Devallois Dominique Ferry, Alain Robert and Marie Dominique LeClerc, Bernard and Bernadette Aumont, who invited me into the warmth and intellectual vitality of their personal and professional lives. A particular note of gratitude goes to Bernard Huin, Director of the Musée Départementale d'Art Ancien et Contemporain; Bernard Houot of the Centre Pédagogique du Documentation Départementale in Epinal; M. Eric Staub, Director of l'Imagerie d'Epinal; and Mlle Elizabeth Molle, photographic liason for the Réunion des Musées Nationaux, who so graciously permitted me to reproduce the majority of the illustrations for this publication.

I also want to extend additional appreciation to staff members at the Musée des Arts et Traditions Populaires, the Archives Départementales des Vosges, the Cabinet des Estampes at the Bibliothèque Nationale de France, the Musée de l'Armée, and the Bibliothèque Municipale de Troyes for their tireless assistance in tracing the aesthetic and documentary trail of the Napoleonic legend.

On this side of the Atlantic, I would like to acknowledge the scholarly fine-tuning that I received from Lois Fink, Albert Boime, Ellen Miles, Wendy-Wick Reaves, and Richard Ahlborn while a postdoctoral fellow at the Smithsonian Institution in Washington, D.C. My continued gratitude also goes to Michael Nash, Philip Scranton, Roger Horowitz, Carol Lockman, and the librarians at the Hagley Museum and Library in Delaware whose unstinting support enabled me to access the extraordinary eighteenth- and nineteenth-century French sources available in their collection.

I am especially grateful to Rodney Olsen, whose careful reading and meticulous eye helped to bring this manuscript into focus and form. Genuine appreciation also goes to Ruth Smith from the Research and Fellowship Office at Temple University for her resourcefulness and astute suggestions about funding this project. Generous grant-in-aid support and several summer fellowships from Temple University enabled me to do the necessary primary research for this project in France. Recognition also goes to members of the Temple University History Department—Bill Cutler, Allen Davis, Herb Ershkowitz, Harriet Freidenreich, Jim Hilty, Mark Haller, Richard Immerman, and Margaret Marsh—who provided invaluable chiding and encouragement to sustain this endeavor. Katie Parkins paid fastidious attention to the final details of the manuscript, while Beatrice Waggaman and Merle Kemp managed to clarify and facilitate the French translations. Particular appreciation also goes to Mark Mattson, cartographer at Temple, who generously helped to design the maps for the book.

I am also grateful to Ruth Bohan and Terry Dolan, whose indefatigable support and friendship enabled me to maintain morale and con-

fidence in my work in cultural history and art. I also owe a considerable debt of gratitude to Bob Bezucha, Lloyd Kramer, Pat Mainardi, Nina Athanassaglou-Kallmyer, Frank Kafker, Suzanne Lindsay, and Karen Offen, all of whom carefully read and critiqued the manuscript. Finally, I thank family members Mary Bernice Broderick, Kathleen and Bob Garfinkle, plus friends—Betty Franks, Payson Stevens, Kathi Olsen, Karl Hufbauer, Jane Mills, Pat Kobes, Carol Dowd, Joan Halpern, Natalie Richman, Shirley Smith, Marilyn Silberfein, Elizabeth Frumin, and Paul Mychaluk—who strengthened my faith in the successful completion of this endeavor. My deepest gratitude goes to my husband, Peter Hickman, for his continuing support, encouragement, and inestimable understanding while I pursued this project to its conclusion. And a final word of appreciation is offered to my buddy, the Little Corporal, who to waited so patiently for his walks.

# Napoleonic Art:
# Nationalism and the Spirit of Rebellion
# in France (1815–1848)

# Introduction

DURING THE TURBULENT YEARS FOLLOWING THE Revolution of 1830, the Pellerin printing firm in Epinal published a series of popular broadsheets about Napoleon Bonaparte that carried revolutionary and populist ideas to customers throughout provincial France. Established during the French Revolution by Jean–Charles Pellerin, the firm printed mostly devotional images, fairy tales, domestic satire, and current events. Pellerin's son Nicholas and his partner, Pierre-Germain Vadet, a survivor of the Battle of Essling, took over the printing firm during the Restoration and reproduced, in mass, a series of fifty-nine illustrations celebrating major events in Napoleon's military career. Initially forestalled by censorship prohibitions during the Bourbon Restoration, the partners gained momentum with the relaxation of regulations after the Revolution of 1830. They subsequently turned out a series of brilliant poster-sized engravings about Napoleon and his legendary armies. Despite their apparent ingenuousness, these popular images conveyed a defiant political message to Orleanist authorities.

Since the nineteenth century, the "Epinal image" has virtually become a national symbol for French popular culture. Today French people believe these vibrant illustrations provided light entertainment for an unsophisticated rural audience. While during the latter part of the century Pellerin produced fanciful illustrations of fairy tales and heroic adventures for children, in earlier decades, prior to the establishment of universal education, such broadsheets were a vital form of communication in regional France. From 1830–1848 the Pellerin printers usually produced five thousand copies of one image per run, and used the wood-block design repeatedly after the initial printing.[1] Book dealers and itinerant peddlers sold the Pellerin prints for a pittance to customers at fairs, villages, and outlying farms. If less literate customers could not read the textual commentary beneath each image, they could nonetheless comprehend the narrative from the illustration.

*Popular culture* and *art* are difficult to define. Traditionally, *popular art* refers to representations created for and used by the common people.[2] More recent scholars of French culture have treated pamphlets from the Blue Library as the reflection of a generic literary culture geared for a general audience.[3] Historians often equate *popular* with religious beliefs and practices that transcended and often threatened the ecclesiastical regulations of the Catholic Church. In such cases, *popular* indicated images and texts that existed either outside of, or on the boundaries of literate and orthodox cultures. Instead of trying to make sharp distinctions between elite and popular, Roger Chartier has pointed out that "it is more important to see how cultural configurations criss-cross and dovetail in representations and cultural practices."[4]

In this study, *popular* refers to broadsides produced by a middle-class printing firm that marketed religious, satirical, and political themes to a diverse audience in provincial France. While these printers tried to attune their inventory to the prevailing culture of the common people, they could do so only indirectly, by producing attractive illustrations in a familiar symbolic and textual format that spoke to their varied clientele. Like most printers, the Pellerin artisans drew their inspiration from urban lithographs and prints. They nevertheless transformed their models into sensational narratives by adding brilliant colors, and by focusing attention on the dramatic action in the foreground of the design.

This arresting emphasis in the Pellerin prints captured the imagination of an audience probably more drawn to adventure tales than to aesthetic features.

Like the arbitrary division between high and popular culture, the distinction between elite art and propaganda is difficult to establish. Traditionally, fine art and propaganda have been treated as opposites, art being intricate, refined, and ideologically pure as compared with propaganda, which is "crude, institutional, and partisan." Such distinctions appear irrelevant, however, if we consider culture (and art) as the symbolic way that societies make sense of their world.[5] Symbols necessarily reflect the social and historical circumstances of their creation. Because representations are necessarily embedded in society and its history, any type of aesthetic expression—be it elite or common—can serve the interests of the particular individuals and groups who produced or used them. Consequently, representations of any variety involve issues of intentionality and power.[6]

While French printing firms often accommodated the existing government, during periods of social and political dissension some editors produced subversive material for popular consumption, thus challenging the political and ecclesiastical status quo. After 1789, both radicals and reactionaries used inexpensive broadsides to undermine or advocate the new revolutionary government. In the early-nineteenth century, liberal minorities designed textual and graphic representations of Napoleon Bonaparte to legitimize their struggle for political enfranchisement. Following the July Revolution, King Louis-Philippe co-opted representations of the legendary Bonaparte from popular lithography to reinforce the prestige and legitimacy of his own claim to the throne.

Hoping to neutralize political factionalism and to integrate revolutionary and bonapartist traditions into a single national epic, the Orleanist king commissioned a series of paintings about Napoleon for the museum at Versailles. At the same time, he displayed bellicose images of Bonaparte in the museum to highlight the moderation and political superiority of his own constitutional system.[7] Instead of emphasizing Napoleon's role as general in the great tradition of historical painting, Louis-Philippe planned a series of paintings for Versailles that portrayed the popular figure of Napoleon as the "Little Corporal." In addition, by mounting a statue of

the Little Corporal on the Vendôme column and returning Napoleon's ashes to Paris, the king attempted to mobilize popular faith in Napoleon I to serve his own political agenda.

Republican Nicholas Pellerin and his bonapartist associate Pierre-Germain Vadet reproduced images of Napoleon for a much different political purpose. Like the Orleanist government, the Pellerin firm monumentalized the legendary figure of the Little Corporal, but unlike official paintings and rituals that dramatized the heroism of the aristocracy, the Pellerin images conveyed a distinctly egalitarian message. By portraying Napoleon as a friend to the common man, often in congenial conversation with soldiers, peasants, and artisans, the Epinal images extended a populist message to Pellerin's customers. The images also questioned the government's timid military strategies by pointing out the valor of Napoleon's armies. With their praise of Napoleon's courage and initiative, the Epinal images thus challenged the pacifist foreign policies of the Orleanist government.

Beyond the work of art historian Michael Marrinan, few scholars have treated the political meaning of Napoleonic representations during the Orleanist regime.[8] To some extent, my interpretation of the Little Corporal in the Pellerin prints concurs with Marrinan's iconographic study of Napoleonic art in *Painting Politics for Louis-Philippe: Art and Ideology in Orleanist France, 1830–1848* (New Haven and London: Yale University Press, 1988). Marrinan emphasized political strategies used by Louis-Philippe to patronize and display sanctioned representations of Napoleon Bonaparte. Though he addressed urban prints and lithography, Marrinan did not explore the origins, production, and dissemination of this important selection of popular prints from Epinal that were marketed in regional France.

Other French historians have attempted to explain how the Napoleonic legend influenced the politicalization of the countryside during the early-nineteenth century. For example, in *Le Culte de Napoléon* (Paris: Editions Albin Michel, 1960), Jean Lucas Dubreton pointed out how the legend was created and adopted as a form of political resistance by veterans of the Imperial armies as well as by liberal artists and writers during the Restoration. His evidence, however, was general and impressionistic. In contrast, R. S. Alexander in *Bonapartism and the Revolu-*

*tionary Tradition in France: The Fédérés of 1815* (Cambridge: Cambridge University Press, 1991) explained how specific groups—former civil servants from the Imperial epoch and Hundred Days Rule—organized to initiate the beginnings of liberal opposition to the Restoration monarchy. In *Old Hatreds and Young Hopes* (Cambridge: Harvard University Press, 1971), Alan Spitzer likewise traced the efforts of Napoleonic veterans who planned several unsuccessful military insurrections in 1819 and 1821.

Like Bernard Ménager in *Les Napoléon du peuple* (Paris: Aubier, 1988), this study addresses the Napoleonic legend in populist texts and representations. Ménager discussed the vicissitudes of the Napoleonic legend by drawing attention to seditious attitudes and behavior associated with the memory of Napoleon Bonaparte. While Ménager's text provided a documentary basis from police files for ascertaining such attitudes, the breadth of his study prevented the development of a more concentrated examination of a particular set of documents. My work amplifies that of Ménager by analyzing a discrete set of texts and images about the Napoleonic legend that were produced by the Pellerin firm in Epinal.

In *Populist Religion and Left-Wing Politics in France, 1830–1852* (Princeton: Princeton University Press, 1984), Edward Berenson described how democratic socialist groups used popular religious texts to communicate political ideas to artisan and working-class groups during the latter years of the July Monarchy. Like Berenson's work, this study investigates how popular imagery permitted the convergence of religious traditions with revolutionary political meanings. While the format of the Napoleonic prints reflects the traditional style of devotional iconography, their political focus suggests the advantages of militant activism.

Unlike previous scholarship, *Napoleonic Art, Nationalism, and the Spirit of Rebellion in France, 1815–1848,* addresses political meanings associated with representations of Napoleon through a study of the Pellerin printers and their political involvements. Printers Nicholas Pellerin and Pierre-Germain Vadet produced texts and images that relayed the heroic itinerary of the most eminent political figure in postrevolutionary France. But in addition to praising Bonaparte's military accomplishments, Epinal renditions of Napoleon and his armies were implicitly critical of the reactionary policies of the Orleanist monarchy. By connecting their own republican and

bonapartist ideas to Napoleonic themes, the Pellerin printers endeavored to legitimize their position and make it convincing to a general audience.

The spirit of anti-Bourbon, anti-Orleanist sentiment promoted by the Pellerin images from 1820 to 1848 certainly helped to shape support for the enfranchisement of a new Bonaparte. Popular representations of Napoleon provided a powerful focal point and catalyst that enabled the French people to bypass traditional loyalties to the Bourbon kings in favor of a charismatic figure who more effectively represented the nation. Louis-Philippe had tried to integrate the figure of Bonaparte into the representational strategies of the July Monarchy, but when subversive implications of the Little Corporal became too threatening, the king withdrew support for such potentially seditious themes. Louis-Philippe's ploy to use Napoleonic art as a fulcrum for national unification ultimately failed. By the July Monarchy however, vendors of Napoleonic broadsides, such as Pellerin, successfully promoted republican and populist themes that fostered opposition to Orleanist rule.

Louis-Napoleon Bonaparte's landslide victory in provincial France during the presidential elections of December 1848 has posed a historical enigma for scholars of early-nineteenth-century France. While most urban areas gave Louis-Napoleon a decidedly lower percentage of the vote, the countryside demonstrated astounding faith in the bonapartist candidate. Bonaparte received 5.4 million votes as compared with the only other viable candidate, Godfrey Cavaignac who gathered 1.4 million. Traditionally, the countryside followed the political leadership of the cities, but in this instance rural voters took an independent stance.[9] Rural support for the bonapartist contender was uncanny, varying from 50 percent to over 80 percent in most provincial regions.[10]

Like other printers who marketed Napoleonic broadsheets prior to the revolution and elections of 1848, the Pellerin firm contributed to enthusiasm for Napoleon Bonaparte in provincial France. Illustrations of Napoleon and his Great Army rekindled memories of military comradery among those who had suffered during the republican and Imperial wars; such themes nevertheless conveyed contemporaneous meanings. Graphic reproductions of France's conquests of Austria, Prussia, Russia, and England revived nascent antagonism toward hated enemies who

had defeated and subsequently occupied France. For those who longed for a previous age of grandeur, the Pellerin prints provided graphic renditions of military valor that renewed waning hope for France's national destiny. In the several decades preceding the Revolution of 1848, popular illustrations of the Little Corporal leading his men into battle offered a symbolic site for the renewed identity and increasing political assertiveness of the French people.[11]

# Prologue: Representing the Legend

DURING HIS ACCESSION TO POWER, NAPOLEON Bonaparte established the interpretive parameters for his legendary persona. After Napoleon's astounding triumphs against the Austrians in 1796 and 1797, representations of General Bonaparte began to fill the symbolic void that resulted from the death of Louis XVI and the end of the French monarchy in the winter of 1793. Despite the republican government's efforts to secure popular allegiance to the revolution by promoting the symbol of Marianne (or Hercules), references to Napoleon provided a more effective focus for a people who were accustomed to venerating the sacred image of their king.[1] Because of long-standing rituals and traditions centered on the French monarchy, heroic representations of the young Corsican general made a more immediate and lasting impact than did allegorical themes prescribed by political leaders during the the French Revolution.[2]

To confirm his legitimacy, Napoleon Bonaparte used both the fine arts and popular art to fabricate a public image that would establish his credibility as a military leader and ruler in postrevolutionary France. Neoclassical and Bourbon references furnished a range of symbols to fashion his public career into a monumental epic for contemporaneous and subsequent generations. Like his Bourbon predecessors, Napoleon portrayed himself as the destined leader of the French nation. In commemoration of his illustrious feats as general of the Republican and Imperial armies, he initiated the construction of the Arch of Triumph, the Etoile, the Vendôme column, and numerous other monuments.

In addition, Bonaparte created a patron saint, and directed his bishops to include St. Napoleon in the official liturgical calendar after his coronation. The emperor proclaimed 15 August to be the feast of St. Napoleon, to be celebrated annually with magnificent parades and fireworks. The Pellerin firm reproduced images of St. Napoleon, patron of warriors, and marketed them in the provinces. Like his Roman predecessors, Napoleon created a public image for popular veneration that would encourage widespread political allegiance.

Bonaparte maintained a comprehensive censorship network that orchestrated public rituals, art, and the press, not only within France but also in occupied territories. During the Empire, censors permitted the publication of only those textual and graphic images that confirmed the emperor's position as the unquestioned master of western Europe. By assuming the Imperial throne, Napoleon I was determined to establish his authority as the guardian of the new European political order. He also wished to assume parity with the members of the Holy Alliance who had previously disparaged his role as sovereign.

After his disastrous campaign in Russia in 1812, however, Napoleon could no longer stem the surge of anger throughout Europe from those who resented the loss of so many young soldiers to the emperor's insatiable appetite for power. From 1814 to 1816, writers and artists such as George Cruikshank portrayed Napoleon as a man consumed by avarice and ambition.[3] The English caricaturist aptly describes the French military aficionado dreaming of wealth, global power, and licensed promiscuity while still a young student at the military college in Brienne. But Napoleon's final defeat at Waterloo and his exile to St. Helena, a rocky island off the coast of western Africa, transformed the black legend of a political monster into that of a tragic hero. Representations of his imprisonment and

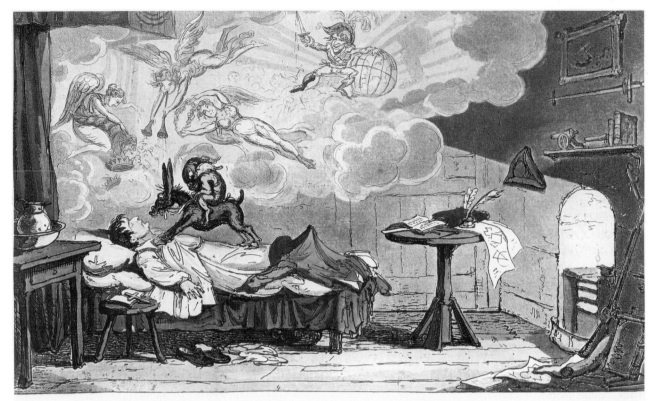

NAPOLEON DREAMING IN HIS CELL AT THE MILITARY COLLEGE.

George Cruikshank, *Napoleon Dreaming in his Cell at the Military College* (1817). Winterthur Library, Printed Book and Periodical Collection, Wilmington, Delaware.

exile portrayed the beleaguered prisoner who through his suffering was purged of his former crimes. Sympathetic memoirs and eyewitness accounts of Napoleon's exile and death in 1821 helped to shift his image from a callous dictator to inveterate defender of the French revolution. This more empathetic view governed most lithographic representations of Bonaparte during the Restoration and July Monarchy.[4]

Napoleonic themes constituted a sort of national trope that transcended cultural distinctions and regional differences. Although the Bourbon government prohibited references to Bonaparte and his armies, popular texts and images managed to slip by orthodox censors. The explosion of Napoleonic art and bric-a-brac during this period suggests, moreover, that the legend was important to a varied social spectrum. In urban areas, notables supported a luxury market consisting of jewelry, silverware, fans, and lamps that replicated characteristic portraits of Bonaparte. The middle classes purchased bronze statues, clocks, and expensive engravings of Napoleon to display privately in their

homes, while less-monied customers in rural areas acquired suspenders, kerchiefs, pipes, and wood-block images of the Little Corporal from itinerant peddlers.[5]

Dramatic representations of Napoleon and his troops held widespread appeal among veterans and relatives marked by their experiences of the Napoleonic wars. Forced to retire from active service after Napoleon's surrender, veterans were obliged to return to their homeland without adequate pensions or the freedom to pursue another career. Despite their tragic experiences during Napoleon's final campaigns, veterans preferred to cultivate memories of their military prowess with the Napoleonic armies. Such representations of heroic grandeur, made available in lithographs and engravings, underlined France's humiliation by the Treaty of 1815 and the discontent of Napoleon's veterans with the Bourbon regime.[6]

Representations of Napoleon and his soldiers also symbolized the dissatisfaction of middle-class groups who felt increasingly disenfranchised by the political strategies of the Bourbon

system. Liberal artists produced images of the Great Army to criticize the Restoration government and the European Alliance that had defeated France in 1815. From 1815 to 1830, contraband pictures of Napoleon and his soldiers conveyed the dissatisfaction of liberal writers and politicians who took issue with the reinstatement of the Bourbons to power and the renewal of institutional practices of the Ancien Regime.[7]

With the publication of Napoleon's memoirs from St. Helena in 1823, Bonaparte became a symbol of political defiance for many individuals and groups who wanted to dispense with the vestiges of the Ancien Regime and restore the liberal and egalitarian principles of the French Revolution. Despite Bourbon censorship, an extensive underground market in Napoleonic prints, texts, and ephemera developed among liberals, artisans, petit bourgeois, and farm laborers, who sustained a clandestine allegiance to the memory of Bonaparte. The production of lithographs and engravings portraying Napoleon and his military campaigns reminded liberals and other dissident groups of earlier opportunities for social and professional mobility during the Imperial regime.

At this juncture, Jean-Charles Pellerin, and his son Nicholas, both printers from Epinal, and Pierre-Germain Vadet, a former tobacco merchant from Neufchatel, began to produce a series of colorful broadsheets on the military history of Napoleon Bonaparte and his inveterate armies. The Epinal prints were arresting. They consisted of poster-sized wood-block designs with a short commentary or legend beneath the illustration. Pellerin's images were usually printed on heavy *vergé* (rag paper) and hand colored with brilliant pigments by women and children. Designed primarily for a semiliterate to literate audience, these pictures provided a visual documentary of Napoleon's campaigns for a regional audience.

After the July Revolution, representations of Napoleon as prisoner and martyr took on added political meaning. From 1832 to 1834, republican groups in Paris, Lyon, and Epinal rallied behind the standard of the Little Corporal to oppose the repressive policies of the Orleanist government. During this same period, Pellerin and Vadet participated in a republican resistance movement in Epinal against the reactionary policies of the Orleanist administration. Despite the reform efforts of liberal and republican leaders, the govern-

ment refused to extend the franchise to a more broad-based middle-class electorate or attend to the growing discontent of the urban working classes. Due to the increasingly oppressive political atmosphere, the Napoleonic broadsides took on a subversive cast.

Because the Pellerin editors promoted the Napoleonic broadsheets for an indigenous audience and published a controversial republican newspaper, the printing firm was repeatedly embroiled in political controversy with the local authorities in Epinal. But after a nearly successful attempt on the king's life in 1835 and Louis-Philippe's efforts to unseat the Orleanist king the following year, censorship regulations became far more stringent. By 1836, the Pellerin firm stopped designing controversial prints of Napoleon I and his soldiers. By 1840, when Louis-Philippe orchestrated the Return of Napoleon's Ashes to France, the administration made a final effort to contain popular political feelings by planning its own ritual celebration of Bonaparte's death and burial.

Despite the censorship laws of September 1835, the Pellerin broadsheets continued to be printed and marketed in regional France during the final decade of the July Monarchy (1840–48). As the immediacy and pain of the wars receded, veterans and soldiers cultivated the heroic legend of Napoleon to connect their own history with the grandeur of Napoleon's conquests. The Epinal engravings tended to portray the inveterate courage of both Bonaparte and his soldiers on the battlefield. For many, these representations of Napoleon's campaigns constituted a "memorial" to loved ones who died in battle. But the commemorative implications of these pictures did not dim their political eloquence. Despite Napoleon's death in 1821 (and the death of his son in 1832), engravings and lithographs continued to represent Napoleon benevolently as a father to his troops, a friend of the common man, and a harbinger of a more sanguine political system.

Popular representations of Napoleon and his armies likewise relayed a populist and millenarian tone that connected France's spiritual and political renewal with the imagined "return" of Napoleon to French soil. This millenarian strain gave added cogency to poster images of Napoleon produced by Pellerin and several other printing firms in northeastern France. The graphic reenactment of Napoleon's conquests, exile, and triumphal return to France undoubt-

edly influenced the unexpected rural support for Napoleon's nephew in 1848. The proliferation of popular prints proclaiming the glory of the Napoleonic epoch helps to explain the extraordinary popular vote given by newly enfranchised Frenchmen to Louis-Napoleon Bonaparte.

The government's inclusion or condemnation of Napoleonic art during the Restoration and July Monarchy attests to the broad political power of these images. Representations of Napoleon were used by some groups to legitimate their prerogatives and by others to resist and oppose the existing political system. Dominant and dissident groups competed to define the legendary persona of Napoleon Bonaparte and thereby enhance their own political interests.[8] King Louis-Philippe included popular references to Napoleon into official iconography to solidify the Orleanist government and secure the allegiance of a more extensive constituency. Concurrently, republican editors Pellerin and his bonapartist associate Vadet used Napoleonic images to criticize the king's pacifist foreign policy and reactionary strategies at home. The Pellerin broadsheets thus contributed to a subversive form of political discourse that ensued in 1830 and eventually exploded during the Revolution of 1848.[9]

# 1

# Political Dissent and the Napoleonic Legend

ON 5 JULY 1816, AN ADJUTANT TO THE MAYOR OF Epinal came to the home of printer Jean-Charles Pellerin with three policemen and six officers from the royal army. With a warrant in hand, the mayor's assistant sealed off and searched the house. Ostensibly, seditious images found in Pellerin's home during the police search included a framed portrait of Napoleon hung in his daughter's room, plus a number of engravings from Pellerin's office portraying Napoleon I and his son.[1]

In addition to Napoleonic art found framed in the Pellerin home, the police also discovered poster illustrations of some six hundred soldiers from the Great Napoleonic Army in the printer's storehouse. Although shop artisans had covered the tricolor flag and Imperial eagle in each print with black ink, this material was confiscated and used as evidence against the printer during his subsequent trial and conviction for sedition against the Bourbon government.[2]

In 1820, Pellerin was again cited by the police for marketing seditious posters representing Napoleon's *Retreat from Moscow* and the *Battle of Waterloo* to peasants and artisans in provincial areas. Though Napoleon was not portrayed in either illustration, Pellerin was put under investigation by the authorities in 1821, not only for producing representations of the Imperial regime but also for allegedly distributing these broadsheets without charge to rural customers. Bourbon authorities considered such heroic representations of the Great Army highly suspect because they put the legitimacy of the Restoration government into question by recalling and highlighting the military glory of Imperial France.[3] Despite continuing censorship prohibi-

tions against Napoleonic art, the Epinal firm tried to negotiate directly with Bourbon authorities during the final years of the Restoration by petitioning the minister of culture for permission to print posters of Napoleon described as general of the Great Army.[4] In 1828, Pellerin supported his petition by claiming that "Napoleon now belongs to history. Pictures of Bonaparte are being sold in Paris and neighboring provinces without hindrance from the authorities." The printer indicated that his business would suffer if he could not compete with his neighbors in such a lucrative market. In response to Pellerin's request, the central ministry refused twice, reasoning that if such art were mass-produced and marketed cheaply among the lower classes in rural areas, it could be politically incendiary.[5]

Founded during the French Revolution, the Pellerin printing firm became one of the most famous producers of popular art in regional France during the early-nineteenth century. By the time of the Restoration, the printer had established a prosperous business that was important to the economy of Epinal, situated between Burgundy and the Vosges Mountains on the banks of the Moselle River. Surrounded by the Vosges mountains to the north and east, the city opened toward the southern plain that led to the rich cultural and agricultural plains of Burgundy. From the sixteenth century, Epinal was governed by a plutocracy of merchants who made their living from taxes on commerce, buildings, and land.[6] In 1863, when Epinal was incorporated into France, the city claimed local industries in leather, pottery, china, and cotton textiles. By the nineteenth century, Epinal

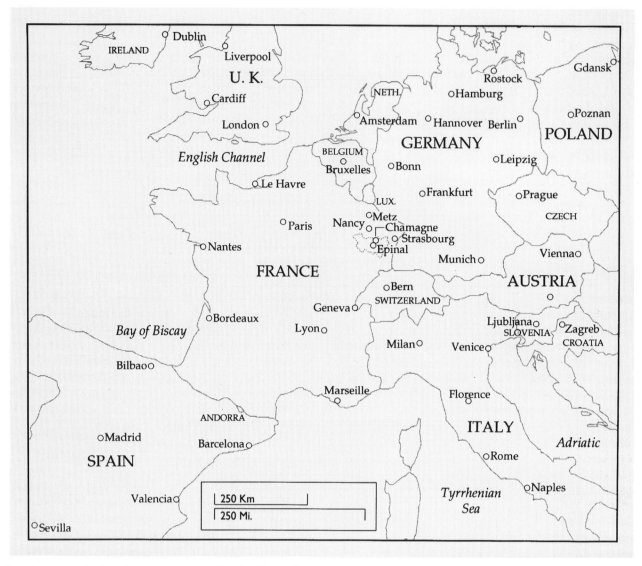

**Location of Epinal on European map. Map by the author.**

housed three to four indigenous printing houses, including the prosperous Pellerin enterprise.

Although Pellerin was in competition with other publishers in northeastern France, the printer soon outpaced his rivals by effectively mass-producing graphic art as well as by publishing small books and broadsheets for popular consumption. Such material was marketed to urban customers through booksellers in Paris and the Northeast, while itinerant peddlers distributed Pellerin's wares to villages, towns, and bourgs throughout most of the French provinces.

Graphic illustrations describing the military career of Napoleon Bonaparte brought both fame and notoriety to the printing firm during the July Monarchy (1830–40). Developed as a series of fifty-nine poster-sized wood-block illustrations, each picture from the Napoleonic series was reproduced at five thousand copies per printing.[7] Because of the minimal cost of the Pellerin prints (a sou or less), and because they were disseminated among peasants and workers, such art became associated with the vision and tastes of the lower classes. By successfully developing a graphic biography of Napoleon Bonaparte for the common people, Pellerin received acclaim as one of the first successful propagators of the popular legend of Napoleon I.

Although Pellerin had been permitted to produce poster art of Napoleon I during the First

Empire and the early years of the July Monarchy, the printer's efforts to reproduce Napoleonic themes were thwarted during the Restoration. No doubt the Epinal printer was limited by the terms of the censorship laws of 1815 and 1822 that forbade the publication of any newspaper, book, or illustration that might libel or threaten the existing government.[8] With the ascendance of the conservative Villèle ministry (1822–27), censorship regulations became even more severe, requiring municipal authorities to examine every book, pamphlet, and broadsheet that came off the press. From 1829 to 1830, the Polignac ministry placed even more stringent regulations on the press, creating intense opposition between liberals in the Chamber of Deputies and the right-wing coalition in the ministry. Particularly during the final years of the Restoration, censors adamantly opposed any textual or graphic reference to Bonaparte (or his son).

Unlike Pellerin, many printers, composers, and creators of Napoleonic art and texts succeeded in evading censorship authorities. Even with increasingly strict regulations to control the press, some local judges considered references to Napoleon to be innocuous, particularly after the exile and death of the French emperor. More tolerant prefects felt that Napoleon should no longer be considered a threat to the political status quo.[9] Their laxity permitted a lively underground market of Napoleonic art, texts, and artifacts about Bonaparte and his armies to flourish in parts of Paris and regional France. As a result of this underground market, the popular legend of Napoleon Bonaparte survived in the face of continuing hostility and prohibitions from the Bourbon government.

Despite several serious confrontations with censors during the Restoration, Jean-Charles Pellerin, his son Nicholas, and his partner, Pierre-Germain Vadet, tried to capitalize on the Napoleonic legend by issuing prints of several of Napoleon's most celebrated battles. To accommodate the Bourbon authorities, the Pellerin atelier did not portray the notorious figure of the former emperor in each composition. Censors, nevertheless, distrusted the printer's persistent desire to produce representations of Bonaparte and his armies. The printer's tenacity suggests that more was at stake than capital gain.

Because the Pellerin founder, his son, and veteran Vadet were active Masons with a history of liberal dissent, the printing firm was under considerable surveillance during the Restora-

tion. The elder Pellerin had served as an elector during the French Revolution, and municipal leader in Epinal during the Directory. Vadet, who received a Legion of Honor medal for serving with Bonaparte at the Battle of Essling, was indicted for his participation in several bonapartist conspiracies during the early Restoration. Through their affiliation with the Freemason lodge in Epinal, the Pellerin printers became engaged in liberal criticism and resistance to the autocratic policies of Charles X. The liberal-bonapartist allegiances of these provincial businessmen reflected aspects of a national political struggle against the Restoration monarchy.

Despite censorship restrictions during the Restoration, the Pellerin firm was one of the first provincial printers to recognize and capitalize on the marketing potential for representations of Napoleon's military career. But because of the seditious nature of bonapartist art, the Pellerin prints also conveyed strong political innuendo. Some consideration of Napoleon's public image from the First Empire up to and through the Bourbon regime can elucidate the social and political meanings associated with portraits of Napoleon when Pellerin and Vadet first began to produce their broadsheets.

From the early phases of his military career to the Imperial regime, Bonaparte developed the outlines of a myth that was to define his public profile for the next several generations. Napoleonic propaganda began as early as 1797, when Bonaparte embellished accounts of his military campaigns against the Austrians in Italy in his carefully edited *Bulletins of the Great Army*.[10] After his accession to the throne as emperor, Napoleon created an imposing public image, not only through written propaganda but also through censorship and artistic patronage. By 1811, only four newspapers existed in Paris, all under strict Imperial surveillance, while only one paper was available in each of the French departments.[11] Since provincial papers depended on excerpts from the famous *Bulletins* published in Paris, Napoleon was able to control and disseminate historical interpretations of his military campaigns both within France and to his satellite territories.

The emperor developed a self-portrait to legitimize his position as France's sovereign by commissioning the most recognized artists of the epoch, such as Jacques-Louis David, to portray him in monumental grandeur.[12] In David's famous *Consecration of the Emperor Napoleon and the*

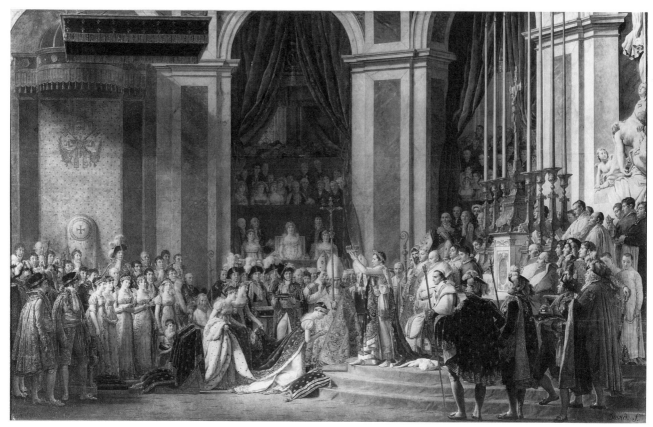

**Jacques-Louis David,** *Consecration of the Emperor Napoleon and Coronation of the Empress Josephine in the Church of Notre Dame, Paris, December 2, 1804.* **Musée du Louvre, Paris. Photo by RMN.**

*Empress Josephine in the Church of Notre Dame* (1808), for example, Napoleon is surrounded by his family and an audience of notables including the pope. Pope Pius VII sits behind Napoleon and Josephine, merely a witness to Bonaparte's regal display of authority. The emperor, dressed in the costume of the first Bourbon king, Henry IV, wears a red robe with golden tassles, a silk sash, and laurel wreath as he lifts a crown above the kneeling figure of Josephine.[13] Through both written and graphic texts, Napoleon created a conservative image to reinforce his authority in France and encourage respect among the other regencies of Europe.[14]

But after his final defeat and exile to St. Helena in 1815, Napoleon collaborated with several associates to publicize his political accomplishments from a more liberal and democratic perspective. These biographies were a response to increasing criticism raised against the emperor during the latter years of the Empire from writers within France such as Chateaubriand, de Staël, Lamartine, and Vigny, who lambasted Bonaparte for his ruthless accession to power.[15] Concurrently, German and English caricaturists derided Napoleon I with macabre drawings and cartoons that portrayed the emperor's insatiable appetite for European territory. Collaborating with Baron Emmanuel de Las Cases, Lieutenant General Gourgaud, the Count of Montholon, Count Bertrand, the English physician Barry O'Meara, and the Italian doctor Antommarchi,[16] Bonaparte endeavored to enlist public sympathy by presenting his own version of recent history and by revealing his mistreatment at the hands of the English.[17] Napoleon's sufferings in exile were presented both as the singular experience of an unfortunate prisoner and as the collective humiliation of the French nation after defeat by the Allied powers.

The *Memorial from Saint Helena* (1823), edited by Emmanuel de Las Cases, described Napoleon's exile to St. Helena from 20 June 1815, when he left his estate at Malmaison, until the English authorities (out of suspicion) forced Las Cases to leave Napoleon at Longwood on 25 November 1816.[18] In the *Memorial*, Las Cases claimed that Napoleon wanted to establish liberal institutions and policies but that the disorder of the revolution demanded greater severity.

From this perspective, Napoleon brought France out of the chaos of the revolution through ostensibly autocratic measures. Las Cases argued that Napoleon, nevertheless, assumed power at a propitious moment in French history:

> Finally citizens of every class in France would have seen Napoleon as an anchor of salvation, as a catalyst being the only one who was capable of saving France, both from the terror of ultra-royalism and from the terror of demagoguery.[19]

In view of the enormous disequilibrium following the Revolution, Las Cases pointed out how Napoleon adopted autocratic policies to preserve French integrity: "The people would have preferred that I was Washington. But I could only be Washington with a crown on my head."[20]

The *Memorial* also depicted Bonaparte as a soldier of the revolution and harbinger of the liberal principles of 1789. Las Cases portrayed Napoleon as a liberator of oppressed nationalities and as a leader who advocated peace and defensive war to protect the principle of freedom. In the *Memorial*, Napoleon fought for the establishment of an egalitarian society:

> I did everything in my power to bring every faction into accord: I gathered you together in the same apartments and allowed you to eat at the same tables and drink from the same cups. Your consolidation [as equals] was my ultimate goal.[21]

According to Las Cases, the Napoleonic legal system was a carefully developed plan to dismember the bonds of unfair patronage practices based on family status and feudal privilege. This latter interpretation found the greatest resonance among educated liberals and disenfranchised commoners, who opposed the reinstatement of the church and nobility to social and political power during the Bourbon Restoration.

A text of rather mysterious origin indicated that Napoleon's attempt in exile to rehabilitate his reputation was replicated by others on the Continent. The *Manuscript from Saint Helena*, purportedly written by Bonaparte, appeared in England and Belgium in 1817 but was forbidden to be printed in France until 1857.[22] Black-market copies of these controversial memoirs were quickly smuggled into Paris, however, where they rapidly gained widespread popularity in liberal circles. Like the *Memorial* edited by Las Cases, the *Manuscript* was a convincing defense of Napoleon's political and military strategies in the face of intense criticism preceding and following his demise from power. In the *Manuscript*, Bonaparte is represented not only as a sagacious military hero and effective administrator who brought France out of the chaos of revolutionary anarchy but also as the representative of the French Revolution and its most constant advocate.

The *Manuscript* treated the emperor's authoritarian policies as a means to establish postrevolutionary civil and political order. Chateauvieux explained that the Imperial wars were not the result of Napoleon's inveterate ambition, but rather the inevitable consequences of a conflict between the old regime in Europe and the new: "I fought to destroy them [the European monarchies] in order to make way for the new order. This was the necessary consequence of changing from one social system to another."[23] The destruction of outdated structures from the former regime was necessary to create a republican society based on the ideas of the Revolution: "Republican structures could not last because it was impossible to create a republic based on the foundation of the old monarchies."[24]

The document also described how Napoleon liberated Frenchmen from the patronage practices of the Ancien Régime and thereby opened up more democratic avenues to power. "That is to say that it was necessary to destroy the Ancien Regime in order to establish equality because equality was the linchpin of the Revolution."[25] Further, the *Manuscript* affirmed that during the Empire, even the lowliest soldier had been able to rise to the highest rank through merit:

> In this country, everyone had equal access to public office. One's origin was in no way an impediment. Equal opportunity to upward mobility was a universal principle in the government. Such mobility was my own avenue to power.[26]

To avoid castes or factional conflicts, Napoleon made clear, "no one was subordinated or excluded," and no individual or any class could legitimately maintain unfair prerogatives over another.[27] In this dramatic tour de force, Napoleon the autocrat became identified with the laws and institutions that undercut hierarchy and privilege.

The democratic persona created by Bonaparte and subsequent editors took on a life of its own, particularly when infused with the expectations, dreams, and frustrations of liberal groups dur-

ing the Restoration. In the gospels of St. Helena, the editors portrayed Napoleon as an enlightened ruler and legendary soldier who led the French to international glory. His authoritarian manner and policies were glossed over in favor of a more appealing symbol that conveyed yearnings for a previous age of remembered glory as well as explicit discontent with the Bourbon government. Although Napoleon often employed autocratic means as a justifiable strategy while he was alive, after his death, liberal writers identified Napoleon with the end of the old feudal monarchies and the establishment of an egalitarian system based on civil and political law.

Fascination in the 1820s with the Napoleonic legacy gave expression to a momentous shift as young people moved from the conventions of their elders to a world based on a vision derived from the Revolution.[28] This younger generation of liberal writers and professionals who emerged from the Imperial educational system during the 1820s was trained to believe that avenues to upward mobility were available through justifiable merit. Yet political and economic positions were not open to most talented young men of this generation who were at odds with royalists and ultras entrenched in power. Consequently, they were obliged to live in poor circumstances with few options for professional advancement. Having inherited the Revolution, young liberals were poised at a moment between anguish and hope, anguish that much of the Revolution might remain an unfinished dream, and hope that they might preserve a common vision for the future. Since this postrevolutionary generation tended to oppose privileges of corporate bodies, classes, and organized religion, the memoirs of Napoleon, whether authentic or apocryphal, became a manifesto marking disassociation from the old regime and allegiance to a new order yet to be realized.[29]

Veterans from the Imperial Army constituted another group whose dreams for career advancement were thwarted during the Restoration. After Napoleon's defeat and the reinstatement of the Bourbons to the French throne, most soldiers from the Great Army were released from active service or forced into retirement. If those on pension wished to pursue other avenues for employment, they were frustrated because Imperial veterans were forbidden to engage in any full-time occupation.[30] While awaiting their return to active service, former officers or *demi-soldes* received a pension or half salary.[31] But the meager salaries offered to these veterans were probably less trying than their treatment at the hands of the Bourbon authorities.

Memoirs from the Restoration period reveal that veterans of the Napoleonic armies were placed under continual suspicion by local authorities for seditious behavior. In his military journal, Captain Leon Coignet states how he was repeatedly denounced by informers who spied upon a number of retired officers and delivered false information.[32] Other soldiers in Coignet's situation experienced similar censure from local authorities when they left active service and returned to their country of residence or origin. They frequently attempted to overcome their marginality and reinforce their self-respect with stories about their military experiences. A lithographic print by Nicholas-Toussaint Charlet reveals a young boy's admiration for a venerable *demi-solde* from the Imperial wars. The admiration of France's younger generation for the accomplishments of the Imperial veteran was a popular theme that Charlet developed in lithographic engravings during the Restoration and July Monarchy. While the young boy salutes the veteran with awe and respect, the latter's crony friends gather in the background (with another young admirer), discussing their war adventures.

Veterans' memoirs generally reflected a persistent faith in the military prowess of the Imperial Army and Napoleon's greatness as a military leader. A diary by Jean-Baptiste Barrès underscored the unflagging devotion in which Napoleon was held by his soldiers. According to Barrès, before the Battle of Austerlitz, the emperor proclaimed to his army, "Soldiers, I cannot better express what I feel for you than by saying that I bear in my heart the love that you show me day by day; Napoleon's soldiers responded with corresponding adulation.[33] When the emperor came to Barrès's bivouac to read a letter that he had recently received;

one of us took a handful of straw, lit it so that he might read it more rapidly. The emperor went from one bivouac to the next. Men followed him with burning torches to light up the path. As his inspection was prolonged, the number of torches increased with soldiers shouting "Vive l'empereur." These cries of love and enthusiasm spread in all directions like brush fire.[34]

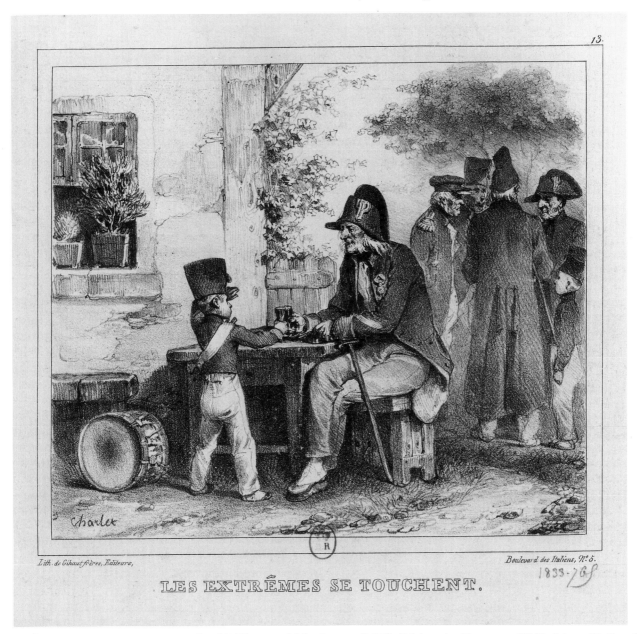

*13.*

Lith. de Gihaut frères, Editeurs,

Boulevard des Italiens, N.º 5.

1833.

## LES EXTRÊMES SE TOUCHENT.

**Nicolas-Toussaint Charlet,** *Extreme [age] Differences Make Contact* **(1833). Cabinet des Estampes, Bibliothèque Nationale de France, Paris.**

According to veteran Coignet, the Little Corporal was beloved for his skill in felling the oncoming enemy:

> When he appeared, he was on foot, he had a little hat and a little sword. He reviewed the troops alone then all of a sudden we heard shouts from the soldiers as Bonaparte departed lifting his little sword.[35]

Fellow devotee Sergeant Bourgogne wrote in his memoirs that he admired Napoleon not only for his military genius but also because the emperor remained beside his troops, whatever the odds, even during the tragic retreat from Moscow in 1812:

> The Emperor in our midst inspired us with confidence, and found resources to save us yet. There he was—always the great genius; however miserable we might be, with him we were always sure of victory in the end.[36]

Such affection expressed by Barrès, Coignet,

and Bourgogne reflected the stubborn faith of veterans who maintained their allegiance to Napoleon despite the distress of political surveillance and reprisals during the Restoration.

Although memories of Bonaparte elicited nostalgia among soldiers who had served in the Imperial armies, during the subsequent regime references to Napoleon also aroused the anger of veterans who were summarily released from military duty. For those veterans who were forced into retirement, political discontent combined with sentiment to create a powerful channel for political rhetoric and dissension. That veterans were unhappy with their situation and prone to political opposition appears to be more than a myth created by the authorities to legitimize their own fears.[37]

The propagation of military art, songs, and ephemera during the Restoration attests to a widespread popular market for Napoleonic representations based on the "remembered" experience of veteran soldiers. Texts, images, art, and memorabilia that portrayed Napoleon (or soldiers from the Great Army) proliferated during the Restoration and intensified in distribution in the years immediately preceding the Revolution of 1830. To some extent, popular texts and representations corresponded with the central ideas found in literary sources associated with the Napoleonic legend such as the *Memorial from Saint Helena*. On the other hand, popular rhetoric about Napoleon conveyed both the nostalgia and political discontent of veterans, artisans, shopkeepers, and working classes in Restoration France.

Popular songs reveal the perspectives of groups who constituted Pellerin's most likely clientele. Military songs celebrated Napoleon and his armies in urban *goguettes,* or singing clubs that frequently included veterans. Les Amis de la gloire (friends of glory), a typical singing club met in a modest Parisian cabaret. Despite a police ban on political songs and discussions, the memory of Napoleon was carefully integrated into the evening's celebrations. Festivities might open with the comment "ici on est pour le petit" (everyone here is for the Little Corporal). After dinner, members of the society sang to the heartfelt strains of the "Ode to the Column" (1818) by Paul-Emile Débraux, a song that expressed sentimental wishes for the "return" of the Little Corporal.[38]

Ah qu'on est fier d'être français
quand on regard la colonne
sur son rocher de Sainte Hélène
honneur à la patrie en cendre
il reviendra, le petit caporal.
Vive à jamais la redingote grise.[39]

[Ah, one is proud to be French
when one looks at the Vendôme column,
On his rock at St. Helena,
Honor to his country still in mourning.
The Little Corporal will return.
Long live [the soldier with] the gray overcoat.]

The humble Little Corporal in bistro lyrics was more accessible to commoners than more sophisticated portraits of Napoleon as commander and general of the Great Army.

Like Débraux, Pierre-Jean de Béranger employed songs to describe characters from the Imperial and Revolutionary wars who reminisced about their battle experiences. His work engendered an extensive audience in Restoration France.[40] He often portrayed the veteran in a country setting, a situation that suggested both forced retirement and political repression, thereby confirming a theme found in popular lithography and poster art. In addition to pacifist connotations associated with the soldier-farmer Cincinnatus, the stalwart fellow in the lithograph holding the Legion of Honor cross and looking off into the distance, suggests the unhappy state of soldiers who were forced into retirement under the Bourbon government.[41] For example, in "The Old Sergeant," Béranger captured the sentimental but bitter connotations surrounding the Napoleonic veteran who returned to his homestead. Despite the peaceful ambiance of the countryside, the underlying message of political discontent probably made the greatest impact on Béranger's audience.

le vieux sergent se distrait de ses maux
et d'une main que la balle a meurtrie
berce en riant deux petits-fils
assis tranquille au seuil du toit champêtre
son seul refuge après tant de combats.[42]

[The old sergeant managed to forget his wounds
And in a hand that a shot had mutilated
He laughed and rocked two small grandsons
Seated tranquilly beneath a rustic roof
His only refuge after many combats.]

The country setting in this poem is at once a

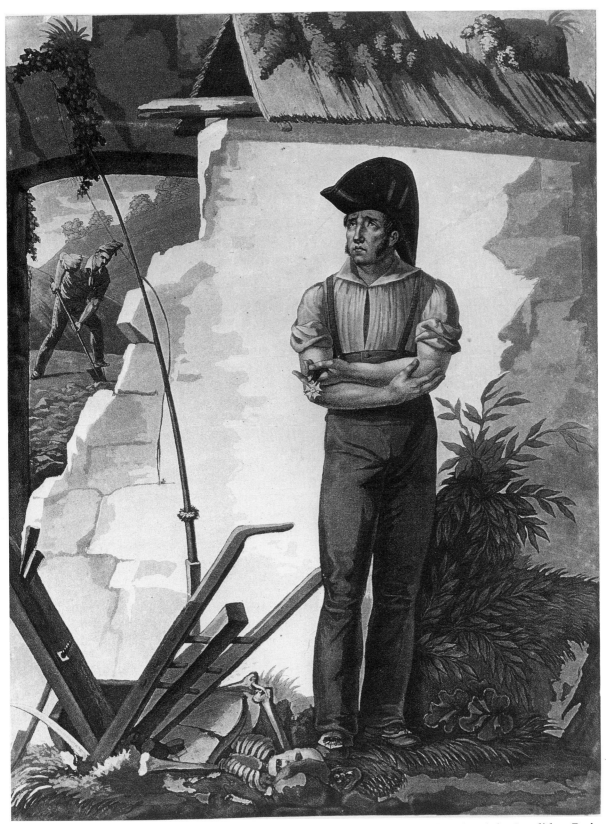

Pierre-Jean de Béranger, *The Soldier Farmer*, aquatint. Musée de l'Armée, Hôtel National des Invalides, Paris.

refuge and at the same time a sort of limbo when compared with the challenges of life in combat.

The veteran's political frustrations were also apparent in Béranger's lyrics for a series of songs on the Napoleonic legend. In "The Old Flag" (1821), for example, a veteran laments the tricolor flag hidden in his farmhouse:

> j'ai mon drapeau dans ma chaumière
> quand secourai-je la poussière
> qui ternit ses nobles couleurs.[43]

> [I have my flag in my cottage.
> When will I be able to shake out the dust
> That dims its noble colors.]

Nostalgia for past glory joins with the veteran's wish to reinstate the tricolor and its bearer to their rightful place in history:

> Il est caché sous l'humble paille
> où je dors pauvre et mutilé
> lui qui, sûr de vaincre, a volé
> vingt ans de bataille en bataille
> chargé de lauriers et de fleurs
> il brille sur l'Europe entière.[44]

> [It is hidden under humble straw
> Where I sleep poor and mutilated.
> So sure of conquest, it has flown
> From battle to battle
> Bearing laurels and flowers
> It blazed over all Europe.]

In his description of the tricolor flag, Béranger contrasts the soldier's nostalgia for the adventures of the Imperial campaigns with the sadness he experiences in forced retirement.

Béranger's "Memories of the People" (1828) celebrated Napoleon's fictional return, a theme repeated in numerous broadsheets during the late Restoration and the July Monarchy. The illustration for a song rendition of the "Memories of the People" describes the figure of an old woman who lays aside her distaff and points out the bust of Napoleon to her extended family, seated about the table. The sculptural representation of the Little Corporal on the mantelpiece suggests the importance of Bonaparte's figurative "presence" in the peasant cottage.

In the lyrics, the old woman describes her unexpected meeting with Napoleon dressed in his legendary hat and overcoat. According to the peasant woman, the emperor entered her cottage with a small escort, sat beside the fire, and demanded something to eat. As if preparing the altar for Mass:

> Je sers piquette et pain bis
> puis il sèche ses habits
> même à dormir le feu invite.
> Au réveil, voyant mes pleurs
> il me dit: Bonne espérance!
> je cours de tous ses malheurs
> sous Paris venger la France.[45]

> [I serve him bread and wine.
> He dries his clothes then
> Slowly falls asleep in front of the fire.
> Upon awakening and seeing my tears
> He says to me: Remain hopeful!
> I am going to release Paris from her misfortune
> And avenge French defeat.]

The final stanzas establish an antiphon between the old woman's hope that Napoleon would return and news of his death. "They said that he would return, that he is going to arrive by sea." But she soon realizes her deception: "My sadness was bitter. It was bitter."[46] By describing a peasant woman's devotion to the Little Corporal, the poem creates a sentimental portrait of the French emperor. It also conveys considerable political nuance by portraying Napoleon as a weary traveler who withdraws for an evening to a humble peasant cottage before returning to Paris to avenge his enemies. Published just two years before the Revolution of 1830, Béranger's reference to Napoleon's return, no doubt, raised the ire of patriotic groups who wanted to avenge France's humiliating defeat at Waterloo.

Though Béranger freely expressed resentment for France's debacle in 1815, the poet did not participate directly in any political party or intrigue. Yet because of his affiliations with Laffitte, Thiers, Cauchois-Lemaire, and other liberal deputies in the Assembly, he was considered to be a liberal republican with firm political views.[47] The famous composer was fined four times and placed in prison twice, once in 1821 and again in 1828, for songs that caricatured the two Bourbon kings.[48] His imprisonment made such a strong impression on his devotees that he was considered a martyr for the liberal cause. His following was extensive: songs by Béranger were not limited to boutiquiers and artisans in Paris; they were also marketed by peddlers to peasants and artisans in the countryside. Béranger, like his associates Débraux, Méry, Barthélémy, and numerous other anonymous composers, was able to develop representations of Napoleon and the Imperial veteran that provoked conservative proponents of the Bourbon government.[49] They found Béranger's poetry to be reprehensible not

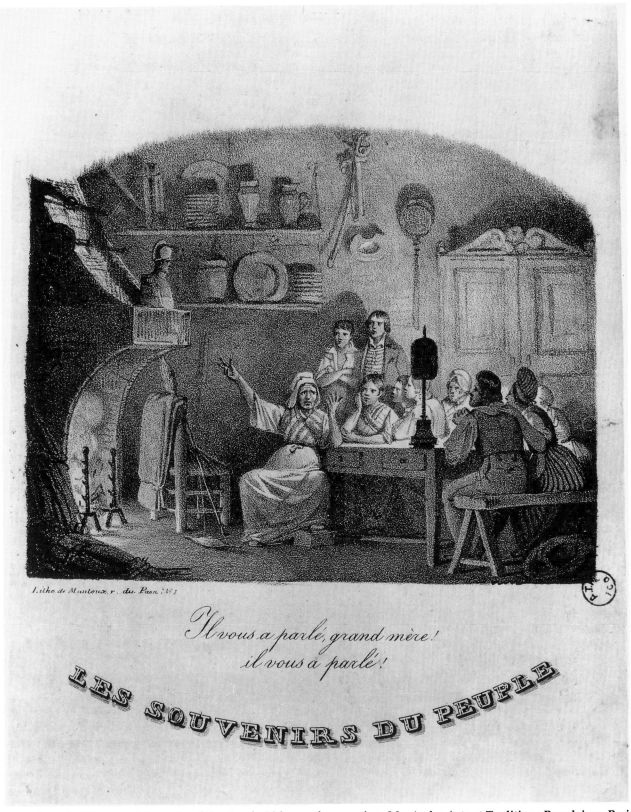

*Il vous a parlé, grand mère !*
*il vous a parlé !*

LES SOUVENIRS DU PEUPLE

Pierre-Jean de Béranger, *Memories of the People.* Lithograph engraving. Musée des Arts et Traditions Populaires, Paris.
Photo by RMN.

simply for its seditious ideas but because he used the Napoleonic legend to denigrate the great and praise the common man.

The explosion of seditious symbolism and rhetoric about Bonaparte and his son reveals the political climate in regional France when Pellerin was considering his decision to market the Napoleonic broadsheets. Since few legitimate channels existed for expressing local political feelings during the Restoration, Napoleonic "shouts," rituals, and representations constituted a spontaneous way for disenfranchised groups to express their political and economic grievances with the Bourbon authorities.[50] Predictably, any sort of reference to Napoleon was seen by the Restoration administration as a potential threat to the regime's security. Police files from this period are consequently replete with reports of seditious remarks, symbols, and disturbances related to either Napoleon or his son. Though filtered through prefectorial records, these shouts reveal an unedited sense of immediacy and imagination that suggests their authenticity.

Due to increasing disappointment after the accession of Charles X to the throne in 1824, for example, Napoleonic expressions increased particularly during the latter years of the Restoration (1826–30).[51] Despite common knowledge of Napoleon's death, many people in the countryside continued to believe that Napoleon would return to France to save his people from economic and political oppression.[52] Whether Napoleon was alive or not, the use of his name had undeniable power to threaten political enemies and to effect a desired political change.

Most often, such remarks denigrated the Bourbon regime by announcing the people's preference for Napoleon. In March 1827, a shoemaker named Pierre Mirende from Nantes spoke in derogatory terms to several sentinels posted near the town garrison when returning from an inn somewhat inebriated: "Vous ne valez pas les anciens; pour moi, je dis 'Vive l'empereur! Vive Napoléon!'" [You aren't the equal of the former armies. For my part, I say: Long live the emperor! Long live Napoleon!] When more soldiers were called to apprehend him, he responded by shouting: "Vous êtes des canailles, de mauvais serviteurs. Vive l'empereur."[53] [You are scoundrels, lousy servants. Long live the emperor!] That same month, M. Mettier, a nondescript in the department of Angers, sang seditious songs about Napoleon in a local inn.

By ridiculing the fleur de lis, his commentary was a pointed denigration of the Bourbon government: "Vive Napoléon! Vive les trois couleurs! . . . la couleur blanche est sale et qui devient jaune. Je n'aime pas."[54] [Long live Napoleon! Long live the three colors! . . . The color white is dirty and is fast becoming yellow. I don't like it.] In May 1827, a peddler named Ferrand was picked up on the streets of Rouen for singing the following refrain: "Va nous t'apprendrons à respecter le Nom du grand Napoléon."[55] [We are going to teach you to respect the Name of the great Napoleon.]

Implicit faith that Napoleon would return clandestinely to rid the nation of the Bourbon kings was expressed in numerous seditious remarks in the several years that preceded the Revolution of 1830. In October 1828, the farmer Joseph Vernault was apparently drinking with a number of peasants in a cabaret in Bressuire, located near Poitiers. After the evening's conviviality, Vernault's associates shouted: "Vive l'empereur. Vive Bonaparte! Qu'il aurait bien le chercher à Paris."[56] [Long live the emperor! Long live Bonaparte! They ought to look for him in Paris.] In November 1828, Massot, the son of a tailor, sang a seditious song publicly in the tribunal of Argentière in the department of Nîmes: "Napoléon est un bon boug. . . . il reviendra . . . pour chasser tous les Bourbons."[57] [Napoleon is a good guy . . . . He will return . . . to hunt down all the Bourbons.] In July 1828, in the commune of Héricourt, the department of Douai, a soldier shouted infamous remarks against the clergy, the nobility, and Charles X with sporadic repetitions of "Vive l'empereur." [Long live the emperor.] Since he was traveling from commune to commune as a beggar, it is likely that this soldier was a veteran from the Napoleonic armies.[58]

From 1827 to 1830, expectations for the return of Napoleon or his son recurred in cycles during the Bourbon Restoration as an expression of defiance against the Bourbon government during a period of political repression and economic want.[59] While acknowledging the unlikelihood of Napoleon's return, workers and artisans renewed their expectations for the return of the son. In the fall of 1827, Jean-Baptiste Maquet, a day worker living in a boarding house in St. Omer, stated:

Les Bourbons sont en France; ils peuvent vivre ici; mais le fils de l'autre est en Allemagne. Il va venir

pour bouleverser toute cette canaille; on croit que Napoléon est mort, mais on verra ça; tous n'est pas mort.[60]

[The Bourbons are in France; They can live here; But the son of the other is in Germany. He is going to get rid of those scoundrels. They say that Napoleon is dead. But it's not over yet.]

Fabulous stories were constructed around the return of Napoleon's son and his accession to the French throne. A thirty-one-year-old itinerant window maker named Sudré shouted the following diatribe:

Que le petit Napoléon avait fiancé la fille du grand Sultan. qu'une fois le mariage fini, il aurait la couronne de France car elle n'appartient plus au rois mais au petit empereur.[61]

[Little Napoleon is engaged to the daughter of the Great Sultan. Once the marriage is concluded, he will be on the French throne because it doesn't belong to the king anymore, but to the little emperor.]

In February 1829, a placard was hung in Gerblantier near Quimper, stating: "Vive Napoléon II! Rejouissez-vous braves français d'un regne qui arrivera cette année."[62] [Long live Napoleon II! Let us rejoice for the kingdom that will be established this year.]

Posters, signs, and ritual expressions about Napoleon I and his heir constituted another form of political sedition against the Restoration government. In April 1826, a young man wrote this familiar expression on the home of a local notable: "À bas les Bourbons. Vive Napoléon."[63] [Down with the Bourbons. Long live Napoleon.] In March 1826, in Lunéville, a garrison town located in the Meurthe et Moselle, a poster was placed on the pillars of the marketplace that read "Vive Napoléon. Vive la république française. À bas les Bourbons."[64] [Long live Napoleon. We salute the French Republic. Down with the Bourbons.] In a number of such cases, Napoleon was associated with a republican system of government opposed to the Bourbon monarchy. An inscription was written on the walls of a church in Champagne in October, 1828: "Vive Buonaparte. Vive Napoléon. Vive la République." [Long live Bonaparte. Long live Napoleon. Long live the Republic.] The message was signed Maiziaire, a carpenter who had apparently worked in the church during the week before this incident.[65] During that same fall, a stranger arrived in the

commune of Toulon claiming that he was Napoleon II. According to the authorities, he cursed the rich and the church, expressing outrageous comments about the king. The prefect concluded that he was simply not in his right mind.[66]

Ritual gestures and street theater expressed symbolic resistance to the Bourbon government with potentially even greater dramatic effect. In May 1829, in Cholet, department of the Marne et Loire, a tricolor flag was surreptitiously attached to a tree along the main street of the commune.[67] More impressive was a play about Napoleon in Russia called *The Russian Spy* that was put on extemporaneously in the streets of Chartres. The main actor, Scavola Boudin, portrayed himself as Bonaparte, dressed in a gray coat, boots, and hat, surrounded by his soldiers who suffered tragically during the retreat from Moscow. Apparently the play was given in other provincial cities, much to the consternation of the provincial authorities.[68] In Montbéliard on 27 July 1829, two effigies representing Napoleon and his son were paraded about by a juggler named Heil. The people shouted bravo! bravo! and clapped with much gusto, creating disturbances in the center of the town.[69] Dramatic improvisations about Napoleon in street theater testify to the currency of such politically explosive themes among plebeian groups. It is worth noting, however, that while these rituals expressed defiance, they rarely encouraged direct confrontation with police authorities.

In 1828 and 1829 when Pellerin requested permission to print popular broadsides about Napoleon, numerous peddlers were cited for marketing engravings and forbidden lithographs about Bonaparte and his son throughout provincial France.[70] In the Northeast, a flourishing market in clandestine art existed. For example, in November 1829, Pierre Certicat from the Haute Garonne was peddling Napoleonic art in the garrison town of Lunéville, just north of Epinal. His hutch was filled with anonymously produced pictures of Napoleon and his son, including the *Debarkation of Napoleon at Antibes* and *Bonaparte's Approach and Arrival in Grenoble*.[71] The peddler Bertrand Bon also traveled through the Northeast in the fall of 1829. In October, Bon was arrested and cited in Alt Kirch for selling a set of Napoleonic posters: *The Duke of Reichstadt, Napoleon's Return from the Island of Elbe, Napoleon's Arrival in Grenoble*, and a print entitled, *The Dream*. Apparently very popular during the final years

of the Restoration, this piece portrays a seated Napoleon with a woman (Marie Louise) sleeping at his feet. Their son, on his father's lap, wears a crown in the form of an eagle. The peddler who carried these poster images claimed that they were purchased from the Debreuil printing house, 8 rue Zacharie, in Paris.[72]

The circulation of seditious representations of Bonaparte became a contested political issue during the final years of the Bourbon regime. In July 1828, the Parisian prefect of police wrote a letter expressing his consternation about the proliferation of objects and images representing Bonaparte:

> During the last month, merchants of images and objects of curiosity no longer display portraits of the king and his family, but rather, shops are currently filled with images of Bonaparte and his son, the duke of Reichstadt, wearing either the uniform of a colonel in the hussards, or in a black suit normally worn by the bourgeoisie.[73]

In his response, the minister of interior, Jules Polignac, responded by echoing the prefect's uneasiness; he observed that such representations "would further the spirit of rebellion" and possibly lead to disturbances of the public peace. The minister added that "images of Napoleon proliferated throughout the capital, even on luxury items such as clocks, furniture, and printed on fine fabrics." Polignac attributed the problem to a "cult of a previous ruler."[74] He found representations of Napoleon's son particularly pernicious.

In August 1828, the police wrote again to the ministry, indicating that "knives with silver handles representing Bonaparte and his son with an eagle and crown are being sold on the boulevards of Paris"; in another the prefect stated that "Portraits of the Duke of Reichstadt are everywhere: on liquor bottles, engravings, even on the base of elegant lamps."[75] In response to this warning, Polignac decreed that "All images of Bonaparte and his son are prohibited from being printed either in Paris or in the provinces." The minister was concerned that this law be in force particularly for "des classes moins éclairées" [for those who were less educated].[76] Polignac's decision to prohibit the production of Napoleonic art for the popular classes prevented the Pellerin firm from beginning their new endeavor in the fall of 1829.

Inferences concerning the possible accession of the Duke of Reichstadt to the French throne inevitably unsettled the Bourbon government. Even more disconcerting was the fact that bonapartist representations abounded as luxury items in Paris as well as prints and ephemera in the provinces. The existence of both luxury objects and common items demonstrated that Napoleon's posthumous popularity transcended geographical and class lines. For example, in Paris and some of the major cities such as Lyon and Bordeaux, Napoleon's images were printed on elegant fabric, modeled in bronze and marble busts,[77] and etched on gold pins.[78] Concurrently, peddlers and shopkeepers sold inexpensive plaster reliefs, cups, suspenders, and pipes. And with these varied forms of expression, Napoleonic art and ephemera conveyed different meanings: expensive, decorative wares might merely reflect a fad for Napoleonic merchandise, but inexpensive poster art and bric-a-brac could also communicate widespread popular discontent with political and economic conditions in Restoration France.

During the Restoration monarchy's final years, workers and artisans used Napoleonic slogans to make specific reference to the failure of the grain harvests. In October 1827, Gabriel Fauqué shouted in the streets of Avignon: "l'Empereur va bientôt revenir; il vous arrangera tous comme il faut; il nous donnera du moins du pain à manger."[79] [The emperor will soon return. He will set things right. Napoleon will at least give us bread to eat.] A sign hung in Arras on 4 May 1829 bore the following indictment of the Bourbon king:

> Vive le roi, ou le pain
> sans un bon roi, pas de pain
> pas d'argent ni aucun époux.
> Vive l'empereur et son successeur.
> Vive Napoléon, roi de Rome.[80]
>
> [Long live the king, or bread.
> Without a good king, no bread.
> No money, no husbands.
> Long live the emperor and his successor.
> Long live Napoleon, king of Rome.]

Grain revolts in 1829 and 1830 brought an increase of seditious activity throughout France.[81] The *Tribune of the Departments* described the situation of workers and the unemployed who were forced into a marginal existence by the dearth of grain. Misery prevailed with many dying of starvation. The *Tribune* observed that "Bands of beggars grew because the larger farmers refused

to offer them charity." "Thieves and the threat of riots," the *Tribune* explained, "can be attributed principally to the despair of these unfortunate people who travel about without work and without bread." To editors of the *Tribune,* it appeared that not only peasants but also many artisans and industrial workers were out of jobs in 1829.[82]

Discontent with the reign of Charles X, the repressive policies of the Polignac ministry, and the failure of the grain harvests in the period from 1827 to 1830 precipitated political conflicts that reached a critical point in July of 1830. From police archives it is apparent that most representations of Bonaparte and his son symbolized liberal-bonapartist opposition to the recalcitrant regime, even to the point of revolution. References to Bonaparte and his son constituted both an appeal for the redress of economic grievances and a demand for political change.

The regime's economic and political crisis helps to explain why, just two years prior to the July Revolution, Nicholas Pellerin and his partner, Pierre-Germain Vadet, a veteran of the Imperial wars, petitioned the authorities to print a portrait of Napoleon Bonaparte. Although their request to the police chief emphasized the innocuous nature of publishing Napoleonic art, the publishers' motives must have been mixed. They were undoubtedly aware of both the marketing potential and the seditious implications of Napoleonic art.

The various types of Napoleonic texts and representations expressed disaffection with the Restoration regime and hope for a more just economic and political order. The symbol of Napoleon allowed young liberals to express their discontent with the obdurate policies of a conservative system that had forestalled economic and political mobility. Principles of social equality propounded in Napoleonic texts became a point of contention for young people educated during the Imperial regime, whose professional ambitions were subsequently thwarted. For thousands of veterans from the Great Army, the Napoleonic myth was created from memories of war associated with the audacity and heroism of its leader. In the eyes of former soldiers, the Little Corporal represented national glory and the hope for eventual reinstatement in active service. While some veterans regarded representations of the Great Army as a way to commemorate lost comrades or to celebrate their military prowess, for others such representations affirmed their defiance of the political status quo.

Like more eloquent texts such as the *Memorial of Saint Helena,* seditious shouts, songs, art, and ephemera about Napoleon expressed a deep-seated concern for the establishment of a more egalitarian political system. Yet, unlike more polished texts that incorporated Napoleonic ideas, populist sedition revealed an almost supernatural faith in the capacities of Bonaparte to rectify economic and political injustices experienced by lower-class and marginal groups during the Restoration monarchy.

By the time that liberal Pellerin and his bonapartist associate Vadet were considering the military biography of Napoleon as a serious project, the legend had assumed a life of its own that was enriched by contributions from various individuals and groups. Despite different voices and levels of cultural expression, references to Napoleon and his son displayed startling similarities that transcended class and cultural distinctions. For liberals, veteran soldiers, artisans, and marginal groups who wished to affirm their opposition to the principles and policies of the existing regime, Napoleonic texts and representations provided Frenchmen with an effective countercode to contest and eventually eliminate the Bourbon lily.

# 2

# The Pellerin Firm and Political Censorship

Two years prior to the July Revolution, the Pellerin firm in Epinal initiated plans to produce and market popular representations of Napoleon Bonaparte and his armies to customers throughout provincial France. Portraits of Napoleon as soldier and corporal captured a mass audience for the Pellerin printers. Their marketing success with the Napoleonic broadsides occurred principally during the Orleanist regime and prior to the restrictive censorship laws of September 1835 that proscribed the publication of most political art.[1] With the inauguration of the Napoleonic epic in 1830, Pellerin produced approximately 20,000 images, but by 1842, his firm reached a total output of 875,000 images, tapering off to 420,000 in 1843.[2]

According to Champfleury, a member of the censorship commission for popular art during the Second Republic, these simple broadsheets in startling primary colors were destined for the unsophisticated tastes of commoners rather than the more refined tastes of the educated bourgeoisie.[3] The Pellerin artisans applied incandescent blues, reds, yellows, and browns to prints from the 1820s, while they added dark greens, brilliant oranges, and deep Prussian blue to prints produced during the 1830s and 1840s. Even with serious themes, the carnivalesque rendering of the Pellerin prints in a bright spectrum of colors accounted for their undeniable charm.

Despite a lack of classical depth and dimension, the graphic portrayal of Napoleon's campaigns relayed the exhilaration of military conquest and glory to Pellerin's customers. The low cost of the Pellerin illustrations made them particularly attractive to a less well-heeled audi-ence. Tradition still calls the Epinal images *feuilles d'un sou* or prints for a penny.[4] And because such broadsheets were so inexpensive, the legendary history of Napoleon Bonaparte was accessible to peasants, artisans, soldiers, and day laborers as well as to curious members of the provincial bourgeoisie.

Since the Northeast was geographically vulnerable to the German border, northeastern France traditionally emphasized aggressive military values. For residents of the Northeast, memories of invasions and foreign occupations in 1792, 1793, 1794, and 1814 were still alive in the 1830s. During the final years of the First Empire, the Northeast provided the highest enlistment percentage of officers and a higher level of recruits than from any other area of France.[5] As a theater of operations during the Napoleonic wars and an important site for military fortifications, the Northeast was a natural market for military art and memorabilia. According to Edgar Gazin, a nineteenth-century specialist in the history of the Vosges, the characteristic profession for males of this region was that of the career soldier. Gazin wrote that the people of this area generally did not develop strength in the creative powers of the imagination. Few artists or poets were born in the Vosges. Rather, Gazin claimed the people of the Northeast were more like worker ants than the artistic cicadas of the South: "The Northeast preferred men of law, scholars, government, and military leaders."[6]

Since the end of the eighteenth century, military imagery in the form of engravings and battle prints had been important as a popular genre in cities throughout the Northeast. While military art was very popular during the French Revolu-

36

tion, by the early-nineteenth century it was most successful in the cities of Strasbourg, Epinal, and Lille.[7] Although urban engravers produced most military themes in the more refined medium of metal engravings for bourgeois customers, northeastern artisans developed prints of the Imperial army in outline form for children to cut out and color. Strasbourg, in particular, specialized in "tiny paper soldiers" that children could reconstruct in order to create their own parade or dress review. From the first *levée en masse* (universal conscription) in 1792, the marketing of small paper soldiers became a practice that spread from Strasbourg throughout Alsace and northeastern France. Such representations of military figures generated popular devotion to Napoleon I, even after his abdication and exile in 1815.[8]

Military art played an important part in Pellerin's inventory as a political theme that represented pride in both the region and nation. By the end of the First Empire, the Epinal printer had expanded an indigenous military tradition into a national market for Napoleonic art. As a national motif, representations of Napoleon I and his armies conveyed an important message to and about France in the early-nineteenth century. Such military themes gave the nation priority over regions, factions, and classes. Although the Northeast was a region that was proud of its history, its great men, and its soldiers, popular representations of the Great Army also stimulated a sense of national identification and contentiousness with France's former enemies. For the Pellerin printing firm, the success of military themes reflected a growing spirit of national patriotism that resonated with customers who had been either directly or indirectly involved in the Napoleonic wars.[9]

In addition to Pellerin in Epinal, several other printing establishments in northeastern France specialized in inexpensive renditions of Napoleon Bonaparte and his armies. Imagery of Bonaparte developed principally in three towns located in the Northeast: Epinal, Nancy, and Metz. While printers from these garrison cities created an important market based on the military epic of Napoleon I, the Pellerin firm in Epinal was the cradle from which other printing enterprises emerged in the Northeast.

During the late Restoration and early July Monarchy, artisans J. B. Thiébault, A. Lacour, and Nicolas Wëndling received their training as apprentices in the Pellerin foyer before establish-

ing themselves as graphic designers of Napoleonic art in Nancy and Metz. Thiébault, a former apprentice with Pellerin's artisan Georgin, produced a sizable inventory of Napoleonic designs for the printer Lacour et Cie in Nancy from 1831 to 1836. Despite this auspicious beginning, Lacour was rapidly overwhelmed by his former employer and competitor to the south such that the Nancien enterprise rapidly went out of business in 1836.[10] By 1838, Lacour had sold most of the Napoleonic woodblocks to an ambitious young printer from Metz named Dembour. Although Dembour and his partner Gangel did not lose their business because of Pellerin, they never surpassed the originality and marketing success of the Epinal firm during fifty years of competition.[11] Like Pellerin, the Metz firm produced wood-block imagery of Napoleon from 1837 until the 1850s, when they switched to lithographic processing.[12]

Faced with keen competition from printing houses in Nancy and Metz, Pellerin nevertheless remained in the forefront as the most successful producer of Napoleonic art in northeastern France. By industrializing the production of the popular image, Pellerin surpassed smaller enterprises. Through an extensive network of merchants and peddlers, the Epinal enterprise managed to distribute popular imagery throughout regional France, in Europe, and in some parts of South America. Due to the firm's originality and marketing zeal, Pellerin became one of the most important regional printing firms in provincial France during the early-nineteenth century.[13]

Although Jean-Charles Pellerin, founder of the famous Pellerin printing firm, was born the son of a carriage merchant in 1756, by the time of the French Revolution he was considered a successful and respected merchant in Epinal. From 1779 to 1836, Jean-Charles demonstrated his resourcefulness and flexiblity by responding skillfully to the demands of a changing market. Prior to the French Revolution, Pellerin first produced colorful faces for watches and clocks and, subsequently, playing cards. Since the manufacture of decorative faces for clocks and cards was relatively free of political implications, Pellerin was not vulnerable to penalties from rigorous censors during the radical phase of the revolution.[14]

By 1800, Pellerin had established himself as a printer of small pamphlets and broadsides in

Epinal, with four printing presses and nearly one hundred employees. In 1809, Pellerin incorporated the use of stereotyping, a method that he had observed at the Hoffman printing house in Strasbourg. Inspired by the Strasbourg firm, Pellerin was among the first to produce a solid metal cast of print type that could be used to mass-produce any number of copies. By 1810, Pellerin was among the few printers selected by Imperial censors from each region of France to be licensed as a printer, a decision that was formalized in December 1811. In addition to publishing small devotional tracts, pamphlets from the Blue Library, regional catechisms, and almanacs, Pellerin printed broadsides with sensational themes that described horrendous crimes or natural catastrophes such as floods, fires, and earthquakes.[15] At the beginning of his printing operation in 1805, Pellerin listed five works being reproduced in 16,000 copies, while at the end of the Restoration, his enterprise was producing thirty works for a total of 100,000 copies.[16]

The transition from the production of brilliant and imaginative playing cards to the design and manufacture of popular imagery presented few technical difficulties. Pellerin used the same procedure for both cards and poster designs, that of cutting the woodblock and later applying color with a stencil technique. Although the printer employed several apprentices to design his wood-block prints, including Grégoire Georgé and Bernard Jaquinot in 1791, several reproductions dating from the late-eighteenth century demonstrate that Jean-Charles cut some of his own wood-block designs.[17] In creating his designs, Pellerin was inspired by metal engravings produced on the rue St. Jacques in Paris. During the seventeenth and eighteenth centuries, a prolific industry in fine engravings had developed to serve the tastes of notables and members of the haute bourgeoisie. Like other regional printers, Pellerin merely selected themes and images from a traditional repertoire of engravings produced in Paris and then had his artisans redesign the illustration in a less expensive wood-block format for popular consumption. The wood-block engraver transformed the expensive urban design into a less costly product that appealed to common laborers and artisans.[18]

By the end of the First Empire, Jean-Charles Pellerin had produced thirty to forty images of the emperor and his family in a popular wood-block format. Pellerin formulated a popular idiom from representations authorized by Imperial censors, which included such themes as the coronation, the emperor on his horse, the emperor as a republican general, the birth and baptism of Napoleon's son, and the king of Rome. According to an official catalog from 1814, Pellerin also printed and marketed pictures including such titles as *Napoleon, the Emperor, Marie-Louise the Empress, The Triumph of Napoleon, The Triumph of Marie-Louise, The Emperor and his Brothers, The King of Naples, The Queen of Naples, Marshall Berthier, The Death of the Duke of Montebello, The Union between France and Austria, The Entry of the French in Moscow, The Return of the Enlisted Man, The Imperial Guard, Chasseurs of the Imperial Guard, Grenadiers of the Imperial Guard, Musicians from the Imperial Guard, French Hussards, The French Infantry, Mameluks,* and *St. Napoleon.*[19] In choosing to duplicate the costumes and pagentry of the Imperial army, Jean-Charles tapped into into a rich tradition in military art previously developed by artisans and printers in Strasbourg. During trips to the busy Alsacian capital, Pellerin was inspired by displays of military engravings designed by a famous local artist, Boersch, as well as by Parisian engravings that depicted famous battle scenes from the Imperial wars.[20]

Although Jean-Charles Pellerin was educated through high-school and fairly well read, private memoirs and ledgers from the firm are not available to explain his particular motives for establishing the printing firm. Despite the lack of primary documentation from the Pellerin atelier, we can make some conjectures about his intentions by considering his public career in Epinal from the French Revolution through the Restoration regime.[21] By all counts, Pellerin was a successful bourgeois businessman and political leader who openly supported the legislative phase of the Revolution.[22] In 1788, with other notables of the town, he signed an agreement to recall the Estates General, and in 1789 he helped to elect those deputies who were responsible for drafting the local *cahiers des doléances* (lists of grievances). From 1790 to the deposition of the king in the fall of 1792, Pellerin was a member of the municipal council of Epinal. While a member of the council, he attended the inauguration of the local national guard and participated in a celebration marking the establishment of a new constitution on 23 July 1791. Although he was chief municipal officer of Epinal on 12 November 1791, Pellerin left public office the following year

in December 1792, shortly after the declaration of the French republic. Even though he had temporarily retired from politics, Pellerin was probably among the notables of Epinal who were invited to a ball to celebrate the brilliant career of young General Napoleon Bonaparte on 28 July 1798.[23]

It would appear that Pellerin withdrew from public activity to pursue his business interests.[24] But with the Austrian invasion and occupation of northeastern France in the spring of 1814, he returned briefly to public office to help manage the rationing and distribution of weaponry for the commune of Epinal.[25] He remained in office after the accession of the Bourbon King Louis XVIII to the throne in December 1814, but again retired from public office a year later following Napoleon's abdication and the reinstatement of the Bourbon monarchy. After 1816, Pellerin tried to stay out of political activities while preparing his son Nicholas to take responsibility for the management of the firm.[26]

In 1786, Pellerin senior helped to establish Freemasonry in the department of the Vosges by supporting the formation of the first lodge in Epinal, La Parfaite Union (the perfect union). Most members of the lodge were notables or former officers from the respected cavalry regiment Noailles. From Masonic records, we know that Pellerin decorated the lodge in 1802 and that he became *surveillant* or head of La Parfaite Union in 1803. In 1812, he endeavored to create a new lodge, La Parfaite Amitié (perfect friendship). Both lodges, however, were combined in 1813 under the original title.[27] Because of the predominantly liberal leanings of its members, the Epinal lodge subsequently became a hotbed of political resistance to the Bourbon autocracy.[28]

In addition to being a Freemason, Jean-Charles was also a deist. Although generally respectful of religion and religious practices, he displayed at times a marked detachment from, and an irreverence toward ecclesiastical protocol. Pellerin's wry attitude toward clerical ceremony was revealed during a brief incident that occurred during the late Empire. While on route to a neighboring village in an open carriage, he wore a violet cape. When the carriage passed through the town, a number of villagers followed him, thinking that he was a bishop who was visiting outlying regions in his archdiocese. Unwilling to put an end to the unexpected charade, Pellerin blessed the folk who surrounded him, and even allowed a few to kiss his hand.[29]

Pellerin's deist beliefs and involvement with Freemasonry did not prevent him from capitalizing on an important market in religious literature and art during the First Empire and Restoration. Devotional themes and representations were the most extensive category in Pellerin's inventory. According to listings in an 1814 catalog, the majority of Pellerin's holdings included representations of Christ, the Madonna, and reproductions of popular saints. Images in the Pellerin catalog also described biblical events such as *The Flood, Joseph before the Pharoah, The Adoration of the Magi, The Flight from Egypt, The Baptism of Christ, The Good Samaritan, The Last Supper, Calvary, and The Cross.*[30] With the resurgence of ecclesiastical power in Restoration France, Pellerin produced an even wider selection of devotional art. In two years, he added sixty images of saints to his already extensive inventory. Pellerin's efforts to invest in the production of religious art corresponded with efforts by the Bourbon kings to reinstate the Catholic Church to power as the most appropriate ally of the French political state. In addition to the reestablishment of ecclesiastical privilege and power, church leaders developed aggressive missionary strategies to bring members of their Christian flock under the tutelage of the orthodox institution. Pellerin clearly geared his market to the resurgence of ecclesiastical zeal.[31]

To secure his standing with the Restoration authorities, Pellerin also reproduced portraits of the Bourbon family. Following the change of political regime in 1815, he printed a bust of Louis XVIII and a series of prints that described the life and death of the Duke of Berry, Louis Antoine Artois, the Duke of Angoulême, and the Duchess of Berry.[32] While trying to accommodate the new Bourbon government, Pellerin nevertheless retained a considerable inventory of Imperial prints in his warehouse.

Issues of political representation became particularly treacherous during the early years of the Restoration. Bourbon censors considered monuments and symbols to be vitally important in realigning the loyalties of both Parisian and provincial groups to the new government. In April 1814, after Napoleon's first defeat, the provisional government promulgated a law that forbade any action, speech, or representation that might be hostile to the new regime. This prohibition referred especially to textual or graphic representations of Napoleon produced during the

# ARRÊTÉ

*Qui supprime tous les Chiffres et Emblêmes qui ont caractérisé le Gouvernement de Bonaparte.*

Le Gouvernement provisoire Arrête :

1.º Que tous les emblêmes, chiffres et armoiries qui ont caractérisé le Gouvernement de Bonaparte, seront supprimés et effacés partout où ils peuvent exister ;

2.º Que cette suppression sera exclusivement opérée par les Autorités de police ou municipales, sans que le zèle individuel d'aucun particulier puisse y concourir ou les prévenir ;

3.º Qu'aucune adresse, proclamation, feuille publique ou écrit particulier, ne contiendra d'injures ou expressions outrageantes contre le Gouvernement renversé, la cause de la patrie étant trop noble pour adopter aucun des moyens dont il s'est servi.

Paris, le 4 avril 1814.

*Signé* François de Jaucourt, le Général Beurnonville, le Duc de Dalberg.

*Par le Gouvernement provisoire :*

*Signé* Dupont (de Nemours), *Secrétaire général.*

Pour expédition et copie conforme :

*Signé* DUPONT (de Nemours).

A BOURG, DE L'IMPRIMERIE DE A.-J.-M. JANINET.

*Arrêté,* **Notice of the Provisionary Government, April 4, 1814, signed by Pierre Samuel Dupont de Nemours. Hagley Museum and Library, Wilmington, Delaware.**

Restoration.[33] When the Bourbon authorities reassumed power in 1815, they continued to see Bonaparte and his son as an imminent threat to the security of the Bourbon throne. Consequently, censors eliminated or destroyed every monument or public reference to the French emperor. In Paris, authorities replaced Chaudet's statue of Bonaparte as emperor on the Vendôme column with the standard bearing the Bourbon lilies. The government likewise removed trophies from Austerlitz, from the Chamber of Deputies, and erased representations of the Imperial eagle from the facade of the Louvre.

After Napoleon's death in 1821, the government tried to reinforce the legitimacy of the Bourbon dynasty with state emblems and statuary. For example, Bourbon authorities requested each department to provide contributions toward the creation of a statue of Louis XIV that was placed in the Place des Victoires. In regional France, municipal leaders melted down busts of the emperor located in the town hall and replaced them with representations of Louis XVIII.[34] Any almanac or pamphlet that referred to Napoleon had to be deleted from the commercial market.[35] The tricolor flag that had waved from church steeples in every commune was destroyed and replaced by the white flag as a reminder of the victorious reinstatement of the Bourbon kings.

During these first precarious years of Bourbon rule, censors were particularly harsh in their treatment of regional printers who published seditious material. On 24 October 1814, a royal ordinance required any printer to send five examples of each print to the Royal Library and to the National Center for the Press in Paris. On 21 March 1820, censorship regulations became even more stringent. According to article 8, "No printed, engraved, or lithographed image could be published without the prior authorization of the government." And in March 1822, the penalty was increased from a fine to certain imprisonment for an offending printer. Several months later, the law stipulated that each publishable item had to be authorized by the Bourbon authorities prior to publication.[36]

While Pellerin attempted to follow press restrictions by producing art and pamphlet literature that favored the regime in power, he did not always succeed in doing so. The political transition between the Imperial regime and the Restoration of the Bourbon dynasty created considerable distress for Pellerin because print orders apparently had been processed during the Empire and received by clients during the Restoration. As a result, some merchant outlets for Pellerin continued to have a selection of Imperial pictures from the Pellerin presses when Restoration censors began to investigate the inventories of regional merchants and book dealers. Pellerin was thus caught in a difficult situation with a storehouse of Napoleonic merchandise considered seditious by the new Bourbon government.

Owing to this happenstance, Pellerin was convicted at the beginning of the Bourbon Restoration of housing and merchandising seditious representations of Napoleon Bonaparte and the Imperial Army. The police search of Pellerin's establishment in July 1816, was a response to a formal denunciation made in early June by a merchant from Châlons-sur-Saône named M. Thierry who claimed to have received a packet of images from Pellerin, among which were several representations of Napoleon and the Imperial Army. Thierry's wife submitted these "seditious" prints of Napoleon to the prefecture. They included *Virginia Chesquière Receiving the Cross of the Legion of Honor*,[37] *The Compassion of the Emperor of the French in Response to the Death of Marshal Lannes, The Duke of Montebello*, and *The Seizure of Moscow*.[38] Following the police investigation and inquest, Pellerin warned his clients to destroy any seditious images of Bonaparte or the Imperial Army; the police began their investigation, however, before Pellerin's clients received his warning. After confiscating Pellerin's records at the time of the search, they raided his clients' reserves.[39]

In response to accusations of seditious behavior, the printer claimed that orders for Napoleonic merchandise had been made during the First Empire, but that the prints were inadvertently sent to clients during the Bourbon regime. His accusers maintained, however, that most seditious material had been mailed to them after February 1816 without their request. A subsequent investigation of Pellerin's clients—booksellers in Arras, Langres, Besançon, Amiens, Troyes, Châlons-sur-Saône, and Rambervillers—provided additional evidence that Pellerin had intentionally mailed Imperial broadsides to unsuspecting clients during the Restoration. At the shop of Voisain in Besançon, one of Pellerin's most regular customers, the police found 151 prints of the Great Army and 38 depicting Napoleon or important personages from the Great Army.[40]

As a result of this police investigation, Pellerin

# RETRAITE DE MOSCOW.

L'armée française après des prodiges de valeur et des succès prodigieux, entra triomphante dans la ville de Moscow: l'ennemi ne pouvait plus rien contre cette invincible armée, les élémens seuls purent la vaincre et l'anéantir. Un froid des plus rigoureux surprit dans sa retraite cette brillante armée et moissonna en moins de 24 heures la plus grande partie de ces guerriers; le reste se traîna péniblement en combattant jusqu'aux bords de la Vistule. C'est là que le brave prince Eugène rallia les débris et parvint par son activité et son courage à contenir un ennemi dix fois plus nombreux. Cette re- traite désastreuse n'en est pas moins un monument de plus à la gloire des français; ils conserveront long-temps le sentiment de leur supériorité.

DE LA FABRIQUE DE PELLERIN, IMPRIMEUR-LIBRAIRE A ÉPINAL.

**Antoine Réveillé, *The Retreat from Moscow* (1820), Pellerin, Epinal. Musée des Arts et Traditions Populaires, Paris. Photo by RMN.**

was tried and convicted on 14 February 1817, for housing and marketing seditious representations of Napoleon and the Imperial regime. The final conviction stated that

> M. Jean-Charles Pellerin, printer, bookseller, and producer of playing cards at Epinal had printed and marketed engravings and images to merchants which represented Bonaparte and his family, the signs and symbols of his regime, his exploits, and songs which praised Napoleon to the point of raising false hopes among the common people.[41]

The printer was condemned to four months imprisonment, a six-hundred-franc fine, and responsibility for the trial expenses. But in response to Pellerin's subsequent appeal to the throne, the king granted him a reprieve from prison; however, he was obliged to pay the des-ignated fine and costs of the trial.[42] Undeterred by this first bout with the authorities, Pellerin soon ran into further difficulties.

In 1821, the printer was again suspected of spreading bonapartist propaganda by selling a broadside entitled, *The Retreat from Moscow*, gratuitously to customers in the region. To accommodate Bourbon censors, Prince Eugene rather than Napoleon was portrayed rallying survivors for a perilous retreat from the brutal Russian winter. Outnumbered ten to one, Napoleon's stepson directs the Imperial infantry and cavalry westward in a hasty retreat. A rumor reached the central ministry in Paris, however, that Pellerin was distributing *The Retreat from Moscow* without cost [as propaganda] to provincial customers. On 6 June 1821, shortly after Napoleon's death on the island of St. Helena, the minister of interior requested another investigation of the

Pellerin firm. Baron Claude Mounier, director general of police, wrote to the prefect of Epinal: "I am sending a copy of a print entitled *Retreat from Moscow*. . . . it was rumored that many such images were being distributed freely in the countryside. Please verify if this is the case and let me know the results of your investigation."[43]

On 11 June 1821, the chief of police in the Vosges responded negatively to the royal censor's accusation, this time taking Pellerin's side in the matter. The prefect indicated that the print had been properly registered and authorized at police headquarters, with five copies deposited in the prefectorial files. Though such a print may have been distributed gratis by someone, the prefect doubted that Pellerin was to blame. He described him as a decent businessman, a man who would respect the basic "order" of society. A month later, after contacting the assistant prefects of local communes in the Vosges, the police chief reconfirmed his initial position. Although examples of such a print had been found among the inhabitants of several villages, no evidence indicated that Pellerin or representatives of his establishment were intentionally involved in seditious activities.[44] According to the assistant prefect, "this engraving had not been distributed anywhere in his arrondissement. And if it had been, rather than displaying it in public, individuals kept it religiously hidden in the privacy of their homes."[45]

The most telling aspect of the controversy was the Bourbon administration's anxiety over the diffusion of Imperial themes to commoners in provincial France. Censors were most intimidated by any indirect reference to Napoleon. According to royal authorities, such clandestine distribution of Napoleonic art implied a felonious disregard for the regime in power. Due to support from the prefecture in Epinal, however, Pellerin was acquitted of all charges in 1821.

By 1822, Jean-Charles Pellerin was sixty-six years old, and had been worn down by the demands of an expanding business and his confrontations with police authorities. At this juncture, he was prepared to cede his business and living quarters to his second son, Nicholas, whom he described as a competent young printer, experienced and respectably certified in his trade. Pellerin's license as a printer and publisher of images had first been issued in 1811 by the Imperial government, and was reissued by Bourbon authorities on 28 October 1814, and again on 8 August 1816. Since the Imperial decree in 1811 had indicated that the brevet was transferable to *son héréditaire* (to an heir or successor), Pellerin Senior naturally felt he could transfer the license to his son. In a letter to the minister of interior on 23 October 1822, he claimed that he was no longer strong enough to manage his business. Nicholas, who was twenty-nine years old and who had been involved in most of Pellerin's affairs during the previous decade, was the founder's choice to take over his business. With a letter of support from the prefect of Epinal and letters of certification from four printers in Epinal, Pellerin sent the petition to the minister of interior.[46] By notarial decree, on 27 December 1822, the founder deeded his home and business to Nicholas and to his son-in-law, Pierre-Germain Vadet. The sale included the print shop, presses, and tools together with 221 wood-block designs.[47]

Receiving no response from the minister of interior, Pellerin repeated his appeal on 13 March 1823. This time the ministry refused, stating that "this family had been seriously involved in the French Revolution." He added, "Both Jean-Charles and his son were convinced Masons with doubtful religious positions. If Nicholas were to become the proprietor of the Pellerin enterprises, he would print all manner of material directed against the Catholic religion and king."[48] Pellerin's reputation as a Mason and liberal proponent of the French Revolution put his political status into question with the Bourbon authorities. As a deist, Pellerin was not likely to be a supporter of the Catholic Church. In addition to the printer's Masonic predilections, his earlier conviction for illegally marketing Napoleonic art undoubtedly influenced the minster's repeated refusals in 1822 and 1823 to transfer Pellerin's license to his son.

After the minister's refusal, the elder Pellerin tabled the matter for the next five years. But on 10 May 1828, he renewed his appeal, emphasizing his age and waning health. This time the appeal was supported with letters from the Duke of Choiseul, a respected member of the House of Peers, by the prefect of Epinal, and by several deputies from the Vosges. The prefect claimed "that Nicholas demonstrated professional competence, that he conducted himself according to correct moral principles, and that he handled the print shop and bookstore very well."[49] In addition to this auspicious backing from the prefect of Epinal, the enterprise re-

ceived noteworthy recommendations from Viscount Simeon, Director of the Humanities, Sciences and Fine Arts in the Vosges. After extensive political maneuvering, Nicholas Pellerin finally received his *brevet* (license) as a printer and book dealer on 12 June 1828.[50]

At the time he officially assumed management of the printing enterprise and bookstore in 1828, Nicholas Pellerin was just thirty-five years old. The young printer had been born on 30 April 1793, at the onset of the radical phase of the French Revolution. Following the death of his elder brother in the Imperial wars, Nicholas, as the secondborn, was eligible to take full responsibility for the business. At fifteen, young Nicholas was apprenticed to four printers in the region of the Vosges, where he learned his trade and became officially certified. On 26 April 1815, at age twenty-two, he was invited to participate in the organization of the National Guard during Napoleon's short stint in power. When he entered the service in August 1815, he was enlisted as a sergeant in the second company of grenadiers, but after only three days he was promoted to officer in the second battalion of the National Guard in the Vosges. While stationed with the National Guard in Metz, Nicholas wrote to his father that he was not terribly fond of military life, and that he would have preferred to remain at the Pellerin atelier. When he returned, Nicholas helped to manage his father's printing business and deal with police authorities during litigation against the firm from 1815 to 1816, and again in 1821.[51]

Pierre-Germain Vadet, a former officer and chevalier of the Legion of Honor from the Imperial armies, became Nicholas's partner and colleague in the management of the firm. Vadet had received the Legion of Honor medal for his services at the Battle of Essling, where he lost a leg fighting with the famous General Bonaparte. In 1815, when Vadet and his brother were forced to retire from service, they subsequently became involved in antiroyalist uprisings and suspected of seditious opposition to the Bourbon government. Because of his bonapartist sympathies, Vadet was sentenced to prison several times and deprived of his occupation as a tobacco merchant in Neufchatel. But the veteran soldier did achieve some respectability after he married Jean-Charles's daughter, Marguerite Pellerin, on 18 November 1818.[52]

Vadet's good standing with his father-in-law eventually put the former soldier in better standing with the authorities in Epinal. In 1822, Vadet entered the printing business and officially became a partner when Nicholas received his license in 1828. Born in 1787, the veteran was six years older than Nicholas. Because of Vadet's early career as an army officer with Napoleon, and because he was suspected of bonapartist resistance during the Restoration, the plan to produce prints of Bonaparte and the Imperial Army was undoubtedly sparked by the energy and imagination of this veteran soldier.[53]

In April 1829, the new partners produced the *Battle of Essling—Death of Montebello* that portrayed the mustached Vadet upside down and falling from his horse in the left forefront of the design. Inspired by Vadet's own experience in battle, the print describes the French offensive against the Austrians on 22 May 1809 at Essling, just outside of Vienna. The Duke of Montebello, mounted with a sword raised in the left of the picture, had just received orders to lead French troops through the center of the Austrian defense. But upon learning that the supply of armaments had been confiscated by the Austrians, the French drew back and prepared to attack the enemy with bayonets. While French troops tried to take the village of Essling (thirteen times), Marshal Lannes, who is seated in the right foreground with his doctor, was wounded in the leg by cannon fire. The Pellerin composition describes the soldiers regrouping around Lannes while a vanguard of courageous infantrymen begins their assault with guns and swords. According to the Pellerin text, despite the vulnerability of their position, French soldiers created a defensive against the enemy "like a granite wall that no one dared to attack." In addition to praising the courage of the Great Army, both text and image celebrated the heroism not only of Marshal Lannes but also of Vadet, who was seriously wounded at the Battle of Essling.[54] By representing the cavalryman near his commander, the Pellerin image praised the courage of the veteran soldier in the heat of battle.

In most business and political matters, Nicholas Pellerin and Pierre-Germain Vadet were associated with other veterans and liberal leaders of the Freemason lodge in Epinal, La Parfaite Union. The lodge was composed primarily of young established members of the bourgeoisie, including liberal professionals, merchants, civil servants, and veteran soldiers.[55] Despite admonitions from the central administration in Paris, Masonic lodges such as La Parfaite Union be-

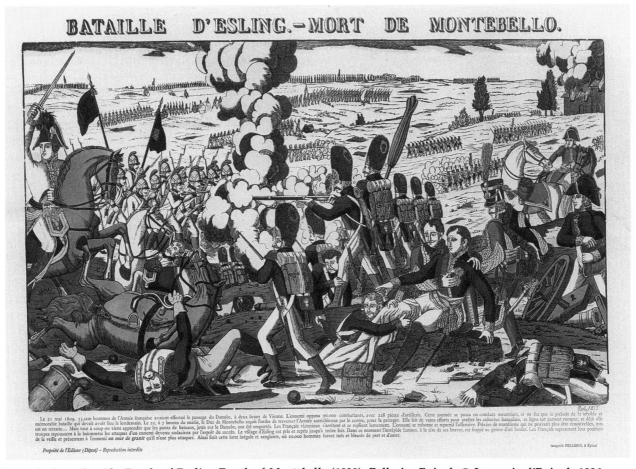

**François Georgin,** *The Battle of Essling-Death of Montebello* **(1829), Pellerin, Epinal. © Imagerie d'Epinal, 1996.**

came deeply embroiled in political controversies such as the expansion of the electorate and the protection of civil and political rights in the tumultuous years immediately preceding the July Revolution.[56]

Vadet and Pellerin were among the majority of veterans and young liberals whose professional ambitions were frustrated by Restoration authorities. Because of his involvement in bonapartist intrigues against the throne, Vadet lost his license as a tobacco merchant and was able to reinstate himself professionally only through his marriage with Jean-Charles Pellerin's daughter. Bourbon censors refused in 1822 to grant Pellerin's son, Nicholas, full rights as a printer and manager of the firm until 1828, after six years of careful surveillance. Owing to father and son's Masonic affiliations and conviction for marketing seditious images of Napoleon, police authorities in Epinal suspected both of possible conspiracy against the church and the Bourbon throne. Were it not for the strong recommenda-

tion proferred by the Duke of Choiseul, Pellerin and Vadet would not have received permission to take over the firm during the final years of the Restoration.

Revealing their allegiances immediately after the transfer of the printing license, Pellerin and Vadet set out immediately to print Napoleonic themes. In September 1828, just three months after receiving his license as a printer, Nicholas requested permission from the local police to publish an image of Napoleon portrayed as general of the Great Army. By the end of October, when the printer received no clear response either from the minister of interior or from the prefect, Pellerin took matters into his own hands and wrote again to the prefecture. In his letter of 28 October 1828, to the police chief the young entrepreneur wrote,

I sent a sample of two designs to the Ministry entitled St. Mary, the Egyptian, and Napoleon; authorization for the second print has not yet arrived.

Napoleon is a common subject which now belongs to history. This and other related themes are published and distributed every day without any hindrance from the authorities. Be assured Monsieur that this print is in no way seditious; moreover, I am determined to publish it.[57]

Despite his boldness, the printer was summarily refused by the police chief in Epinal, who conveyed the minister's decision to Pellerin.[58]

Undaunted, the young printer requested the police chief to direct a letter on his behalf to the central ministry. Using the prefect as a mediator, Pellerin reiterated that "the same image [he was proposing for publication] was being distributed in other departments, notably the neighboring Meurthe and Moselle where the law against Napoleonic imagery had fallen into obsolescence." If Pellerin did not meet such an important demand for Napoleonic art, it would severely damage his business and divert trade to printers in other regions.[59] In his effort to support the printer, the prefect emphasized that all dangerous symbols had been deleted. Napoleon was coiffed in a white cockade, a symbol that could not be considered threatening to the authorities. But the second response from the ministry, like the first, forbade authorization of any portrait of Napoleon for public sale. The minister of interior refused Pellerin precisely because "this image may be sold in large volume among a widespread lower-class population because of its low cost." The most threatening aspect of the image was its appeal to the "lower classes." The ministry added that if these images were being sold in other departments, it was the fault of certain local authorities, not of the law or the central government.[60]

The prefect, having no choice but to concur with the minister's decision in this matter, sent a letter to Pellerin that pointed out the illegality of his publishing Napoleonic art. "Authorization cannot be granted for a publication prohibited by the law of March 22, 1822."[61] At this point, Nicholas stopped petitioning the government and agreed to withdraw the design of General Bonaparte. Despite the censure of Napoleon's portrait, Nicholas and Vadet decided to continue to print art that commemorated the Imperial epoch but did not portray the figure of Bonaparte. Through such clever maneuvers with censorship restrictions, the firm managed to receive authorizations to print *The Retreat from Moscow* in 1820, *The Battle of Waterloo* in 1822, *The Battle of Essling*

in 1829, and *The Battle of the Pyramids* in 1830, just weeks before the July Revolution.

Pellerin's repeated appeals demonstrate that he wanted to tap the prolific market in Napoleonic images and memorabilia that flooded the provinces in the several years preceding the Revolution of 1830. Though he initiated a series of prints on Napoleon's military campaigns for obvious commercial reasons, he was certainly not indifferent to the political implications of this art. Though he and Vadet managed to follow regulations regarding the publication of Imperial art, neither partner favored prints that would enhance the Bourbon regime. In accommodating the censors, their efforts were halfhearted, belying their preference for representations of Bonaparte and his Great Army.

During the first flush of freedom after the Revolution of 1830, the printers rushed to produce a representation of Napoleon. The Pellerin partners requested authorization to print a portrait of Bonaparte, even before they asked for permission to publish portraits of Louis-Philippe (8 October 1830) and of Queen Marie Amelia (13 April 1831).[62] On 6 September 1830, the Epinal firm was finally able to register a portrait of Napoleon I for mass production and distribution. The whimsical picture of Napoleon as a colonel of the Imperial Guard included no textual commentary. The image described Bonaparte mounted on his famous white horse brandishing a copy of the Civil Code in his hand, most likely referring to the Charte recently signed by the new Orleanist king. Following the July Revolution, Pellerin phased out most other graphic themes in favor of a series of brilliantly colored broadsides that portrayed Napoleon's military career.

While Louis-Philippe associated himself with the Napoleonic legend to give greater credence and glamor to his regime, Pellerin and Vadet undoubtedly adopted the legend as a commercial venture to expand their market. But to presume that the production of Napoleonic art was purely a profit-making endeavor does not concur with the political history of the Pellerin firm during the previous decade. Both Pellerin Senior and Junior took several critical risks during the Restoration in order to produce and market so-called seditious representations of Napoleon's Imperial Army.

That Pellerin and Vadet proposed to print Napoleonic art at the end of the Restoration may not have been accidental. Jean-Charles and Nich-

olas Pellerin most likely shared the liberal principles of the Masonic lodge in Epinal that took issue with the Bourbon regime. Veterans such as Vadet yearned for the renewal of national as well as personal glory through an aggressive military policy that would assuage the bitterness of French defeat in 1815. Thus, at the juncture of the July Revolution, Napoleonic art was politically loaded for both partners. Rather than ingenuousness or pure capital gain, the motives impelling the printers to produce Napoleonic themes suggested political awareness and intent, particularly during the stressful years that preceded and followed the Revolution of 1830.

# 3

# Creating the Popular Image

Populist faith in the memory of napoleon Bonaparte and his son helped to foster the outburst of revolutionary enthusiasm in 1830. During the "three glorious days" of the July Revolution, crowds shouted seditious cries about Bonaparte in the streets of the capital. The insurrection began in the workers' quarter of Paris on 28 July, when workers, soldiers, and national guardsmen lifted the tricolor shouting, "Down with the Bourbons," "Long live the Republic," "Long live the emperor." The insurgents then seized a supply station located at the nearby arsenal and distributed military weaponry to the disgruntled populace.[1] Despite the fervor of the struggle in the barricaded streets of the capital, those who participated in the violence were neither organized nor focused on a specific political agenda. While many revolutionaries considered themselves bonapartists, others identified themselves as republicans, which left a small group of liberal activists who supported the Orleanist cause.

In their efforts to establish a constitutional monarchy, the Orleanist coalition received substantial backing from a number of articulate liberals and political leaders such as Jacques Lafitte, Adolphe Thiers, and François-Auguste Mignet.[2] The Duke of Orleans was not sure of his own position until confronted with a petition from a group of deputies who journeyed to his estate at Neuilly to present their case. Louis-Philippe accepted their invitation to return to Paris as a candidate for the throne and was publicly confirmed when the Marquis de Lafayette embraced him on a balcony of the Hotel de Ville. Watching the dramatic scene, crowds in the courtyard be-low cheered the old soldier's official gesture of confidence in the Orleanist candidate.[3]

To avoid factional disputes from contending political groups, liberal political leaders engineered a rapid transfer of power from Bourbon to Orleanist rule. After Charles X appointed Louis-Philippe lieutenant general of the kingdom on 1 August, leaders from the Chamber of Deputies made sure that he was sworn in on 9 August as king, not of France but of the French people.[4] In contrast with the sumptuous coronation of Charles X in Rheims cathedral, this coronation was brief and unpretentious. Surrounded by deputies and peers, the Duke of Orleans pledged his allegiance to the charter in the halls of parliament. The formal investiture consisted only of the king's oath witnessed and signed by representatives from both houses of parliament.[5]

To expand his limited political base, Louis-Philippe sought additional support by tapping into grassroots enthusiasm for the memory of Bonaparte. By incorporating the Napoleonic legend into official art and ritual, he endeavored to redirect admiration for Napoleon's remarkable military and administrative achievements to his own government. The king adopted the Imperial symbol of the tricolor flag and further glamorized his public image by constructing a series of monuments using Napoleonic symbols and iconography. In 1831, he commissioned 165 medals describing the reign of Napoleon Bonaparte. In 1833, he appeared to salute the populist symbol of the Napoleonic legend by placing a statue of the Little Corporal atop the Vendôme column in Paris. In 1836, he refurbished the public museum at the Versailles palace with histori-

cal paintings from the Ancien Regime and the Napoleonic era.[6] Finally, in 1840, a decade after Victor Hugo initially proposed the return of Napoleon's remains, and in response to Adolphe Thiers's initiative, the king sponsored a lavish burial ceremony at the Hotel des Invalides in Paris.

Though Louis-Philippe tried to appropriate popular enthusiasm for the Napoleonic legend, journalists and artists such as Daumier por-

trayed the king as mediocre, a pale reflection of the legendary French hero. Daumier's satirical illustration for *Le Carivari* depicts the flaccid face of Louis-Philippe in the less than flattering form of a pear. Portrayed with multiple personae, the bust portrait of the king lacks singularity or strength of character. To a liberal generation bred on the romantic fires of Napoleonic adventure, the Bourgeois monarchy appeared drab and unexciting.

**Honor Daumier, *The Past, the Present, the Future* (1833). Cabinet des Estampes, Bibliothèque Nationale de France, Paris.**

While the new king espoused the principles of a *juste milieu* (moderation) to reconcile opposing factions, large sectors of the nation continued to celebrate Napoleon I rather than Louis-Philippe as the central figure in France's apotheosis.[7] In Hippolyte Bellangé's print, *The Postillion's Silhouette* (1830), a child traces Napoleon's profile cast by the light of a flickering candle on the wall of a peasant cottage. Produced in 1830, the picture reveals how the people's devotion to Napoleon I would eventually supersede any false allegiance to Louis-Philippe. In contrast with the flabby features of the Orleanist king, the engraver underlined the firm, aquiline profile of the French warrior.[8]

The Bellangé composition also alludes to Greek traditions about a young potter named Dibutade, who traced the profile of her beloved on the wall of her room. By rendering his profile, the young woman attempted to preserve her lover's image prior to his departure for battle.[9] Though the print retains the mysterious and slightly erotic tinge of the ancient myth, a child points not to the shadow of the bereaved lover, but instead to the profile of the celebrated hero.[10] The youngster's key role in the composition underlines the ingenuous nature of people's faith in Napoleon. Though unable to bring their leader back from exile, Napoleon's devotees could, nevertheless, re-create his image and thus revive his symbolic presence in their lives.

With the relaxation of state censorship after the July Revolution, representations and textual narratives about Bonaparte circulated freely throughout Paris.[11] In addition to celebrating the revolution and removal of the Bourbon dynasty from power, the profusion of art and ephemera about Bonaparte in Parisian bookstores and bric-a-brac shops revealed the irrevocable vitality of the Napoleonic legend in the capital. Paintings representing popular devotion to the Little Corporal flooded the Paris Salon with military and genre scenes.[12] Concurrently, numerous plays extolling Napoleon's feats of heroism received favored billing in Parisian theaters.[13]

During the initial euphoria following the July Revolution, printers marketed representations of Bonaparte to an avid public in the capital. While Parisian firms had produced steel engravings and lithographs of Napoleon and his armies clandestinely during the Bourbon Restoration, after 1830 printers and artisans could sell engravings commercially without fear of political surveillance. Noted writers such as François Gui-

zot, Adolphe Thiers, and Alphonse de Lamartine included pictures of Napoleon's political career to illustrate their respective interpretations of the French Revolution and Empire.[14]

In contrast with the varied texts and representations about Napoleon made available in the city, the most important media form in regional France was the popular print, or broadsheet. Throughout the provinces, popular wood-block prints were a necessary form of entertainment and information, particularly for those who did not have ready access to urban texts by reason of distance or cost. As compared with more expensive metal engraving, mass-produced wood-block designs of Napoleon's military career were accessible to a general audience. Because of their attractiveness and readability, such representations of Napoleon's adventures could touch semiliterate customers in ways that textual narratives by Balzac, Hugo, and Stendhal could not.

Nicholas Pellerin began to market his series of broadsheets portraying highlights in Napoleon's military career shortly after the revolution of 1830. Although Pellerin's chief engraver, François Georgin, did not have direct access to commissioned art produced and exhibited in Paris, he was exposed to more sophisticated models of Bonaparte through the availability of engravings and lithographs, many reproducing official or salon paintings. Engraved or lithographic copies of official portraits painted by Imperial artists such as Jacques-Louis David, Antoine-Jean Gros, and Jean-Auguste-Dominique Ingres influenced subsequent wood-block renditions of Bonaparte done by the Pellerin atelier. Most of Georgin's prints would suggest that the artisan copied an earlier piece, even to the point of accurately replicating costume, gestures, and positioning. Nevertheless, by magnifying the key figures and placing them in the foreground of his own compositions, Georgin imposed a narrative style that made his own illustrations both unique and compelling.

In addition to accentuating the major figures in each of his prints, Georgin eschewed the majestic image of the French emperor characteristic of Imperial art in favor of the less imposing but more appealing portrait of Napoleon as a soldier and friend to the common people. To do this, Georgin adopted representations of Napoleon as the Little Emperor or Corporal found in lithographs and engravings from the Restoration and the early years of the July Monarchy. Pellerin's chief artisan drew from a rich tradition of Napo-

Hippolyte Bellangé, *The Postillion's Silhouette* (1830). Cabinet des Estampes, Bibliothèque Nationale de France, Paris.

leonic themes developed by engravers of military art such as Joseph and Carl Vernet, Nicolas-Toussaint Charlet, and Denis-Auguste-Marie Raffet. Though inspired by anecdotes and caricatures about Bonaparte done by Parisian engravers, Georgin's work was far more direct and uncontrived. The artisan's forthright renditions of Bonaparte as a simple soldier and military comrade apparently met the expectations of peasants, artisans, and petit bourgeois customers for a genuinely accessible political hero.

François Georgin was born 18 August 1801, to André Georgin, a carter in Epinal, and Marguerite Thouvenot. His father died prematurely on 1 July 1806, leaving four children and a wife who was expecting another child.[15] Marguerite became a day laborer after the death of her husband, while Felix Hubert Georgin, an uncle from the father's family, took custody of the children.[16] His uncle on his mother's side, Joseph Thouvenot, a veteran of the Imperial wars, inspired Georgin's early passion for stories about Napoleon and the Great Army.[17]

In 1814, at twelve years of age, François Georgin became an apprentice in the Pellerin atelier, where he quickly distinguished himself as an adept and gifted engraver.[18] During the early years of the Bourbon Restoration, the young artisan was released from military service because his brother was on active duty with a royal infantry regiment. He subsequently received his trade license as an engraver in 1821. After having established himself as a permanent employee in the Pellerin firm on 21 June 1827, Georgin married Anne Christine Rémy, who had been raised by her step-brother, a weaver from Epinal.[19]

Antoine Réveillé, a veteran from the Imperial wars and devoted admirer of Bonaparte, trained François Georgin in the art of wood engraving. In 1820, the master craftsman, who fought and survived the Russian campaign, designed the first illustration for the Napoleonic series, entitled *The Retreat from Moscow*. To emphasize the bravery of Napoleon's beleaguered troops, he magnified the resolute figures of Prince Eugene and his officers with firm, thick lines in the foreground of the composition. Two years later Réveillé encouraged the young apprentice to create his first military piece, entitled *The Battle of Waterloo*.[20] The complex treatment of the approaching armies and perfectly balanced perspective in *Waterloo* suggests that Georgin, like other engravers, drafted the design from a

more sophisticated metal engraving or lithographic print produced in Paris.[21] But Georgin added his own idiosyncratic touches to make the picture meaningful and attractive to his audience. In his own rendition of *Waterloo*, Georgin shows the Imperial Guard in the left of the composition, who, though outnumbered, prepare to take up arms and renew their last decisive stand against the Allies. On the right, a column of English soldiers marches forward offering a white flag to the beleaguered French troops. The editor's caption underlines the determined response apparent in the faces of Napoleon's finest regiment. "La Garde meurt et ne se rend pas." [The Old Guard may die, but never surrenders.]

Because the artisan derived many of his models from urban illustrations, his designs cannot be disengaged from the so-called fine arts—paintings and engravings that were copied and reproduced during the First Empire and Restoration. But Georgin also drew from the resources and conventions of popular texts and images. The enlarged scale used to depict saints in popular prints may explain why Georgin magnified the figures of Napoleon and his entourage in many of the Epinal prints. Using heavy outlines to evoke flat, linear forms, Georgin's compositions also displayed the rudimentary style found in wood-block illustrations from the Blue Library.[22] Though Georgin may not have invented the stylistic approach used in his wood-block prints, he nonetheless infused his pictures (and their coloration) with freshness and naïveté that made his work so appealing.

Georgin produced his most celebrated prints during the earlier phase of his career, from 1821 to 1840. Some Restoration engravings were unsigned, but by the 1820s, most of Georgin's engravings carried his signature or initials. He signed his illustrations in the spirit of the craftsman who felt that his work was "bien fait" (well done).[23] After 1840, his style acquired greater polish through his increasing adeptness in the development of perspective and dimension. While his later work was more sophisticated, it unfortunately lacked the spontaneity and ingenuousness of his earlier compositions.

After 1850, the Pellerin firm began to replace the tedious process of wood-block printing with lithography.[24] Georgin, nevertheless, continued his work as the firm's specialist in wood engraving until he died at the age of sixty-two on 24 March 1863.[25] Though the artisan designed over two hundred woodblocks, he received the most

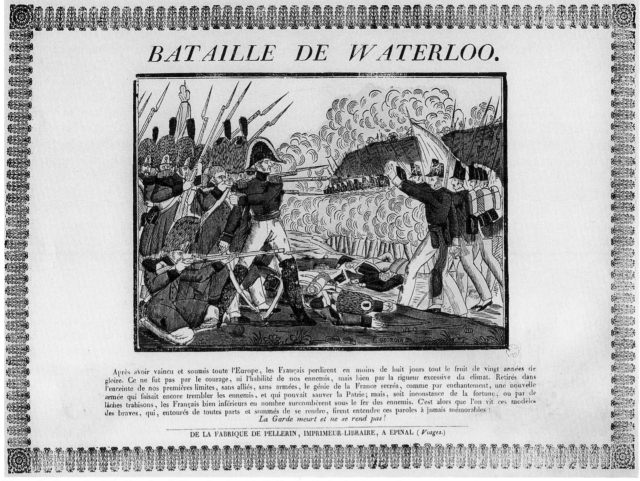

## BATAILLE DE WATERLOO.

Après avoir vaincu et soumis toute l'Europe, les Français perdirent en moins de huit jours tout le fruit de vingt années de gloire. Ce ne fut pas par le courage, ni l'habilité de nos ennemis, mais bien par la rigueur excessive du climat. Retirés dans l'enceinte de nos premières limites, sans alliés, sans armées, le génie de la France recréa, comme par enchantement, une nouvelle armée qui faisait encore trembler les ennemis, et qui pouvait sauver la Patrie; mais, soit inconstance de la fortune, ou par de lâches trahisons, les Français bien inférieurs en nombre succombèrent sous le fer des ennemis. C'est alors que l'on vit ces modèles des braves, qui, entourés de toutes parts et sommés de se rendre, firent entendre ces paroles à jamais mémorables :
*La Garde meurt et ne se rend pas !*

DE LA FABRIQUE DE PELLERIN, IMPRIMEUR-LIBRAIRE, A EPINAL (*Vosges.*)

François Georgin, *The Battle of Waterloo* (1822), Pellerin, Epinal. Musée des Arts et Traditions Populaires, Paris. Photo by RMN.

extensive acclaim for the Napoleonic series of illustrations produced by Pellerin. Georgin engraved and signed most of the Napoleonic themes; as Pellerin's chief craftsman during the Orleanist regime, his inimitable style also marked most of the unsigned prints in this series.[26] While other members of the atelier might have cut the designs, Georgin's forthright and lively inspiration contributed in no small measure to the reputation and commercial success of the Pellerin atelier.[27]

Most artisans, including Georgin, cut the design directly into the wood, producing a mirror copy of the original drawing. They cut into the grain lengthwise to create a firm line, using wood from cherry, pear, and apple trees that could hold small details. After removing the background areas, craftsmen left a raised surface of a quarter to an eighth of an inch. Engravers then inked this surface and placed paper on top.

By applying pressure from a spoon or burnisher to the back of the paper, they created the actual image. To print popular imagery more effectively, the Pellerin atelier added several large stereotype presses that used metal models taken from the original woodblocks. This method produced an even copy composed of both image and descriptive legend or prayer.[28]

Wood engravers usually designed a different block for each color. But the Pellerin printers employed the technique of *pochoir*, used since the fifteenth century for inexpensive graphics such as comics, broadsides, cartoons, and wallpaper.[29] The pochoir process employed a series of stencils placed over the black and white image to imprint the colors in specific areas. Pellerin hired women and children to hand color the black and white designs imprinted by stereotype presses.[30] The printer covered the proof of the imprinted design with one stencil at a time, and

applied each pigment until the composition was filled with all the designated colors.

Since imagery was so fundamentally embedded in Latin-Catholic ritual traditions, popular graphics like Georgin's were integral to French culture. The image was more powerful in France than in Protestant Anglo-Saxon countries that stressed the biblical text. Georgin's art drew from graphic traditions that prevailed in regional France from the fifteenth through the nineteenth centuries. Throughout this period, the predominant style of devotional imagery remained fundamentally gothic. Illuminated with a brilliant palette of three to four primary colors, the popular wood-block print resembled the rich hues of a stained glass window set in cloisonné fashion and etched with heavy black outlines. Traditionally, the image was printed on rough *vergé* paper, approximately 640 by 420 centimeters in size. Although most popular images were finished in a sharply linear fashion, they were rarely framed or mounted to create an ambiance of prestige and status for an aristocratic salon or bourgeois parlor. Rather, the humble wood engraving was usually pinned to the wall of a peasant cottage or placed discreetly in an armoire or kitchen cupboard as a talisman against unforeseen misfortune.[31]

Due to the development of lithography, provincial artisans, such as Georgin, could work with more sophisticated models such as engravings and military albums that described Napoleon's camp life and battle experiences during the Revolutionary and Imperial wars. Improvements in the production of lithography permitted official paintings and Salon art to be reproduced and marketed to provincial printers and booksellers in the provinces.[32] During the Restoration, established engravers and lithographers in Paris began to produce and sell their work anonymously to regional printing houses in Orleans, Chartres, Le Mans, Amiens, Beauvais, Toulouse, Lille, Cambrai, and Epinal.[33]

The availability of lithographs and engraving copies of famous paintings in the provinces may account for the striking similarity in elite portraits of Napoleon done by such artists as Gros, David, and Ingres, as compared to popular representations of Bonaparte done by the artisan Georgin. For example, portraits of the French rulers on horseback were common in official art from the Ancien Regime to the July Monarchy. David's depiction of Napoleon on a rearing charger with flowing red cape, leading his troops across the Alps, is perhaps the most dramatic commissioned piece of this genre. David's painting bore little resemblance to Georgin's rendition of the same theme, perhaps because, at the time, the artisan lacked the skills necessary to depict movement with diagonal lines or evoke three dimensions with sophisticated foreshortening techniques. In the print entitled *Napoleon the Great* (1830), Georgin nevertheless managed to execute a bold and colorful portrait of Napoleon dressed as an infantry colonel (of the Imperial Guard) mounted triumphantly on his famous white steed, Marengo.[34] Using a flat, linear style, Georgin shows Napoleon riding stiffly on a mount that teeters upward slightly like a wooden rocking horse. Although Georgin attempted to create the illusion of storm clouds at the top of the print, the clouds appear to be more like a plank of gray suspended from the upper frame than a true panorama of sky. And while the artisan could not match the lift and dynamic power of David's magnificent charger, the simplicity of his approach is refreshingly direct and uncontrived.

Georgin's composition demonstrates greater similarity to a painting by Baron Gros that was done in 1804, entitled *The First Consul at Marengo*. The Pellerin print presents a mirror copy of the Gros painting: horse and rider in the Gros work face toward the left of the design, while Georgin's horse and rider face to the right. The saddle in red with gold tassels, however, is identical in both the painting and print, as is the shape and position of the horse's head. In addition, Napoleon's uniform with black bicorne hat and epaulets is identical, and his dark greatcoat, though ornamented in the Gros, is draped similarly over the horse in both versions. Bonaparte appears more restrained and circumspect in the Gros painting, as he prepares to review his soldiers. The more schematized version by Georgin presents Napoleon alone, with one arm raised holding a scroll in a gesture of victory. Despite differences in style, the similarities in costume, gesture, equestrian trappings, and general positioning of horse and rider indicate that Georgin used the original or a copy of the Gros painting

**Jacques-Louis David,** *Passage over the Great St. Bernard.* **Malmaison, Paris. Photo by RMN.**

**NAPOLÉON LE GRAND**

**François Georgin,** *Napoleon the Great* **(1830), Pellerin, Epinal. © Imagerie d'Epinal, 1996.**

**Baron Antoine Gros,** *The First Consul at Marengo,* **Malmaison, Paris. Photo by RMN.**

to create his own, livelier wood-block design.

In the Epinal print entitled *Napoleon at the Camp of Boulogne* (1835), the Pellerin artisan reversed the compositional structure of another painting by David, entitled The *Oath of the Army Made to the Emperor after the Distribution of Eagles on the Champ-de-Mars, December 5, 1804.*[35] To develop his own interpretation of Napoleon distributing the Legion of Honor medal to his men, the popular artist used the same stairway structure as in David's description of the emperor offering the Imperial Eagle to his eager troops. In the David painting, Napoleon stands at the top of the stairs with one arm outstretched in a grandiloquent gesture, initiating an oath to encourage his men to continue their victorious record under the banner of the Imperial eagle.

In contrast with the heightened drama of the David piece, the Epinal artisan describes Napoleon's position at the top of a platform with greater restraint as he prepares to offer the Legion of Honor medal to a recipient ascending the steps. David's Napoleon is dressed lavishly in Imperial robes and crowned with a laurel wreath, while the popular artist depicts Napoleon in the informal uniform of a colonel, wearing only his bicorne hat, officer's jacket (with epaulets), and black boots. The simplification of dress as well as the sobriety of tone in the popular print celebrates military courage rather than Imperial munificence. Such unaffected representations of Bonaparte evoked a sense of national pride among soldiers and admirers who coveted the military award.

While Pellerin's atelier often achieved remarkable fidelity to paintings from the Imperial

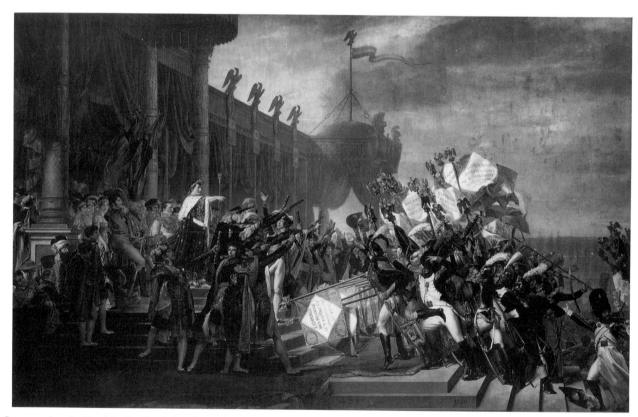

Jacques-Louis David, *Oath of the Army Made to the Emperor after the Distribution of Eagles on the Champs-de-Mars, December 5, 1804 (1810).* Museum of Versailles, Paris. Photo by RMN.

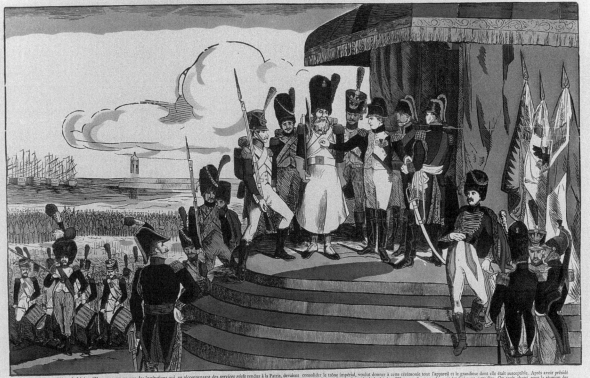

*Napoleon at the Camp of Boulogne* (1835), Pellerin, Epinal. © Imagerie d'Epinal, 1996.

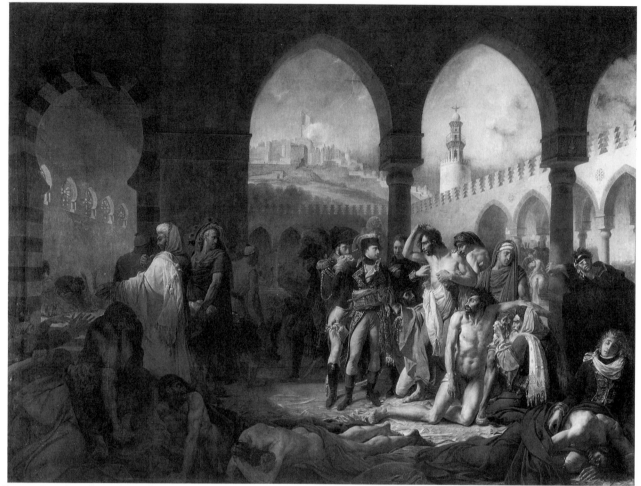

Baron Antoine Gros, *Napoleon Visiting the Plague Victims of Jaffa* (1804). Musée du Louvre, Paris. Photo by RMN.

epoch, under Georgin's mindful direction engravers such as Jean-Baptiste Thiébault made imaginative changes to enliven the popular composition.[36] In Thiébault's rendition of *Bonaparte Touching the Plague-Ridden* (1835), he drew from the famous piece by Gros entitled *Napoleon Visiting the Plague Victims of Jaffa* (1804). Similarities between the Pellerin print and the Gros painting appear in overall composition and theme rather than in precise details. The Gros version of *The Plague-Ridden* is monumental, presenting Napoleon beneath pointed arches that open onto a courtyard showing a side view of a Roman wall with a Moslem mosque visible in the distance. In the popular print, Thiébault deleted the lofty arches; instead, he framed the scene with a less pretentious low-vaulted arch that opens onto a barrel-vaulted wall bearing the tricolor flag.

Though colorful and engaging, the popular print displays none of the majesty apparent in the Imperial painting. The figure of Napoleon in the Gros work is tall and princely, illuminated by light filtering down from the heavens. Napoleon has removed his glove to touch the half-clothed figure of a plague-ridden man who raises his arm to point to his wounds. An audience of sick and attending figures regards Napoleon with reverence as if he were a semidivine presence who could heal their wounds or bring solace to their suffering.[37] The dramatic staging of the Gros painting suggested that, like the French kings (or Christ himself), Napoleon had extraordinary powers to heal his people.[38]

Notably, Thiébault moved the dramatic encounter between Napoleon and the plague-ridden soldier from midlevel in the Gros painting into the very forefront of his own design. While this technique heightened the dramatic emphasis, the engraver nonetheless renders Napoleon more simply, as an officer attending to the needs of his men. In contrast with the slender and elegantly dressed figure of Bonaparte in

Jean-Baptiste Thiébault, *Bonaparte Touching the Plague-Ridden* (1835), Pellerin, Epinal. © Imagerie d'Epinal, 1996. *Also see* color plate 1.

the Gros piece, Thiébault presented a sturdy and stocky military leader surrounded by his soldiers. Nuances of the miraculous and supernatural are not as apparent in the popular print. Instead of the miraculous, Napoleon's visit to his plague-ridden soldiers demonstrates his steadfastness as an officer responding to the call of duty. Pellerin's commentary conveyed a message that was far more down to earth and direct: "He wanted to show those who were ill that the plague was not as contagious as they thought. When he left, the officers from his guard chided him for his lack of prudence. 'It was my duty,' he replied calmly, 'I am their general and leader.'"[39] Rather than emphasizing his charismatic role as ruler, both the Pellerin text and illustration affirm Napoleon's resolve as military commander to stand by his plague-ridden troops.

For the most part, Imperial paintings portrayed Napoleon I as the irreproachable master of western Europe. Whether representing him as emperor or statesman, commissioned artists tended to execute imposing interpretations of the emperor, emphasizing his divine election as well as meritorious assumption to the French throne. Ingres produced such a rendering of the French emperor in which Napoleon, like Jupiter, sits on his throne holding a staff in one hand and the sign of justice, or *molitar*, in the other. In the Ingres portrait, Napoleon assumes the magnificence of his forerunner Charlemagne, wearing a white and red velvet robe with a Carolingian collar, crowned with a gold laurel wreath. Looking directly out of the canvas toward the viewer, the emperor expresses both fearlessness and authority. In most official coronation portraits from the First Empire, Napoleon presented himself as the most viable successor to the French throne, and heir apparent to the empire of Charlemagne.

Out of thirty-seven representations of Bonaparte signed by Georgin, the artisan rendered Napoleon as an emperor in only one illustration.

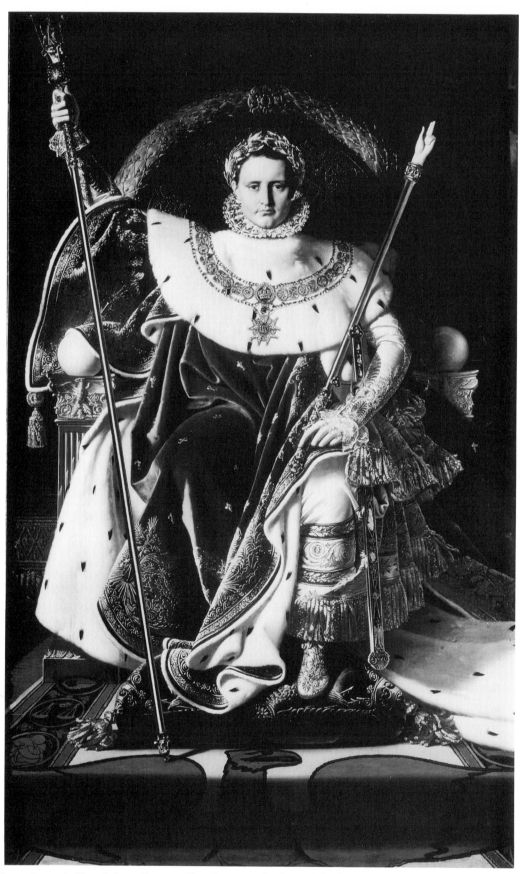

**Jean-Auguste-Dominique Ingres,** *Napoleon on the Imperial Throne in Ceremonial Dress* **(1804). Musée de l'Armée, Hôtel National des Invalides, Paris.**

# LA FAMILLE IMPÉRIALE

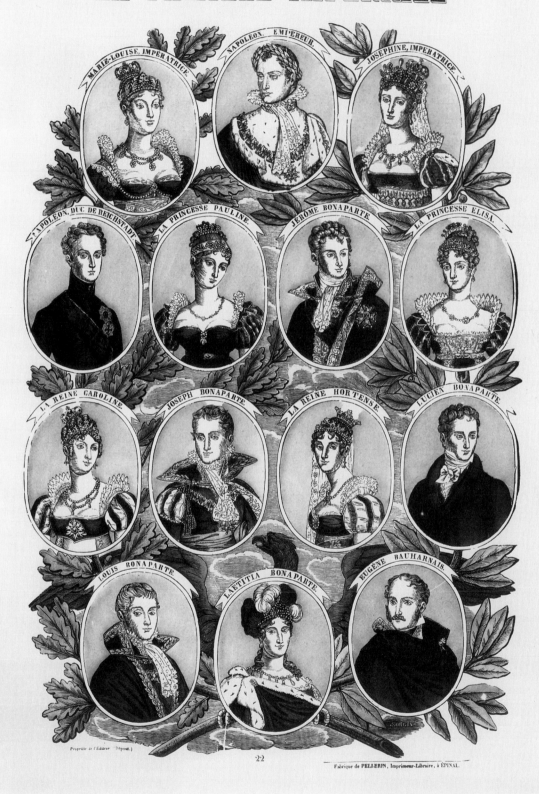

**François Georgin,** *Imperial Family* (1833), Pellerin, Epinal. Imagerie d'Epinal, 1996.

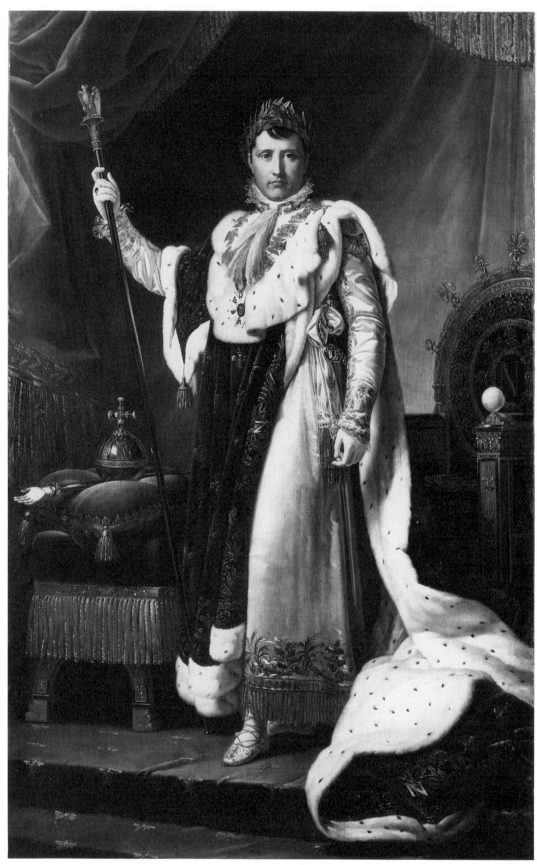

François Gérard, *Napoleon I*. Musée du Louvre, Paris. Photo by RMN.

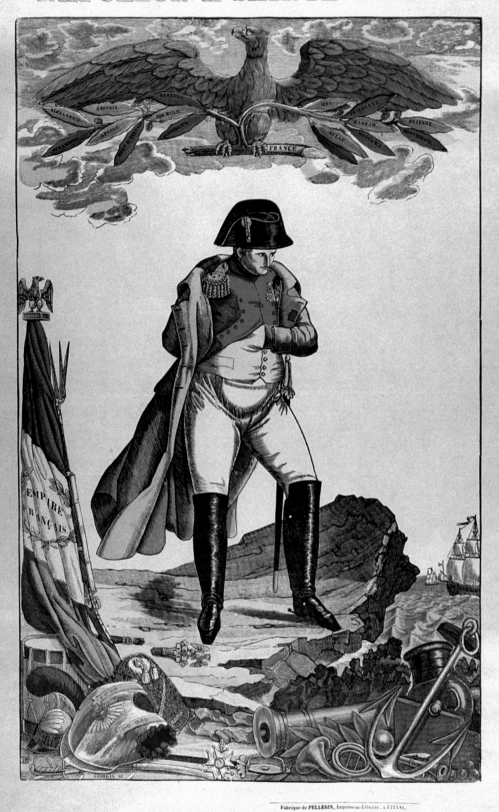

François Georgin, *Napoleon at St. Helena* (1832). Pellerin, Epinal. © Imagerie d'Epinal, 1998, Archives Départementales des Vosges. Photo by J. Laurençon.

Jean-Baptiste Thiébault, *Napoleon Touching the Plague-Ridden* (1835). Pellerin, Epinal. © Imagerie d'Epinal, 1998, Archives Départementales des Vosges. Photo by J. Laurençon.

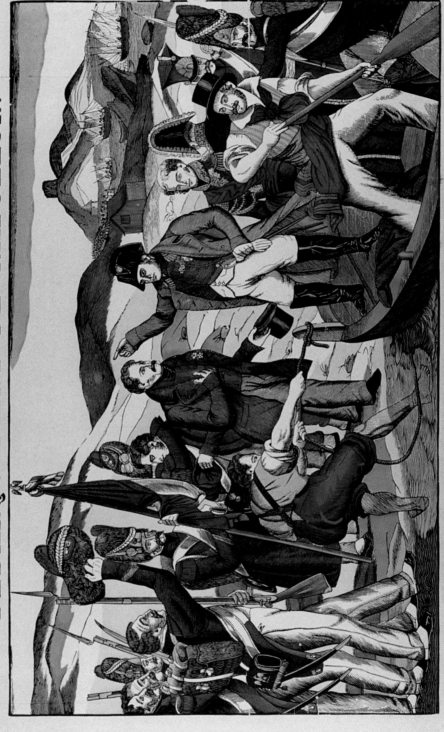

*The Debarkation of Napoleon* (1835). Pellerin, Epinal. © Imagerie d'Epinal, 1998, Archives Départementales des Vosges. Photo by J. Laurençon.

Charles Maurin, *St. Peter, Prince of the Apostles* (1840). Pellerin, Epinal. Musée des Arts et Traditions Populaires, Paris. Photo by RMN.

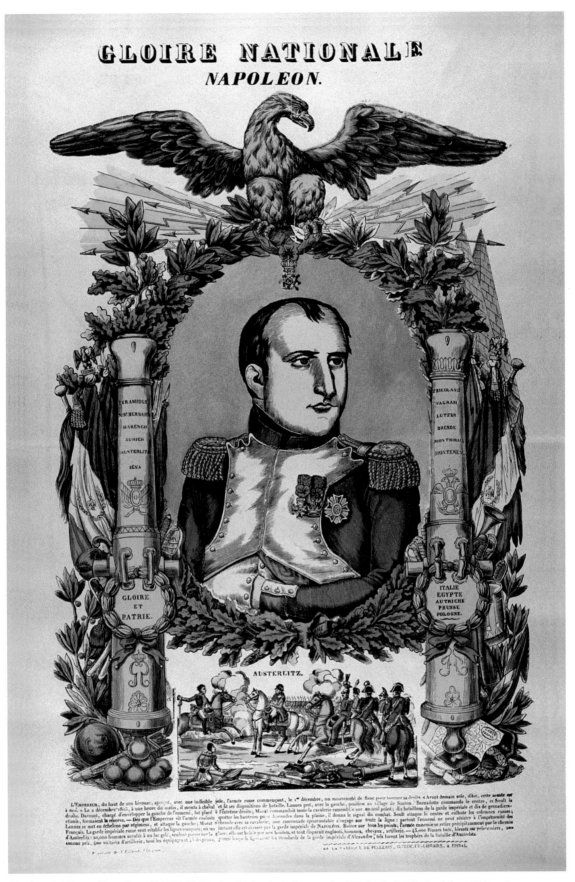

*National Glory, Napoleon* (1835). Pellerin, Epinal. © Imagerie d'Epinal, 1998, Archives Départe-mentales des Vosges. Photo by J. Laurençon.

François Georgin, Jean Baptiste Thiébault, *The Apotheosis of Napoleon* (1834). Pellerin, Epinal.
© Imagerie d'Epinal, 1998, Archives Départementales des Vosges. Photo by J. Laurençon.

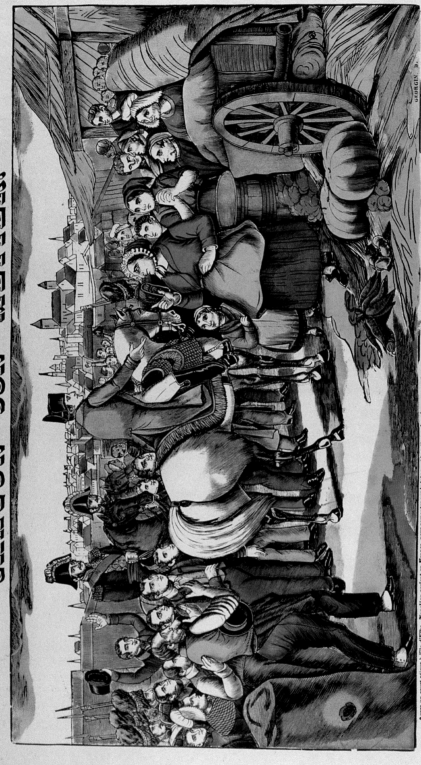

François Georgin, *Everyone Has His Own Trade* (1835). Pellerin, Epinal. © Imagerie d'Epinal, 1998, Archives Départementales des Vosges. Photo by J. Laurençon.

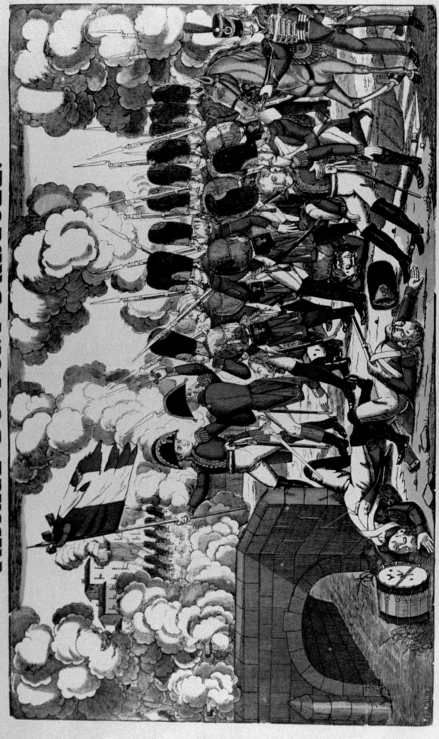

François Georgin, *Passage over the Arcole Bridge* (1833). Pellerin, Epinal. © Imagerie d'Epinal, 1998, Archives Départementales des Vosges. Photo by J. Laurençon.

In *The Imperial Family* (1833), Georgin presents a medallion bust of the emperor dressed in a coronation costume that is very similar to the coronation portrait of the emperor by François Gérard. Medallions of Bonaparte's two wives, Marie-Louise and Josephine, flank the bust portrait of the emperor in the upper tier of the composition. Georgin includes Napoleon's son, the Duke of Reichstadt, plus Bonaparte's sisters and brothers framed within medallions located in the three tiers below the emperor. Notably, all the members of Bonaparte's family, including his mother, Laetitia Bonaparte, wear formal state attire indicating their status within the Imperial system. While such a lavish portrait of Bonaparte and his family might suggest the artist's sympathies for the Imperial system, during the five decades that Georgin worked in the Pellerin atelier, he produced no other representation of Napoleon (or his family) in Imperial attire.[40]

Instead of Imperial splendor, Georgin drew principally from engravings from the Imperial and Restoration periods that represented Napoleon's concern for the common people. To emphasize Napoleon's solicitude for his people, Georgin selected a number of engraving models from the First Empire done by the artisan Jean-Baptiste Debret that showed Napoleon's response to those who were adversely affected by war.[41] In Debret's *Sire, My Mother Is Old and Infirm*, an old woman, the mother of a grenadier, petitions Napoleon to return her son from active service in order to care for her. Flanked by officers of the Imperial Guard, Napoleon is dressed as a cavalry colonel and mounted regally on his white steed. According to the legend below the illustration, Bonaparte receives the petition of the old woman *avec bonté* (with unusual munificence). In the spirit of the French kings, he grants the indigent woman's request and allots her a lifetime pension.

In using the Debret print as model for his own design entitled *Napoleon and the Mother of the Grenadier* (1834), Georgin adopts the same pedagogical tone as the Imperial engraver, pointing out Napoleon's solicitude for the poor and suffering peasant. Although the wood-block design reverses the Debret composition, Georgin retains the same positioning in the Epinal version. However, he features Napoleon not as colonel, but as the Little Corporal dressed informally in his half-open greatcoat and bicorne hat, reining back his horse to speak with the peasant woman. Georgin has also added a full view of several rustic

cottages in the midground and background left of his design. In addition to these bucolic touches, Georgin includes a parade of marching troops who spiral forward from the countryside toward Napoleon and his entourage in the foreground. The artisan cleverly connects Bonaparte to his surroundings through the formal organization of the composition as well as through its dramatic message.

As the soldier presents Bonaparte to his mother, she stretches out her hand to give him a letter. The Pellerin text explains the old woman's petition: "'My son,' and she could not finish her phrase for the tears." Despite the difference in station (reinforced by differences in level) between the emperor, the peasant woman, and her son, Napoleon responds to her tearful request with unexpected candor and generosity. "My dear old woman," replies Napoleon, "you will soon have your son back and while waiting for him, you will receive a pension of 600 francs from my own purse."[42] The more familiar tone of the Epinal commentary emphasizes Bonaparte's genuine compassion for the old woman.

Georgin's characteristic avoidance of Imperial display in the Napoleonic designs underlines his preference for more spartan representations of Napoleon as a soldier in bivouac or battle. Rather than as emperor, he preferred to represent Napoleon I as a cavalry "colonel" in the Imperial Guard, or in the unassuming bicorne hat and greatcoat of the Little Corporal, as he was affectionately called by his troops. During his military campaigns, Napoleon had avoided ostentation by wearing an informal uniform without plumes or elaborate ornamentation to designate his rank. Eschewing the formal retinue of an officer, Napoleon preferred the uniform of a foot soldier or cavalryman of the Imperial Guard. The sobriquet Little Corporal was first associated with Bonaparte during his early campaigns against the Austrians in Italy. Although he wore the informal uniform of a colonel with epaulets, he often appeared with a gray overcoat that covered emblems of rank. According to tradition, the nickname Little Corporal was given to Bonaparte by older soldiers in Italy who joked about his short stature and youthful appearance.[43] The Pellerin atelier turned the affectionate nickname into a sign of popular homage and esteem.

To create engaging episodes about the Little Corporal, in conjunction with Vadet and Pellerin, the Pellerin atelier reworked a number of

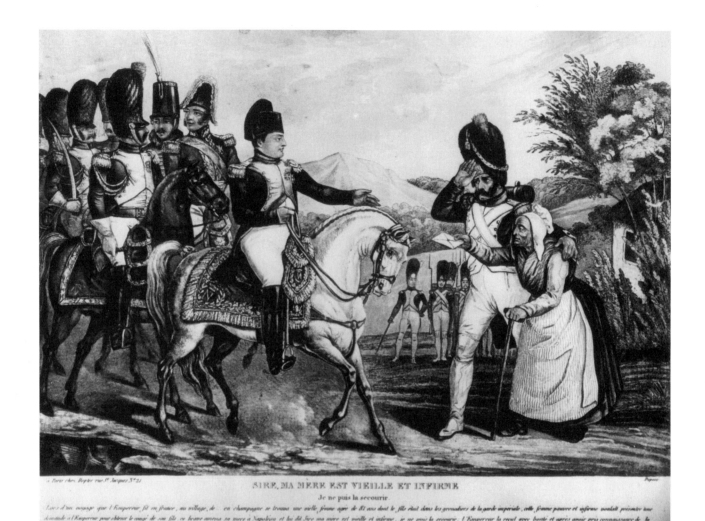

SIRE, MA MÈRE EST VIEILLE ET INFIRME

Je ne puis la secourir.

Jean-Baptiste Debret, *Sire, My Mother Is Old and Infirm* (First Empire). Musée des Arts et Traditions Populaires, Paris. Photo by the author.

# NAPOLÉON ET LA MÈRE DU GRENADIER.

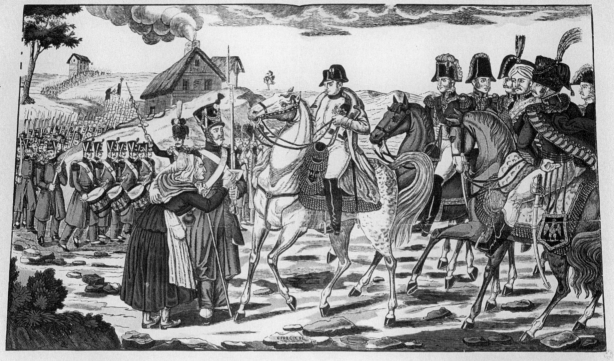

QUELQUE temps après son couronnement (en 1804), NAPOLÉON, devenu Empereur des Français, voulut revoir les lieux où il avait fait ses premières études militaires. Accompagné de quelques intimes, auxquels il pourrait communiquer les pensées et les émotions que devaient lui causer les souvenirs de son enfance, il partit pour la Champagne, et se dirigea vers Prienne, où il passa quelques jours, qui ne furent perdus ni pour l'État, aux soins duquel il consacrait chaque jour plusieurs heures, ni pour l'humanité, car il répandit ses bienfaits sur tous ceux qui eurent quelque chose à lui demander, et sur toutes les personnes qu'il avait connues autrefois. — Quelques troupes avaient été réunies sur ce point, l'Empereur en passait souvent la revue. Un jour qu'elles arrivaient au lieu du rendez-vous, un grenadier sort des rangs, va prendre sa vieille mère, âgée de plus de 80 ans, qui vit près de là, et la présente à NAPOLÉON. Elle tenait à la main une pétition. « Mon bon monsieur l'Empereur, lui dit-elle, mon fils..... elle ne put achever. — Bien, bien, accordé, répondit le grand homme. Ma bonne vieille, vous aurez votre fils bientôt; en attendant, je vous fais une pension de 600 francs à prendre sur ma cassette particulière. — Merci, mon l'Empereur, » dit le grognard; et il emmena sa vieille mère pleurant de reconnaissance.

*Propriété de l'Éditeur. (Déposé)*

A ÉPINAL, CHEZ PELLERIN, IMPRIMEUR-LIBRAIRE

François Georgin, *Napoleon and the Mother of the Grenadier* (1834), Pellerin, Epinal. © Imagerie d'Epinal, 1996.

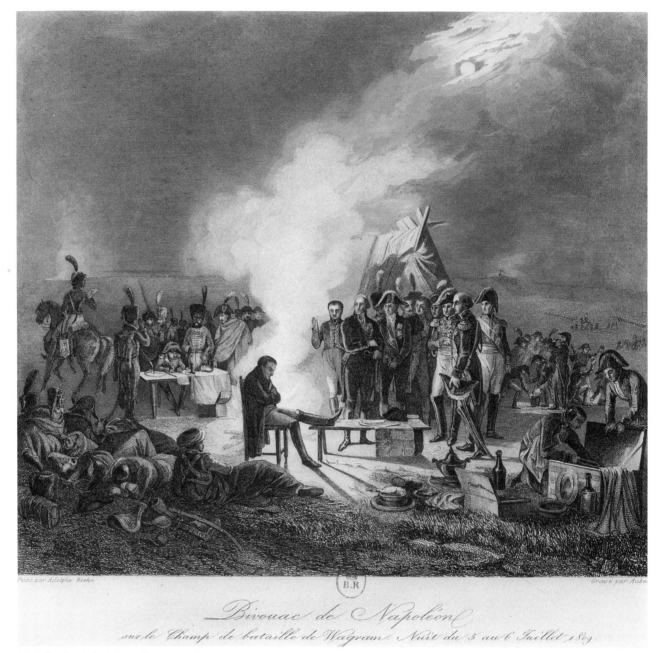

*Bivouac de Napoléon*
*sur le Champ de bataille de Wagram. Nuit du 5 au 6 Juillet 1809.*

**Adolphe E. Gabriel Roehn, *Napoleon's Bivouac for the Battle of Wagram* (First Empire). Cabinet des Estampes, Bibilothèque Nationale de France, Paris.**

engravings done by artist Adolph E. Gabriel Roehn during the First Empire. One of Roehn's most haunting compositions, entitled *Napoleon's Bivouac for the Battle of Wagram*, shows Napoleon seated in meditation beside the campfire while his men look on with reverence and wonder. *Napoleon's Bivouac* was certainly the inspiration for Pellerin's version of *The Eve before the Battle of Austerlitz* (1835). While attentive officers await di-

rections from their leader, firelight flickers beside the bent figure of Bonaparte dozing. In both designs, a seated Napoleon rests one leg on a makeshift table and sits with folded arms; his attitude suggests the solitude of a great leader on the eve of an impending battle. To emphasize the iconography of the Little Corporal, the Pellerin artisan added the famous bicorne hat to the seated figure beside the campfire. The en-

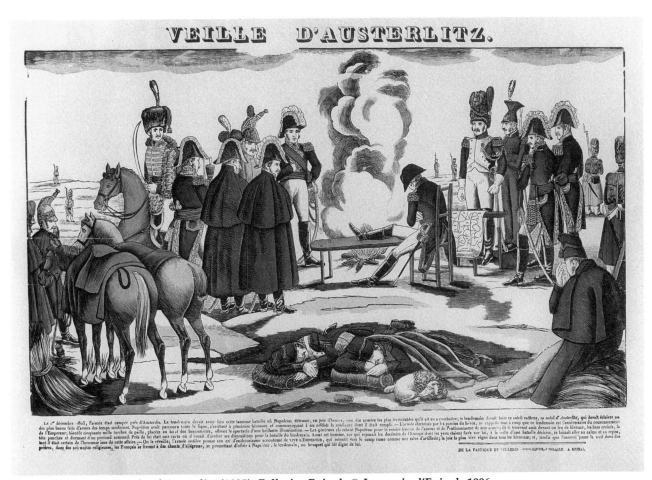

*The Eve before the Battle of Austerlitz* (1835), Pellerin, Epinal. © Imagerie d'Epinal, 1996.

graver also included a sentinel in a green cape in the right foreground (symbolizing either the artist himself or an ardent admirer), who weeps as he contemplates the possible rout of Napoleon and his troops at Austerlitz.[44]

Another early model for the Little Corporal was Eleanor Anne Trollé's lithograph of Napoleon in exile (1819).[45] In the print, Bonaparte looks melancholy and reflective as he gazes out from the rocky shore of St. Helena. Trollé describes Napoleon in the characteristic garb of the Little Corporal with his bicorne hat, greatcoat, boots, and sword of Austerlitz. Though his rounded figure and paunch suggest portraits of the elder statesman, his face appears unusually young and firm. While distinguishing medals and the Legion of Honor star are partly visible beneath the lapel of his coat, the engraver accentuates the intensity of his expression and the resoluteness of his stance. Prepared for action, Napoleon impatiently awaits his release from exile.

Trollé's lithograph undoubtedly served as the model for Georgin's *Napoleon at St. Helena.* Though the Epinal print is a mirror copy of the Trollé portrait, Georgin has created a livelier Napoleon leaning slightly forward with one hand under his vest and one arm behind. To explain the meaning of his picture to his viewers, the artisan has added allegorical and political symbolism. The anchor, fallen helmet, and cannon aptly describe Bonaparte's defeat and exile to foreign soil. The enormous eagle and laurel leaves suspended above Napoleon emphasize the unquestionable power of the Imperial symbol. But the tricolor flag in the left foreground and the ship in the distant right suggest the political optimism associated with Napoleon's memory. Whether pondering his destiny or awaiting release from captivity, the Little Corporal remains stalwart and firm.[46] Such representations of Bonaparte as soldier and corporal offered a heroic alternative to veterans and com-

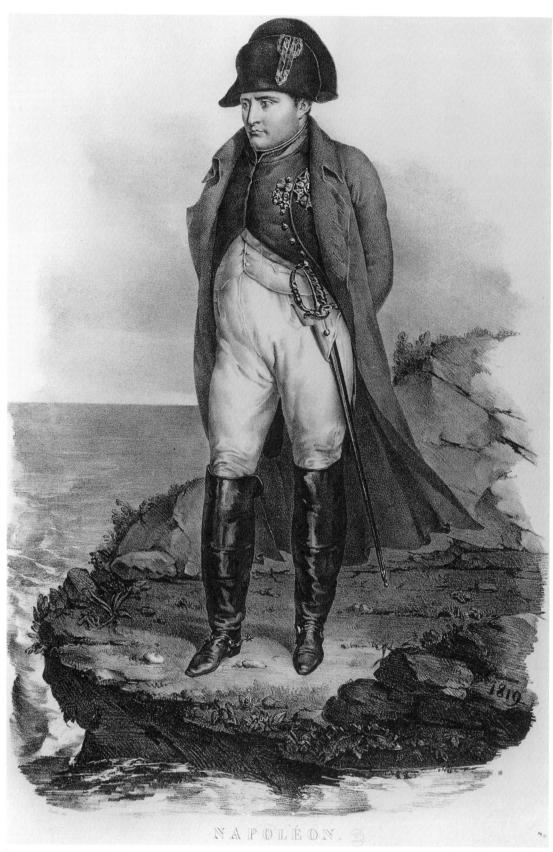

NAPOLÉON.

**Eleanor Anne Trollé,** *Napoleon in 1819.* Musée de l'Armée, Hôtel National des Invalides, Paris.

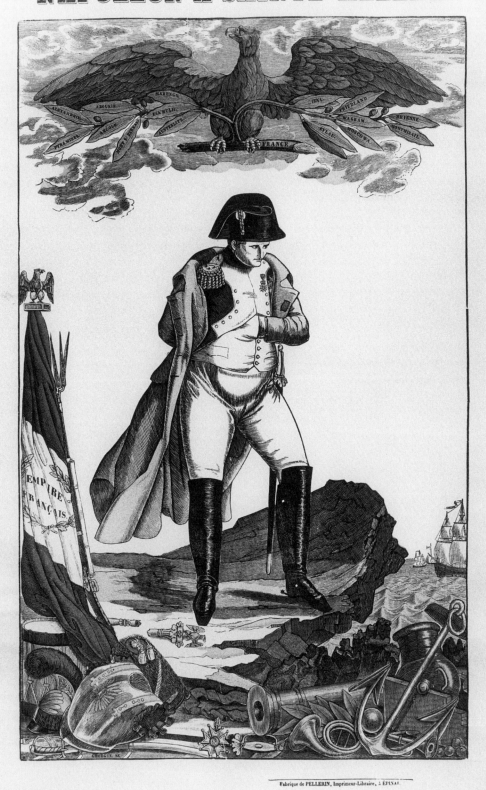

**François Georgin,** *Napoleon at St. Helena* **(1832), Pellerin, Epinal.** © Imagerie d'Epinal, 1996. *Also see* **color plate 2.**

moners during the lackluster years of the Or-
leanist regime.

Pellerin's audience was also drawn to repre-
sentations of the victorious French armies dur-
ing the July Monarchy. Liberals and bonapartists
especially welcomed themes of military glory
that overshadowed France's defeat in 1815 and
the fainthearted military policies of the Bourbon
and Orleanist kings. Demonstrating a resurgent
spirit of military adventure and the renewed de-
sire of revenge for Waterloo, Georgin designed a
series of battle scenes that reflected these
yearnings for the resurgence of French national
glory. Compositions emphasizing the heroism of
the Napoleonic armies in battle were the most
popular items in the Pellerin series on Napo-
leon. Of the fifty-nine Napoleonic themes pro-
duced by the Pellerin firm, eighteen described
battle scenes about Bonaparte and his legendary
armies. Such triumphal representations of Na-

poleon's military campaigns undoubtedly rein-
forced feelings of national pride and patriotism
among Pellerin's audience.

Like earlier engravers, Georgin avoided the
use of allegory and described Napoleon's mili-
tary encounters with classical simplicity.[47] He did
not, however, simply render a distant view of
the battlefield and surrounding landscape, char-
acteristic of military art during the First Empire.
Instead, the artisan developed a form of adven-
ture narrative that magnified important person-
ages, such as Napoleon and his officers, in the
foreground of the design. By emphasizing the
focus of action in each composition, Georgin
drew his audience visually into the battlefield.
In these dramatic scenarios, the artisan enabled
his audience to participate in an impressive eu-
logy to heroism, patriotism, and service to
country.

While Georgin's interpretations of Napoleon's
military campaigns resembled many engravings

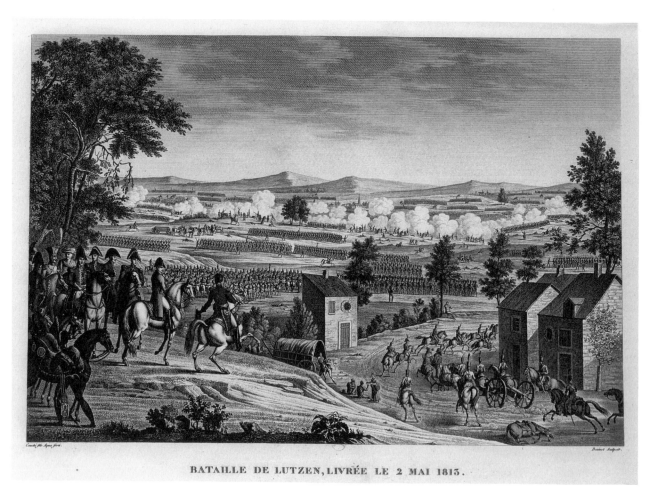

BATAILLE DE LUTZEN, LIVRÉE LE 2 MAI 1813.

Carl Vernet, *Napoleon at the Battle of Lutzen.* Cabinet des Estampes, Bibliothèque Nationale de France, Paris.

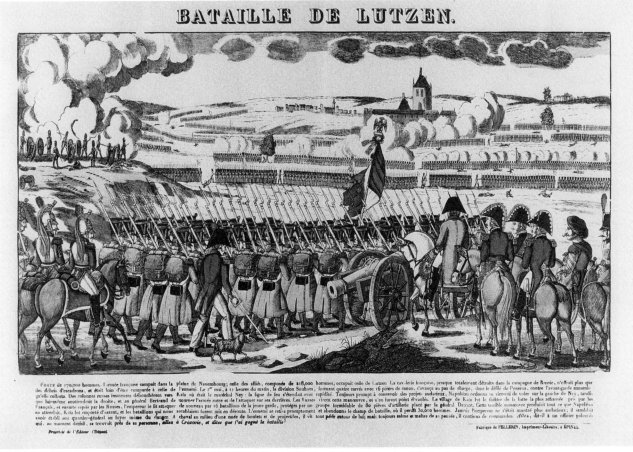

**BATAILLE DE LUTZEN.**

François Georgin, *The Battle of Lutzen* (1833), Pellerin, Epinal. © Imagerie d'Epinal, 1996.

by the Imperial artist Carl Vernet, the Pellerin artisan changed the perspective of the viewer in his own work.[48] In Vernet's *Napoleon at the Battle of Lutzen* (April 1833), the viewer shares the distanced position of a military strategist. But Georgin's version of Lutzen plunges the viewer into the center of battle. In both engraving and popular print, Napoleon and his officers are situated in the foreground of the design, with the Imperial cavalry charging around the house to the right, backed by blocks of moving infantrymen in the background. Georgin, however, moved the mounted figure of Napoleon from a marginal position on the sideline into the center foreground, where he is in direct confrontation with enemy troops.[49] By shifting the figure of Bonaparte from a marginal to a central position, Georgin underlined Napoleon's role as a catalyst not only for the French army but also for the nation.

Georgin's unique contribution is nowhere more apparent than in nine engravings that the artisan reproduced from a series of illustrated volumes published by Pellerin during the Restoration. Military scenes taken from Bovinet et Couché Fils engravings found in François Tissot's *Les Trophées des armées françaises de 1792 à 1815* furnished the most important documentation for Georgin's military designs.[50] In adapting the Bovinet et Couché Fils original of *The Battle and Passage over the Bridge of Lodi*, Georgin made some major changes. He enlarged the figures of the gunners and their cannons as well as the wounded figures lying beside the bank of the river. In addition, to create his thematic narrative, he lifted the minute figures of Napoleon and his officers located on the left side of the bridge in the Bovinet and Couché Fils original and shifted this coterie of mounted figures to the foreground of his own composition.[51] Georgin's transfer of Napoleon and his officers from the Bovinet et Couché Fils original to the front of his own composition established Bonaparte as the chief protagonist in the victorious campaign.

The theatrical effectiveness of this technique

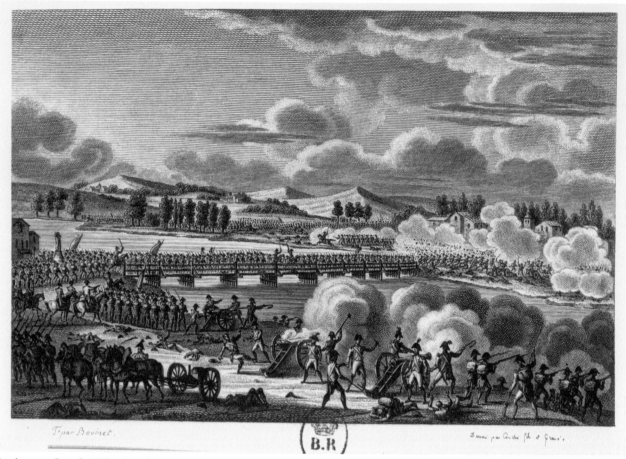

Bovinet et Couché Fils, *Battle and Passage over the Bridge of Lodi* (1821). Cabinet des Estampes, Bibliothèque National de France, Paris.

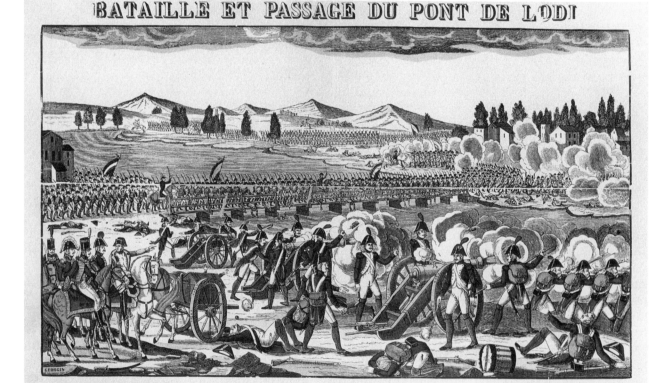

BATAILLE ET PASSAGE DU PONT DE LODI

L'ARMÉE autrichienne, échappée au désastre de Fombio, s'était retirée derrière l'Adda, pour s'en faire un rempart. — L'avantgarde de l'armée française l'atteignit, le 11 mai 1796, au pont de Lodi. Beaulieu, avec toute son armée, était rangé en bataille pour en défendre le passage ; 50 pièces de canon avaient été placées pour foudroyer les Français s'ils osaient le tenter. — BONAPARTE, poursuivant l'ennemi, entre dans Lodi, et fait placer son artillerie en batterie. Dès l'instant que l'armée est arrivée, elle se forme en colonne serrée, le second bataillon en tête, et suivie par tous les bataillons de grenadiers, elle s'avance au pas de charge et aux cris de *Vive la République!* L'on se présente sur le pont, l'ennemi fait un feu terrible; la tête de la colonne paraît hésiter, mais les généraux Berthier, Masséna, Lannes s'y précipitent, et le pont est franchi. L'artillerie ennemie est enlevée; les Français renversent tout ce qui s'offre à leurs coups, et sèment de tous côtés l'épouvante, la fuite et la mort. Dans un clin-d'œil l'armée autrichienne est éparpillée. — La victoire remportée à Lodi ouvrit aux Français le chemin de Milan, où ils entrèrent le 14 mai.

*Propriété de l'éditeur. ( Déposé. )*

Fabrique de PELLERIN, Imprimeur-Libraire, à EPINAL.

François Georgin, *Battle and Passage over the Bridge of Lodi* (1834), Pellerin, Epinal. © Imagerie d'Epinal, 1996.

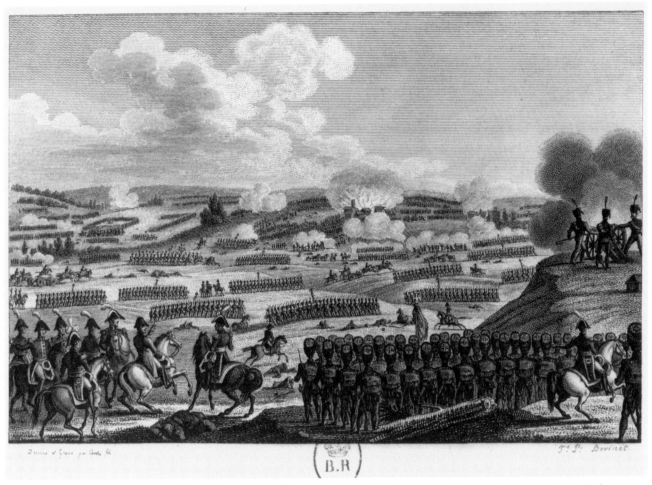

Bovinet et Couché Fils, *Battle of Iena* (1820–21). Cabinet des Estampes, Bibliothèque Nationale de France, Paris.

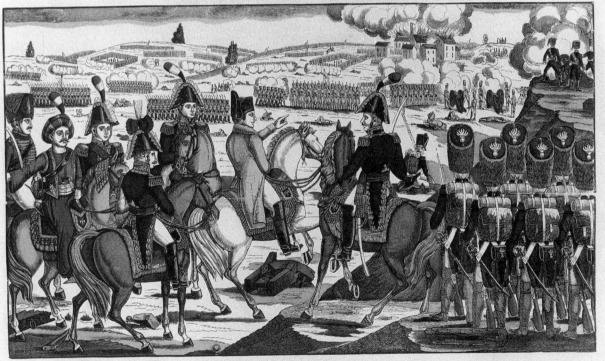

BATAILLE D'IÉNA.

L'EMPEREUR arriva à Iena le 13 octobre 1806, à deux heures après-midi. Placé sur un plateau ou se trouvait notre avant-garde, il reconnut que l'ennemi occupait une forte position sur la chaussée de Weimar à Iéna. Le lendemain matin, un brouillard très-épais couvrait les deux armées. L'Empereur parcourait les lignes ; il fit connaître aux soldats que les Prussiens étaient cernés comme les Autrichiens l'avaient été dans la campagne précédente qu'ils chercheraient à faire une trouée, et que la réputation des corps qui les laisseraient échapper, serait à jamais flétrie. A ce discours prononcé d'un ton véhément, l'armée ne répondit qu'un mot: *Marchons!* et soudain la fusillade commença. Les Prussiens, étonnés d'une aussi brusque attaque, coururent aux armes. Jusqu'alors le brouillard avait caché une partie des opérations; mais un beau soleil d'automne vint éclairer l'atmosphère, et les deux armées s'aperçurent à portée de canon. En moins d'une heure, 300,000 hommes et 800 pièces de canon se livrèrent au plus effroyable carnage. Présent partout, l'Empereur dirigeait toutes les opérations. Prévenu que deux nouvelles divisions du corps du maréchal Ney, qu'il attendait, venaient d'arriver sur les derrières du champ de bataille, il fit charger notre première ligne de réserve. Son choc fut épouvantable : en un clin-d'œil l'ennemi fut en pleine retraite. En vain il eut recours aux bataillons carrés, lorsque, frémissant de voir la victoire se décider sans elles, nos divisions de dragons et de cuirassiers, ayant Murat à leur tête, fondirent sur eux : artillerie, cavalerie, infanterie, tout fut massacré, culbuté ou pris. La perte de l'ennemi dans cette mémorable journée, fut de 60,000 hommes, dont 20,000 restèrent sur le champ de bataille, 30 drapeaux, tous les bagages, et 300 pièces de canon.

*Propriété de l'Editeur. (Déposé.)*

De la Fabrique de PELLERIN, Imprimeur-Libraire, à EPINAL.

François Georgin, *Battle of Iena* (1834), Pellerin, Epinal. © Imagerie d'Epinal, 1996. *Also see* color plate 3.

is most apparent in Georgin's version of the *The Battle of Iena*, compared with that of Bovinet et Couché Fils. In the popular rendition of *Iena*, Georgin moved Napoleon and his officers from the middle of the Couché Fils engraving to the foreground of his own composition. The artisan then enlarged and highlighted conversational gestures between Napoleon and his officers, pushed the second plane of marching troops farther to the back, and lifted the horizon of the composition almost to the upper border of the picture.[52] By emphasizing Napoleon's interchange with his officers in the front of the design, Georgin reveals the sense of mutuality and confidence that existed between Bonaparte and his men. The same relational dynamic extends from Bonaparte and his officers to the troops marching behind them.

Unquestionably, the nine battle scenes from the Bovinet et Couché Fils album furnished a formal inspiration for the Epinal prints of the same title.[53] Georgin, however, emphasized the central narrative by drawing Napoleon and his officers to the front of the picture. Placing the interaction between Napoleon, his officers, and his men in relief made the battle scenes more accessible to a semiliterate audience. Viewers not able to read the textual commentaries could, nonetheless, understand graphic renditions of Napoleon's exploits. Most importantly, by enlarging the figure of Napoleon with his soldiers, the artisan highlighted the pivotal and salutary role played by Napoleon in France's political destiny.[54]

In establishing a dramatic focus for the Napoleonic images, Georgin was undoubtedly inspired by anecdotal prints and military vignettes done by lithographers during the Restoration and July Monarchy. Like famous engravers such as Raffet and Charlet, Georgin avoided representations of Napoleon as emperor or statesman in favor of less imposing interpretations of Bonaparte as a humble soldier and campmate. The artisan also adopted a more informal narrative approach to describe the triumphs of Napoleon's troops in action or the melancholy of veterans who had lost their beloved leader. Through exposure to prints by Charlet and Raffet, Georgin developed a democratic language and style that not only reflected but eventually challenged the representational strategies of the July Monarchy.

Charlet executed numerous political lithographs and caricatures about Napoleon and the common soldier during the Restoration and July Monarchy. The engraver learned about the Napoleonic wars through his father, a "dragoon" officer under Napoleon. After his father's death, Charlet was deeply influenced by his mother's fervor for Bonaparte. Charlet entered the studio of Gros, where he studied painting and lithography. As early as 1817, he began designing lithographs and paintings that dramatized the desperate situation of Imperial veterans under the Bourbon regime, and their continued devotion to Napoleon Bonaparte.[55]

In a print entitled *Es cuirassier Z au 4ème* [You are Weapons Maker Z from the Fourth], published in 1829, Charlet describes an unexpected encounter between the Little Corporal and the veteran from the battles of Austerlitz, Jena, Friedland, and Wagram. Charlet portrayed the soldier, who had charge of preparing armaments and weapons, as a common laborer. His pick rests in front of a stone block as he salutes Napoleon, who identifies him by regiment and division. The cheering figures behind the fence form an audience celebrating the momentous encounter between Napoleon and the astonished veteran. By showing Bonaparte's admiration for the former weapons maker, Charlet established an ironic contrast with the actual professional and political oppression veterans experienced during the Restoration regime.

Charlet probably furnished much of the inspiration for military art done by his student and contemporary, Raffet. Born in Paris in 1804, Raffet became a painter, engraver, designer, and lithographer of considerable repute during the Restoration and July Monarchy. From 1824 to 1829 he was admitted to the studio of Charlet, who instructed him in lithography. The designers worked together and traded themes and anecdotes from the campaigns of the Great Army. In 1829, Raffet became a student of Gros, and through his influence was admitted to the Ecole de Beaux Arts.[56] When he did not receive the Prix de Rome in 1831, Raffet left painting almost completely and devoted himself primarily to engraving and lithography.[57] In January 1832, the first edition of his famous album, published by Gihaut Frères, emphasized Napoleon's legendary charisma with his men.[58]

Raffet portrayed a virtually indissoluble, al-

ÈS CUIRASSIER Z'AU 4.me

Austerlick, Jena, Friedland, Wagram.

**Nicolas-Toussaint Charlet,** *You are Weapons Maker Z from the Fourth* **(1829). Cabinet des Estampes, Bibliothèque Nationale de France, Paris.**

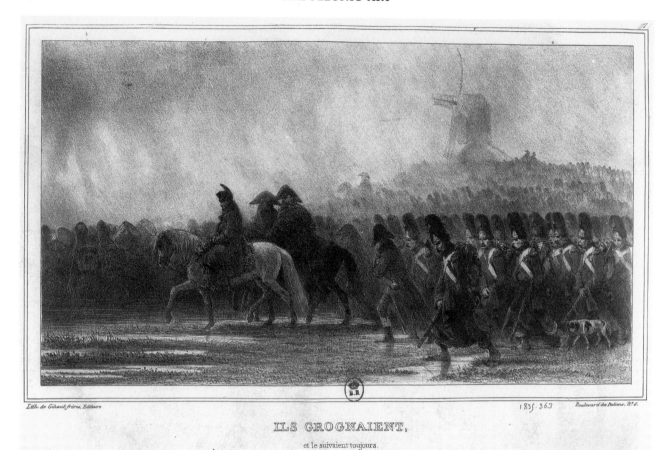

ILS GROGNAIENT,

et le suivaient toujours.

**Denis-Auguste-Marie Raffet,** *They Grumbled and Continued to Follow Him* **(1836). Cabinet des Estampes, Bibliothèque Nationale de France, Paris.**

most mystical connection between Napoleon and his armies. One famous lithograph from the Gihaut Frères volume by Raffet shows Napoleon leading a bevy of tattered troops out of Russia (1836). Drawn by their leader, his soldiers follow reluctantly on foot, some wearing shoes, others with rags on their feet. The title of this engraving—*Ils grognaient et le suivaient toujours* [*They Grumbled and Continued to Follow Him*]—characterizes the spirit of veterans from the Great Army who were teasingly nicknamed *les grognards* (the grumblers). In *Long Live the Emperor*

(1832), Napoleon's men celebrate his presence in the center of the battle; even when wounded on the ground, soldiers toss their hats in the air and raise their arms, shouting, "Long live the emperor."

Raffet also pointed out Napoleon's openness to common soldiers through his willingness to participate in an ordinary camp ritual. In a whimsical illustration, Raffet depicts Napoleon beside a campfire, surrounded by soldiers who offer him "the best and most well-done potato" (1832). In this print, Raffet portrays Napoleon in

**Denis-Auguste-Marie Raffet,** *My Emperor, It's the Best and Most Well-done Potato* **(1832). Cabinet des Estampes, Bibliothèque Nationale de France, Paris.**

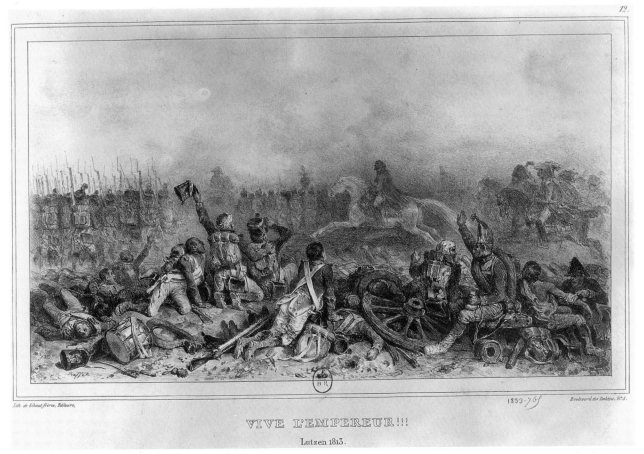

VIVE L'EMPEREUR!!!

Lutzen 1813.

**Denis-Auguste-Marie Raffet,** *Long Live the Emperor* **(1832). Cabinet des Estampes, Bibliothèque Nationale de France, Paris.**

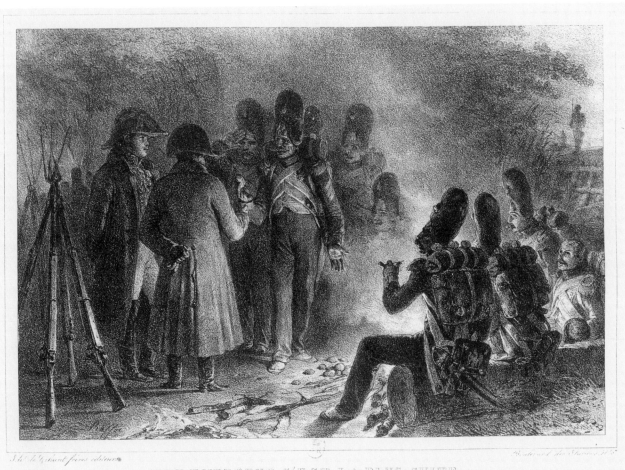

MON EMPEREUR C'EST LA PLUS CUITE.

LA PETITE LAITIÈRE.  LA PETITE VENDANGEUSE  LA PETITE MARCHANDE DE FLEURS.

LE PETIT BATELIER.  NAPOLÉON.  LE PETIT BERGER.

LE PETIT ECOLIER.  LE PETIT SAVOYARD.  LES PETITS FAGOTS.

A LILLE, chez CASTIAUX, Libraire.  569  Imprimerie de BLOCQUEL.

**Anonymous, *The Little Milkmaid,* aquatint, Lille, Castiaux. Musée des Arts et Traditions Populaires, Paris. Photo by RMN.**

the traditional bicorne hat, greatcoat, pants, and boots of the Little Corporal. Raffet's print emphasizes Bonaparte's humble response when he accepts an ordinary potato from his men. By connecting Napoleon with the common people, Raffet set a trend that prevailed in prints and engravings during the early years of the July Monarchy.[59]

Georgin was undoubtedly inspired by the democratic approach Charlet and Raffet used to portray Napoleon's cordial and unassuming manner with commoners. The artisan also drew from anonymous prints that depicted Napoleon as a friend to the people. Rather than being associated with the powerful and elite, Napoleon as corporal reflected the undistinguished yet courageous qualities of the common man. In an anonymous lithograph printed in Lille during the July Monarchy entitled *The Little Milkmaid* (n.d.), young people representing the humblest stations surround the symbolic figure of the Little Corporal. Portrayed like small statuettes, each childlike figure represents a different trade: from that of a schoolgirl to a shepherd, milkmaid, flower girl, grape seller, and young artisan. The lithograph of the Little Corporal surrounded by young commoners reveals how the engraver designated Bonaparte as the quintessential "man of the people."

Like Raffet and Charlet, Georgin portrayed the humble image of Napoleon informally conversing with his officers and men. The Pellerin artisan also conveyed the message of solidarity and mutuality between Napoleon and his men that was apparent in Raffet and Charlet's engravings. But Georgin did not embellish the figure of Napoleon and his army with mystical clouds of smoke and heightened chiaroscuro as did Raffet, nor did he caricature the Napoleonic veteran as did Charlet. Instead, Georgin portrayed the unassuming figure of Bonaparte surrounded (often on the same level) by soldiers, peasants, and artisans. In *The Debarkation of Napoleon* (1835), for example, the Pellerin artisan presented the Little Corporal and his officers arriving in southern France after their escape from the island of Elba. Soldiers, workmen, and a bourgeois townsman (hat in hand) welcome the French leader as he arrives in the Bay of San Juan.[60] The soldiers who greet Napoleon have relinquished the Bourbon banner and replaced it with the Imperial standard. Georgin shows how French soldiers and citizens respond elatedly to Napoleon's debarkation. By placing the central figures of the design (soldiers, workers, and middle class) on a horizontal plane, proportionately the same size and height as Bonaparte, the artisan relayed a distinctly egalitarian message to his audience.

Georgin portrayed Napoleon both as a military hero and as a leader who was accessible to his people. In a print entitled *Everyone Has His Own Trade*, produced in 1835, Georgin portrays an informal conversation between Napoleon and a vegetable seller. While an avid group of peasants and artisans surrounds and greets their leader, a hefty peasant woman with a child pushes through the crowd to speak with Bonaparte. The text points out that, like Jesus of Nazareth, Napoleon does not hesitate to meet with a woman of lower station: "As soon as Napoleon saw the efforts of this woman of the people to reach him, he signaled his generals to move aside and told her to come closer and speak." Both illustration and text suggest Napoleon's good-humored affability with a simple market woman. Dressed as the Little Corporal, Bonaparte appears to be available, even to an obstreperous vegetable seller. Georgin's composition piques the viewer's interest by showing the surprising mutuality between the legendary hero and the nondescript peasant.

Although Georgin derived the majority of his designs from earlier compositions, he transcribed them into a format and language that appealed to a general audience in regional France. Through the availability of lithographs and print engravings, the Epinal atelier worked from designs produced during the First Empire by Roehn and Debret, and from copies of commissioned works by David, Gros, and Gérard. In addition, Georgin used military engravings from the First Empire and Restoration designed by artists such as Carle Vernet and Bovinet et Couché Fils. With access to urban engravings and lithographic prints, Georgin was able to select and rework earlier military themes and compositions into attractive wood-block designs marked by his own unique style and vision. Georgin adopted the fraternal and comradely way Napoleon related to his soldiers in prints by Raffet and Charlet. Though his style was often stiff and repetitive, the artisan managed to evoke the excitement of Napoleon's interaction with his troops. By enlarging and placing Napoleon and his soldiers in the foreground of his compositions, Georgin made the figure of Napoleon Bo-

# DÉBARQUEMENT DE NAPOLÉON.

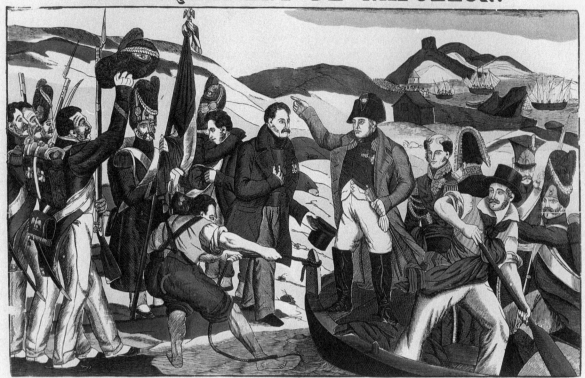

Le 26 février 1815, à une heure après midi, la garde impériale et les officiers de la suite de Napoléon reçoivent l'ordre de se tenir prêts à partir. Les dispositions nécessaires à cet effet avaient été secrètement prises dans le port. A cinq heures, on se presse sur le rivage, au cri de *Vive l'Empereur!* A huit, un coup de canon donne le signal du départ. A neuf, l'Empereur et sa suite ont quitté l'île d'Elbe. *Le sort en est jeté!* s'était écrié Napoléon, en mettant le pied sur son navire. (Il montait le brick de guerre l'*Inconstant*. Il n'avait avec lui que Drouot, Cambronne, Bertrand, et ses 400 grenadiers. Jusque-là Napoléon avait gardé son secret: *Grenadiers*, dit-il alors, *nous allons en France, nous allons à Paris!* Les grenadiers l'auraient suivi partout; au nom de *France*, l'amour de la patrie se manifesta plus fortement encore que le dévouement au chef; le cri de *Vive la France* domina celui de *Vive l'Empereur*. — Le 1er mars, à trois heures de l'après-midi, la flotille de l'île d'Elbe entre dans le golfe de Juan, quitte le pavillon blanc parsemé d'abeilles, et reprend la cocarde tricolore,

aux cris de *Vive la France! vivent les Français!* A cinq heures, Napoléon met pied à terre, et son bivouac est établi dans un champ d'oliviers. *Voilà un heureux présage*, dit-il; *puisse-t-il se réaliser!* Aussitôt le débarquement effectué, Napoléon avait chargé un capitaine et 25 hommes de s'introduire dans Antibes; ils devaient se présenter comme des déserteurs de l'île d'Elbe, reconnaître les dispositions de la garnison, et chercher à se la rendre favorable; mais un zèle imprudent fit échouer cette tentative. Enfin, après plusieurs jours de marche, le 20 mars, à huit heures du soir, jour anniversaire de la naissance de son fils, Napoléon reparaît à Paris. Il est accueilli avec enthousiasme par la foule qui se rassemble, se grossit sur son passage, et lui forme un cortège jusqu'au Carrousel; là citoyens et soldats le reçoivent dans leurs bras et le portent ainsi jusque dans les appartemens des Tuileries. Depuis, il a plusieurs fois répété que *ce moment fut un des plus beaux de sa vie*.

*Propriété de l'Éditeur (Dépôt) – Reproduction interdite.*

Imagerie PELLERIN, à Epinal

*The Debarkation of Napoleon* (1835), Pellerin, Epinal. © Imagerie d'Epinal, 1996. *Also see* color plate 4.

# CHACUN SON MÉTIER.

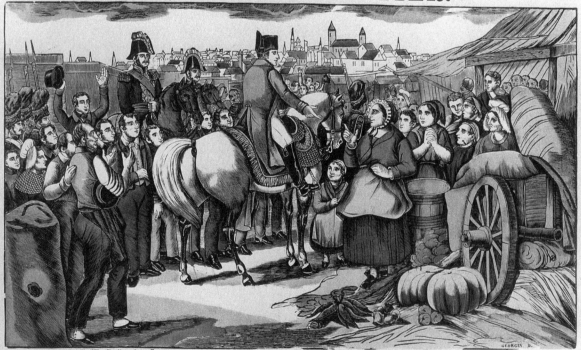

GEORGIN, D.

Après un court séjour à l'île d'Elbe, Napoléon revient en France, pour remonter sur le trône qu'il avait abandonné pour son fils. Les Français, auxquels l'avènement de Louis XVIII n'avait pu faire oublier le Grand Homme, le reçoivent au milieu de mille acclamations d'enthousiasme. Il traverse la France, presque porté en triomphe sur les bras de ses soldats; partout la population accourt sur les routes pour le voir et le saluer par des cris d'allégresse et d'espérance.

Napoléon arrive à Paris; la foule se porte sur la place du Carrousel. Au milieu de la multitude qui l'entoure, il aperçoit une femme du peuple tenant un enfant par la main, et qui fait tous ses efforts pour s'approcher de lui. Aussitôt Napoléon fait écarter ses généraux, va droit à elle, et l'invite à parler. La marchande de légumes; car c'en était une, met en usage le plus

beau style que puisse lui fournir son imagination, et s'exprime ainsi: *Sire, excuses de la liberté; c'est que, voyes-vous, j'vous aimons ben. Quand vous êtes parti, et qu'j'ons vu les Bourbons prendre vot' place, j'm'ai trouvée vexée! maintenant, qu'vous r'voilà, j'vas vous dire ce qui faut que vous fassies pour que la même chose ne r'arrive plus....* Napoléon l'interrompt au moment où elle va lui développer ses belles idées sur la politique: *Ma bonne femme, chacun son métier; mêlez-vous de vos affaires, vendez vos légumes, soignez bien vos choux et vos carottes, laissez-moi le soin de la politique, et tout ira pour le mieux, si chacun fait ce qu'il doit.*

*Propriété de l'Éditeur. (Dépôt.)*

Fabrique de PELLERIN, Imprimeur-Libraire, à ÉPINAL.

naparte and his soldiers both immediate and accessible to his audience.

In addition to heroic renditions of Napoleon as a military leader, the artisan described Bonaparte in less imposing ways. Like his contemporaries, he avoided Imperial trappings and ecclesiastical symbols to emphasize the unassuming demeanor of the Little Corporal, a symbol that had become familiar to audiences in both urban and provincial France during the July Monarchy. Georgin presented Napoleon in democratic terms as a soldier who could engage in an easy conversation with commoners. He often described Bonaparte in direct and gracious commerce with peasants, soldiers, and commoners. For Georgin and his audience, Napoleon was not only a friend of the common man but also the quintessential embodiment of France and her people.

While lithographers and engravers such as Georgin reproduced the populist image of Napoleon with soldiers and commoners, Louis-Philippe commissioned more formal representations of the Little Corporal to reinforce his own legitimacy as ruler.[61] By appropriating Napoleon as corporal, the Orleanist king wished to disassociate himself from the clerical and hierarchical traditions of the Ancien Regime. Through the creation of numerous monuments to Napoleon and his veteran armies, the king attempted to harness the legend for his own political purposes. Louis-Philippe, however, was limited by the conventions of official art. While he endorsed representations of Bonaparte in monumental paintings, relief, and sculpture, he could not transcend the material disparities between the fine arts in the capital and the popular broadsheets that proliferated in regional France. Consequently, the Epinal representations of the Little Corporal leading his people to renewed conquests and glory could not be contained within the more restricted terms of the Orleanist system. By the end of the first decade of his rule, the king realized that he could neither assume nor restrain the implicit power of the *populist* legend.

François Georgin, *Everyone Has His Own Trade* (1835), Pellerin, Epinal. © Imagerie d'Epinal, 1996. *Also see* color plate 5.

# 4

# St. Napoleon

AFTER THE REVOLUTION OF 1830, PELLERIN firm pioneered the production of broadside illustrations of Napoleon's military career. Though most regional printers continued to publish religious and fictional material, the Epinal editors concentrated on Napoleon, presenting one of the first political biographies done graphically for a provincial audience.[1] With the relaxation of censorship restrictions from 1830 to 1835, Pellerin switched from producing mainly devotional prints to publishing broadside illustrations of Napoleon and his legendary armies.[2] Making this shift from religious to secular themes was risky for Pellerin and Vadet, who stood to lose a profitable market in devotional literature and art.[3]

Due to the innovative skills of Pellerin's chief artisan, François Georgin, the Napoleonic prints brought monetary success and unquestioned fame to the Pellerin atelier. Georgin's representations of Napoleon's exploits catered to widespread yearnings for an imposing but nonetheless accessible political hero. Drawing from popular lithographic traditions, the artisan featured the Little Corporal as the protagonist in most of his designs. Georgin drew his audience into the graphic narrative by emphasizing the dramatic tension between Napoleon and the approaching enemy. Through his audacious use of color and his compositional flair, the artisan imbued each composition with freshness and verve.

In most of his wood-block designs, Georgin portrayed Napoleon as the Little Corporal, a figure disengaged from hierarchical traditions connected with Imperial or Bourbon rule. By avoiding the trappings of either empire or monarchy, Georgin evoked the humble soldier and military comrade who had become a populist symbol in post-Imperial France. Popular representations of the Little Corporal signified both the egalitarian principles of 1789 and French military preeminence in western Europe. In addition to the heroic dimensions of the symbol, images of Napoleon as corporal conveyed the unassuming qualities of the common citizen and soldier.

Representations of the Little Corporal also presumed Napoleon's experience of defeat and imprisonment on the island of St. Helena. Publications about his sufferings in exile recast pejorative attitudes toward Bonaparte into a more favorable light. Sympathetic artists and writers portrayed Napoleon as a political hero and martyr rather than as a ruthless dictator. Counteracting memories of Bonaparte's final defeat and abdication in 1815, portraits of Napoleon as the Little Corporal likewise stressed his symbolic role in the political renewal of the French nation. Pictures of Napoleon as a military leader elicited yearnings for the reinstatement of national prestige and glory.

The popularity of Napoleonic prints, songs, and ephemera in regional France confirmed not only the vitality of his legend but also Bonaparte's continued influence in provincial culture. Some consideration of Chistian imagery and practices can help to explain the development of such widespread enthusiasm for Napoleon Bonaparte, particularly after his death. Because of devotional customs, Pellerin's customers likely infused illustrations of the Little Corporal with religious meanings and associations. As with the religious icon, broadside images of Bonaparte

made the commander immediately present to his audience. Through the Epinal illustrations, viewers could address their frustrations and desires to a tangible representation of their esteemed leader.

Religious iconography played a formidable role in Pellerin's own inventory, from the French Revolution through the July Monarchy. Like regional printers in Orleans, Lille, Cambrai, and Lyon, the Pellerin firm developed a solid market in religious iconography drawn chiefly from biblical stories or from medieval tales published in the Blue Library.[4] Pellerin's catalog from 1814 included scenes from the Old Testament regarding the history of creation and events in the lives of Christ and the Holy Family together with numerous images of the Madonna. According to the printer's records, he published sixty religious prints during the first year of the Restoration.[5] His most successful illustrations included Saints Hubert, Alexis, Barbara, Catherine, Jacques de Compostelle, Nicholas, and Agatha.[6] By 1822, 125 images of saints were in circulation. In 1823, 23 new images were added, 20 in 1824, 2 in 1828 and 1 in 1830.[7] By 1842, the Epinal firm was publishing nearly a million images a year, mostly of saints.[8]

Pellerin reproduced many popular representations of saints with symbolic logos, including St. Catherine carrying a palm leaf as a sign of her martyrdom in one arm and the sword of faith in the other. The background detail showed the wheel upon which she had been tortured. St. Margaret likewise carried the palm of martyrdom while she stepped on the tail of a green dragon coiled about her legs. Framed in a baroque relief filled with sacramental and ecclesiastical symbols, St. Peter held the key to the Church folded across his breast while Christ with an angelic choir was suspended in the clouds above his head. In addition to these popular patrons, many devotional prints praised practices ascribed to women, such as religious devotion, motherhood, and keeping the home. Surrounded by a frame of acorns and oak leaves (signs of sturdiness and longevity), St. Anne opened a scriptural papyrus and read to her daughter Mary. Few such symbolic references were obscure to believers generally acquainted with Catholic devotional traditions.

From the Counter-Reformation period, the Catholic Church encouraged the production of popular images and pamphlets about the Christian saints to reinforce religious devotion.[9] Devotional prints and their accompanying legends combined to encourage an empathetic as well as inspirational connection between the viewer and the image. While the colorful image could touch the sentiments of the viewer, the accompanying text encouraged faith, veneration, and prayerful adoration. Popular religious engravings were not simply informative or decorative; rather, the Church used these rudimentary images to encourage the faithful to model their lives after the example of Christ and the saints.[10] Popular hagiography thus offered not only an inspirational but also an ethical lesson, encouraging the faithful to follow the example of the Christian saints.

The story of redemption portrayed in the lives of the saints encouraged the renunciation of material wealth and power. Forsaking worldly affairs, the saint normally withdrew from familial responsibilities and political activity to concentrate on spiritual endeavors. A favorite saint's life from the Epinal region who exemplified this model was that of St. Hubert. His sacrifice of wealth and station was proverbial. When the young nobleman went hunting one day, he chanced upon a stag of great size. At the moment when he was about to slay the animal, Hubert saw a cross between its antlers and he heard these words: "Hubert, Hubert, why are you wasting your time? Don't you realize that you are destined to love and serve God your creator?" During this encounter, the voice directed Hubert to leave the royal court and his family to follow a religious vocation under the guidance of the saintly Bishop Lambert.[11]

In a popular narrative about St. Anthony, the editor presented the ethical lesson at the very beginning of the tale: "After the death of their noble parents, Anthony and his sister gave away all their wealth and abstained from pleasures and luxuries associated with the world." The saint chose a "hidden" life of penance and prayer. To follow this calling, Anthony withdrew to a monastery in the desert, where he established a hermitage founded on the principles of humility and charity: "His vocation was to honor the hidden life of Christ through his retreat into the desert. Thus, he retired into the secrets of solitude."[12] Despite St. Anthony's choice of poverty, pilgrims were drawn to the saint's hermitage where, gifted with divine favor, he could heal, perform miracles, and prophesy. Such beneficent powers were a consequence of divine election as well as the saint's decision to renounce worldly affairs and station to pursue a life of asceticism and prayer.

Pellerin's shift from religious to Napoleonic

# Cantiques spirituels.

## CANTIQUE

*Sur Sainte Catherine, Patrone des Filles. 25 Novembre.*

*Sur l'air : Il pleut, il pleut, Bergère.*

Vierge, dont on admire
Les sublimes vertus,
Glorieuse Martyre,
Victime pour Jesus :
Quel est votre mérite
Aux regards du Seigneur ?
Sa justice l'excite
A vous combler d'honneur.

Illustre Catherine,
Même en vos jeunes ans,
Votre sainte doctrine
Confond les faux savans ;
Elle en fait la conquête
A l'adorable Roi,
Et fait courber leur tête
Sous le joug de la Foi.

Vous fûtes, toujours pure,
Dompter la volupté,
Et de votre torture
Vaincre la cruauté.
Pour Dieu, victorieuse
D'un monde séducteur,
Votre âme généreuse
Brave encor sa fureur.

O que vous fûtes sage
De faire un si beau choix !
En prenant pour partage
De plaire au Roi des Rois.
A suivre ce grand Maître
Combien on est heureux !
Qu'il sait bien reconnaître
Nos efforts généreux.

Pour un moment de peines
Qu'on prend à le servir,
Il nous rend à mains pleines
Un éternel plaisir.
Vous en faites l'épreuve
Dans un bonheur divin ;
Sa bonté vous abreuve
De délices sans fin.

Notre foiblesse extrême
Se confie en vos soins ;
Au Seigneur qui vous aime
Exposez nos besoins.
Obtenez-nous la grâce
D'imiter vos vertus ;
Afin de trouver place
Au séjour des Elus.

## CANTIQUE

*En l'honneur de la Sainte Vierge.*

*Sur un air nouveau.*

Pour chanter votre gloire
Mère du Roi des Rois,
Par nos chants de victoire
Nous unissons nos voix.
O Vierge incomparable !
Agréez les accens
Qu'un zele invariable
Inspire à vos enfans.

Dans cette belle Fête
Votre pied triomphant
Brise, écrase la tête
Du perfide serpent
C'est en vain qu'il épie,
Pour lancer son venin ;
Sa jalouse furie
Contre vous ne peut rien.

Jamais nulle souillure
N'atteignit votre cœur ;
Votre ame toujours pure
Charme l'œil du Seigneur
Il vous comble de grace
Dès le premier instant ;
Et son bras se surpasse
En vous sanctifiant.

La tache originelle
N'eut pas prise sur vous :
Cette faveur nouvelle
Vous distingua de tous ;
Et vous seule conçue
Sans nulle iniquité,
Vous fûtes revêtue
De toute Sainteté.

Vierge de Dieu chérie,
Sans égale en grandeurs,
De notre ame flétrie
Réparez les malheurs
Ah ! soyez, ô Marie !
Après Dieu, la douceur,
La paix, l'espoir, la vie,
L'amour de notre cœur.

Objet de nos hommages,
Et de nos doux transports,
Au milieu des orages
Secondez nos efforts :
Que votre aide soutienne
Ici-bas tous nos pas ;
Et qu'elle nous obtienne
Enfin un saint trépas.

# Sainte Catherine.

De la Fabrique de PELLERIN, Imprimeur-Libraire à EPINAL. (*Vosges.*)

*St. Catherine* (1814), Pellerin, Epinal. Musée des Arts et Traditions Populaires, Paris. Photo by RMN.

François Georgin, *St. Margaret* (1824), Pellerin, Epinal. Musée Départementale d'Art Ancien et Contemporain, Epinal. Photo by the author.

Charles Maurin, *St. Peter, Prince of the Apostles* (1840), Pellerin, Epinal. Musée des Arts et Traditions Populaires, Paris. Photo by RMN. *Also see* color plate 6.

*St. Anne, Mother of the Virgin* (early nineteenth century) Pellerin, Epinal. Musée Départmentale d'Art Ancien et Contemporain, Epinal. Photo by the author.

# CANTIQUE SPIRITUEL

## SAINT HUBERT.

### CANTIQUE
A L'HONNEUR
### DE SAINT HUBERT.

Air : *Du bon Jésus.*

Ouvrons notre mémoire,
Et élevons nos yeux
Jusqu'au centre des cieux,
Pour publier la gloire
Du bien-aimé de Dieu :
C'est le grand saint Hubert,
Si réclamé par tout l'univers ;
Publions en tous lieux
Le pouvoir de ce saint glorieux.

Parmi la loi païenne
Saint Hubert fut né
D'une noble lignée,
Fils du duc d'Aquitaine,
En France fut renommé ;
Pour son premier exploit
Il fut s'offrir au service du roi,
Où il fut promptement
Fait capitaine à son contentement.

Hubert, en son jeune âge,
Eut l'honneur d'avoir,
Comme ayant du pouvoir,
Floribanne en mariage,
Fille du comte Dagobert ;
Demeurant à Louvain,
La chasse était son plus grand entre-
tien.
Le plaisir et la joie
De saint Hubert était parmi les bois.

Le Seigneur, par sa grâce,
Fit changer ce païen
Au nombre des chrétiens ;
Dans une partie de chasse,
Le jour du Vendredi-Saint,
Chassant dans la forêt,
Il guide un cerf et le poursuit de près ;
Comme un chasseur,
Il espère en être le vainqueur.

Le cerf lui résiste,
Lui disant : Crois-moi,
Chasseur, arrête-toi ;
En vain tu fais la poursuite
Au divin Roi des rois.
Regarde-moi dans ce lieu,
Figure-toi que je suis ton vrai Dieu :
Je viens te convertir,
Quitte la chasse et bannis le plaisir.

Hubert mit pied à terre,
Et fut bien surpris
De voir ce Crucifix
Entre les bois d'un cerf
Qu'il avait tant poursuivi :
Prosterné à genoux,
Disant : Seigneur, que me demandez-
vous ?
Dites-moi en ce lieu
Ce qu'il faut faire pour plaire à mon
Dieu !

Sitôt la voix répète,
Lui disant : Hubert,
Va trouver saint Lambert,
Évêque de Maëstricht,
Car il doit te baptiser ;
Tu apprendras soudain
De ce grand homme à vivre en chré-
tien :
Tu seras patron des chasseurs
Et des Ardennes, pour faire ton
bonheur.

Hubert s'en fut à Maëstricht
Trouver saint Lambert,
Lui dit, d'un cœur ouvert :
Très-digne et saint évêque,
Vous devez me baptiser :

Je viens, les larmes aux yeux,
Me prosterner de la part de Dieu ;
Soyez mon protecteur,
Enseignez-moi la vraie loi du Seigneur.

Saint Lambert le baptise,
Charitablement
Lui apprit à l'instant
A vivre selon l'église
Et en vrai pénitent :
Après quoi saint Hubert,
Pendant sept ans resta dans un dé-
sert,
Se traitant en rigueur,
Se nourrissant de racines et de pleurs.

Après que ce saint homme
Eut bien souffert,
Étant dans le désert,
Dieu l'envoya à Rome
Pour le récompenser :
Un ange du Seigneur
Lui donne la sainte étole et la clé,
Qui fera préserver
Tous les chrétiens d'animaux enragés.

Saint Hubert, patron des Ardennes, qui avez eu l'avantage de voir l'image d'un Dieu crucifié entre les bois d'un cerf, et qui avez reçu une sainte étole miraculeuse par le ministère d'un ange, nous vous supplions de nous appliquer charitablement la vertu de ce présent divin, et de nous préserver par vos mérites de tous dangers, de rage, du malin esprit, fièvres, tonnerre et autres malheurs. Priez pour nous, ô grand saint Hubert ! afin qu'il plaise à Dieu nous octroyer un jour la grâce de vous voir dans le Ciel.

DE LA FABRIQUE DE PELLERIN, IMPRIMEUR-LIBRAIRE, A ÉPINAL.

François Georgin, *St. Hubert* (1830), Pellerin, Epinal. © Imagerie d'Epinal, 1996.

# SAINT ANTOINE, ERMITE.
## 141

**CANTIQUE.**

Air : Or dites-nous, Marie.

Du séjour de la gloire,
Bienheureux, dites-nous,
Après votre victoire,
Quels biens possédez-vous?

Ces biens sont ineffables :
Le cœur n'a pas compris
Quel trésor admirable
Dieu garde à ses amis.

Mais daignez nous instruire
Du prix de vos vertus :
Dites ce qu'on peut dire
Du bonheur des élus?

Loin du trouble et des armes,
Voir, aimer le Seigneur,
En jouir sans alarmes,
C'est-là notre bonheur.

Martyrs, dont le courage
Triompha des bourreaux,
Quel est votre partage
Après de si grands maux?

Tous, la couronne en tête,
La palme dans les mains,
Nous chantons la conquête
Du Sauveur des humains.

Docteurs, fameux oracles,
Interprètes des cieux,
Par quels nouveaux miracles,
Dieu frappe-t-il vos yeux.

Ah! quel bonheur extrême
D'aller en sûreté
Dans le sein de Dieu même
Puiser la vérité.

Vous, humbles solitaires
Que l'Egypte a produits,
De vos jeûnes austères
Quels sont enfin les fruits?

Pour tous nos sacrifices
Et nos saintes rigueurs,
Un torrent de délices
Vient inonder nos cœurs.

Vous, épouses fidèles
Du plus fidèle époux,
Pour des ardeurs si belles,
Quels plaisirs goûtez-vous?

Épouses fortunées,
Nous pouvons en tout lieu,
De roses couronnées,
Suivre l'agneau de Dieu.

Vous qui du riche avare
Eprouvez les froideurs;
Compagnons du Lazare,
Quelles sont vos douceurs?

Nous mangeons à la table
Du Roi de l'univers :
Le riche impitoyable
Est au fond des enfers.

Et vous qu'un pain de larmes
Nourrissait chaque jour,
Quels sont pour vous les char-
mes
Du céleste séjour?

Une main secourable
Daigne essuyer nos pleurs,
Un repos désirable
Succède à nos douleurs.

Mais quelle est la durée
D'un si charmant repos?
Dieu l'a-t-il mesurée
Sur celle de vos maux?

Dieu qui de nos souffrances
Abrégea les moments,
Veut que ses récompenses
Durent dans tous les temps.

Ah! daignez nous apprendre,
En cet exil cruel,
Quelle route il faut prendre
Pour arriver au ciel.

Si vous voulez me suivre,
Marchez en combattant;
Et sans cesser de vivre,
Mourez à chaque instant.

Mais la peine est extrême;
Comment vivre toujours
En guerre avec soi-même,
Et mourir tous les jours,

Si la route est fâcheuse,
Le trône est plein d'appas,
Une couronne heureuse
Pour de légers combats.

**AUTRE CANTIQUE.**

Sion, de ta mélodie,
Cesse les divins accords;
Laisse-nous près de Marie,
Faire éclater nos transports.
La Reine que tu révères,
Le digne objet de tes chants,
Apprends qu'elle est notre
mère,
Et fais place à ses enfants.

Mais comment de cette en-
ceinte
Percer les voûtes des cieux!
Descends plutôt, Vierge sain-
te,
Et viens régner en ces lieux.
Viens d'un exil trop sévère
Adoucir les longs tourments :
Ta présence, auguste mère,
Sera chère à tes enfants.

Pour toi nous sentons nos
âmes
Brûler, en ce divin jour,
Des plus innocentes flammes,
Du plus généreux amour.
Ah! puissions-nous te plaire
Consacrer tous nos instants,
Et prouver à notre mère
Que nous sommes ses enfants!

Sur tes autels, ô Marie!
Tous, d'une commune voix,
Nous jurons toute la vie
D'être soumis à tes lois.
De notre hommage sincère
Puissent ces faibles garans
Flatter notre tendre mère,
C'est le vœu de ses enfants.

## ORAISON.

Seigneur tout-puissant, daignez exaucer les ferventes prières que nous vous adressons par l'intercession de ce grand saint; donnez-nous la grâce d'imiter ses vertus, et accordez-nous la force nécessaire pour persévérer dans l'exacte observance de vos saints commandemens, afin de mériter un jour une place dans le séjour des justes. Ainsi soit-il.

Fabrique de PELLERIN, Imprimeur-Libraire, à ÉPINAL.

*St. Anthony, the Hermit* (1842), Pellerin, Epinal. © Imagerie d'Epinal, 1996.

themes marked a startling transition from the contemplative and ascetic model found in the lives of Christian saints to that of an aggressive military figure who endeavored to change the course of European history. The addition of portrayals of Bonaparte's public career to the traditional inventory of religious texts and images indicates that popular tastes were changing, from a preoccupation with Christian salvation to interest in the secular destiny of the French nation. Departing from the ascetic and unchanging model of sanctity presented in devotional art, graphic and textual representations of the Little Corporal praised his actions in the world—his statesmanship as well as his military conquests. In contrast with illustrations of Christian asceticism, textual and graphic representations of Napoleon I presented a model who was intensely ambitious and political.[13]

Georgin successfully conveyed Bonaparte's military achievements by portraying his courage and initiative in battle. In the Epinal prints, the Little Corporal was usually mounted and stationed in the foreground, rallying his troops before an armed confrontation. The political commentary beneath the illustration emphasized Bonaparte's skill in organizing the course of the campaign. The text below *Napoleon at Arcis–on–Aube* describes how "Napoleon was constantly in the center of the foray. Surrounded by a whirlwind of charging cavalry, he could disengage himself only with a sword."[14] Pellerin's commentary for *The Battle of Iena* explained how the Little Corporal was able to destroy opposing hosts and maneuver troops rapidly to France's advantage: "The emperor was everywhere and directed every operation."[15]

Because of Napoleon's charismatic leadership, he inspired his men to take aggressive action. In the textual commentary for *The Battle of Marengo,* for example, Napoleon admonishes the temerity of his soldiers, "'Frenchmen, we have spent too much time going backward; the moment is here to take a decisive step forward.' Immediately the

**François Georgin, *Napoleon at Arcis-on-Aube* (1835), Pellerin, Epinal. © Imagerie d'Epinal, 1996.**

artillery shot furiously for ten minutes and the Austrians were beaten along the front lines."[16] Through both graphic and literary texts, the artisan (and editor) drew their audience into that decisive moment when Bonaparte encouraged his men to assume responsibility for their own political destiny.

While the Napoleonic broadsides were overtly secular, Pellerin's customers nevertheless imbued such illustrations with Christian meanings. Popular texts and images of Napoleon elicited veneration as well as admiration for the military impresario. Representations of the Little Corporal fused with familiar religious traditions to create a political metaphor that touched provincial customers. Religious traditions thus enabled Pellerin's customers to renew their allegiance both to Napoleon and to the revolutionary ethos associated with his memory.

During the First Empire, Napoleon I was aware of the importance of religious propaganda when he employed devotional means to secure the support of his people. To encourage their fealty, Bonaparte revised the official French catechism and required his constituents to promise obedience to himself as well as to God. In the catechism printed in 1806, Napoleon inserted a chapter that added a political dimension to Christian faith and practice. Lesson 7 of the *Imperial Catechism* described the duties of the faithful:

> We owe our emperor Napoleon I love, respect, obedience, fidelity, military service, and taxes required for the preservation and defense of the Empire and throne. We also owe the emperor our fervent prayers for his salvation and for the spiritual and temporal prosperity of the State.[17]

Through the *Imperial Catechism*, Napoleon affirmed his position as a political leader and chief spokesman for the French Catholic Church.

To encourage the allegiance of his Catholic constituency, Napoleon created a patron saint who would be celebrated regularly in the official liturgical calendar. Shortly before the conclusion of the Concordat with the Church in the spring of 1802, Napoleon insisted that his bishops verify the existence of a patron named St. Napoleon, who would be included in the French liturgical calendar. Cardinal Jean-Baptiste Caprara, delegated to this research, found a patron for Napoleon in the martyrology of St. Hieronymous. From his research, the cardinal discovered a young Roman warrior named Eopolis or Neopo-

lis. Having lived during the persecutions of Diocletian and Maxmilian, Neopolis was martyred when he refused to pledge his allegiance to the Roman emperor. Because of his resistance, the young soldier was tortured and killed in a prison located in Alexandria. When Bonaparte received this information, he encouraged the church to sanctify Neopolis as St. Napoleon, the patron of warriors.[18] The feast day of the new saint on 15 August corresponded with the conclusion of the Concordat and the birthday of the First Consul.[19]

Shortly after the establishment of the Concordat in the spring of 1802, Pellerin printed a wood-block illustration of St. Napoleon as a Roman soldier standing in prayer between a martyr's palm and an imperial sword with shield. The legend above the picture identified "St. Napoleon, Roman Officer." Below the illustration, the commentary described St. Napoleon's feast day on 15 August as a celebration that would also commemorate France's religious alliance with the Vatican.[20]

Because popular images of St. Napoleon were subsequently published by Pellerin and other regional printers during the course of the nineteenth century, it appears that the demand for representations of St. Napoleon caught on and survived well beyond the Imperial regime. Pellerin listed several versions of the warrior saint in catalogs from the Restoration, the later years of the July Monarchy, and the early part of the Second Empire. In two separate prints, Pellerin portrayed the saint as a Roman soldier dressed in full armor carrying a shield and sword. The earlier print published in 1842, shows the warrior saint standing over wounded and dead soldiers in front of a fortified medieval town. The commentary for *St. Napoleon, Patron of Warriors* consisted of the following prayer:

> God, strong and powerful, protector of all armies who have fought in your name to sustain your Church, make it possible that the inspiration and model given us by the glorious St. Napoleon may help us triumph over the enemies who would try to disturb our exercise of devotion to you, and those who would endeavor to diminish the faith of your followers whom you deign to enlighten and protect through your power from harm. Through Jesus Christ. Amen.[21]

A later lithograph of St. Napoleon published during the second Empire, displays a gothic frame filled with representations of saints, bishops, apostles, and familiar symbols of the

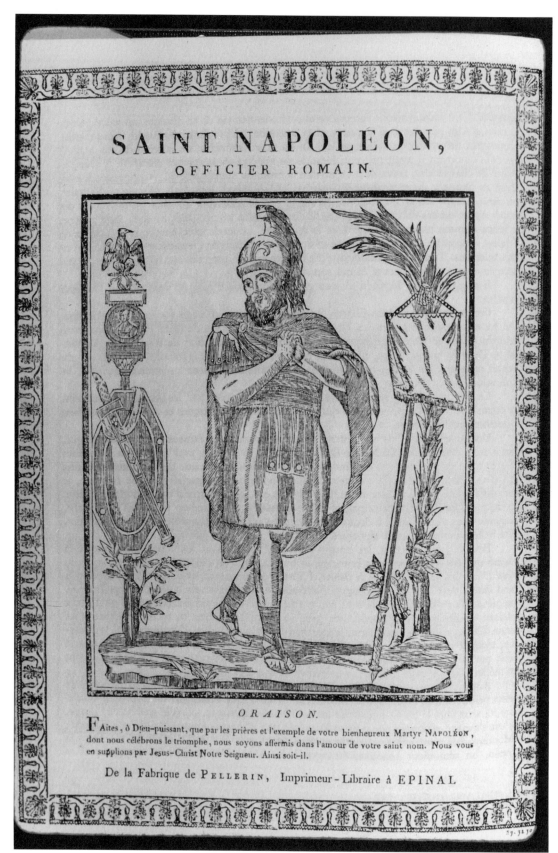

*St. Napoleon, Roman Officer* (1816) Pellerin, Epinal. Musée Départmentale d'Art Ancien et Contemporain, Epinal. Photo by the author.

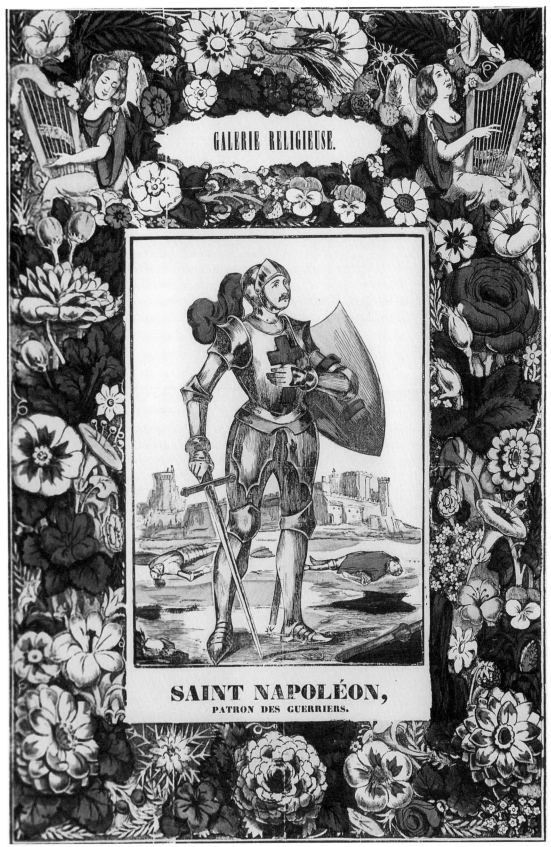

*St. Napoleon, Patron of Warriors* (1842), Pellerin, Epinal. Cabinet des Estampes, Bibliothèque Nationale de France, Paris.

sacraments, the cross, the Eucharist, and the Blessed Trinity. The Pellerin firm thus designed and continued to mass-produce illustrations of St. Napoleon ten to forty years after the canonization of the saint during the Imperial regime.[22]

After Napoleon's final defeat at Waterloo and the reinstatement of the Bourbon monarchy (1815–30), Pellerin was obliged to print images of St. Napoleon clandestinely.[23] Because Restoration authorities considered graphic or textual references to Napoleon threatening to the security of the new regime, they suppressed any type of Imperial symbol or representation of Napoleon I.[24] In 1814, Bourbon censors took down Chaudet's statue of Napoleon portrayed as emperor mounted on top the Vendôme column and replaced it with a flag bearing the dynastic white lily. In the department of the Vosges, local authorities burned Imperial flags and melted down seals from the First Empire.[25] In the town of Epinal, they destroyed the bust of the emperor located in the city hall.[26] During the initial years of the Bourbon regime, police surveillance of peddlers who sold popular literature and art was severe. Police seized any almanac that contained references to Napoleon or his son. Censors also forbade the sale of the *Imperial Catechism* until the chapter devoted to Napoleon had been deleted.[27]

In addition to destroying public references to the former emperor, the kings Louis XVIII and Charles X reinstated Bourbon authority by forging a political alliance with the Catholic Church. According to the constitutional charter of the new regime, the church became a "cornerstone of legitimacy" for the restored monarchy, and Catholicism again became the official religion of state.[28] In 1814, bishops who had refused to serve Napoleon were made members of a ruling ecclesiastical body and were authorized to direct the religious policies of the Restoration church. Concurrently, the Bourbon government fostered the success of Catholicism by supporting the pastoral renewal of the clergy and by encouraging the expansion of religious and lay organizations throughout France. By incorporating the political and educational strategies of the Ancien Regime, the Restoration government set the Catholic Church beside the state as a bulwark against the deleterious influences of the French Revolution and Empire.[29]

Pellerin's success in selling religious broad-

sides was certainly due to his astute response to a political climate that favored the renewal of the Catholic Church. By 1816, he had developed an extensive commercial network for his prints in towns and villages throughout the Northeast. Evidence gathered from his trial for marketing Napoleonic prints shows that he sold his images chiefly through town book dealers. During the First Empire and early years of the Restoration, Pellerin developed local outlets for his merchandise primarily in the Northeast. The printer had distributors in Arras, Amiens, Langres, Besançon, and Châlons-sur-Saône. During this period, he employed at least one traveling salesman, M. Maroteau, who promoted his merchandise in the towns of Langres and Arras. Trial records also indicate that Pellerin did a steady business with merchants in burgeoning towns and urban centers in the north and southeast—Troyes, Annonay, Arbois, Châlons-sur-Marne, Vitry le François, Lyon, Villier, and Cotterrat.[30]

Though Pellerin's market flourished with commercial connections to an extensive network of small-scale, local merchants, the country peddler best explains how the Pellerin firm developed a national market for his popular prints and texts during the Restoration. Prior to the extension of railroads into the provinces during the Second Empire, peddlers were the mainstay of rural commerce.[31] Networks of traveling merchants journeyed from the Savoie, the Haute Garonne near the Pyrenees, and the village of Chamagne in the Vosges. Peddlers carried a varied selection of popular pamphlets, newsheets, songs, and imagery, often interspersed with hardware, fabrics, lacework, and ribbons. They would replenish their inventory at urban outposts during their travels, purchasing texts and images from a major outlet such as the Pellerin warehouse in Epinal.

Since the village of Chamagne was several hours walking distance from Epinal, the peddlers of Chamagne, or so-called Chamagnons. provided the Pellerin firm with a broad network of itinerant merchants.[32] Many fantastic descriptions exist of the Chamagnons peddlers, "who sallied forth each year with their wives and children selling cheap trinkets, religious pictures, songs and little books—traveling in painted wagons bearing scenes from plays they would act in, and waving batons to keep time with the songs they sang en route."[33] The region around Chamagne was famous for its singing peddlers: "Who doesn't know about these wandering

singers from the Chamagne," asked a contemporary observer. "The peddlers of Chamagne abandon their homes at the end of autumn and spread out in the cities, bourgs, and villages of France."[34] Peddlers from Chamagne were reputed to be heavy drinkers and clowns, always ready for petty thieving from local homes or for stealing a chicken from the barnyard.[35] The Chamagnons were despised by lay teachers in the region, who called them *marchands de mensonges* (merchants of lies) rather than *marchands de chansons* (merchants of songs). Some teachers from the region claimed the Chamagnons sold indulgences, false relics, and even magical potions to help hens lay eggs in abundance.[36]

The Chamagnons peddlers were most noted for selling religious prints and sacred objects designed for personal devotions. When peddlers appeared on the public square, "They had large wooden hutches which closed with shutters. In the interior of the box, the colporteur usually suspended rosaries and images of piety. Arriving at a village, they opened their hutch—revealing wax images inside that represented characters in the drama being portrayed. The peddler would then open the box and begin pointing out the characters from the play with a stick." The drama usually represented a mystery play or simple rendition of the Nativity.[37] One peddler from Chamagne carried a pine hutch with the crucifixion on an upper shelf and the legend of St. Hubert kneeling in front of a stag on the lower shelf.[38] After the skit, the peddler and his wife displayed merchandise including jewelry, hardware, images, and small texts that might replicate the songs they were singing.

According to police records, the Chamagnons peddlers left their village in the fall of the year to return for planting the following spring.[39] Registered passports indicate that approximately forty percent of the peddlers from Chamagne who sold their wares during the July Monarchy traveled alone. The remaining 60 percent traveled as families or with friends.[40] Departmental records reveal that 628 people resided in Chamagne in 1841 (including 130 houses and 150 households in the village). During the Restoration and July Monarchy, forty to fifty passports for peddling were issued per year to residents from the commune. Counting family members in the year 1840, sixty to one hundred people left for this round of marketing. Including women and children who accompanied each licensed peddler, approximately one hundred residents from Chamagne registered to travel each year. Taking one hundred as the average, one-sixth of the population from Chamagne were peddlers in any given year.[41]

Since Epinal was only fifteen kilometers from the town of Chamagne, the Chamagnons peddlers furnished the most immediate network of traveling salesmen for both the Faguier and Pellerin printing firms, the two most successful printing firms in Epinal during the Restoration and July Monarchy.[42] Carrying a hutch filled with pamphlets, religious art, and images of Napoleon, these so-called Chamagnons traveled on well-established routes throughout the provinces. Some of the Lorraine peddlers traveled in concentric circles within the Lorraine, while others traveled to more remote regions, passing through major cities to reprovision their wares. Few crossed the French border into Germany or the Netherlands, due primarily to their difficulty with other languages. The Lorraine peddlers did not carry their Catholic prints and devotional tracts into Protestant areas such as Montbéliard. They avoided Gascony, the Haute Savoie and Haute Garonne as well, since these regions were already tended by local peddlers. While the Chamagnons traveled in Burgundy, Normandy, and the Vendée, they avoided Morbihan in Brittany, which was a cultural island onto itself. Stopping in major provincial cities, and sometimes Paris, these itinerant salesmen traveled through most other regions of northern, northeastern, and northwestern France.[43]

Beyond marketing their merchandise in the village square or at regular country fairs, the colporteur traveled from farm to farm offering imagery, texts, and hardware to peasants and hired hands.[44] Although their merchandise was not expensive, peddlers would often exchange a print or broadside for an overnight stay in the barn adjacent to the main house or cottage. In some cases, peddlers were known to accept a collection of bones (that could be melted down for glue), ashes, or animal skins in exchange for a print or pamphlet.[45]

But the nominal price of a popular print does not necessarily correspond with the value customers attributed to these designs. When asked why few nineteenth-century prints were preserved by families and clerics from the village and environs of Chamagne, the former mayor observed that these items were considered "sacred." According to religious traditions in the Northeast, when devotional images became

France

National Capital
Foix o City
International Boundary
Provincial Boundary
Lozere Province Name
100 km
0                    100 Miles

*Routes Frequented by (460) Peddlers from Chamagne, (from information in)* Les Colporteurs de Chamagne: Étude d'après *leurs passeports 1824–1861.* Inspection Academique des Vosges, Centre Départementale du Documentation.

weathered or torn, they were burned like sacred objects rather than being preserved like decorative possessions or mementos. Whether the subject matter was fictional, political, or religious, the popular image was treated and disposed of in the same manner.[46]

Religious customs influenced the meaning as well as treatment of popular prints in the provincial household.[47] The image was not merely a symbol or decorative item in the home. Religious broadsheets were also a locus for ritual veneration and prayer. Traditionally, pilgrims purchased devotional art to commemorate or celebrate their journey to a sacred shrine or chapel. Representations of a saintly patron were often hung in the guild as a form of corporate identification or in a craftsman's stall as a sign of Christian devotion. To encourage devotional practices at home, local clerics often reproduced inexpensive illustrations of a village saint or patron for their parishioners.[48] The church encouraged the distribution of devotional prints as a way to endorse both religious orthodoxy and the saintly vocation.

But para-Christian traditions approaching magic and fetishism continued to flourish in provincial France during the early-nineteenth century. Based on such practices, the images of Christ, the Virgin, and representations of saints were called *images de préservation* (images for protection) or *feuilles de saint* (paper saints). While religious prints could serve a decorative purpose on the walls or chiminey above the fireplace in a peasant cottage, they were also used as talismans to protect the well-being and fortune of the rural householder and his family. For this reason, peasants often placed religious engravings in unexpected locations such as in clothes and lingerie chests, inside cupboards, in enclosed wooden beds, and sometimes on the inside of metal boxes that stored valuable items and served as portable altars. In some instances, farmers placed religious images in the barn or henhouse to protect livestock and poultry from unforeseen disaster.[49]

Religious art provided a form of symbolic expression that responded to the most immediate desires, needs, and fears of people living in the countryside. Peasants enacted pagan-Christian rituals associated with a particular saint to protect themselves against the uncertainties of provincial life. Rural residents believed that saints were capable of functioning as supernatural protectors against the capricious and malevolent elements of the universe. Devotion to a particular saint was a way to prevent calamity or to ward off the dangers of unwanted disease and misfortune. According to Christian devotional traditions, whoever looked at St. Christopher would not die that day. St. Nicholas was the caretaker of children. Sts. Blaise and Guérin, particular favorites in the Vosges, attended to livestock and animals.[50] St. Vincent helped vine growers with their delicate harvest, while St. Hubert could cure the afflicted of madness and fever. St. Margaret would come to the aid and assistance of pregnant women or women in labor. The most important saint during the cholera epidemic that struck France during the July Monarchy was St. Roch, a figure who protected those threatened by the plague. The caption beneath an image from the fifteenth century reads, "St. Roch, glorious martyr, cure us from the plague and all evil. . . . St. Roch, bishop and martyr, protect us from every plague."[51] The continued success of popular religious art, particularly during the epidemic in 1832, suggests that peasants and commonfolk used colorful representations of the Madonna and saints as the focus for devotional practices believed to alleviate suffering and disease.[52]

Provincial residents also treated the saint or divine presence as a mediator who could rectify disparities between rich and poor, aristocrat and commoner, the powerful and the powerless.[53] Popular religious practices tended to associate God, Christ, and the saints with a fundamental notion of justice that rewarded the hardworking and the poor, but punished the arrogant and the well-to-do. Divine justice in popular traditions and tales involved the creation of a more equitable society through supernatural intervention.[54] Representations, symbols, and myths provided Christians with a form of solace and relief from poverty and distress.[55]

From an experiential perspective, the image did not merely represent the saint, but made the legendary figure accessible and present to the viewer.[56] It is unlikely, however, that most viewers could distinguish the symbol from its meaning; rather, rural believers responded to the saintly figure by experiencing the material "presence" of the image. That is, the portrait was in a certain felt sense the person portrayed. Representations of saints (or Napoleon Bonaparte) could thus function both as focus for commemoration and appeal. The broadsheet illustration

made the attributes (and powers) of the person represented both present and available to the viewer.[57]

Since Napoleonic prints and symbols were reproduced in the same manner as representations of Christian saints, illustrations of the Little Corporal were likely viewed in a manner similar to religious art and statuary. As with the religious figure, representations of Napoleon would then have functioned as a ritual focus for devotion and succor. One witness indicated that Napoleon's picture was often hung beside that of the Madonna or Christ in farmhouses located in the Champagne or in the forest regions of the Dauphiné. Peasants covered their heads when standing in front of Napoleon's image.[58] Because people in the countryside were accustomed to ritual practices associated with devotional art, the extraordinary powers ascribed to Napoleon were likely conflated with the supernatural resources of the Christian saint.[59] Victor Auger, a writer during the Second Empire, began a sentimental treatise on the emperor by describing a series of popular prints decorating a peasant cottage: "Every French farm had a dark crucifix, a plaster representation of the Madonna, an illustration of Geneviève de Brabant . . . and finally a large poster of the emperor—sometimes standing on the Vendôme column, more often serenely mounted on his spirited stallion."[60]

Popular artists, composers, and writers attempted to describe how peasants, artisans, and veterans of the Great Army viewed the Little Corporal. While these portraits were obviously speculative and in some cases satirical, repeated references to Napoleon as Christ or Messiah give credence to the existence of popular religious beliefs surrounding the legendary memory of the French emperor. For example, many artists attributed Bonaparte's valor and skills to a divinely inspired charisma. In Hippolyte Bellangé's whimsical lithograph published in 1835, a peasant stands in front of his hearth addressing a priest seated before the fire. The peasant points to a print of Napoleon that hangs beside the chimney. He gestures upward toward the picture of the Little Corporal, and declares to the surprised curé: "Tenez voyez-vous, Monsieur le Curé, pour moi le v'la l'Père éternel." [Look here, Reverend Father, this for me is the eternal Father.] The bravado of expression and assuredness of the pose suggest the peasant's unquestioning faith in the quasi-divinity of the Little Corporal. According to the memoirs of Henri

Houssaye, "Napoléon devient symbole fétiche, dieu pénate." [Napoleon has become a symbolic fetish and household god.] During the Restoration and Orleanist monarchies, Napoleonic representations flooded the popular market in Paris and in the provinces. Napoleon was usually portrayed as the Little Corporal in pitchers, bottles, ink holders, pipes, tobacco pots, plates, chimney plaques, fans, tongs, hangers, purses, and lamps.[61]

While the dissemination of both devotional and political statuettes to regional customers might seem incongruous, images in paintings, prints, and china during the early-nineteenth century often described peddlers marketing Napoleonic statuettes together with figurines of Christ, the Madonna, and saints. Lithographs depicting rural merchants selling figurines of the Little Corporal with devotional statuary display the commingling of profane and sacred merchandise. In appropriating such varied merchandise, customers may have infused political representations of Napoleon with the supernatural powers attributed to Christ and the saints.

In *The Country Doctor*, published in 1833, Honoré de Balzac attempted to describe popular feelings about Bonaparte using quasi-religious terms and metaphors. Balzac presented such feelings through the veteran, Goguelot, who recalls his military experiences during the Imperial wars.[62] Goguelot's rendition of Napoleon's life and military adventures takes place in a large barn during a winter *veillé* (evening gathering) among local peasants from the Chartreuse. At the *veillé*, peasants gather to gossip, share entertaining tales, and discuss current events. Women weave and darn while the men smoke and listen to the most educated or garrulous member of the gathering. In his extensive monologue, Goguelot says that the emperor was "more than an ordinary man": "He used to sleep in the snow, just like the rest of us—in short, he looked just like an ordinary man; but I who am telling you these things have seen him myself with grapeshot whizzing about his ears."[63]

With increasing exaggeration, Goguelot offers numerous examples of Napoleon's superhuman capacities: "Another marvel! He discovered that he was immortal! and feeling sure of his ease, and knowing that he should be emperor forever."[64] Goguelot concluded defensively: "A lot of them say he is dead! Dead? . . . They do not know him, that is plain! They go on telling that

TENEZ VOYEZ-VOUS, M<sup>r</sup> LE CURÉ,

Pour moi le v'la.....l'Père Eternel.

Hippolyte Bellangé, *The Peasant, The Priest, and Napoleon* (1835). Cabinet des Estampes, Bibliothèque Nationale de France, Paris.

*The Images,* engraving on china, Breil et Montereau. Musée des Arts et Traditions Populaires, Paris. Photo by RMN.

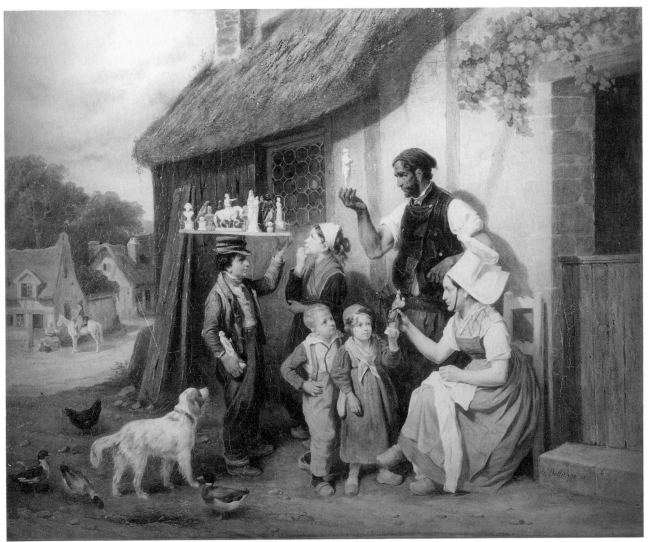

**Hippolyte Bellangé,** *The Peddler of Plaster Figurines.* **Musée des Arts et Traditions Populaires, Paris. Photo by RMN.**

fib to deceive the people, and to keep things quiet for their tumble-down government."[65] Balzac maintains that the efforts of the Orleanist regime to underline Bonaparte's death could not diminish the people's faith in the certain immortality of their beloved hero.

Amateur composers from the Restoration and July Monarchy also made religious as well as secular references to Napoleon Bonaparte in their lyrics.[66] A song composed in Charmes, a tiny village located near the Pellerin firm in Epinal, was discovered and recorded by the noted French folklorist Charles Nisard. The ballad compares Napoleon's suffering and death on St. Helena with Christ's passion and death:

Jésus par sa puissance
Sauva le païen par le péché perdu
Napoléon sauva la France
Comme Jésus, il fut vendu,
A la suite d'odieuses peines
Jésus sur une croix mourut
Napoléon à Ste. Hélène
a souffert comme Jésus.

[Jesus through his power
redeemed the pagan lost in sin.
Napoleon saved France, but
Like Jesus, he was betrayed.
Following his horrible punishment
Jesus died on a cross.
Napoleon on St. Helena
suffered like Jesus.]

Just as Christ redeemed the sinner, so Napoleon saved France from her enemies. But like the peasant in the Bellangé print who revered Napoleon as his "eternal Father," this rustic song reveals the composer's devotion to both God and Napoleon:

> Sans être trop fanatique
> Je tiens à ma religion
> Peu importe qu'on me critique
> J'aime Dieu et Napoléon
> . . . j'adore l'un dans son saint temple
> Et de l'autre je chante de ses vertus.[67]

> [Without being too fanatical
> I maintain my religion
> It does not matter if others criticize me
> I love God and Napoleon.
> I worship the former in his holy temple
> And the other, I sing of his virtues.]

Religious elements found in contemporaneous renditions of Napoleon in prints, pamphlets, and songs from the early-nineteenth century reflected popular aspirations for a leader who, in his extraordinary life and tragic death, was imbued with divine features associated with Jesus Christ or the Christian saints. Popular texts and images often represented Napoleon with supernatural qualities and attributes, such as the peasant in the Bellangé lithograph who identified the Little Corporal with God the Father. Balzac also showed how a veteran officer from the Imperial wars characterized Napoleon as an immortal hero. Local songs demonstrated popular faith in Napoleon's supernatural powers to defy his enemies. Because pagan and para-Christian practices continued to flourish in regional France during the early-nineteenth century, Pellerin's customers most likely addressed representations of the Little Corporal with the sort of fervent expectations traditionally accorded to familiar Christian saints.

From the Bourbon Restoration through the July Monarchy, veneration for Napoleon took on a political as well as a religious cast in songs, art, and statuary. During the Restoration, representations of Napoleon and his son reflected the faith of artisans and marginal groups in Bonaparte's solicitude for the common man and in his power to rectify political injustices. Such popular groups also expressed belief in Napoleon both as a benevolent father and savior who would attend to their needs. The symbol of Napoleon I thus remained a rallying point for peasants, artisans, veterans, and others who took issue

with the Bourbon regime. By referring to Napoleon I and his son, various groups expressed their respective discontentment with economic and political conditions in Restoration France.

Since Napoleon's death and that of his son in 1832 became key events in the Pellerin series, it is apparent that the Epinal printers meant to sustain (and profit from) popular fascination with Napoleon's interment. Artists, liberals, and devotees of Bonaparte, such as Victor Hugo, were infuriated by the government's refusal to bring Napoleon's ashes back to Paris in 1830.[68] Pellerin began to produce memorial studies of father and son just when the dynastic claims of bonapartism appeared forestalled.[69] The disappearance of Napoleon's heir in 1832 and subsequent defeat of political bonapartism undoubtedly furnished an incentive for the Pellerin firm to commemorate the deaths of Napoleon I and II.

In a series of mourning prints, the Epinal printers described not only the death of Napoleon and his son but also the political disenfranchisement of the Bonaparte family in Orleanist France. But in a more general sense, the Epinal broadsides brought Napoleon I and the Duke of Reichstadt back to the French people for celebration and mourning. Though Pellerin made a concerted effort to design most of the funeral prints in secular terms, customers could interpret the images in various ways—as representations with particular commemorative, political, or religious meanings. While those who could understand the commentaries benefited from the literal meaning of the prints, less literate customers depended upon their understanding of allegorical or Christian symbolism in the mourning narratives.

In addition to political information conveyed in the memorial prints, Napoleon's death also elicited religious meanings associated with Christian interment and mourning. Despite Pellerin's secular interpretation of the emperor's death and burial, both composition and textual commentary supported popular beliefs about Napoleon's alleged immortality. Seditious shouts and popular songs during the Restoration indicated that many provincial residents would not accept any purely secular notion of Napoleon's death. Trained in Christian doctrines, peasants and commoners were accustomed to believe in personal immortality and the resurrection of the "just."

Pellerin's first illustration of Napoleon's death

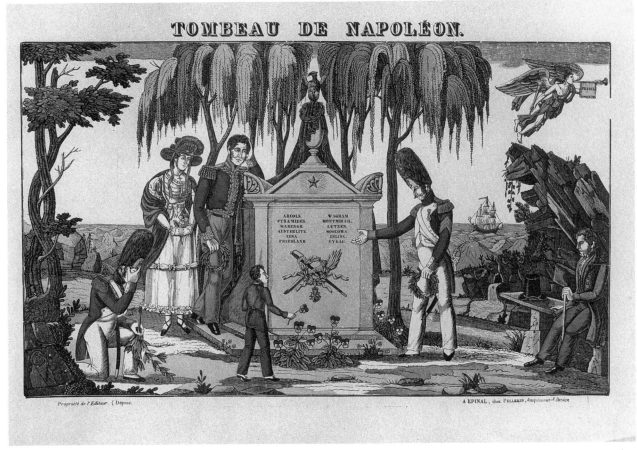

François Georgin, *Tomb of Napoleon I* (1832), Pellerin, Epinal. © Imagerie d'Epinal, 1996.

described his burial using the neoclassical format of a traditional mourning picture. Usually designed by women using silk or paint, mourning art was often placed in the parlor above the fireplace to honor a loved one or a great political figure.[70] Although the illustration included no commentary, the *Tomb of Napoleon I* (1832) used many symbols characteristic of the mourning composition. The traditional urn placed above the gravestone symbolizes the departed, while the weeping willow tree, in addition to representing the bent figures of the mourners, refers to the resurrection and regeneration of life.[71] The ship in the background could have referred to Napoleon's exile and death on St. Helena, but it was also a common symbol for hope and immortality. Symbolic figures surround the tomb, lamenting the departure of the valiant military leader with classic gestures of grief: In addition to the grieving woman and man dressed in black, two soldiers representing Imperial veterans mourn the death of their leader. One kneels with a willow branch in his hand and weeps; the

other, holding a laurel wreath, stands beside the tomb and points emphatically to the list of Napoleon's victories. A small child (representing France's youth) carries a pansy as he approaches the monument with wonder. The pansy comes from the French *pense y* (remember him), a reminder not to forget France's legendary hero. An Imperial eagle perches on the urn, which is covered with somber drapes and topped with a laurel crown, suggesting the bust and epaulets of the departed warrior. The allegorical symbol of fame soars above the grieving entourage on St. Helena, conveying news of the event and its import to soldiers and veterans who likewise mourn the emperor's passing.

Although subtly rendered, religious elements play a more salient role in Pellerin's rendition of the *The Funeral March* (1835).[72] In the colorful representation of Napoleon's funeral, the artisan presents a parade of infantrymen carrying Napoleon's remains to the temporary burial ground on the rocky island of St. Helena. Flanked by a military escort and civilians, the cortege bearing

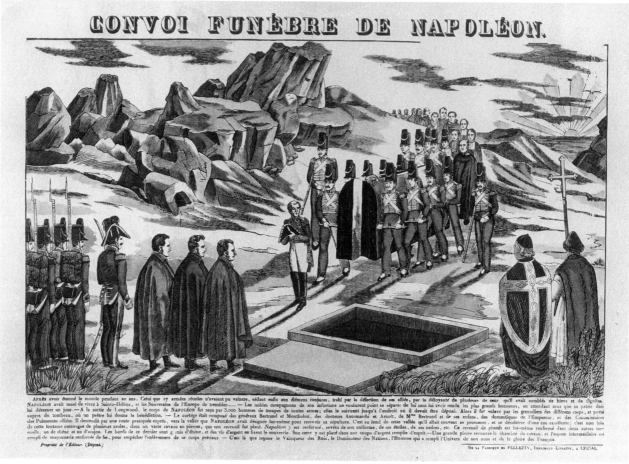

*The Funeral March* (1835), Pellerin, Epinal. Imagerie d'Epinal, 1996.

Napoleon's casket approaches the gravesite while officers and three civilians stand at attention in the left foreground. Unlike other illustrations of Napoleon's death, the print includes explicit references to the Catholic Church by showing a priest and an acolyte with a cross at the head of the grave. Even though the gaping black hole looks like a somber portal to the underworld, the print's message is not funereal. A bright yellow sun radiates bands of light as it rises above the sea in the upper right of the composition, a prescient sign of Napoleon's resurrection.

The position of the cross below links the burial hole to the brilliant orb emerging in the east. Instead of finale, Napoleon's death on St. Helena becomes a new birth in glory. The Pellerin text reminds the audience, "This is where the Conqueror of Kings is laid to rest; the Lord of Nations, the Man who has filled the Universe with his name, and with the glory of the French people."[73] The Pellerin editor characterized Napo-

leon as the archetypal figure who marked Europe with his name and memory. As Christ was resurrected in glory, Napoleon would be reborn triumphantly in the memory and political aspirations of the French people.

The mounting of Napoleon's statue on top of the Vendôme column in July 1833 temporarily satisfied popular pressure for the return of Napoleon's ashes to France. The column functioned, moreover, like a secular cross that lifted the inimitable figure of the Little Corporal above the capital. Pellerin produced *Napoleon on the Column* in December 1833, five months after the government's unveiling of Napoleon's statue.[74] The Pellerin illustration presented the exiled leader surrounded by the lyrics to several popular songs dedicated to Napoleon. In the opening stanza on the left, the poet stresses the tragic irony of Napoleon's suffering and death in exile while affirming his certain immortality in the people's memory:

# NAPOLÉON SUR LA COLONNE.

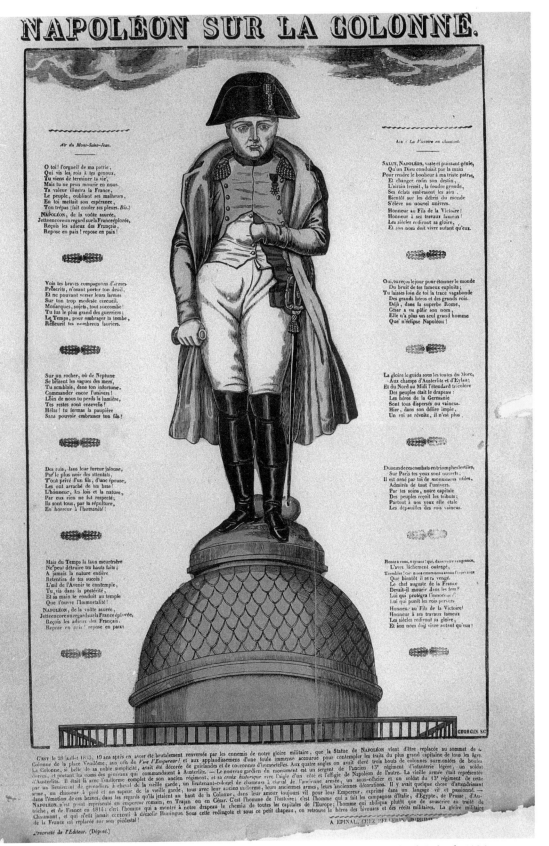

François Georgin, *Napoleon on the Column* (1833) Pellerin, Epinal. © Imagerie d'Epinal, 1996.

## APOTHÉOSE DE NAPOLÉON.

François Georgin and Jean-Baptiste Thiébault, *The Apotheosis of Napoleon;* (1834), Pellerin, Epinal. © Imagerie d'Epinal, 1996. *Also See* color plate 7.

O toi, l'orgueil de ma patrie
Qui vis, les rois à tes genoux
Tu viens de terminer ta vie
Mais tu ne peux mourir en nous.[75]

[Oh you, pride of my country
Who saw, kings at your feet
Your life has just ended
But you cannot die in us.]

The poet recommended that every nation should become aware of the horror of his martyrdom. The overall import of Georgin's image combined with the second stanza in the right column confirmed Bonaparte's preeminence in history. "Elle n'a plus un seul grand homme qui n'éclipse Napoléon."[76] [There is no other great man who could overshadow Napoleon.] Both illustration and text encompassed Bonaparte's cruel death in exile as well as his symbolic return to France as corporal atop the Vendôme column.

In a more metaphorical sense, François Geor-

gin's *Apotheosis of Napoleon* (1834) described the resurrection and return of the Little Corporal to political glory. Georgin and his associate Thiébault translated Christ's manifestation in glory into a political eulogy to Napoleon Bonaparte.[77] In the *Apotheosis*, a pantheon of heroes surrounds the figure of the Little Corporal and welcomes him into this celestial domaine. Genghis Khan, Caesar, Turenne, Frederick, and Sesostris greet Napoleon on the right side of the composition, while famous officers from the Great Army—La Salle, Hoche, Kleber, and Desaix—celebrate Bonaparte's arrival on the left side of the print. Instead of angels with celestial harps, bards laud Napoleon's valor with song. The throne of the Egyptian pharoah Sesostris, placed in the center of the composition, glows like an enormous sun.

Georgin's presentation of Napoleon as colonel wearing his bicorne hat in the center of the heroic entourage celebrates not simply the famous

general of the Great Army or the Imperial Lord, but the transcendent symbol of the Little Corporal, ally and comrade to his people.[78] Bonaparte's arrival in "heaven" has been transformed into a panoply of European heroes and warriors who give homage to the French leader. Stationed in power among the "elect," the Little Corporal represents not only French glory but also the aspirations of the common soldier for personal prowess and renown.

Throughout the Epinal series, the Pellerin prints show how soldiers both respected and venerated Napoleon as the Little Corporal. In *Sire, this Shroud Is Worth the Cross* (1837), Napoleon mounted and dressed for battle stops to express concern for a grenadier who has been wounded in battle. Sighting the wounded soldier while riding into the heat of the foray, Bonaparte reigns in his horse and tosses his famous greatcoat (which identified the Little Corporal) to the dying man. According to the text below the illustration, "Bonaparte shouted to the

stricken young man, 'Tache de me le rapporter, je te donnerai en échange la croix que tu viens de gagner.' " [Bring it back to me when you can. In exchange I will give you the (Legion of Honor) cross which you have just won.]

In the image and text, the Pellerin editors transformed the religious anecdote associated with St. Martin, who gave his coat to a beggar, into a secular parable. The famous greatcoat that Napoleon wore in battle becomes a revered memento coveted by the dying soldier. In the Pellerin print, the solicitious gesture of the Little Corporal was comparable to the legendary benevolence of St. Martin.

The grenadier who knew that he was mortally wounded, replied to the Emperor: 'Sire, this shroud which I have just received is well worth the cross,' and he died in the Imperial greatcoat. The emperor lifted up the soldier who had fought in the Egyptian army and ordered that the young man be buried in his [Napoleon's] coat.[79]

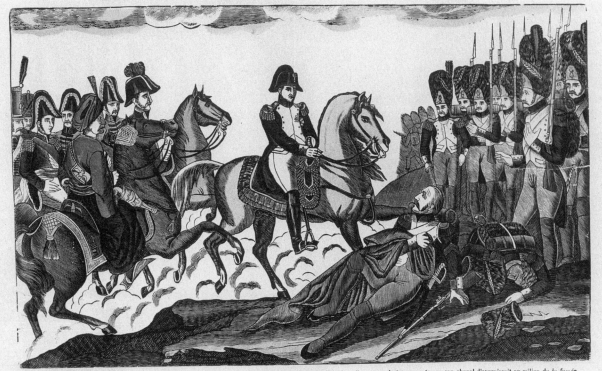

*Sire this Shroud is Worth the Cross* (1837), Pellerin, Epinal. © Imagerie d'Epinal, 1996.

Such images undoubtedly functioned as a form of memorial and tribute to those vast numbers of young men who had died during Napoleon's ambitious campaigns. In receiving Napoleon's greatcoat, the dying soldier expressed his gratitude for the honor of being wrapped in and identified with the characteristic greatcoat of the Little Corporal. But in addition to commemorating the deaths of Imperial soldiers, the Napoleonic broadsides also perpetuated and renewed Napoleon's "legendary presence" for his devotees.

Familiarity with Christian traditions associated with popular imagery helps to explain the impact of the Napoleonic legend in regional France during the Restoration and July Monarchy. Rural customers treated representations of Napoleon according to rituals and practices traditionally associated with devotional art. Portrayed as the Little Corporal, Bonaparte reflected both the humble and heroic qualities of the common French soldier. The very existence and accessibility of the Napoleonic broadsides ensured that rural groups would continue to celebrate his memory and legendary ventures.

In addition to commemorating the death of the former emperor, representations of Bonaparte, like those of Christian saints, became a focus for adoration and even magical mediation; Napoleon I nonetheless embodied qualities that were clearly distinct from religious models found in popular texts and illustrations. Instead of renunciation, sacrifice, or withdrawal, Napoleon demonstrated the appeal of action, involvement, and strategic planning. The Epinal illustrations described Napoleon as thoroughly engaged in political history. Unlike representations of the saints in popular art and literature, Bonaparte did not assume a passive or receptive role, either in terms of his own life or the destiny of the French nation. Instead, Napoleon "initiated," "directed," and "led" his country with adeptness and foresight. In popular texts and images from Epinal, Napoleon was an active force who determined and even redirected the course of European history.

In some respects, posthumous representations of Napoleon conveyed greater power than portraits produced while Bonaparte was alive. The communication of political meanings through religious attitudes and practices gave added weight and power to illustrations of Napoleon and his armies. Treated as sacred icons in provincial households, pictures of Napoleon could function as channels for political enthusiasm. Like "images of protection," Napoleonic art inspired commoners in the provinces to hope for Napoleon's extraordinary resurrection and return. Georgin's prints animated populist yearnings for political justice and liberation from social and economic oppression. If not a Christian patron, then perhaps "Saint" Napoleon could redress the grievances of his people.

As with the Christian saint, Napoleon's death merely anticipated his rebirth and return in glory. The suffering and death of the tragic hero in 1821, like that of the Christian martyrs, aroused sympathy and increasing allegiance to the memory of the Little Corporal, who had died in exile. The impact of Pellerin's mourning series should be seen from this perspective, not as a purely secular statement, but rather as a political narrative imbued with religious meanings. During the latter years of the Orleanist regime, images of Napoleon Bonaparte provided religious as well as political incentives for the renewal of revolutionary fervor.

# 5

# Orleanist Co-optation and Bonapartist Broadsides

EPINAL REPRESENTATIONS OF NAPOLEON AS SOLdier and corporal conveyed the most essential characteristics of the Napoleonic legend. In addition to symbolizing a rebirth of the spirit of 1789, the Little Corporal also reflected the military heroism and courage of the French people. Popular illustrations of Bonaparte as the Little Corporal were the result of a continuing interaction between the public image that Napoleon himself created during his political career and representations developed by later artists who, in endeavoring to reach a general audience, portrayed the Little Corporal in his idiosyncratic attire. Dressed in an unadorned bicorné hat, greatcoat, and boots, Napoleon became a familiar figure in paintings, lithography, and popular prints that were marketed in Paris and provincial France during the early years of the July Monarchy. Because he embodied both the exceptional qualities of a military commander as well as the humble characteristics of the common soldier, the symbol of Napoleon as corporal functioned effectively as a political catalyst for the nation.

The Parisian printing firm Gihaut Frères produced several lithographic albums by Raffet that portrayed the haunting figure of the Little Corporal either alone or surrounded by his soldiers. Raffet's lithograph entitled *The Idea* (1834) shows a mature Napoleon seated by the fire with the shadow of the sword of Austerlitz propped at his side. A candle glows behind Bonaparte, illuminating several books and battle plans spread out on the table, while he sits pensively with arms folded, warming himself by the fire. Such representations of the Little Corporal emphasized qualities that made Bonaparte attractive to

commoners—his indomitable wit, firmness of character, and personal charisma.

During the first decade of his reign, King Louis-Philippe encouraged the inclusion of anecdotal portraits of Napoleon as corporal for official paintings and public monuments designed to endorse his regime. The king used Napoleonic representations to develop more extensive grassroots support for an essentially elitist political system. In 1831, he asked the artist Emile Seurre to create a statue of the Little Corporal to mount on the Vendôme column in the center of Paris. The Vendôme column was an enormous bronze monument constructed from twelve hundred enemy canons melted down after the Battle of Austerlitz. The statue of Bonaparte in his famous bicorne hat and overcoat was unveiled on 28 July 1833, a little more than a year after a series of working-class revolts that broke out in Lyon and Paris. By reproducing a statue of Napoleon as the Little Corporal, the king endeavored to celebrate Bonaparte's memory while purging it of inflamatory connotations.[1] By endorsing the symbol of the Little Corporal, the king hoped to redirect bonapartist enthusiasm toward his own regime. Nonetheless, because Seurre's statue was located near a working-class sector of Paris, during the remainder of the decade the administration continued to worry about its potential to incite revolutionary fervor among the lower classes.[2]

In addition to the Vendôme column, from 1833 to 1837 Louis-Philippe established a major national museum by revamping a portion of the Versailles palace to house a series of paintings that described the most important political

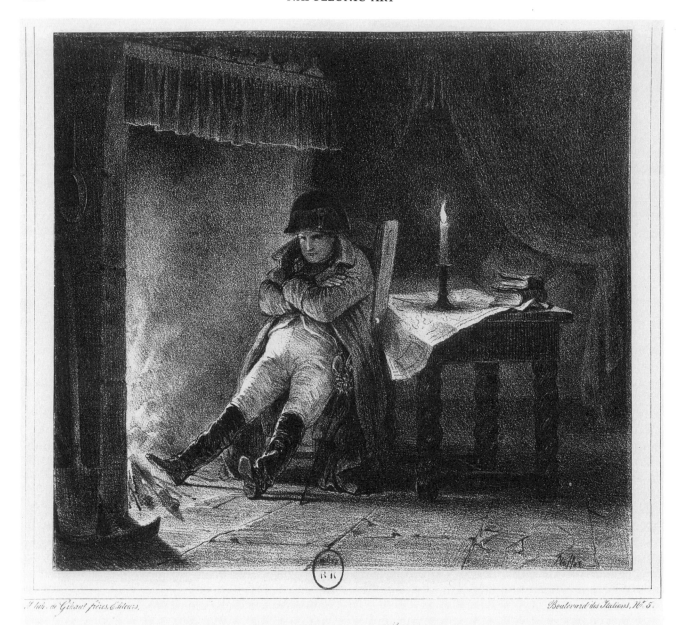

LA PENSÉE.

**Denis-Auguste-Marie Raffet, *The Idea* (1834). Cabinet des Estampes, Bibliothèque Nationale de France, Paris.**

events in French history.[3] By including scenes from the Ancien Regime, the Revolutionary epoch, and the Imperial period, the king developed a museum dedicated to "all the glories of France."[4] The largest exhibit room in the museum, the Gallery of Battles, was filled with thirty-three battles mounted chronologically from the time of Clovis and Martel to representations of the Imperial wars. In this extensive gallery, the king intended to rewrite French national

history using a heroic vocabulary derived from romantic-classical art that would appeal to a general audience.[5]

Horace Vernet executed the final series of paintings for the Gallery of Battles, which highlighted the stalwart figure of the Little Corporal leading his troops in battle. In Vernet's renditions of Iena, Friedland, and Wagram, the artist drew his inspiration from contemporaneous representations of Bonaparte found in lithographs

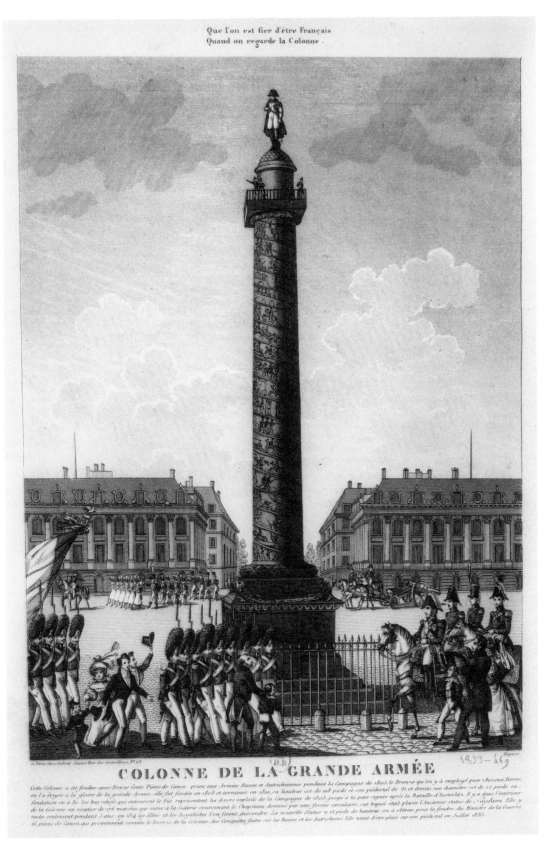

*Column of the Great Army* (1833), Collection da Vinck. Cabinet des Estampes, Bibliothèque Nationale, de France, Paris.

Horace Vernet, *The Battle of Wagram* (1836). Versailles, Paris, Photo by RMN.

by Charlet, Raffet, and Bellangé. In each of the three paintings, Vernet singled out and dramatically magnified the figure of the Little Corporal against the skyline as the dramatic focus in the forefront of each composition. Although this technique reflected the tradition of portraiture from the Ancien Regime that monumentalized the warrior-king, Vernet also created an anecdotal effect by highlighting Napoleon's response to a momentary interchange between Bonaparte and his men on the battlefield.

*The Battle of Wagram* (1836) was the final and most startling rendition of Napoleon in the Gallery of Battles. The scene was derived from the *Bulletin from the Austrian Campaign #24*. Mounted on his famous white arabian, the Little Corporal surveys the battle scene with a spyglass in one hand and a half-opened battle plan in the other. From his position on an embankment, the emperor observes the initial advance of a regiment of French artillerymen against the Austrians. After General Bessières sends out orders for a supporting brigade of cavalrymen, the horse he is riding is shot by an unexpected volley of gunfire. An officer in the foreground dismounts to notify Napoleon of the incident. Despite the confusion of the moment, the Little Corporal remains undisturbed, planning his next strategic move while his marshals rein in their impatient horses behind their leader. In the *Battle of Wagram*, Vernet portrays Napoleon as a commander who firmly directs the helm of state with a temerity that Louis-Philippe no doubt envied. Vernet endowed the figure of Napoleon with the

assurance and authority the king needed to counter escalating political dissension and criticism that emerged after his first year in power.

From 1831 to 1836, the security of the Orleanist throne was put increasingly on the defensive by legitimist as well as republican and bonapartist factions. In 1835, the government passed a series of censorship laws designed to screen out any representational theme that might challenge the authority of the government. After repeated threats against the life of the king and the unsuccessful coup attempt of Louis-Napoleon Bonaparte in 1836, graphic references to the Little Corporal were gradually phased out of official art commissioned by the government. In response to Louis-Napoleon's unsuccessful coup at Strasbourg, the king began to look less favorably on commissions about Napoleon that evoked military or revolutionary themes. Due to such uneasy political conditions, government authorities preferred to encourage public monuments that would reinforce the prerogatives of the Orleanist throne.[6]

After 1836, authorities began to remove potentially seditious representations of Napoleon from the public domain and replace them with more sedate and conservative images of the former emperor. Several months after Louis-Napoleon's coup, for example, the Salon refused to exhibit a painting that the king had commissioned from Joseph Beaume, entitled *The Departure from the Island of Elba*, which was originally destined for one of the historical galleries at the Versailles palace. Beaume's painting of Napoleon's return to France proved to be unsettling after the emperor's nephew endeavored to stage an insurrection against the government.[7] In 1837, the minister of interior, Montalivet, demanded that the artist David d'Angers modify a sculptural relief of Napoleon as a republican general leading his revolutionary armies into battle that the government had originally commissioned for the front pediment of the Pantheon. When republican d'Angers refused to modify his design, the monument remained veiled for over a month, and d'Anger's followers feared that it would be destroyed.[8]

In 1838, the government displayed its preference for a mural by Jean-Claude Ziegler in the apse of the Madeleine Church that described the apotheosis of Napoleon as emperor. The mural portrays Christ, Mary Magdalene, and a host of saints in the upper echelon, with Napoleon below, dressed in coronation attire accepting the

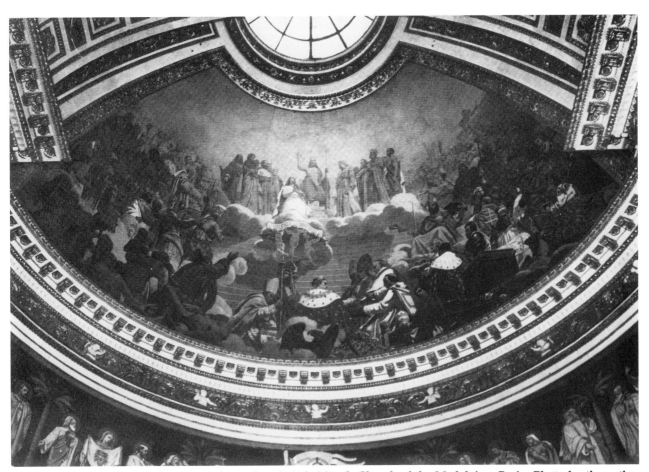

Jean-Claude Ziegler, *The Apotheosis of Napoleon* (1838). Mural, Church of the Madeleine, Paris. Photo by the author.

crown from Pope Pius VII. Great figures in the (implicit or explicit) history of the church are portrayed such as Clovis, Constantine, Frederick Barbarossa, Joan of Arc, Dante, Raphael, and Charlemagne. Because Ziegler's painting celebrated the traditional hierarchies of church and state, showing Christ and his disciples in the upper tier, and Napoleon's Concordat with the church in the second tier, the mural conveyed a decidedly less threatening message than the Pantheon relief of Napoleon and his "republican armies" executed by David d'Angers.[9]

Louis-Philippe's incorporation of Napoleonic representations varied during the first decade of his regime, from initial tolerance to increasing selectivity and political defensiveness. By including Napoleonic themes in official paintings and rituals at the beginning of his reign, Louis-Philippe conveyed an ambiguous message. Though the king participated in the resurgence of Napoleonic enthusiasm during the July Revolution to support his new government, he grew increasingly fearful of the revolutionary implications of bonapartist symbols or political bonapartism. Thus, while the Orleanist monarch erected a statue to the Little Corporal, preferred numerous commissions of Napoleon I, and established a museum that included a sizable collection from the Napoleonic era, he firmly banished members of Bonaparte's family from France.[10] Such defensive strategies increased in response to political dissension, press criticism, and the failed coup d'état of Napoleon's nephew. By the end of his first decade in power, the king phased out potentially provocative representations of the Little Corporal in favor of the more conservative image of Bonaparte as emperor.

During this period of factional strife from 1832 to 1836, when the government became more guarded, graphic and textual allusions to Napoleon as Little Corporal became a left-wing code for republicans and bonapartists (who joined ranks after the death of Napoleon's son) to criticize, challenge, and eventually overturn the Orleanist throne.[11] To such dissident groups, Napoleonic art served as a manifesto for political freedom and the elimination of privileges associated with the Ancien Regime. Although republicans and bonapartists, like the Orleanists, firmly disavowed the political prerogatives of the noblesse and the Catholic Church, republican

groups did not agree with the Orleanist decision to limit the franchise to wealthy property holders through elevated tax qualifications. Instead, republicans campaigned for an expanded electorate, the permanent abolition of censorship, and the eradication of hereditary peerage. Populist references to the Little Corporal also accommodated republican programs to address the economic and educational needs of the urban working classes.[12]

Representations of the Little Corporal and soldier likewise expressed republican desires to revenge France's humiliating defeat in 1815 and to signal the military renewal of French power in Europe. For republicans, bonapartists, dissatisfied artisans, and workers, Napoleonic prints served as a rallying point against the pacifist foreign policy of the Orleanist government.[13] Louis-Philippe feared that any aggressive move on France's part might either precipitate the Bourbons back into power or invite another Allied invasion of French territory.[14] The king's policy of peace and reconciliation at any cost, however, provoked the ire of left-wing groups who were particularly sensitive to Russia's invasion of Poland and the threat of Dutch and Prussian troops remaining in Belgium after 1831. In opposition to the king's timorous foreign policy, republicans and bonapartists advocated aggressive military action against the Continental powers to assist nationalist movements in Italy, Belgium, and Poland.[15]

Because of working-class unrest and republican vilifications in the press, the government made a concerted effort to stop the circulation of republican pamphlets and newspapers and to close down all republican organizations. After demonstrations occurred in Paris, Lyon, and Grenoble in the spring of 1832, the administration forced republican organizations to go underground. By 1834, a contingent of conservative and doctrinaire leaders including the king, the Duke of Broglie, and François Guizot were firmly established in power and prepared to eliminate or subvert any political threat to the central government.[16] Legitimist hopes had been fundamentally discredited by the despoiled reputation of the Duchess of Berry. Republican organizations, moreover, were divided and forced to operate secretly due to heavy censorship penalties and the threat of imprisonment. After the recurrence of working-class violence in

the spring of 1834, the government clamped down on most republican organizations and journals.[17] The attempted assassination of the king in July 1835, and the coup effort made in 1836 by Louis-Napoleon Bonaparte led to the final political entrenchment of the Orleanist regime.[18]

The only major organization that managed to continue political subterfuge against the government while sidestepping censorship authorities was the society of Freemasonry.[19] From 1830 to 1833, the Masonic lodge in Epinal, La Parfaite Union (the perfect union) became a leverage point for political leadership in the Vosges as well as a covert vehicle for underground republican organizations and press propaganda. Composed primarily of veteran soldiers, doctors, lawyers, notaries, civil servants, and successful merchants such as the Pellerin partners, Masonry in Epinal created a temporary cover of respectability that protected republican activists and leaders of the carbonari from government censure.[20]

Though formerly a respected notary and member of the republican organization Aide-toi, le-ciel-t'aidera (Help yourself, the heavens will help you), Freemason Nicholas Dominique Gerbaut edited a contentious republican newspaper (1831–33) entitled the *Sentinelle of the Vosges* that was published by the Pellerin firm.[21] Masonic brothers Jean Mathieu, a lawyer, and Léopold Turck, a veterinary and medical doctor, who also were editors for the republican paper, became influential leaders of two republican organizations in Epinal, Les Droits de l'Homme (the rights of man) and Les Amis du Peuple (the friends of the people), during the first six years of the Bourgeois monarchy.[22] While both Nicholas Pellerin and Vadet served on the municipal council of Epinal during the early years of the July Monarchy, the printers received the most extensive praise in Masonic records as "'brothers' who together collaborated for the glory of our (Masonic) imagery."[23]

Veteran Pierre-Germain Vadet likely engineered the production of a series of prints that praised Napoleon Bonaparte as general and corporal of the Great Army. An official in Napoleon's government during the Hundred Days and subsequently involved in several bonapartist conspiracies during the Second Restoration, Va-

det managed to assume greater leverage in the firm after the relaxation of press censorship in 1830. Following the July Revolution, Vadet encouraged his partner Nicholas Pellerin to focus the firm's resources on the production of Napoleonic broadsides for mass dissemination throughout regional France. In addition to selecting the illustrations that François Georgin used as models for his designs, Vadet probably edited many of the commentaries. Both the Napoleonic veteran and his chief craftsman were undoubtedly proponents of Napoleon's military and revolutionary legacy to the French nation.

Since the Vosges had been occupied by Austrian and Prussian troops in 1814, residents in northeastern France offered a promising market for Napoleonic memorabilia about French military conquests. And because of prevailing fears that Prussia and Austria might again invade from the eastern frontier, Masonic brothers Vadet and Pellerin found a ready audience in the region for prints of Napoleon's legendary campaigns against France's most persistent enemies.

Some of the Pellerin designs used Masonic and classical symbolism to underscore Napoleon's heroism. In the three-quarter bust portrait of Napoleon I entitled *National Glory-Napoleon* (1835), for example, the Pellerin atelier presented the military hero surrounded by symbols taken from Roman antiquity as well as from Imperial France.[24] The bust profile of Bonaparte is framed within a large laurel wreath, which for the Romans was a symbol of military as well as intellectual achievement.[25] The eagle (associated with Zeus) that hovers above the composition on a bed of lightning-shaped arrows, was adopted by the Roman emperors and subsequently by Napoleon as the standard for Imperial France. In *National Glory*, Napoleon is dressed in the uniform of a colonel in the cavalry of the Imperial Guard. The facial study appears to have been drawn from David's *Napoleon in His Study*. The most remarkable visual similarities between the David painting and the popular print are the round face, the expression, and the lock of hair that falls on the emperor's forehead. In the three-quarter bust portrait, Bonaparte sports his colonel's epaulets, while the Legion of Honor cross with a tiny Imperial crown is suspended above his head.[26]

Below the portrait is a miniature depiction of the Battle of Austerlitz that was taken from Fran-

*National Glory-Napoleon* (1835), Pellerin, Epinal. © Imagerie d'Epinal, 1996. *Also see* color plate 8.

**Jacques-Louis David,** *Napoleon in His Study* **(1812). Samuel H. Kress Collection, National Gallery of Art, Washington, D.C.**

çois Gérard's famous *Battle of Austerlitz* (1804). The cannonball and bullets placed below the pillar on the left balance with battle plans at the base of the pillar on the right. The two pillars (shaped like gun barrels) on either side of Bonaparte are marked with his most celebrated conquests—to his left, the battles of the Pyramids, Mt. St. Bernard, Marengo, Austerlitz, Iena, and to his right, Friedland, Wagram, Lutzen, Dresden, and Monterreau. The Prussian insignia appears on the left pillar while the right reveals the double-headed eagle of Imperial Austria.

Although the gun-shaped barrels certainly refer to Napoleon's military training as an artilleryman, they also suggest the two pillars used to suspend the roof in the Masonic Temple of Solomon. According to Masonic traditions, three pillars—Ionian, the Doric, and Corinthian—supported the Masonic Temple. The Ionian column representing wisdom and the Doric representing strength clearly frame the heroic profile of Napoleon in *National Glory*.[27] The tricolor flag behind the two columns was the republican banner adopted by Louis-Philippe as a standard for the July Monarchy, but the flag was also a replica from the original standard that identified the Jacobin republic and subsequently the Empire. In addition to praising French military triumphs, the Pellerin atelier depicted Napoleon as a political icon for the French people. Surrounded by symbols of warfare and conquest, the bust portrait of Bonaparte in *National Glory-Napoleon* becomes an imposing focal point for the celebration of French patriotism.

Pellerin's artisans François Georgin and J.B. Thiébault also incorporated Masonic references in their brilliant interpretation, the *Apotheosis of Napoleon* (1834). The structure and symbolism found in this dramatic eulogy bear a striking resemblance to the seal of the Freemason lodge in Epinal, la Parfaite Union.[28] The pyramid in the background left of the design was a common symbol used in Freemasonry for the divine trinity—to think well, speak well, and do well—or by the revolutionary terms, "liberty, equality, and fraternity."[29] In the Masonic seal, a five-pointed star is suspended above the door to the throne of Solomon. The star was a common Masonic sign that referred to the elimination of religious superstition and dogma and the struggle to achieve freedom through scientific and material progress.[30] Abbé Bertaud, a contemporary of Pellerin and Freemason, wrote:

> [The five-pointed star] represents man released from authoritarian and religious dogmatism, who accepts no other guidelines than reason and welcomes no other friends than those of Science and Material progress.[31]

Masonic references and symbols in the Seal for the Epinal lodge describe a secular domain freed from ecclesiastical dogmatism and the weight of Catholic traditions or ritual practices. During the nineteenth century, Masonic lodges formed around the deist and revolutionary principles of its predominantly bourgeois membership. Many Masonic brothers from La Parfaite Union, such as Pellerin, were particularly committed to commercial, engineering, and educational improvements in the Vosges.[32]

**Seal for the Masonic Lodge** *The Perfect Union,* **Epinal. Salle des Manuscrits, Bibliothèque Nationale de France, Paris.**

Timbré et Scellé
Nous Garde des
et Sceaux dela

Gastambide, *Inside View of the Lodge, "The Third Hope"* (1790). Archives Municipales de Bordeaux, Bordeaux.

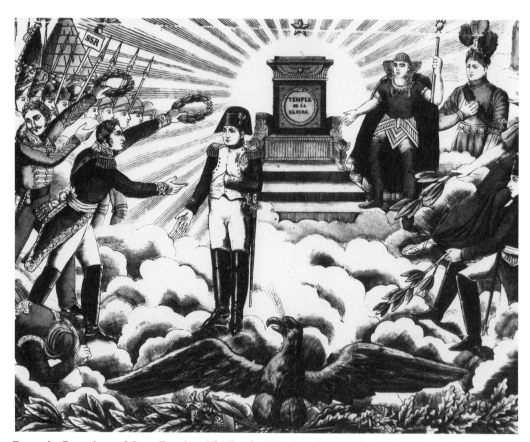

François Georgin and Jean-Baptiste Thiébault, *The Apotheosis of Napoleon* (1834), (close up of the Little Corporal) Pellerin, Epinal. © Imagerie d'Epinal, 1996.

In addition to allusions to Masonic symbols, the composition of the *Apotheosis*, with a chair/ throne at the top of the stairs, resembles the Masonic plan for the reception of a master or journeyman initiate. According to Masonic traditions, the initiate passes by the pillars and mounts the stairs to the throne on the opposite side, where the Great Master is seated. In the Pellerin print Napoleon, like a journeyman initiate, enters the temple and moves toward the empty seat of the Masonic master placed at the top of the stairs. The brilliant light of the "eastern sun" radiates outward as Sesostris beckons the Little Corporal to assume the Egyptian throne marked, "Temple of Glory." The explanatory legend below the Pellerin illustration affirms that, "No other man from any other historic period could be considered equal to the Man (Master) of the nineteenth-century. . . . France owes her laws, her monuments, and her glory to the Creator of the Empire. He led his nation to the Temple of Immortality.[33] As the Little Corporal approches the throne of glory, his placement in the center of the composition confirms his preeminence, not only as France's greatest military hero, but also as the recognized Master of Western Europe.[34]

Such references to Napoleon's superior military status addressed the humiliation France experienced after Napoleon's defeat in 1814 and the subsequent Allied occupation after Bonaparte's exile to St. Helena. Fear of legitimist conspiracies from 1831 to 1832, moreover, combined with worries about the eastern frontier encouraged political dissidents in northeastern France to coalesce around the question of French prestige and self-protection. To prevent another Allied invasion of France or the restoration of the Bourbon dynasty by foreign conquerors, republican leaders in Epinal organized a defense movement. Pierre-Germain Vadet was one of the founders of a local defense association entitled the National Association to Protect the Independence of the Country and the Permanent Expulsion of the Elder Branch of the Bourbons.[35] Vadet helped to launch the Association in March 1831 with a manifesto signed by Masonic cohorts from Epinal.[36] The fundamental goals of the National Association were to take revenge for the humiliating treaty of 1815 and to champion the liberal principles initially promoted by the Orleanist monarchy.[37] Although the government soon frowned upon a federal defense system, the formation of associations to defend the country from real or imagined crisis marked the first

seasoning experience for republican activists since the July Revolution.[38]

During the spring of 1832, Vadet dealt specifically with a major legitimist conspiracy precipitated by the return of the Duchess of Berry and her son, the Bourbon heir Henry V, from England. In March 1832, the Duchess arrived in southern France with plans to take over Provence and the Vendée. The following May, Vadet received a number of appeals from the Midi to produce and market legitimist posters to a general audience in regional France. In November, Vadet again reported legitimist solicitations to the prefect in Epinal. In his letter, the veteran forwarded the most recent request that he had received from a printer in Brittany who designated the legitimist themes that he wanted Pellerin to print from five lithographic originals. These included a picture of the Duchess of Berry with her son, the Duke of Bordeaux; the Duke of Bordeaux on horseback as colonel in the Guard; the Duke holding mademoiselle by the arm; the Duchess with two children; and the Duke portrayed in Scotland. The anonymous letter stated the political reasons for the request:

> I wish, Dear Sir, that these prints support not the present government (because I am among those who believe that the promises of the July Revolution have not been fulfilled) but another popular throne which will be realized when this regressive regime will have experienced our opposition.[39]

In his response to the legitimist agent, Vadet firmly refused to print political posters for the Bourbon cause. The former veteran explained his situation to the prefect of Epinal:

> Monsieur, my loyalty to the national throne established by the sovereign people of France in 1830 impels me to inform you of an appeal made to us from a city in Brittany on the 20th of this month for the production of poster art concerning Henry V and the Duchess of Berry.[40]

The legitimist insurgent's belief that the Pellerin prints were an effective way of advertising the Bourbon cause in regional France confirms the allegedly political function of these prints. From Vadet's unequivocal refusal to produce or market legitimist art, it is clear that the Pellerin firm was not indifferent to the political import of the material that they published. By notifying the prefecture of his unwillingness to participate in the Bourbon intrigue, Vadet temporarily secured the confidentiality of the authorities.[41]

A print entitled *Everyone Has His Own Trade*

(1835) (see page 82) underlined Vadet and Pellerin's opposition to the reinstatement of the Bourbon Kings. The legend below the Epinal illustration explains popular reactions to Napoleon's escape from Elba and return to power in the spring of 1815. The Pellerin editor describes the people's elated response to Napoleon's arrival in southern France and march northward to Paris: "He traveled across France, almost always carried on the shoulders of his soldiers. Everywhere along the road, his people greeted him with shouts of joy and hope."[42] When he enters Paris, a crowd carries him to the Place of the Carousel, just adjacent to the Louvre. After his arrival, the editor points out, Napoleon did not attempt to address the elite, but turned to a "woman of the people." When the vegetable seller approaches Napoleon she explains her political concerns to Bonaparte with exquisite candor:

> Sire, Excuse my forwardness. I do this only because I love you so much. . . . When you left, the Bourbons took your place. I was so angry, and don't want that to happen again.

Napoleon replies with a combination of humor and sarcasm, scolding her for her lack of faith:

> My good woman, each person has his own trade [task in life]. . . . Sell your vegetables; take care of your cabbage and your carrots. Leave the business of politics to me and everything will work out for the best if everyone does his duty.[43]

Napoleon chides the peasant woman for her fears, while at the same time discouraging her involvement in political matters. The Bourbon question was "his" business.[44]

Eschewing Bourbon issues, the Pellerin industries preferred to market broadsides and memorabilia about Napoleon's military conquests to armed services stationed along the northeastern frontier. The Third Army Division was stationed in the departments of the Meurthe et Moselle and the Vosges with headquarters in Metz, and a marshal with his division was stationed in Nancy. The Third Division was also located in Belfort, to south of Epinal on the Swiss border.[45] The town of Epinal had a major garrison (called Contādes) located on the Moselle River, just adjacent to the town. And because Epinal was a national recruitment center for the Vosges, the garrison served as a registration and training center for some 700 to 1,600 enlistments per year.[46] After political disturbances that occurred between 1832 and 1834 in the town, a regiment of 500 to 800 men from the cavalry division of dragoons was stationed each year in the garrison.[47] Although the population in Epinal and its environs was about 15,000 in 1831, a military contingent of some 1,500 to 1,900 men represented an important group of customers in the region.[48] Young soldiers were likely consumers not only of Pellerin's merchandise but also of republican ideas being touted by Pellerin's Masonic associates.

In March 1831, the minister of interior, Montalivet, wrote to the prefect of the Vosges, Baron Henry Simeon, warning him to keep an eye out for political pamphlets, prints, and propaganda that could corrupt military personnel. In a continuing effort to maintain good appearances, Simeon responded that he did not believe soldiers in Epinal were being affected by republican propaganda. Consequently, he did not want to clamp down too severely on the troops stationed in the Vosges.[49] In August of the following year, however, the new minister of interior, the Duke of Broglie, wrote again to the prefect, this time demanding that the police in Epinal prohibit soldiers from purchasing or becoming involved with the Masonic leader and editor of the republican newspaper, Nicholas Gerbaut. According to police records, the editor of the *Sentinelle des Vosges* was trying to engage young soldiers in the republican underground.[50]

Because of their apparent ingenuousness, the Pellerin prints were not initially implicated in police efforts to censure republican propaganda. In October 1832, however, Nicholas Pellerin became involved in the republican conflict by agreeing to publish Gerbaut's contentious *Sentinelle*. Pellerin stepped in when the paper ran into serious political difficulties and financial problems due to legal penalties and defense costs arising from its editorial policies. When the paper was founded in 1831, the editorial board initially supported the spirit and principles of the July Revolution, but after the authorities began to clamp down on all political organizations in the spring of 1832, the newspaper became a vehement critic of the Orleanist administration. Pellerin's backing of this enterprise does not correspond with the printer's reputation for caution and moderation.[51] In 1832, Pellerin was a respected member of the municipal council in Epinal. According to the prefect, Pellerin became involved with the republican paper to protect his

own interests and to modify the editorial policies of the paper.[52] When he began to publish the republican paper, the printer formally requested that the two most radical editors, Turck and Mathieu, withdraw from the paper. The police chief inferred that Pellerin would back the newspaper to alleviate tensions between republican leaders and the police department.[53]

But Pellerin's involvement with the *Sentinelle* was perhaps not as ingenuous as police records indicated. In fact, the newspaper was founded by a *carbonari* [organization] that planned to propagate its ideas either through legal means or political subterfuge.[54] In addition to his collaboration with chief editor Nicholas Gerbaut, Pellerin also worked with Masonic brothers from the *Sentinelle* who had strong political convictions. These included Jean-Baptiste Chevalier, a member of the carbonari; Marc Puton, a veteran from the Great Army; Sebastien Deblaye, also a veteran soldier and a member of Aide-toi, le ciel t'aidera; Joseph Mougeot, a lawyer from the Vosges and member of the carbonari; and Joseph Colin, a republican lawyer from Epinal.[55] Since most of these young men were born during the French Revolution (1783–93), they were about the same age (thirty-seven to forty-seven) and were very marked by the militant goals of the Revolution.[56] After the reinstatement of the National Guard in 1831, Pellerin's masonic associates Chevalier, Turck, Gerbaut, and Deblaye were elected officers in the National Guard by their respective divisions until the administration removed them from their command in 1832 and 1833 for suspected political infractions.[57] Because of prohibitive tax qualifications, none of Pellerin's Masonic brothers could run for political positions in the parliament. A traditional group of notables and propertied elite who had been in power during the Restoration returned to office after the Revolution of 1830.[58]

Despite the printer's promise to modify the the *Sentinelle's* editorial policies, the overall tenor of the newspaper did not change markedly after Pellerin began publishing it in October 1832. Many republican themes that occurred repeatedly in the *Sentinelle* also appeared in commentaries for the Napoleonic prints. For example, the antilegitimist position expressed in numerous *Sentinelle* editorials is also evident in the graphic and textual commentary for the Pellerin print *The Return from the Island of Elba* (1833). After fleeing captivity on the island of Elba, Napoleon arrives in the Gulf of San Juan with a small corps of officers and four hundred men from his Imperial Guard. Townsfolk greet Napoleon by lifting their hats and waving the tricolor while several officers, recognizing their former leader, welcome the Little Corporal and kiss his hand.[59]

Instead of emphasizing the moment soldiers and townsmen greet Napoleon, the editorial commentary explains the political reasons for his return to France:

> When the emperor learned that the French people had lost all the rights which had been gained by twenty-five years of combats and conquests, and that the French army had been attacked, he resolved to take the initiative and change things—and to re-establish the Imperial throne.[60]

The commentary underlines the people's misfortune in losing their political rights after foreign invasion and defeat in 1814. In the final lines from *The Return from the Island of Elba*, Napoleon reminds the entourage of soldiers who welcome him, "The Bourbon throne is illegal because it was not based on the will of the people." Napoleon disavowed the autocratic policies of the Bourbon dynasty by saying to the people: "Yes, *You are the Great Nation.*"[61]

In subsequent remarks, the Pellerin commentator emphasizes the importance of popular sovereignty by describing not only the response of soldiers and well-dressed townsmen to Napoleon's return but also the reaction of the peasants in the countryside.

> Peasants learning of his arrival ran to him from all sides and demonstrated their elation with ardor. Enormous crowds hurried to see him pass by.[62]

According to the narrative, Bourbon troops put down their weapons and agreed to follow the Little Corporal.

> Soldiers picked up their cockades and with a tear in their eye—they lifted the tricolor with great enthusiasm—"We have been waiting for you for a long time," said the brave people to the Emperor. "Finally you have arrived to deliver France from the insolence of the nobility, the pretensions of priests, and the shame of enslavement to a foreign power."[63]

For those able to decipher the Pellerin text, the broadside conveyed genuine disenchantment with the church, the aristocracy, and the com-

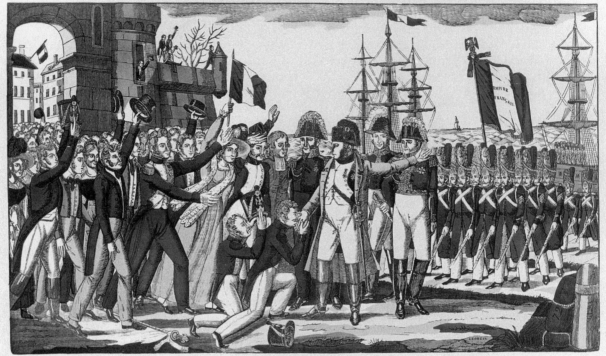

François Georgin, *The Return from the Island of Elba* (1833) Pellerin, Epinal. © Imagerie d'Epinal, 1996.

promising foreign policy of both Bourbon and Orleanist monarchies.

The legend beneath the *Return from the Island of Elba* reiterated themes from the *Sentinelle* concerning the corruption of the Catholic Church, the privileges of the *ancienne noblesse* (former nobility), and the weakness of French foreign policy. Revealing their anticlericalism, the editors repeatedly chided the church for extracting money from Christians for normal church services such as marriage and funerals.[64] *Sentinelle* editorials also pointed out the hypocrisy and self-serving strategies of many of the higher clergy.[65] But the editors most harshly lambasted the political prerogatives of notables and the government's efforts to reinstate hereditary peerage:

The nobility was born from the principle of absolute power; and is one of its most monstrous offspring; This [abuse of power] explains the origins for titles, favors, privileges, which exclude and depreciate every other group.[66]

To replace privilege with democracy, the editors firmly advocated expanding the electorate by decreasing property and income qualifications.[67] Like the Chartists in England, the *Sentinelle* editors believed that political equality would eventually foster greater economic justice and thus alleviate the deprivations of the working classes.

Because editors of the *Sentinelle* tended to equate the doctrinaire leaders of the Orleanist government who had participated in the Restoration regime with the Bourbon nobility, the term "Bourbon" in the Pellerin prints also referred to Louis-Philippe's ministers. The *Sentinelle* castigated certain members of the Orleanist ministry as legitimist traitors because "doctrinaire politicians can be distinguished from true legitimists only by the slightest of nuances."[68] The editors emphasized Adolphe Thiers's collaboration with the Bourbon government in repressing the military uprisings in 1822 and defending Charles X in 1830.[69] Allegations of legitimist involvement were also made against

François Guizot because of his enthusiasm for the Count of Artois, the brother of Louis XVI, who led a conspiracy to destroy the National Assembly during the French Revolution,[70] and his responsibility for the repeated escape of *chouans* (legitimist conspirators) from prison.[71] Likewise, the editors characterized Marshal Soult as a chameleon who sided with Napoleon or the Bourbons depending on the moment: "Alternatively, [he is] a servant of the Bourbons or Napoleon, attached to every party or victor, a maniac for power, worshiper of titles and privileges."[72] Since many of the doctrinaire leaders in the Orleanist administration were portrayed either as opportunists or legitimist sympathizers, the Pellerin editors identified them with the retrograde policies of the Bourbon system.[73]

The *Sentinelle*, like the Napoleonic prints, incorporated military metaphors to deprecate the government's pacifist foreign policy. An editorial entitled "On nous joue" [We are being dallied with] described the dangers of French reticence in the face of Russian, Austrian, and English ambitions. "We are being dallied with, we repeat, we are being dallied with and perhaps betrayed."[74] The *Sentinelle* outlined France's response to the threat of another European war with the Quadruple Alliance: "Therefore, let's go to war! Since war will precipitate all our diplomatic inanities into certain failure."[75] War was the only viable response to external and internal enemies who threatened French integrity and freedom.

Republicans considered legitimist intrigues to be the most insidious, not because of any real political danger, but because legitimist sympathizers in France could establish political ties with Prussia, Russia, and Austria to invite a future invasion. To underline the importance of military preparedness, the *Sentinelle* quoted Garnier Pages, editor of the *National*. Pages emphasized that in such cases of national emergency, "every soldier is a citizen, and every citizen becomes a soldier."[76]

Referring to the glorious epic of the revolutionary and imperial wars, the editors reproached the Orleanist administration for their hesitation to defend their Polish and Belgian allies: "There once was a time, a time filled with glorious memories, when a French soldier did not understand the command to 'march backward.'" The editors thus reproved a government for asking an army that had prided itself on innumerable victories to turn around and march backward: "Tell us old warriors, soldiers of the republic and of the empire, you who as fearless conquerors have gauged, with your own eyes, the height of the pyramids."[77] The editors thus disparaged the Orleanists for a pacifist foreign policy that disgraced the French armies.[78]

The editors of the *Sentinelle* continued to refer to Napoleon and his armies as the vanguard of the French Revolution. Combat, they believed, was a way to release both France and other European nations from the oppression of the Ancien Regime. Republican editors of the *Sentinelle* felt France should be a citadel for the protection of civil and political rights in Continental Europe. Aggressive warfare, not pacifism, would permit the extension of Enlightenment values and politics. If Russia managed successfully to intimidate or invade Europe, despotism would ensue. But French rule would foster the progress of European societies based on principles of national autonomy and political freedom.[79]

Pellerin's renditions of Napoleon's military exploits in 1833 reinforced republican frustrations with the king's refusal to take action against France's former enemies Russia, Prussia, and Austria. *The Battle of Lutzen* highlights Napoleon's initiative and courage during an assault against the Russians in Prussia. In the print, Napoleon is mounted, dressed as the Little Corporal, facing the plain of Lutzen with his officers. Sixteen batallions of his guard and eighty artillery units are routing Russian troops encamped in the village of Kaia. The Pellerin editor emphasized the emperor's initiative and courage: "Never did the emperor act with greater audaciousness; he seemed to have established his headquarters in the very heart of danger, where he watched everyone perish around him." Despite the arrival of the enemy, Napoleon remains *calme et maître de sa pensée* (calm and self-assured) as he orders his soldiers into the battlefield. In the midst of the fighting, Napoleon shouts to a Polish officer, "Go to Kracow and announce that I won the battle!"[80]

In April 1833, Pellerin addressed the question of political freedom with another broadside print, *Passage over the Arcole Bridge*. The Pellerin composition shows Napoleon bearing the republican standard as he leads his troops across the bridge during the Italian offensive against the Austrians in 1796. Carrying a tattered version of the tricolor in one hand and a sword in the other, the indomitable figure of Napoleon, dressed as an infantryman in the Imperial Guard, motions his troops forward. Dying and wounded soldiers are portrayed in the foreground of the print, pre-

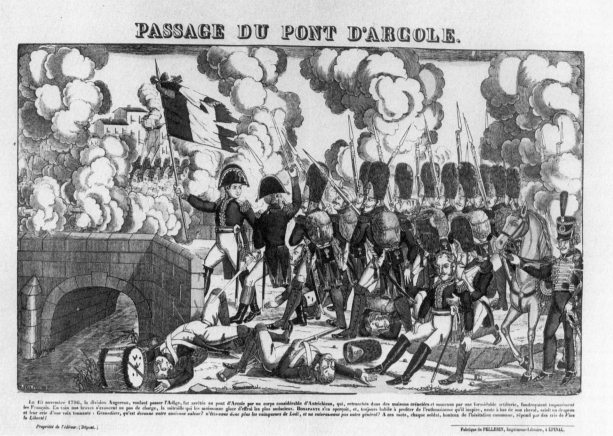

**PASSAGE DU PONT D'ARCOLE.**

Le 15 novembre 1796, la division Augereau, voulant passer l'Adige, fut arrêtée au pont d'Arcole par un corps considérable d'Autrichiens, qui, retranchés dans des maisons crénelées et soutenus par une formidable artillerie, foudroyaient impunément les Français. En vain nos braves s'avancent au pas de charge, la mitraille qui les moissonne glace d'effroi les plus audacieux. BONAPARTE s'en aperçoit, et, toujours habile à profiter de l'enthousiasme qu'il inspire, saute à bas de son cheval, saisit un drapeau et leur crie d'une voix tonnante : *Grenadiers, qu'est devenue votre ancienne valeur? n'êtes-vous donc plus les vainqueurs de Lodi, et ne suivrez-vous pas votre général?* A ces mots, chaque soldat, honteux de l'hésitation commune, répond par des cris de *Vive la Liberté!*

Propriété de l'éditeur. (Dépost.)                                              Fabrique de PELLERIN, Imprimeur-Libraire, à ÉPINAL.

**François Georgin,** *Passage over the Arcole Bridge,* **Pellerin Epinal. © Imagerie d'Epinal, 1996.** *Also see* **color plate 9.**

saging the bloody conflict that will ensue on the opposite side of the bridge. Despite the print's incorrect perspective and lack of sophistication, the Pellerin artisan developed a spartan, militant composition that underlined the seriousness of the political statement.

The theme for *Arcole* was undoubtedly derived from earlier representations of the young martyr who crossed the bridge of Arcole during *Les Trois Glorieuses* (the three victorious days of the July Revolution) to plant the flag of freedom in the center of Paris. Representations of a young man carrying a flag over the Arcole bridge were very popular in prints and engravings following the Revolution of 1830. According to a number of such prints, when the youth lifted the revolutionary flag, he requested that his heroism be remembered: "My friends, if I die, remember that I deserve the name Arcole."[81] Bonaparte's fervor is also evident in the commentary beneath the Pellerin print. Napoleon shouts to his men, "'Grenadiers, what has become of your former valor? Won't you follow your general? Aren't you

the victors of Lodi?' With this reproach, each soldier ashamed of any more hesitating began to advance shouting "'Vive la liberté!'" (Here's to Liberty). Napoleon then lifts the revolutionary standard and leads his infantry forward.[82] In view of the government's opprobrium against political organizations after 1832, the shouted phrase constituted a statement of political defiance by Pellerin and his Masonic collaborators.

Beginning in the fall of 1832, the Pellerin firm published the nefarious *Sentinelle des Vosges* and designed illustrations for the Napoleonic epic to the exclusion of most every other graphic theme. During that period, the government made a concerted effort to put the republican newspaper out of business.[83] The *Sentinelle* valiantly attempted to defend itself against the punitive measures of the local administration. But in the course of public accusations and recriminations from October 1832 to May 1833, the Pellerin firm continued to publish the radical republican bi-weekly, much to the consternation of the local authorities. When the prefecture closed the pa-

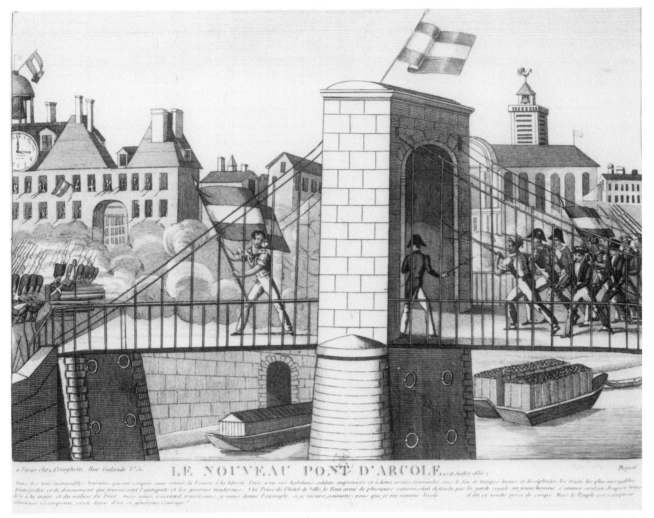

*The New Bridge of Arcole* (1830), Collection da Vinck. Cabinet des Estampes, Bibliothèque Nationale de France, Paris.

per down in the spring of 1833, it was apparent to republican leaders such as Gerbaut and Pellerin that civil freedoms could not be exercised without legal reproof or underhanded police retaliation.[84] And by the fall of 1833, the Great Orient likewise suspended the Masonic lodge in Epinal from further operations.[85]

After the *Sentinelle* was forced out of business and the Masonic lodge closed, Pellerin nonetheless continued to publish republican propaganda. He printed and marketed a radical republican almanac, the *Almanach du peuple* (Almanac of the people), each year from 1832 to 1841. The author of the almanac was probably Léopold Turck, doctor from Plombière and one of the founding editors of the *Sentinelle*. Printed at ten thousand copies per issue, the *Almanac* sold for twenty-five centimes to artisans and

farmers who wanted tips on agriculture, health, and ways to economize their meager resources. Because of its rudimentary table of contents, the almanac was apparently not examined carefully by the authorities. From 1832 to 1841, Pellerin marketed the almanac to local book dealers in Nancy, Toulouse, Lille, Reims, Rouen, and Paris as well as through itinerant peddlers to customers in the countryside.

The final pages of each issue were filled with political material and criticism of the government for its policies toward the poor and working classes. The almanacs for 1834 and 1835, for example, produced a detailed account of the atrocities committed by the government against the working classes in Lyon and Paris. A fictional spokesman for the rural classes, the peddler Père Simon, emphasized repeatedly how

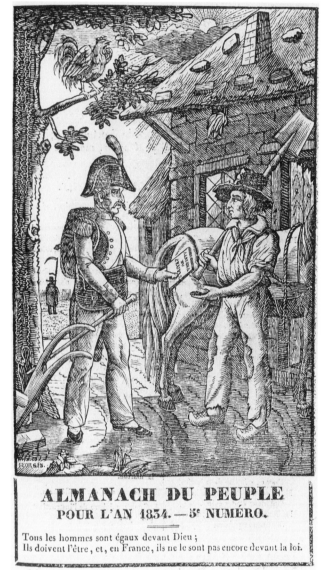

**ALMANACH DU PEUPLE**
POUR L'AN 1834. — 5ᵉ NUMÉRO.

Tous les hommes sont égaux devant Dieu ;
Ils doivent l'être, et, en France, ils ne le sont pas encore devant la loi.

François Georgin, *Cover for the Almanac of the People for the year, 1834,* Pellerin, Epinal. Special Collections, Bibliothèque Municipale de Nancy, Nancy.

the government's unjust taxation policies on salt, wine, and tobacco placed an unfair burden on the rural poor.[86]

The image on the cover of the *Almanach du Peuple* was produced by François Georgin. A veteran soldier, dressed in the same uniform that Napoleon often wore as a colonel in the cavalry of the Imperial Guard, hands a printed (republican) paper to a farmer. Representations of the soldier and farmer from the Restoration and July Monarchy reflected a fundamental alliance between the military and the peasantry.[87] The cock, a revolutionary symbol of the French republic, is

perched in a tree above the two men. The sun rises behind the farmer's cottage, signifying hope for disenfranchised peasants and workers. The caption beneath the Georgin illustration reads, "All men are equal before God; they ought to be, but in France, this is not yet the case under the present law."[88]

In February 1834 the Chamber of Deputies began to discuss the reinstatement of Law 291 to prohibit all political gatherings. The law's proscription of the right of assembly was aimed particularly at Les Droits de l'Homme (the rights of man), a republican organization accused of fomenting working-class unrest and violence during the preceding year. Concurrently, demonstrations among discontented artisans began to occur in Lyon, where republican leaders of Les Droits de l'Homme tried to organize hat makers, carpenters, masons, and silk weavers to voice economic grievances against master guildsmen and shop owners. Subsequent demonstrations in April, however, solidified the government's opposition to republican and working-class demands. Much to the consternation of republican proponents, the law against assembly was passed in April 1834 without serious opposition from either house.[89]

When the law against associations was being debated in the assembly in February 1834, Pellerin printed several pictures of Napoleonic battles from the revolutionary epoch. Despite increasing censorship pressures against republican groups, the Pellerin firm continued to print Napoleonic art without direct censure from the authorities, even though some of the Pellerin commentaries expressed adamant discontent with the recalcitrance of the administration. For example, in the midst of the apparent mayhem of wounded and fleeing soldiers described in the *Battle of Marengo* (1834), Napoleon manages to rally his troops for a renewed assault. Dressed as the Little Corporal, Napoleon leads his officers from the left midground of the composition galloping into the center of battle. In spite of the carnage and confusion that prevail in the foreground of the scene, Napoleon appeals to his soldiers: "Frenchmen, we have spent too much time going backward; the moment is here to take a decisive step forward. I am accustomed to sleeping on the battlefield."[90]

In the *Battle and Passage over the Bridge at Lodi* (1834) (see page 74), Napoleon makes an even more urgent appeal to his men to march over the bridge to confront a tight column of oncoming

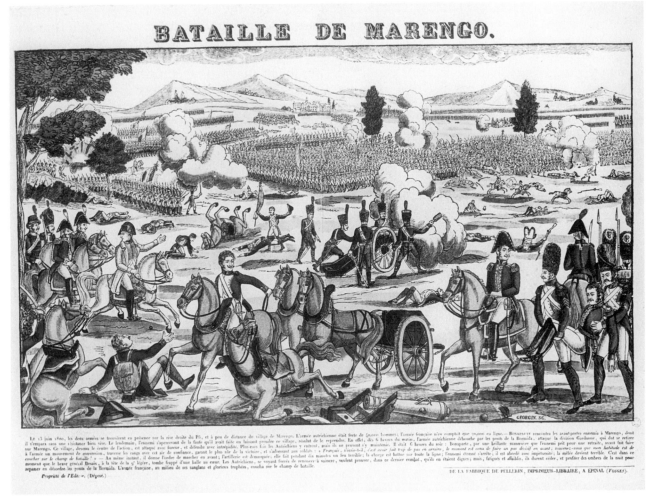

François Georgin, *The Battle of Marengo* (1834), Pellerin, Epinal. © Imagerie d'Epinal, 1996.

Austrians. In the left foreground, Napoleon converses with his officers and points to the artillery division stationed along the river that is firing cannons in support of the infantry marching over the bridge. Despite the Austrian's hefty offensive, Napoleon gives orders to continue the advance. Led by Berthier, Massena, and Marshal Lannes, the French troops keep moving until they reach the Austrian encampment and seize the enemy's weapons. As they carry the tricolor flag across the Lodi, Napoleon's grenadiers shout, "Vive la République."[91] For a print produced in the spring of 1834, when republican groups were under assault from the administration, the editor's incorporation of the phrase "Long live the Republic" was probably not coincidental. With the poster image of *Lodi*, The Pellerin atelier made an impassioned textual and graphic statement in favor of the beleaguered republican movement.

Due to the repressive strategies of the Orleanist government, by May 1834 most republican organizations could no longer function. The most brutal strike of working-class groups occurred on 9 April in Lyon, leading to subsequent violence in Paris on 12 and 13 April.[92] Under government directives, the army and national guard crushed the insurrections. The trial for the April insurrections took place on 5 May 1834, when 162 republicans were convicted for participating in the disturbances.[93] When the venerable leader of moderate republicans, the Marquis de Lafayette, died that same month, most republican leaders had been either silenced or imprisoned.[94]

Pellerin, nevertheless, emerged from the *Sentinelle* debacle and republican *défaite* (defeat) in 1834 apparently unscathed. The spring after the insurrections in Lyon and Paris, the Pellerin atelier added several prints that included workers to the Napoleonic series. *The Debarkation of Napo-*

leon (1835) and *Napoleon's Entry into Grenoble* (1835) highlight the enthusiasm of workers, middle-class citizens, and soldiers for the intrepid Little Corporal who returned from exile to regroup the French nation. In *The Debarkation of Napoleon,* (see page 82) Bonaparte arrives on the shoreline of southern France, where he is greeted by soldiers, a civilian official wearing the Legion of Honor cross, and a muscular man in overalls drawing the boat to shore. Another well-dressed man in britches and top hat directs the boat with oars as Napoleon's entourage waits patiently to disembark. While the print includes members of the middle class and the working class, the main theme is the interaction between the Little Corporal and the soldiers on land who shout and lift their hats: "The first of March, at three in the afternoon the flotilla from the island of Elba enter the Bay of San Juan. His entourage of grenadiers put down the white canopy covered with bees, and pick up the tricolor cockade with a cry of 'Vive la France! Vivent les fran-

çais!'" [Long live France. Long live the French.]"[95] Although the phrase *Vive la France* is certainly less controversial than previous references to *la liberté* (liberty) or *la république* (the republic), the worker in overalls who draws the Little Corporal to shore suggests a revolutionary alternative to Bourbon (and Orleanist) political systems. In the concluding remarks, the editor pointed out Napoleon's charisma with his soldiers: "'Grenadiers,' Napoleon said, 'we are going to France; we are going to Paris.' His grenadiers would have followed him anywhere."[96]

While soldiers are also featured in the welcoming party for *Napoleon's Entry into Grenoble* (1835), men in work shirts, aprons, and some in overalls appear in the left forefront of the composition, raising their fists triumphantly as Napoleon and his Imperial Guard approach on horseback. To encourage his recognition and to disarm his opponents, Napoleon wears the familiar accoutrements of the Little Corporal. When the

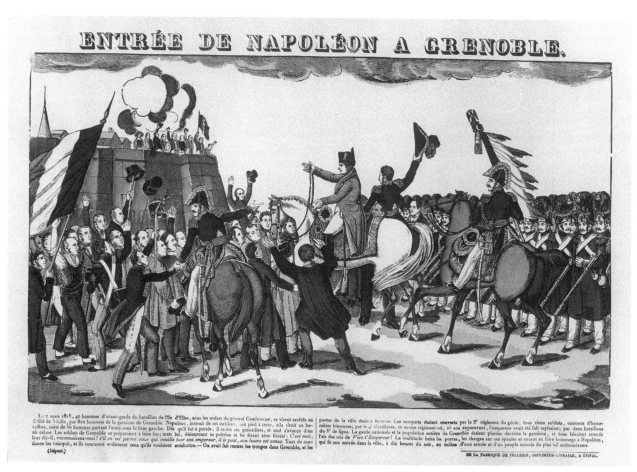

François Georgin, *Napoleon's Entry into Grenoble* (1835). Pellerin, Epinal. © Imagerie d'Epinal, 1996.

townsmen on the ramparts of the city recognize their former leader, they shout and wave the tricolor. Concurrently, soldiers in the left foreground raise their hats on swords to welcome his return from exile. The Pellerin commentary for *Napoleon's Entry into Grenoble* describes the famous incident when Napoleon encountered Bourbon troops at Laffrey (several kilometers from Grenoble) who attempted to stop Bonaparte and his military escort from advancing farther into France:

As soon as he was within firing range of the defending battalion, he stopped his grenadiers, and stepped forward calmly. The soldiers from Grenoble prepared to open fire—but uncovering his chest, he stared at them with a look of pride. "It's me—he said—don't you recognize me? If anyone among you would like to kill his emperor, he can do it—his hour has come."[97]

Napoleon so impressed the opposing troops with his courage that the forces who had intended to deter Bonaparte instead ran to embrace him. Subsequently, townspeople broke through the city gates in order to pay homage to the former emperor who entered the city at ten o'clock in the evening.[98]

Pellerin's acclamatory descriptions of Napoleon's return did not correspond with prevailing attitudes toward King Louis-Philippe from 1834 to 1835. After the government's repressive actions toward the working classes, police noted the increase of seditious cries that praised the republic and lambasted the Orleanist king.[99] Though the Fieschi attempt to murder the king on 28 July 1835 was masterminded by leaders of Les Droits de l'Homme, seditious remarks reflected serious and widespread discontent with the Orleanist monarchy during the spring and summer of 1835. Police records were filled with comments from the working classes such as "Vive la république," "À bas Louis-Philippe" [Down with Louis-Philippe], or "Mort à Louis-Philippe" [Death to Louis-Philippe]. While some prefects attributed these remarks to legitimist troublemakers, the police tended to associate most disturbances with further republican strategems.[100]

But Giuseppe Fieschi's near-successful attempt on the king's life in July 1835 led to the passage of a comprehensive series of censorship laws to prevent further political intrigues against the Orleanist throne. The series of laws that were passed in September 1835 forbade any reference to a change in dynasty, to the Bourbon kings, republican, or any form of government other than the Orleanist system. The government felt that any threats to the person of the king or his authority were crimes against the state that could be tried by the House of Peers (rather than by jury) with penalties from ten thousand to fifty thousand francs.[101]

By passing the September laws, the government linked provocative political illustrations with political violence. Therefore both houses issued harsh proscriptions against any graphic or textual theme that might provoke political demonstrations: "The purpose of the law is to destroy the bad press, the anarchic press [whether it be] republican or royalist, that is to say, the hostile press."[102]

In addition to prohibiting political prints, engravings, and poster images, the government also attacked political lithography or caricature that criticized the king, his family, or the ministry. Such engravings, posters, or lithography could not be sold or displayed without *l'autorisation préalable de l'autorité* (prior authorization from the government.)[103]

Since the September laws forbade any reference to the Bourbon government or to the republic, Pellerin was forced to modify not only subsequent plans for the Napoleonic series but also the commentaries beneath future print designs. While police records do not indicate that Pellerin had a direct altercation with the authorities in Epinal regarding the publication of Napoleonic art, he was certainly influenced by the abrupt change in censorship regulations after September 1835. The following December, Pellerin presented four new designs to the police department for authorization. When the prefect forwarded these images to the minister of interior, he permitted them to be printed because the commentaries were descriptive and not politically subversive.[104] Consequently, Pellerin managed to publish five designs in the spring of 1836—*Napoleon at Arcis-sur-Aube, Napoleon at Monterreau, Honor to the Courageous Wounded, The Entry of Napoleon into Madrid,* and the previously authorized *Battle of Waterloo*—without apparent censure or deprecations from the authorities.

In August 1836, Pellerin requested permission to print several bonapartist broadsides, *The Battle of Eylau,* and a print without commentary entitled, *Napoleon and His Son.* Although the representation of Napoleon's son and heir did not appear at that time to be inflammatory, Georgin's brilliant portrayal of Napoleon and the

# NAPOLÉON ET SON FILS.

François Georgin, *Napoleon and His Son* (1836), Pellerin, Epinal. © Imagerie d'Epinal, 1996.

Duke of Reichstadt was published one month before the aborted coup of Louis-Napoleon Bonaparte. The determination of the Pellerin printers to publish bonapartist themes, even at the risk of government censure, suggests a genuine political commitment to the cause of bonapartist succession. Veteran Pierre-Germain Vadet was likely responsible for the continued investment of the printing firm in favor of political bonapartism.[105]

Following Louis-Napoleon's attempted coup on 30 October 1836 in Strasbourg, references to the Napoleonic legend or to dynastic bonapartism became equally suspect to the authorities. Pellerin subsequently presented very few new designs of Napoleon and his illustrious armies to the authorities for authorization. The Epinal printer instead resumed publishing less provocative themes, such as devotional art, generic entertainment, illustrations for fairy tales, or annotated stories from the Blue Library. In addition to current events and occasional portraits of the royal family, Pellerin added a series of brightly stenciled prints to his repertory depicting soldiers in dress attire and regional groups in fanciful folk costumes.

But the famous series of Napoleonic poster prints that Pellerin produced during the early years of the July Monarchy could not be forestalled by the threat of increased censorship. After the September laws of 1835, the prefect in Epinal ruled that previously authorized designs could be printed and marketed without further examination.[106] Since wood-block designs could last for several generations, it is likely that Pellerin reused some fifty-two engravings of Napoleon and his armies that had been authorized prior to 1837.[107] Several other firms in the Northeast such as Deckherr brothers in Montbéliard and Dembour et Gangel in Metz continued to reproduce Napoleonic prints similar to the Pellerin designs. From 1830 to 1835, Deckherr Brothers produced eleven prints on Napoleonic themes while Dembour et Gangel in Metz reproduced twenty-seven illustrations (1836–49), many derived from graphic themes originally produced by the Pellerin firm.[108] Thus, Epinal, Metz, and Montbéliard formed a triangular cluster of outposts in the Northeast that promoted Napoleonic themes. The location of these three printing firms enabled peddlers to secure representations of Bonaparte and his victorious armies for regional marketing during the latter years of the July Monarchy (1836–48).

Despite the censorship laws of 1835 and increased apprehensions following Louis-Napoleon's insurrections in 1836 and 1840, the Napoleonic legend could not be completely subverted or co-opted by the Orleanist government. The triumphal vision of Napoleon's armies proved far more appealing to republican groups than did the king's program for peace and moderation. The continued demand for Napoleonic broadsheets in regional France, moreover, enabled the Pellerin printers to ignore censorship controls and prosper in an underground market during the turbulent years that preceded the Revolution of 1848.

Representations of Napoleon's military campaigns portrayed not only French glory, but also revenge against the Quadruple Alliance that had defeated and occupied France in 1815. Representations of Napoleon and his erstwhile heir continued to resound not only with the expectations of militant republicans but with those of soldiers, peasants, artisans, and day workers for the renewal of French prestige and for release from political oppression. In contrast with the increasingly autocratic profile of the Bourgeois Monarchy, references to the Little Corporal promoted populist as well as republican notions of political justice. Since Napoleon embodied widespread aspirations for the renewal of French glory and the egalitarian principles of 1789, his image became a powerful focus for the resurgence of national political sentiments. Pictures of Napoleon and his indefatigable armies provided the French people with a symbolic vehicle to identify and express their discontent with the timorous and defensive strategies of both Bourbon and Orleanist systems.

# Epilogue

WHEN REPUBLICAN LEADER ADOLPHE THIERS BE-
came prime minister in March 1840, he managed
to convince the king and his council of ministers
to begin negotiations with England for the re-
turn of Napoleon's Ashes to France. That July,
the king's third son, the Prince of Joinville, de-
parted with the French delegation to repatriate
Napoleon's remains from St. Helena. Returning
to Cherbourg on 30 November the delegation
transferred the body to a steamboat that jour-
neyed slowly up the Seine to Paris. After arriv-
ing in Courbevoie just outside of the capital,

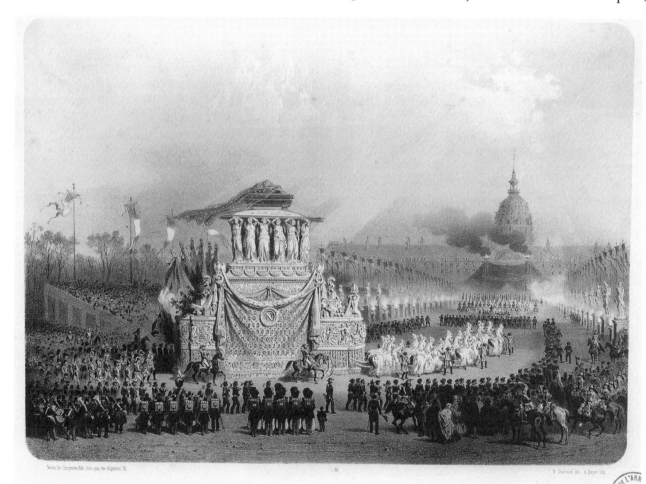

**A. Bayot after a lithograph by E. Guérard,** *Arrival of the Ashes of Napoleon I in Paris.* **Chapentier, Musée de l'Armée,
Hôtel National des Invalides, Paris.**

136

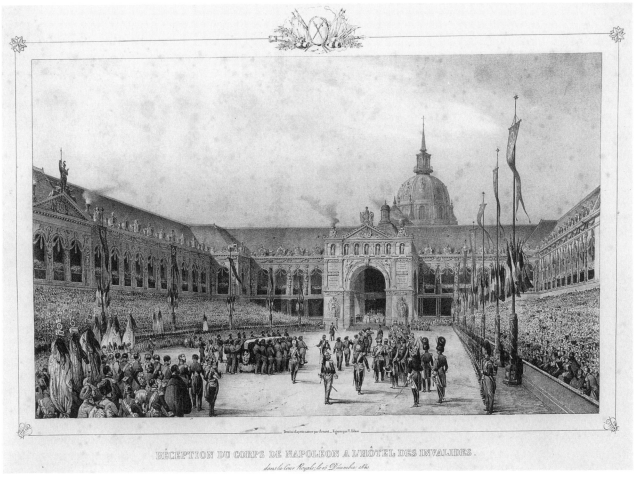

Arnout and V. Adam, *Reception of Napoleon's Body at the Hôtel des Invalides.* Musée de l'Armée, Hôtel National des Invalides, Paris.

Napoleon's remains were placed inside an elaborate carriage encircled by twelve caryatids (symbolizing Napoleon's victories) and pulled by sixteen horses draped in gold. The cortege proceeded through the Arch of Triumph, down the Champs Elysée, and over the Seine River to the Hôtel des Invalides. The Invalides was an extensive complex of buildings founded by Henry IV in 1604 as a residence for French war veterans and completed by Louis XIV in 1671. After much debate, the government had selected the Invalides as a burial site for Napoleon's remains since it was already a memorial for some of France's greatest military heroes.[1]

When the carriage arrived in the esplanade of the Invalides, it was taken to the Court of Honor, where candles had been illuminated. While the choir chanted a resonant *de profundis*, the archbishop of Paris, Monsignor Affre, welcomed the coffin with prayers and began the funeral ritual.[2] Subsequently, the young prince saluted the cof-

fin and formally offered Napoleon's remains to his father, Louis-Philippe. According to the official excerpt in the *Moniteur,* the prince said, "Sire, I present the body of the emperor Napoleon." The king replied, "I receive it in the name of France."[3]

Plans for the return of Napoleon's body to France engendered widespread enthusiasm for an aggressive military policy in Europe and in the Near East. Due to the resurgence of chauvinistic fervor, France was about to become involved in a major European war triggered by tensions in the Middle East. In 1839, war had broken out between the sultan of Turkey and the pasha of Egypt, Mehemet Ali, who was considered to be a humanitarian leader and long-standing ally of France. However, when England, Austria, Prussia, and Russia signed a treaty on 15 July 1840 to support the Ottoman leader, resentment in France shifted to outright support for the beleaguered Egyptian leader. Some dissident groups

viewed the treaty of 1840 as a repetition of 1815 and therefore advocated aggressive military action not only to protect Egypt but also to secure territory in the Rhineland that had been lost after the Treaty of Paris.[4]

The return of Bonaparte's remains corresponded with a continuing republican struggle for the extension of civil, political, and economic rights in Orleanist France. For disenfranchised minorities as well as nationalist groups who sought liberation from foreign domination, representations of the Little Corporal provided a focus for political discontent. The democratic image of Bonaparte opposed legitimism, hereditary privileges, and patronage systems that continued to flourish within the Orleanist government. Despite rigorous censorship laws in 1835 that prohibited the publication of most textual or graphic criticism of the government, the Napoleonic legend retained its nascent power to defy the bland and prosaic public image of the Orleanist monarchy. For discontented republicans, bonapartists, artisans, and veteran soldiers, Napoleonic grandeur and justice seemed preferable to the government's petty domestic politics and sycophantic maneuvers with the European powers. And despite the fact that bonapartism had no extensive organizational basis for opposition to the crown, Louis-Napoleon Bonaparte's attempted coup in Boulogne on 9 August 1840 added kindling to a potential conflagration.

Consequently, in the ceremony for the Return of Ashes, the administration avoided dangerous allusions to the Napoleonic legend by designing an elaborate but restrained performance with little political innuendo. Plaster statues of allegories and notables from French history lined the avenues and esplanade of the Invalides to emphasize Napoleon's position within, but not above, French history.[5] During the ritual procession and burial, no symbolic reference was made to Napoleon as the Little Corporal. Napoleon's remains were camouflaged behind a neoclassical, baroque decor embellished with Imperial and Orleanist symbols. Victor Hugo charged that despite the superficial pomp of the funeral procession, it was apparent that the Orleanist government had intended to conceal the actual remains of the former emperor from the people who adored him.[6] After the funeral, Napoleon's casket was placed in a sunken crypt in the Church of the Invalides, an elegant basilica designed by Jules Hardouin Mansart, located in the rear court of the building. Since the fortresslike design of the Invalides was surrounded by a moat, it was apparent that while acknowledging Napoleon's place in French history, the adminsitration intended to remove Napoleon's remains spatially as well as symbolically from the general purview of the public.

In 1841, Pellerin published five scenes from the Return of Ashes rendered in a realistic but flat and unimaginative manner that duplicated Parisian engravings of Napoleon's exhumation, funeral, and burial.[7] Pellerin's *Napoleon's Funeral Carriage* is portrayed with the static quality of a classical relief rather than the naive freshness of a colorful wood-block design. The complex portrayal of the funeral cortege in the *Transfer of Napoleon's Ashes to the Invalides* displays the pomp and flamboyance of an important state occasion, but it is rendered with rigorous formality and lacks the naive animation of earlier Pellerin designs. In the series of prints for the Return of Ashes (published only once, in 1841), the Pellerin firm obviously yielded to the orthodox political strategies of the Bourgeois monarchy.

During the first decade of the July Monarchy, Nicholas Pellerin was in a difficult bind. While continuing to maintain relationships with brothers from the local Masonic lodge who were active in republican resistance to the Orleanist government, Pellerin also tried to meet the terms of the police in Epinal to protect his business interests. Despite censorship prohibitions inaugurated in September 1835, the Pellerin firm continued to publish fifty-two illustrations of Napoleon that authorities believed did not threaten the crown. The editorial remarks in a newspaper that he published after the Revolution of 1848 indicate that Pellerin was not simply an opportunist. From editorials written during the Second Republic, it is apparent that he maintained the republican principles and reforms that he had espoused during the early years of the July Monarchy. But because he could not express his political views directly during the most heated period of the republican controversy, Pellerin conveyed the most salient republican issues indirectly through poster texts and images of Napoleon Bonaparte. Pellerin's genius was to have employed a political symbol that apparently supported but potentially undermined the legitimacy of the July Monarchy.[8]

Pierre-Germain Vadet was undoubtedly the primary agent responsible for the production of the Napoleonic broadsides. Having received rec-

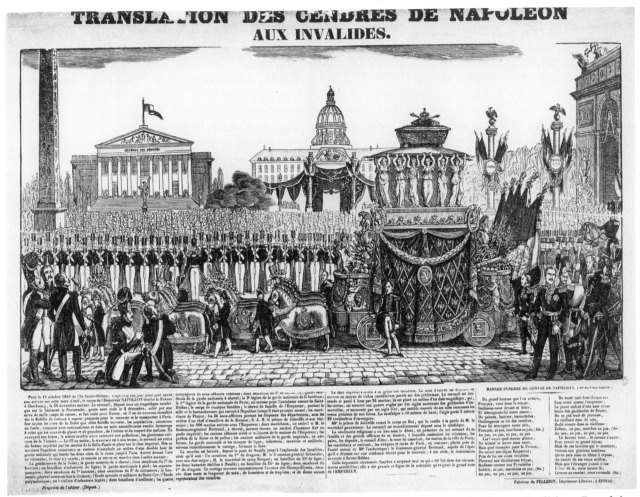

A. Guey, *Transfer of Napoleon's Ashes to the Invalides* (1840), Pellerin, Epinal. Musée des Arts et Traditions Populaires, Paris. Photo by RMN.

ognition as a chevalier of the Legion of Honor during the Napoleonic wars, Vadet remained devoted to Bonaparte during the remainder of his career. After having served in Napoleon's adminstration during the Hundred Days, the veteran participated in several insurrections against the Bourbons following Napoleon's abdication in 1815. When he became a [de-facto] partner with Nicholas Pellerin during the early years of the Restoration, Vadet set the tone of the enterprise by promoting battle themes from the republican and Imperial wars. While the Pellerin prints could not portray Napoleon directly, they nonetheless alluded to the imposing presence of the legendary commander. During the July Monarchy, Vadet collaborated most closely with Pellerin's chief artisan, François Georgin, by selecting lithographs and engravings of Napoleon and his armies that inspired Georgin's inimitable designs. During both the Bourbon and Orleanist regimes, Vadet showed his mettle through his determination to publish Napoleonic art, to the exclusion of any other political theme.

While representations of Napoleon Bonaparte reflected the republican and bonapartist ideologies of the Pellerin printers, the import of these images, nevertheless, transcended the particular motivations of the producers. During the early-nineteenth century popular representations of Napoleon and his soldiers resonated with a provincial audience who had been directly involved with Napoleon during the Imperial wars, or were relatives and friends of veterans from Napoleon's Revolutionary and Imperial armies. Though the Pellerin prints portrayed the death and burial of Bonaparte in graphic detail, these images enabled commoners to commemorate and relive their adventures with Napoleon in

foreign lands. Even after 1821, the proliferation of seditious cries and shouts about Napoleon suggested that for many peasants, veterans, artisans, and workers, Bonaparte had never died. Moreover, Béranger's songs along with Charlet's, Raffet's, and Bellangé's lithographs celebrated the symbolic "presence" of the French commander who, in popular traditions, had been so accessible to soldiers and commonfolk.

Louis-Philippe attempted to incorporate popular versions of the Little Corporal into official rituals and representations to create grassroots support for his government. The king employed Napoleonic themes both to reinforce the prestige of his own government and to placate those who adhered to more revolutionary positions. But public representations of Bonaparte and his republican armies proved to be more incendiary than the king had anticipated. Consequently, during the Return of Ashes he tried to eliminate potentially provocative references to the Little Corporal that might arouse widespread political dissension. Popular representations of Napoleon produced by printers such as Pellerin, nevertheless, retained a commemorative power that surpassed the king's efforts to use the legend exclusively in support of the Orleanist state.

The nation's preference for Bonaparte and his heir cannot simply be explained by nostalgia for the splendor of the Empire and the legendary triumphs of the Imperial armies. Nor was Napoleon's appeal merely a reaction to the vestiges of seigneurial and ecclesiastical privilege in the countryside. For Pellerin's clients, religious practices associated with devotional art influenced how people interpreted popular images of Napoleon. Representations of Napoleon fused with familiar religious traditions to create a political metaphor that touched provincial customers. Depending upon their reception and appropriation, images of the Little Corporal embodied both secular and religious perspectives: Napoleon could be understood as the harbinger of an impending democratic revolution, and as a savior who would redeem his people from social and economic injustice. The merger of religious and democratic ideas about Napoleon Bonaparte unleashed populist aspirations for the renewal of French military glory and egalitarian justice.

Several months before the outbreak of the 1848 revolution, a pilgrimage took place to a shrine erected in honor of Napoleon Bonaparte near Dijon.[9] The statue of the Little Corporal, described as rising from the dead, was placed outdoors near the village of Fixin as a commemoration of Bonaparte and as a center for pilgrims. Thousands of people came to celebrate the inauguration of the statue on 19 September 1847.[10] A veteran from the Great Army, Captain Claud Noisot, commissioned the famous artist François Rude to create the bronze *Resurrection of Napoleon* that was placed in a small glade surrounded by rocks on top of a craggy hill outside of Dijon.[11] The location suggested both the Mount of Olives and the Garden of the Resurrection.[12] Rude's outdoor cenotaph represents the Little Corporal stretched out on a steep rock with waves beating against a stony precipice, apparently a symbol for St. Helena.[13] The Imperial eagle lies crushed at Bonaparte's feet, marking the final demise of the Empire. But Napoleon's accoutrements signal the imminent rebirth of democratic and republican France. Wearing the characteristic uniform of the Little Corporal and crowned with a laurel wreath, a youthful Napoleon lifts his head and torso as if he were rising from his tomb and ready to pull back his famous greatcoat, which covers him like a shroud.[14]

In his inaugural speech, Captain Noisot announced to the crowd of pilgrims that Napoleon was the Christ of modern times, a contemporary Messiah to the French people. Noisot indicated that the monument represented the rebirth of democracy and France's hope for a new sense of political cohesion. In his final statement, the old veteran explained the significance of Napoleon's "resurrection": "Napoleon is about to rise from the dead—his spirit is that of democracy which illuminates and inspires all those who have come to witness his resurrection." At the conclusion of his inaugural speech, the crowd shouted "Vive Napoléon, vive l'empereur!" [Long live Napoleon! Long live the emperor!][15] An engraving of the event shows a long line of pilgrims dressed in bourgeois and peasant attire trailing over the hills of Beaune to Bonaparte's shrine. As they are leaving, the procession continues to celebrate the spirit of the "risen" Napoleon:

> Night arrived and after the fireworks, the crowd carried in their hearts and imagination the living representation of Napoleon. They left taking every available road, and while on route, they sang the Marseillaise, songs by Béranger, and other national hymns.[16]

This popular demonstration to the memory of Bonaparte took place in September 1847, just

**François Rude,** *Resurrection of Napoleon* **(1847). Musée d'Orsay, Paris. Photo by RMN.**

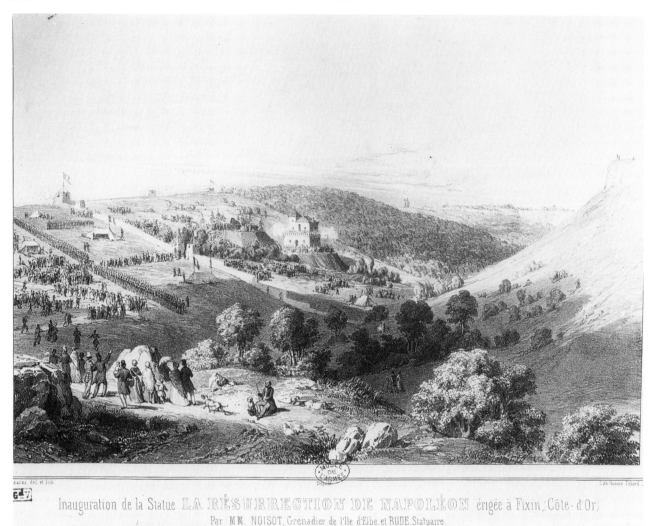

Inauguration de la Statue LA RÉSURRECTION DE NAPOLÉON érigée à Fixin, Côte-d'Or)
Par MM. NOISOT, Grenadier de l'Île d'Elbe, et RUDE, Statuaire.

François Rude, *Inauguration of the Statue, "The Resurrection of Napoleon" mounted at Fixin, Côte-d'Or.* Musée de l'Armée, Hôtel National des Invalides, Paris.

four months before the Revolution of 1848. For some Frenchmen, Napoleon may have signified nostalgia for the days of Imperial glory or aspirations for the renewal of French military bravado in Continental Europe and the Middle East. But for these pilgrims, the statue in the Burgundian countryside represented the legendary soldier of the French Revolution who had symbolically "returned" to his people.[17] Compared with the government's formal interment of Bonaparte's remains in the Invalides, François Rude's representation of Little Corporal rising from the dead proferred a far more fitting celebration of Napoleon's "continued presence" for veterans and commoners. The Dijon pilgrimage demonstrated, moreover, how the representation of a deified Napoleon was not simply the idiosyncratic dream of a veteran soldier but was also a

vision that inspired provincial residents during the latter years of the July Monarchy.[18]

The compelling power of Napoleon's "presence" in popular prints and ephemera may help to explain the election of Louis-Napoleon Bonaparte to the presidency of the Second Republic on 15 December 1848. The popularity of Napoleon's nephew was the result of a convergence of publicity surrounding the emperor's nephew and popular traditions that preserved Napoleon's memory in rural regions of France. Louis-Napoleon's rise to power also reflected the merger of political bonapartism with socialist movements that emerged during the later years of the July Monarchy. After his failed coup of 1840, Louis-Napoleon was detained in France at the chateau of Ham. During his imprisonment,

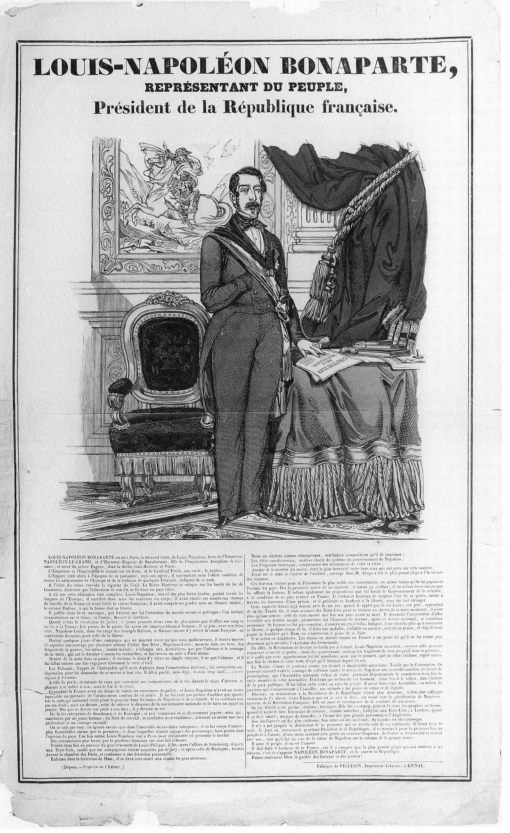

*Louis-Napoleon Bonaparte, Representative of the People, President of the French Republic* (1848), Pellerin, Epinal. Musée des Arts et Traditions Populaires, Paris. Photo by RMN.

he continued to write and receive visitors. His *Napoleonic Ideas* was directed primarily to a literate public, but *The Extinction of Pauperism*, originally appearing as a series of articles in *The Progress of the Pas-de-Calais*, was later reedited as a book that proposed state intervention to improve the condition of workers. The latter treatise became the basis for Napoleonic propaganda among the working and industrial classes prior to the presidential elections of 1848.[19] Beyond Louis-Napoleon's essays and writings, he engaged in very little political campaigning prior to his election. While urban regions were less enthusiastic, most rural areas gave Louis-Napoleon from 80 to 90 percent of the vote.[20]

The election results in rural France confirmed the vitality of a heroic myth sustained by textual and artistic representations of Napoleon. In 1848 rural electors envisioned release from tax collectors, notaries, privileged landowners, and state officials through the election of Louis-Napoleon. Having lost faith in the faltering Orleanist system, the French people redirected their faith toward a messianic figure whom they believed would release them from social injustice. This explains why regional residents cast their vote, not for the outmoded splendor of the Bourbon kings, nor the lackluster image of Louis-Philippe, but for the legendary memory of Napoleon I.

In the century that followed the French Revolution, representations of Napoleon Bonaparte became a powerful catalyst in the formation of the French nation. Broadside illustrations of Napoleon and his armies offered the French people a vision that generated aspirations for the renewal of French glory. Scenes of Napoleon's triumphs over members of the Quadruple alliance fueled continuing anger toward the monarchies that had defeated France in 1815 and continued to threaten French security in subsequent decades. In combining both the charisma of a military commander with the unassuming demeanor of the Little Corporal, popular illustrations of Napoleon elicited the allegiance of an emerging national constituency. The militant and democratic profile of the Little Corporal in the Pellerin broadsides furnished rural residents with political incentives to resist and eventually eliminate the French monarchy in favor of a second Napoleon.

# Notes

## INTRODUCTION

1. Dépôt légal, 8T 12 (1829–41), Archives Départementales des Vosges, Epinal. The Pellerin firm noted five thousand copies per run during the late Restoration and the early years of the July Monarchy.

2. For a more extensive presentation on this more traditional notion of popular art, see Pierre Louis-Duchartre and René Saulnier, *L'Imagerie populaire* (Paris: Librairie de France, 1925).

3. For the most classic discussion of popular literature in the Blue Library, see Geneviève Bollème, *La Bible bleue* (Paris: Flammarion, 1975); or her initial work on the subject, *La Bibliothèque bleue: La Littérature populaire en France du seizième au dix-neuvième siècles* (Paris: Collection Archives Nationales, 1971).

4. Roger Chartier, *Cultural History: Between Practices and Representations*, trans. Lydia G. Cochrane (Ithaca: Cornell University Press, 1988), 38.

5. Lisa Tickner, *The Spectacle of Women: Imagery of the Suffrage Campaign, 1907–1914* (London: Chatto and Windus, 1987), xi. Because both art and propaganda are intended to produce meanings, they cannot be addressed in different categories. The more important question is whose interests are served by any particular representation.

6. Keith Moxey, "Hieronymus Bosch and the 'World Upside Down': The Case of *The Garden of Earthly Delights*," in *Visual Culture*, ed. Norman Bryson, Michael Ann Holly, and Keith Moxey (Hanover and London: Wesleyan University Press, 1994), 107: "Instead of regarding the image as a finished product, that is a reflection of intellectual activity taking place in another sphere, the image will be regarded as part of a social process." See also Keith Moxey, *The Practice of Theory: Poststructuralism, Cultural Politics, and Art History* (Ithaca and London: Cornell University Press, 1994), 43.

7. Michael Marrinan, *Painting Politics for Louis-Philippe: Art and Ideology in Orleanist France, 1830–1848* (New Haven and London: Yale University Press, 1988), 150–53: Although Louis-Philippe mounted major Napoleonic battle scenes in the Versailles palace such as *The Battle of Aboukir*, he established a deliberate contrast between the ruthlessness of the Napoleonic era with the moderation and stability of his *juste milieu*.

8. See also Michael Driskel's analysis of Charlet's representation of Napoleon and the Napoleonic veteran in *As Befits a Legend: Building a Tomb for Napoleon, 1840–1861* (Kent Ohio: Kent State University Press), 32–33.

9. André-Jean Tudesq, *L'Élection présidentielle de Louis-Napoléon Bonaparte* (Paris: Armand Colin, 1965), 208. Paris and Lyon were the only exceptions, remaining firmly in the Bonapatist camp.

10. Maurice Agulhon, *The Republican Experiment, 1848–1852*, trans. Janet Lloyd (Cambridge: Cambridge University Press, 1983), 72; See also Tudesq, *L'Élection présidentielle de Louis-Napoléon Bonaparte*, 205–17.

11. Thomas Crow, *Painters and Public Life in Eighteenth-Century France* (New Haven and London: Yale University Press, 1985), 25: Crow points out how public involvement with the Salon during the eighteenth century furnished a means for criticism and opposition to the established regime. He describes how a "once disenfranchised audience begins to assume power using representation as an avenue for opposition."

## PROLOGUE: REPRESENTING THE LEGEND

1. Lynn Avery Hunt, *Politics, Culture and Class in the French Revolution* (Berkeley and Los Angeles: University of California Press, 1984). Hunt demonstrates how the revolutionary government endeavored to replace the symbolic role of the king—first with the symbols of Marianne (or liberty) and subsequently with the figure of Hercules—during the radical phase of the French Revolution

2. Marie-Madeleine Martin, *Histoire de l'unité française: L'Idée de la patrie en France des origines à nos jours* (Paris: Presses universitaires de France, 1982), 305: The French Revolution influenced the renunciation of traditional ties to the king, church, community, and family, but did not offer a meaningful alternative grounded in the genuine historical experiences of the French people.

3. Illustration by George Cruikshank found in *Life of Napoleon: A Poem in Fifteen Cantos*, by Dr. Syntax [William Comb], embellished with thirty engravings (London, 1817).

4. Beatrice Farwell, *French Popular Lithographic Imagery, 1815-1870* (Chicago: University of Chicago Press, 1981). Volume 8 from this collection, *Historicism and Exoticism*, includes a comprehensive selection of lithographic prints representing the Napoleonic legend.

5. Frédéric Masson put together an enormous collection of nineteenth-century art and ephemera about Napoleon that is currently located at the Fondation-Dosne Thiers, Bibliothèque Thiers in Paris. The collection includes items for the upper-middle classes such as lamps, dolls,

ink pots, statuettes, paintings, tobacco boxes, medallions, and less expensive merchandise such as pipes, suspenders, and kerchiefs that were accessible to less-monied classes.

6. Nina Maria Athanassoglou-Kallmyer, "Sad Cincinnatus: 'Le Soldat Laboreur' as an Image of the Napoleonic Veteran after the Empire," *Arts Magazine* 60 (May, 1986): 67.

7. Louis-Girard, *Les Libéraux français, 1814–1875* (Paris: Aubier, 1985), 96–99: Girard identified *Le Globe* as a key journal printed by Charles de Rémusat and his "brigade" of young intellectuals that after 1824 took issue with the Bourbon government through open discussions on literature, religion, and philosophy.

8. Richard Terdiman, *Discourse/Counter-Discourse: The Theory and Practice of Symbolic Resistance in Nineteenth-Century France* (Ithaca and London: Cornell University Press, 1985), 25, 343: Since culture is a field of struggle, symbolic and linguistic realms are characterized by conflict and contradiction. Terdiman points out how the struggle for the control of meaning is preeminent in languages of culture. While dominant discourses attempt to envelop and neutralize their antagonist, counterdiscourses seek to repudiate and replace dominant meanings with a freer and more democratic system.

9. Unless otherwise specified, the author is responsible for the English translation of all French documents used in the following study.

## CHAPTER 1. POLITICAL DISSENT AND THE NAPOLEONIC LEGEND

1. André Philippe, "Jean-Charles Pellerin poursuivi pour vente d'images séditieuses" in *La Révolution dans les Vosges* 17 (Epinal: Société anonyme de l'imprimerie Fricotel, 1927), 6: The black and white engravings found in Pellerin's office were entitled *Negotiations of the Emperors at Niemien, Napoleon in Berlin, Napoleon Receiving a Spanish Delegation,* and *The Baptism of Napoleon II (the Duke of Reichstadt).*

2. Ibid., 1–15: Pellerin was in a difficult spot during the transition in 1815 from the First Empire to the Restoration. He, like many other printers, was caught with a warehouse filled with texts and representations of the Imperial regime. Consequently, Pellerin tried to get rid of seditious illustrations of Napoleon by including them with regular orders of other prints made by his clients. The complaint of one such client led to a general police investigation in 1815 and a trial on 16 July 1816.

3. Jean-Marie Dumont, *Les Maîtres graveurs populaires* (Epinal: L'Imagerie Pellerin, 1965), 56: By not representing Napoleon Bonaparte in these illustrations of the Imperial army, the printer had hoped to escape censure.

4. In the Pellerin print ascribed to this period, Napoleon wore the uniform of a cavalry colonel in the Imperial Guard rather than the specific accoutrements of a general. In most Imperial and post-Imperial representations, Napoleon was portrayed either in the uniform of an infantry colonel or commander of the cavalry.

5. Dumont, *Les Maîtres graveurs populaires,* 57–59.

6. Charles Charton and Henri Lepage, *Le Départment des Vosges statistique, historique, et adminsitratif.* (Epinal: Gérard , Gley, 1845), 2:81–198. Epinal was never part of a large feudal estate. Although the Epinal family, who lived on an estate outside of the city, promised general feudal protec-

tions, the city was never under direct feudal jurisdiction.

7. Dépôt légale, 8T 12 (1825–40), Archives Départementales des Vosges. After the original design was cut into the wood, the woodblock could have been used many times. Depending upon their use, some woodblocks lasted from fifty to one hundred years.

8. Robert Justin Goldstein, *Political Censorship of the Arts and the Press in Nineteenth-Century Europe* (Basingstoke, Hampshire: Macmillan, 1989), 44: Copies of any noncensored paper had to be submitted to local censorship authorities either prior to, or at the time the paper was published. In this manner, the authorities could prevent its'distribution if the paper were considered objectionable.

9. Bernard Ménager, *Les Napoléon du peuple* (Paris: Aubier, 1988), 67.

10. Jean Tulard, *Le Mythe de Napoléon* (Paris: Armand Colin, 1971), 36–37: Apparently, many different groups from different cultural levels read the *Bulletins of the Great Army.* These included bourgeois, petit bourgeois, Salon guests, and sons of Imperial veterans such as Victor Hugo, Alexander Dumas, and Gérard de Nerval.

11. Tulard, *Le Mythe de Napoléon,* 35.

12. Jacques-Louis David enjoyed preeminence during the Empire, not only as the first painter in the Imperial court, but also as the founder of an international studio with a prominent and extensive following. Notable artists who studied with David include François Gérard, Antoine-Jean Gros, and Jean-Auguste-Dominique Ingres.

13. Antoine Schnapper, *David* (New York: Alpine Fine Arts Collection, 1982), 220–42: David began his first painting of the *sacre* showing Napoleon placing the Imperial crown on his own head while the pope sat as a passive witness behind the imperious Bonaparte. But the final version begun in 1805 and completed in 1808 describes Napoleon crowning Josephine. The official canvas also presented a striking panorama of Napoleon's family, the ecclesiastical entourage, and court attendants seen from the cardinals' gallery in the front row.

14. For a better understanding of how precisely Napoleon used art to manipulate the viewer's response, see the provocative exegesis of the Battle of Eylau and Marengo by Michael Marrinan, "Literal/Literary/'Lexi': History, Text, and Authority in Napoleonic Painting," *Word and Image* 7, no. 3 (July–September 1991): 177–99.

15. In *Dix ans d'exile* (1818) and *Considérations sur la révolution française,* Mme Germaine de Staël attacks Bonaparte for his ruthlessness and lack of principle. Chateaubriand questions Bonaparte's legitimacy and autocratic conduct in the brochure "De Buonaparte et des Bourbons" (1814) and in his *Mémoires d'outre-tombe.* Raised with strong legitimist ideas, Lamartine questioned Bonaparte in several of his earlier prose pieces such as "Manuscrit de ma mére" (1814) and the poem "Bonaparte" (1820) in his *Nouvelles Méditations.* In his *Journal d'un poète* (1830–47), Vigny remained firmly at odds with the Napoleonic myth during his artistic and political career. Vigny could never condone Napoleon's deceptiveness or lack of genuine humanity.

16. Count Emmanuel Dieudonné de las Cases, *Mémorial de Sainte-Hélène: Journal de la vie privée et des conversations de l'empereur Napoléon à Sainte Hélène* (London: Colburn, 1823); Barry E. O'Meara, *Napoléon en exile* (London: W. Simpkin and R. Marshall, 1822); Count Charles Jean Tristan de Montholon, *History of the Captivity of Napoleon at Saint Helena* (London: H. Colburn, 1846–47); F. Antommarchi, *Les Derniers Moments de Napoléon, 1819–21* (Paris, 1825); Général

Gaspard Gourgaud, *Sainte Hélène: Journal inédit*, (1815–18) (Paris: E. Flammarion, 1899) or *Talks of Napoleon at Saint Helena with Général Baron Gourgaud* (Chicago: A. C. McClurg, 1903). Henri Gratien Bertrand's *Cahiers de Sainte Hélène* were not fully edited and published until 1951–59 in Paris by Paul Fleuriot de Langle.

17. Las Cases, Gourgaud, Montholon, Bertrand *Napoleon à St. Hélène*, ed. Jean Tulard, Vol. 2, (Paris; Laffont, 1981), 474–75. The author describes Napoleon's suffering, particularly under the surveillance of Governor Hudson Lowe: "The remainder of Napoleon's life would be only a long and cruel agony. He [Hudson Lowe] prescribed the most outrageous restrictions for the emperor. He severely limited Napoleon's personal domain, and arbitrarily circumscribed his travels (about the island), and even tried to control the content and extent of the emperor's conversations."

18. The memoirs of Napoleon's experiences on St. Helena by Las Cases received unusual acclaim when they were published in Paris in 1823, two years after the death of the exiled leader, and were followed later by translations in Dutch, German, and English.

19. Las Cases, *Napoléon à St. Hélène* (1981) 233: "Alors toutes les classes des citoyens, toutes les factions auraient vu avec plaisir dans Napoléon un ancre de salut, un point de ralliement, seul propre à sauver tout à la fois de la terreur royale et de la terreur démogagogique."

20. Ibid., 104: "On eut voulu que j'eusse été Washington. . . . Je ne pouvait être qu'un Washington couronné."

21. Ibid., 219: "J'ai fait tout au monde pour accorder tous les partis: je vous ai réunis dans les mêmes appartements, fait manger aux mêmes tables, boire dans les mêmes coupes; votre union a été l'objet de mes soins."

22. *Manuscrit venue de Sainte Hélène d'une mannière inconnue*, ed. Jean Rumilly (Paris: Horizons de France, 1947), 105–58: Considerable controversy surrounded the authorship of this work. While some predictably attributed it to Bonaparte or his companions on St. Helena, others suggested the liberal leader Benjamin Constant. Some even believed it was a subtle parody by Mme de Staël. Not until 1841 did Frederic-Jacob Lullin de Chateauvieux, a Swiss devotee of Bonaparte, confess to having authored the *Manuscrit*.

23. *Manuscrit venu de Sainte Hélène d'une mannière inconnu* (Paris: Gallimard, 1974), 126–27: "je me battais pour les détruire, et pour faire du neuf. C'était la conséquence inévitable d'un passage d'un système sociale à un autre."

24. Ibid., 75: "La forme républicaine ne pouvait plus durer parce-ce que on ne fait pas de républiques avec de vielles monarchies."

25. Ibid., 42: "C'est à dire qu'il fallait y détruire l'ancien régime pour y établir l'égalité parce qu'elle est la cheville ouvrière de la Révolution."

26. Ibid., 77: "Mais dans cette nation tous étaient également appelés aux fonctions publiques. Le point de départ n'était un obstacle pour personne. Le mouvement ascendant était universel dans l'état. Ce mouvement a fait ma force."

27. Ibid., 93: "Je donnai ainsi pour ressort à l'empire un lien général. Il unissait par leurs intérêts toutes les classes de la nation, parce que aucune n'était subordonnée ni exclue."

28. Alan Spitzer, *The French Generation of 1820* (Princeton: Princeton University Press, 1987), 186: "Victor Cousin's appeal to an emerging generation as the last best hope of a suffering nation, Jouffroy's eulogy for the predestined apostles of a new era, or the St. Simonian summons to the 'génération actuelle' to prepare the organization of a new social system articulated the widespread conviction that a unique destiny was not the product of some inborn merit, but of history, above all of the gigantic historical divide of the revolution."

29. Ibid, 35–70, 171–205, 265–66.

30. Athanassaglou-Kallmyer, "Sad Cincinnatus," According to Kallmyer, "Farming was the only occupation permitted since it was an innocuous way to supplement their pension."

31. Nina Maria Athanassoglou-Kallmyer, *Eugene Delacroix: Prints, Politics, and Satire, 1814–1822* (New Haven: Yale University Press, 1991), 5: Based on an ordinance passed in July 1815, the Bourbon government disbanded most of the Imperial Army that had supported Napoleon during the Hundred Days. The next year, the government attempted to cut back and purge the army of dissident elements who remained loyal to Bonaparte. "By 1816, the army which in its heyday comprised about 500,000 was reduced to a minimum of 150,000. More than 300,000 soldiers were sent home and restituted to their previous existence, primarily as peasants in rural regions." Concurrently, numerous officers were placed on inactive duty as *demi-solde* pensioners.

32. *Les Cahiers du Capitaine Coignet*, ed. Jean Mistler (Paris: Hachette, 1968), 313–54.

33. Jean-Baptiste Barrès, *Memoirs of a Napoleonic Officer*, ed. Maurice Barrès, trans. Bernard Miell (London: Greenhill Books, 1988), 93.

34. Ibid., 74 "Un de nous prit une poignée de paille et l'alluma pour faciliter sa lecture. De notre bivouac il fut à un autre. On le suivit avec des torches alumées en criant: 'Vive l'Empereur.' Ces cris d'amour et d'enthousiasme se propagèrent dans toutes les directions comme un feu électrique."

35. *Cahiers du Capitaine Coignet*, 47: "il parait . . . il était à pied. Il avait un petit chapeau et une petite épée. Il monte les degrés seul, et tout d'un coup, nous entendons des cris et Bonaparte de sortir et de tirer sa petite épée.

36. Adrian Jean-Baptiste François Bourgogne, *Memoirs of Sergeant Bourgogne*, ed. Paul Cottin (New York: Doubleday and McClure Co., 1899), 193.

37. That popular stories about Napoleon developed from traditions attributed to veterans of the Imperial armies is the most widely accepted explanation for the origins of the popular legend. Jean-Lucas Dubreton in *Le Culte de Napoléon, 1815–1848* (Paris: Editions Albin Michel, 1960), Jules Dechamps in *Sur la légende de Napoléon* (Paris: Librairie Ancienne Honor Champion, *1931*) and Jean Tulard in *Le Mythe de Napoléon* (Paris: Armand Colin, 1971) contended that veterans of the Great Army preserved and elaborated memories of their war experiences in the form of oral fragments and tales, shared in cabarets and bistros, that were later refined into poetry, prose, and visual images by educated artists and writers. In contrast with this more popular interpretation, Isser Woloch in *The French Veteran from the Revolution to the Restoration* (Chapel Hill: University of North Carolina Press, 1979) and Jean Vidalenc in *Les Demi-soldes* (Paris: Librairie Marcel Rivière et Cie, 1955), concluded that most pensioners during the Restoration were motivated more by self-interest and the desire to return to active service than by romantic allegiance to the former emperor.

38. Touchard, *La Gloire de Béranger* (Paris: Librairie Ar-

mand Colin, 1968), 1:203–4: In 1818 there were around three hundred *goguettes* in Paris, while in 1836 there were at least five hundred. The names of most famous *goguettes*—such as Les Francs-Gaillards, Les Braillards, Les Bons Enfants, and Les Grognards—reveal the Rabelaisian quality of these gatherings. Because of political suspicions during the Restoration, no more than twenty people were allowed to assemble for an evening meal and subsequent revelry.

39. Ibid., 203–4: Débraux's songs were similar to those of the famous Béranger, but most of Débraux's compositions were written earlier. Even before Béranger had written "Le Vieux Drapeau" (1820), Débraux had composed "La Mort de Brune" (1815), "T'en Souviens-tu" (1817), and "La Colonne" (1818). Subsequently, Débraux became famous for "Sainte Hélène" (1821), "Comment L'oublier" (1821), "Bertrand au Tomberau de Napoléon," "Les Cinqs Fleurs," and "La Redingote Grise."

40. Dubreton, *Le Culte de Napoléon*, 238–39: A collection of popular songs by Béranger published in 1821 sold eleven thousand copies in one week.

41. Athanassaglou-Kallmyer, "Sad Cincinnatus," 67: According to Kallmyer, artists portrayed the Imperial veteran in a rural setting and described him as a loyal and peace-loving citizen to assuage the suspicions of Bourbon authorities. Representations of the solider-farmer recalled the classical story of Cincinnatus, the Roman general who preferred farming to war, but who left his beloved fields to serve his country.

42. Pierre-Jean de Béranger, "Le Vieux Sergent" (1823), in *Oeuvres complètes* (Paris: Fournier, 1834), 3:59.

43. Béranger, "Le Vieux Drapeau" (1821), in *Oeuvres complètes* 2:26.

44. Ibid., 26.

45. Béranger, "Les Souvenirs du peuple" (1828), in *Oeuvres complètes* 3:216.

46. Ibid. 217, "Ma douleur fut bien amère, Fut bien amère."

47. Touchard, *La Gloire de Béranger*, vol. 1: 437: Béranger's political ideas corresponded with the liberal perspective conveyed by the *National*, the *Constitutional*, the *Globe*, the *Figaro*, and the *Courrier français*."

48. Ibid., 413.

49. Ibid., 436.

50. Ménager, *Les Napoléon du peuple*, 42: According to Ménager, the "good bourgeois" citizen did not participate in seditious shouts during the Bourbon Restoration, nor did many peasants. Most cries and seditious signs came from artisans and workers, with evidence of sporadic involvement from soldiers and pensioners.

51. Ibid., 21, 66: Nonetheless, popular forms of political rhetoric did not exist in a vacuum. In many cases the level of seditious behavior corresponded with a change in national politics such as the deaths of Napoleon and the Duke of Berry in 1821, or the rise and fall of liberal political power in the French Chamber of Deputies.

52. Ibid., 21: Faith in Napoleon's return repeated itself cyclically in the form of seditious shouts and symbolic activities. Police files revealed an increase in seditious activity in the springtime with the renewal of warmer weather.

53. "Cris et placards séditieux," March 1827, BB 18/ 1147, Archives Nationales, Paris.

54. "Cris et placards séditieux," March 1827, BB 18/ 1147, Archives Nationales, Paris.

55. "Cris et placards séditieux," May 1827, BB 18/1148, Archives Nationales, Paris.

56. "Cris et placards séditieux," October 1828, BB 18/ 1164, Archives Nationales, Paris.

57. "Cris et placards séditieux," November 1828, BB 18/ 1165, Archives Nationales, Paris.

58. "Cris et placards séditieux," July 1828, BB 18/1170, Archives Nationales, Paris.

59. Ménager, *Les Napoléon du peuple*, 67–69.

60. "Cris et placards séditieux," September 1827, BB 18/ 1152, Archives Nationales, Paris.

61. "Cris et placards séditieux," June 1828, BB 18/1162, Archives Nationales, Paris.

62. "Cris et placards séditieux," February 1829, BB 18/ 1168, Archives Nationales, Paris.

63. "Cris et placards séditieux," April 1826, BB 18/1137, Archives Nationales, Paris.

64. "Cris et placards séditieux," March 1826, BB 18/ 1136, Archives Nationales, Paris.

65. "Cris et placards séditieux," October 1828, BB 18/ 1166, Archives Nationales, Paris.

66. "Cris et placards séditieux," February 1829, BB 18/ 1170, Archives Nationales, Paris.

67. "Cris et placards séditieux," May 1829, BB 18/1171, Archives Nationales, Paris.

68. "Cris et placards séditieux," September 1829, BB 18/ 1179, Archives Nationales, Paris.

69. "Cris et placards séditieux," July 1829, BB 18/1174, Archives Nationales, Paris. The prefect of Montbéliard feared that these antics could lead to more serious political trouble.

70. "Cris et placards séditieux," April 1828, BB 18/1160, Archives Nationales, Paris.

71. "Cris et placards séditieux," November 1829, BB 18/ 1176, Archives Nationales, Paris.

72. "Cris et placards séditieux," October 1829, BB 18/ 1175, Archives Nationales, Paris.

73. Prefect of Paris to the minister of interior, "Objets et desseins séditieux saisis à Paris." July 1828, F7/6706, Archives Nationales, Paris.

74. Minister of interior to the prefect of Paris "Objets et desseins saisis à Paris," July 1828, F7/6706, Archives Nationales, Paris.

75. "Objets ou desseins saisis à Paris," August 1828, F7/6706, Archives Nationales, Paris.

76. "Objets et desseins séditieux saisis à Paris," 3 April 1829, BB 18/1170, Archives Nationales, Paris.

77. "Objets séditieux saisis à Paris," November 1827, F7/6706, Archives Nationales, Paris.

78. "Objets séditieux saisis des colporteurs" from the Gironde (Bordeaux) March 1827, F7/26, Archives Nationales, Paris: The prefect of Bordeaux said that gold pins with representations of Bonaparte and his son were being marketed by jewelers in the capital of the Gironde.

79. "Cris et placards séditieux," October 1827, BB 18/ 1145, Archives Nationales, Paris.

80. "Cris et placards séditieux," 4 May 1829, BB 18/1171, Archives Nationales, Paris.

81. "Émeutes" (1829–30), BB 18/1171, Archives Nationales, Paris: An enormous file in the Archives Nationales describes revolts that multiplied throughout France during this period. Such revolts were attributed to the dearth and high price of grain as well as to indirect taxes that were so greatly resented by provincial farmers. See also: *Tribune des départements* (July 1829), microfilm 140, Salle des Périodiques, Bibliothèque Nationale, Paris: Taxes on salt, wine, and tobacco were particularly hated by small farmers.

82. The *Tribune des départements* 3 (10 June 1829), micro 130, Salle des Périodiques, Bibliothèque Nationale, Paris: "Les petits propriétaires et surtout des ouvriers ont beaucoup à souffrir de la cherté des céréales. Des troupes de mendiants se formaient encore sans la charité de beaucoup des cultivateurs. Des vols et des menaces d'incendie ne peuvent être évidemment attribués qu'au désespoir de ces malheureux sans ouvrages et sans pain."

## CHAPTER 2. THE PELLERIN FIRM AND POLITICAL CENSORSHIP

1. Mayor of Epinal to the prefect, Baron Simeon, January 1832, 9bis M6, Archives Départementales des Vosges: "among the most important industries in Epinal is a publishing house which specializes in imagery, small books of prayer, canticles, playing cards, and employs approximately fifty workers a day."

2. Dumont, *Les Maîtres graveurs* populaires 53–54.

3. [Jules-François Felix Husson] Champfleury, *Histoire de l'imagerie populaire* (Paris: E. Dentu, 1869), xi: Print collectors disdained the popular wood-block print in mid-nineteenth-century France. They claimed that the brilliant colors found in such prints corresponded with the rougher nature and tastes of the peasantry.

4. This term refers to the cheapness and accessibility of Epinal prints in French tradition.

5. Frédéric Bluche, *Le Bonapartisme* (Paris: Presses universitaires de France, 1981), 42: The patriotic provinces of the Northeast—Champagne, Lorraine, Alsace—were the locus for the development of the Napoleonic legend, taking form initially as a cultural rather than a strictly political expression of bonapartism.

6. Edgar Gazin, "Moeurs, traditions, légendes dans le département des Vosges," in *Le Département des Vosges*, ed. Léon Louis-(Epinal: Léon Louis, 1889), 4:550–51.

7. Duchartre and Saulnier, *L'Imagerie populaire*, 60.

8. François Lotz, *Les Petits Soldats d'Alsace* (Strasbourg: Editions des dernières nouvelles d'Alsace, 1977), 12: The first type of military art was printed in black and white, to be later colored by hand; after 1845, such images were printed in color, later to be cut with scissors, attached to cardboard, and then mounted on small pedestals to create representations of military reviews or campaigns.

9. François Roth, "Nation, armée, politique à travers les images d'Epinal, *Annales de l'Est*, 32, no. 3 (1980): 195–213. The courageous soldier was a model type in Epinal art from the First Empire well into the Third Republic. Military themes became particularly pertinent after the loss of Alsace-Lorraine in the Franco-Prussian War.

10. Adolphe Aynaud, "Notes sur l'imagerie de Nancy," in *Le Vieux Papier* (Paris, 1957), 1–7.

11. "Brevet des imprimeurs," F 18/2003, Archives Nationales, Département de la Meurthe et Moselle, Paris: Dembour wanted to create an art that was more indigenous to the region of Alsace. He established the engraving firm Dembours in 1833, and in 1840 he began a printing and publishing enterprise with his partner Gangel.

12. Adolphe Aynaud, "L'imagier inconnu de Metz [Jean Wëndling]," in *Le Vieux Papier* (Paris, 1954), 1–11.

13. Duchartre and Saulnier, *L'Imagerie populaire*, 28–29: According to Duchartre and Saulnier, in comparison with other regional printers of popular art, "Pellerin finit par rester seul maître du terrain." [Pellerin ended up the single master in his field.]

14. Much of the biographical material concerning the founder of the Pellerin printing firm came from the excellent monograph written by Jean-Marie Dumont, former archivist of the Vosges, entitled *La Vie et l'oeuvre de Jean-Charles Pellerin, 1756–1836* (Epinal: l'Imagerie Pellerin, 1956).

15. Ibid., 41: During the Restoration, Pellerin indicated that he would duplicate most broadsides, or *canards*, at the rate of 3,000–4,000 copies per original; however, if a sensational event should attract a larger audience, he would publish from 10,000 to 16,000 copies per sheet.

16. Ibid., 43:

17. Ibid., 38: Jean-Marie Dumont disagreed with the early-nineteenth-century archivist of the Vosges, André Philippe, who maintained that Jean-Charles Pellerin began printing imagery after 1800. After a careful examination of the following prints, Dumont affirmed that Pellerin began printing popular imagery in the eighteenth century, most likely prior to and during the French Revolution. According to Dumont, the following religious images were designed and cut by Jean-Charles Pellerin: *Notre Dame des hermittes, St. Nicholas*, and a number of humorous cartoons such as *La Grande querelle entre le mari et l'espouse à qui portera la culotte, Le Grand diable d'argent, Le Barque à Caron*, plus several illustrations of tales from the Blue Library such as the *Adolescence de Paul et Virginie*, and, finally, *Le Départ et le retour du soldat*, which was signed by Pellerin during the Consulate.

18. René Perrout, *Les Images d'Epinal* (Paris: Paul Ollendorff, n.d.), 89.

19. André Philippe, "Les Débuts de l'imagerie populaire à Epinal: Les Images Napoléoniennes de Jean-Charles Pellerin, 1810–1815," in *L'Art populaire en France* (Paris: Librairie Istra, 1929), 67.

20. Perrout, *Les Images d'Epinal*, 89.

21. According to former archivist of the Vosges, Jean-Marie Dumont, most of the primary documents for the Pellerin firm or records kept by the founder were burned in a fire in the Pellerin warehouse in 1889.

22. Dumont, *La Vie et l'oeuvre de Jean-Charles Pellerin*, 20: After the death of Pellerin's first wife in 1789, a notarial inventory consisting of oak furniture, a china service, crystal, his wife's jewelry, and a well-stocked wine cellar indicated that the printer lived in very comfortable circumstances.

23. Ibid., 23–27.

24. Ibid., 27: While Pellerin supported the establishment of a constitutional government in France, the printer stepped down from public office after the radical republican government had suspended the king's authority and imprisoned the monarch in the fall of 1792.

25. Ibid., 29.

26. Ibid., 32.

27. Ibid., 28.

28. Jean-André Faucher, *Les Francs-maçons et le pouvoir: De la révolution à nos jours* (Paris: A. Perrin, 1986), 72–73, 75–76: During the First Empire through the Restoration, the Great Orient tried unsuccessfully to encourage local lodges to separate Masonry from political involvement. Despite this policy, many Masonic lodges, particularly in northeastern France, were influenced by liberal and bonapartist ideologies through their association with militant carbonari groups that had tried to engineer a republican insurrection against the Bourbon government in December 1821. More-

over, lodges led by younger members in Paris such as Les Amis de la verité and La Parfaite union in Epinal took a liberal and antiauthoritarian stance, particularly during heated political debates in the latter years of the Restoration.

29. Dumont, *La Vie et l'oeuvre de Jean-Charles Pellerin* 32: Despite Pellerin's usually serious demeanor, the Epinal printer enjoyed the charade and refused to reveal his true identity.

30. Dépôt légale, 8T11 (1810–27), Archives Départementales des Vosges. Among 600 pamphlet titles attributed to the Pellerin publishers during the First Empire, 40 were fairy tales, and over 150 referred to religious and devotional works.

31. Guillaume de Bertier de Sauvigny, *The Bourbon Restoration*, trans. Lynn M. Case (Philadelphia: University of Pennsylvania Press, 1966), 302: On 5 October 1814, an ordinance was passed that allowed Catholic bishops to open an ecclesiastical school in each department. Observance of the Sabbath and holy days was made mandatory by the government, and Napoleon's Concordat with the Catholic Church was abrogated and replaced by the earlier Concordat of 1516.

32. Dépôt Légale, 8T 10–11, Archives Départementales des Vosges.

33. Philippe, "Jean-Charles Pellerin poursuivi pour vente d'images séditieuses" 4:15. With the fall of the empire and the return of the Bourbons after Napoleon's Hundred Days in power, censorship was reestablished. A law in November 1815 prescribed severe penalties for any action, speech, or type of propaganda that could be considered hostile to the Bourbon monarchy. This included any portrait or symbol of Napoleon in power, such as the laurel wreath or the letter *N*.

34. Dubreton, *Le Culte de Napoléon*, 243.

35. "Surveillance de colportage" (1815), IZ5/18, Archives Départementales des Vosges, Epinal.

36. Dumont, *La Vie et l'oeuvre de Jean-Charles Pellerin*, 55.

37. Virginia Chesquière was a fictional woman soldier whom Napoleon recognized for her bravery in battle.

38. Dumont, *La Vie et l'oeuvre de Jean-Charles Pellerin*, 5.
39. *Ibid.*, 59.

40. André Philippe, *"Les Débuts de l'imagerie populaire à Epinal: Les Images Napoléoniennes de Jean-Charles Pellerin, 1810–1815, 164:* In addition to evidence proferred by M. Thierry from Châlons-sur-Saône, images of Napoleon and the Imperial Army were also confiscated chez Méjét in Rambervillers, chez Gorillot in Arras, chez Caron-Vitel in Amiens, chez Voisain in Besançon, chez Bardin-Patenôtre, chez Veuve André in Troyes, and chez Riboulon of Annonay.

41. Philippe, *"Jean-Charles Pellerin poursuivi pour vente des images séditieuses,"* 8.

42. Dumont, *La Vie et l'oeuvre de Jean-Charles Pellerin*, 60.

43. *Ibid.*, 60. "Je vous transmets ci-joint un exemplaire ayant pour titre la *Retraite de Moscou et* et paraissant être sortie de l'imprimerie du sieur Pellerin, imprimeur-libraire à Epinal. Suivant l'avis anonyme que vous trouverez au dos de l'estampe, le sieur Pellerin la ferait répandre aujourd'hui avec profusion et gratuitement dans les campagnes. Je vous prie de faire vérifier jusqu'à quel point cet avis peut être fondé et de me communiquer les résultats des informations."

44. *Ibid.*, 61: Prefect of the Vosges to the director-general of police, 11 June 1821: "Mais s'il était vrai, comme

on l'annonce dans l'avis anonyme que vous m'avez transmis, que cet ouvrage fut répandu gratuitement soit par le sieur Pellerin . . . soit par tout autre, alors on ne pourrait certainement voir dans ce fait qu'une intention coupable. (Ce serait de la part du sieur Pellerin une chose bien étrange et qui ne peut se présumer d'après son caractère. Les opinions qu'il professe sont celles, je le crois, d'un ami de l'ordre). Je n'ai à cet égard aucun renseignement; rien jusqu'ici au surplus, ne me donne lieu de croire que l'estampe qui vous a été signalée ait pu attirer l'attention d'un maire particulier dans le département."

45. *Ibid.*, 62: "Cette gravure n'a été distribuée sur aucun point de cet arrondissement et que si elle l'a été, ce n'a pu être qu'à des individus qui la conservent religieusement dans le secret de la maison, mais non avec une profusion qui auroit rendu la distribution publique."

46. Jean-Charles Pellerin to the Viscount Martignac, minister of interior. 23 October 1822, "Dossier des brevetés," F18/2111, Archives Nationales, Paris.

47. Dumont, *La Vie et l'oeuvre de Jean-Charles Pellerin*, 66: Though Pellerin had formally transferred the business to his son in December 1822, the founder had not received approval from the minister of interior.

48. minister of interior to the prefect of Epinal, April 1823, "Dossier des brevetés," F18/2111, Archives Nationales, Paris: "Le sieur Pellerin appartient à une famille qui n'a point de principes religieux et dont la conduite dans la révolution n'a pas été bonne. De plus on le croit franc-maçon ainsi que son père. En résultat on ne pense pas que cet homme soit digne de la confiance du gouvernement et tout porte à croire que s'il avait un brevet, il imprimerait volontiers toute espéce d'ouvrages dirigés contre la Religion et le Roi."

49. Prefect of Epinal to the minister of interior, 2 June 1828, "Dossier des brevetés," F18/2111, Archives Nationales, Paris: "Le sieur Pellerin fils n'a jusqu'ici donné lieu à aucune plainte par sa conduite morale . . . qu'il dirige depuis plusieurs années les deux établissements de son père et qu'il parait posséder la capacité nécessaire pour l'exercice de la double profession d'imprimeur et de libraire."

50. Printing license of Nicholas Pellerin, 12 June 1828, "Dossier des brevetés," F18/2111, Archives Nationales, Paris.

51. Dumont, *La Vie et l'oeuvre de Jean-Charles Pellerin*, 22: There are only a few other references to Nicholas in the archives. On 31 August 1826, the Pellerin heir married Anne-Marguerite Villemin, the daughter of an elector and an established bourgeois from Epinal. And on 17 December 1827, Nicholas recorded the birth of his first son in the local *états civils*.

52. *Ibid.*, 57: since Marguerite had framed portraits of Napoleon I hanging in her bedroom during the censorship investigation of the Pellerin firm, it is likely that Vadet and Mlle Pellerin shared a similar political passion.

53. For further information on Vadet see Jean Bossu, *Les Origines de la Franc-Maçonnerie dans les Vosges*, Deuxième Partie (St. Die: Thouvenin, 1953) 26; See also Dumont, *Les Maîtres graveurs populaires*, 3, 8, 26.

54. Text beneath *la Bataille d'Esling-mort de Montebello* (1829), Pellerin, Georgin, Epinal: "Le 22 mai, à 7 heures du matin, le Duc de Montebello reçoit l'ordre de traverser l'Armée autrichienne par le centre pour la partager. Elle fait de vains efforts pour arrêter les colonnes françaises, sa ligne est partout rompue, et déjà elle est en retraite. Mais

tout à coup on vient apprendre que les ponts de bateaux, jetés sur le Danube, ont été emportés. Les Français victorieux s'arrêtent et se replient lentement. L'ennemi se reforme et reprend l'offensive. Privés de munitions qui ne peuvent plus être renouvelées, nos troupes repoussent à la baïonnette les attaques d'un ennemi devenu audacieux par l'espoir du succès. Le village d'Esling est pris et repris jusqu'à treize fois. Dans ce moment intrépide, Lannes à la tête de ses Braves, est frappé au genou d'un boulet. Les Français reprennent leur position de la veille et présentent à l'ennemi 'un mur du granit' qu'il n'ose pas attaquer. . . ."

55. Bossu, *Les Origines de la Franc-Maçonnerie dans les Vosges*, 28–30.

56. Ibid., 30: In 1828, three electors from the lodge—Mougeot, Sebastien Deblaye, and J. Genin—initiated a circular against the authoritarian policies of the Restoration government.

57. Nicholas Pellerin to the prefect of Epinal, 28 October 1828, 9 bis M14, Archives Départementales des Vosges: "J'ai déposé au secrétariat général les épreuves des deux estampes ayant pour titres Ste. Marie, l'Egyptienne, et Napoléon . . . la seconde ne m'est pas encore parvenue. . . . Napoléon appartenant maintenant à l'histoire, on publie tous les jours, dans la capitale et les départements des ouvrages et des gravures qui le concernent, sans aucune entrave des autorités. Soyez assuré, M. le préfet, que cette estampe ne porte aucun caractère séditieux et que je me suis déterminé à la publier."

58. Dumont, *Les Maîtres graveurs populaires*, 56–57.

59. Prefect of Epinal to the minister of interior, 4 June 1829, 9bis M 14 (1828), Archives Départementales des Vosges. "aujourd'hui, Le Sieur Pellerin qui annonce les avoir fidèlement suivies, réclame contre cette mesure, en exposant que la vente de la même estampe a été autorisée dans d'autres départements et notamment dans celui de la Meurthe ou il parait que la loi qui la prohibe serait tombée en désuétude; que beaucoup de marchands lui en avait demandé des exemplaires—qui'il leur a refusés; qui'ils se les sont procurés ailleurs et qu'il en est résulté pour lui un dommage considérable."

60. Minister of the interior to the prefect of the Vosges, 15 June 1829, 9bis M14, Archives Départementales des Vosges: "C'est précisément parce que cette estampe pouvait être distribuée à un grand nombre d'exemplaires, à cause de la modicité de son prix, que je n'ai pas cru l'autoriser. Si ces graveurs semblables ont été approuvés dans d'autres départements, c'est un tort qui a eu l'autorité"

61. Prefect of Epinal to Nicholas Pellerin, 24 June 1829, 9bis M14, Archives Départementales des Vosges, This letter underlined the minister's unequivocal refusal: "il n'y a pas lieu d'autoriser une publication défendue par la loi du 25 mars 1822.

62. *Napoleon le grand* was undoubtedly the image that Pellerin and Vadet had intended to publish during the Restoration (1829). According to Nicole Garnier and Maxine Préaud in *Catalogue complète de l'imagerie d'Epinal* (Paris: Rénion des Musées Nationaux, Bibliothéque Nationale, de France 1996), the print was approved for publication on 6 September 1830 during the relaxation of censorship immediately following Louis-Philippe's accession to the throne.

## CHAPTER 3. CREATING THE POPULAR IMAGE

1. Sauvigny, *The Bourbon Restoration*, 447.

2. David Pinkney, *The French Revolution of 1830* (Princeton: Princeton University Press, 1972), 146. Thiers presented a petition to the wife and sister of the Duke of Orleans, requesting their support in the establishment of a constitutional system. Mme Adelaide, sister of the duke, accepted Thiers's proposal on behalf of her brother.

3. Ibid., 161.

4. Pamela Pilbeam, *The 1830 Revolution in France* (New York: St. Martin's Press, 1991), 83. Note Louis-Philippe's oath of office (quoted in Pilbeam): "I swear faithfully to observe the Constitutional Charter, to govern with and by the law, to dispense justice to all and to have as my sole guide the interests and well-being of the French people."

5. Ibid., 194.

6. Marrinan, *Painting Politics for Louis-Philippe*, 153. Louis-Philippe mounted paintings at the palace of Versailles to emphasize the violent and despotic nature of the Napoleonic era compared with the more sanguine alternative of stability and peace under his constitutional system.

7. René Rémond, *Le Droite en France de la première restauration à nos jours* vol. 1 (Paris: Aubier, Éditions Montaigne, 1968), 7. According to Rémond, in contrast with their sentiments regarding the Napoleonic era, French people perceived the Orleanist regime "sans idéal, sans convictions, et sans grandeur."

8. John Graham, *Lavater's Essays on Physiognomy: A Study in the History of Ideas* (Berne, Frankfurt, and Las Vegas: Peter Lang, 1979), 24. Graham includes illustrations of two Greek warriors from Lavater's *Essays on Physiognomy*. In describing the nobility and purity of the Greek profile, Lavater points out: "je leur trouve une mâle énergie, un esprit ferme et tranquille." [I find a masculine energy in them, a spirit (that is) steadfast and serene] Lavater's notions about the connection between physiognomy and character undoubtedly influenced the aquiline profile used to emphasize Bonaparte's firmness and courage in engravings from the Restoration and July Monarchy.

9. Robert Rosenblum, *Transformations in Late-Eighteenth-Century Art* (Princeton: Princeton University Press, 1969), 21–22.

10. In tracing Bonaparte's silhouette, the child mimics the process of silhouette portraiture that was so fashionable during the late-eighteenth and early-nineteenth centuries.

11. Pilbeam, *The Revolution of 1830*, 94. Freedom of the press was unequivocally established by the July constitution: "Censorship will never be re-established." During the first year of the Orleanist regime, the press and printing industry enjoyed relative license. However, by 1831, the Orleanist regime began to enforce increasingly severe censorship restrictions.

12. Richard R. Brettell, *French Salon Artists, 1800–1900* (New York: H. N. Abrams, 1987), 3: "At its simplest level, the Salon was a state-sponsored exhibition of contemporary art in all major media—painting, sculpture, graphic arts, photography and architecture—chosen by a jury of artists, which was selected in a manner approved of by the government." Sponsored by the Royal Academy of the Fine Arts in Paris, the Salon was first inaugurated in 1667 to exhibit the work of its members. By the nineteenth century, however, the Salon featured the work of a broad spectrum of artists from both France and other European countries. While exhibitions were held biennially at the beginning of the century, by the July Monarchy the Salon was an annual media event that assured French precedence in the arts.

13. Ménager, *Les Napoléon du peuple*, 81: According to Ménager, some ninety-seven plays about Bonaparte were

mounted on the Parisian stage between 1830 and 1840.

14. Each writer recorded aspects of French history and the French Revolution that most suited his own particular political perspective. While Guizot wrote his *Considerations on the History of France from the Earliest Times until 1848* emphasizing the constitutional phase of the Revolution of 1789, Lamartine focused on the middle road of the Gironde party in his *History of the Girondists*, while Adolphe Thiers elaborated and praised the more radical aspects of the revolution in his *History of the French Revolution*.

15. Dumont, *Les Maîtres graveurs populaires*, 29. Nicholas, the eldest son, became an unskilled workman, or *manoeuvrier*; François, the second in line, was apprenticed as an engraver; while Marie, the first daughter, married M. Joseph, a locksmith in Epinal. Madeleine, the youngest in the Georgin clan, indicated no professional affiliation for herself; however, municipal records indicated that she married a workman who later became a rural postman.

16. Ibid., 28.

17. Lucien Descaves, *L'Humble Georgin: L'Imagier d'Epinal* (Paris: Firmin-Didot et Cie, 1932), 15.

18. Ibid., 21–22.

19. Ibid., 29. From this alliance, François Georgin had five children of his own: Anne Christine, born in October 1829; Clemence-Adèle, born in December 1832; Eugénie, born 20 February 1837; and Alphonse Françoise, born in 1845. Two children died as infants.

20. Dumont, *La Vie et l'oeuvre de Jean-Charles Pellerin*, 47.

21. Jean Mistler, François Blaudez, and André Jacquemin, *Epinal et l'imagerie populaire*, (Paris: Librairie Hachette, 1961), 105. Borrowing and copying were accepted practices among wood-block engravers, who also copied freely from one another. But even when derived from a recognized original, most popular prints did not identify either the copyist or original engraver.

22. Marie Dominique LeClerc, "Les Avatars de Griséldis," *Marvels and Tales* 5, no. 2 (1991): 200–234. A good number of small pamphlets known as the "Blue Library" circulated in France from the latter part of the sixteenth century to the end of the nineteenth century. The poorly printed brochures with worn type printed on cheap paper, and illustrated with woodblocks or previously used engravings were very inexpensive. These booklets constituted for the masses an avenue to written culture. In addition, their mode of distribution—by peddlers in urban or rural areas—enabled their widespread diffusion. The tradition of popular literature originated with the printer Nicholas Oudot of Troyes at the beginning of the seventeenth century. It was in Troyes that the formula for popular literature became most systematic and successful. The dynasty of the Oudot family was soon imitated by other colleagues in Troyes, but also by other Parisians and provincial printers. The editorial strategy was simple: it consisted of appropriating existing texts, rewriting them [through revision and simplification] in order to put such texts at the disposal of everyone."

23. Pierre Louis-Duchartre in Jean-Marie Dumont, *Les Maîtres graveurs populaires*, vii; See also ibid., 32. According to Dumont, Georgin signed 210 wood-block prints from 1814–1853. The artisan used various symbols for his signature, placed at the bottom of the print: F. Georgin, F. G. G., G. F., F. G., G. G., G., or simply Georgin. Some of his earlier religious prints were not signed and are therefore difficult to identify.

24. Beatrice Farwell, *The Charged Image: French Litho-graphic Caricature, 1816–1848* (Santa Barbara, Calif.: Santa Barbara Museum of Art, 1989), 10–11. In comparison with the lithographic image drawn with crayon on stone, "the wood engraving [cutting the image in relief on end-grain rather than side-grain wood with engravers' tools] was slow and difficult to produce." See also Dumont, *Les Maîtres graveurs populaires*, 29.

25. Aynaud, "L'Imagier inconnue de Metz," 1–11. When his own health began to decline, Georgin trained younger students such as Wëndling, Somny, and Jean-Baptiste Vançon, students who later established themselves as respected engravers for other printing houses in the Northeast.

26. Out of a total of some fifty-nine designs done by Pellerin for the Napoleonic series, including several illustrations for Napoleon II plus four anonymous prints published after 1840 representing *The Return of Ashes*, Georgin signed forty-one.

27. Dumont, *Les Maîtres graveurs populaires*, 30, 32.

28. Dumont, *La Vie et l'oeuvre de Jean-Charles Pellerin*, 41. Having observed the operation of several stereotype presses during a trip to Strasbourg, after 1809 Pellerin developed his own version of the procedure. For this reason he became kown in the Vosges as an "inventor" of the stereotype press; for more information on the process of making wood-block designs see Donald Saff and Deil Sacilotto. *The History and Process of Printmaking* (New York: Holt, Rinehart, and Winston, 1978), 38–48.

29. Elizabeth M. Harris, *The Art of Pochoir* (Washington, D.C.: Smithsonian Catalogue, National Museum of American History and Technology, 1977), 1.

30. Dumont, *Les Maîtres graveurs populaires*, 52. In 1829, Pellerin employed forty-five workers and in January 1832 he employed fifty. In August 1841, he had ninety workers, among whom twenty-two were children. He employed eighty-eight workers in 1845 with fifty children.

31. For further information on the distribution and use of popular images, see the next chapter, on religious art and the distribution of popular prints in early-nineteenth-century France.

32. Farwell, *The Charged Image*, 18; See also Walter Benjamin, *Illuminations* (New York: Harcourt, Brace and World, 1968), 220; and Harrison C. White and Cynthia White, *Canvases and Careers* (New York and London: John Wiley and Sons, 1965), 79, 160. Lithography, which was invented at the beginning of the nineteenth century, helped to spread real involvement with art. It was cheap enough to provide works for mass circulation as single-page illustrations or inserts; moreover, through lithography, ill-paid copyists duplicated Salon paintings for marketing as inexpensive reproductions. Thus, elite paintings were popularized and made more available through lithography.

33. René Saulnier, *Les Sources d'inspiration de l'imagerie populaire: Un Curieux exemple de copies successives* (Strasbourg: Le Roux, 1948), 127–33.

34. Napoleon's costuming verified by Major Gérard-Jean Chaduc, conservator, Musée de l'Armée, Hôtel National des Invalides, Paris.

35. The Pellerin atelier may have had access to David's *Le Distribution d'aigles* through an engraving done by the artist John Quarterly, who rendered a lithographic copy of the David painting. Though the print was not signed by Georgin, the master craftsman undoubtedly contributed to its execution.

36. Adolphe Aynaud, "Les Thiébaults, graveurs nan-

ciens," *Le Vieux papier* (Paris, 1955): 1–8; See also Dumont, *Les Maîtres graveurs populaires*, 45–46. Jean-Baptiste Thié- bault was born in Nancy in 1809. He received his first ap- prenticeship as an engraver with the owner of Desfeuilles in Nancy in 1819. From his signature on four wood-block designs, it is apparent that he worked briefly for Pellerin during the July Monarchy (1834–35) and then returned to Nancy, where he married Marie Catherine Desfeuilles. Be- cause of his short tenure with Pellerin, Thiébault likely worked briefly under the surveillance of Pellerin's chief craftsman, François Georgin.

37. Walter Freidlaender, "Napoleon as Roi Thauma- turge," *Journal of the Wärburg and Courtauld Institutes* 4 (1940–41): 129–41. The Gros painting represents French troops who had captured the city of Jaffa in Syria after having indiscriminately massacred local residents of the city and two to three thousand Turkish troops who had taken refuge in the citadel. In vain, the soldiers had re- quested clemency from Napoleon. Although Bonaparte's troops had contracted the plague earlier, it reached critical proportions when the French army arrived in Syria. In ef- forts to dispel French dismay about Napoleon's inhumane massacre of the Turks and the disaster experienced by his troops in the Middle East, Gros developed this monumental statement of Bonaparte's courage, compassion, and possi- bly miraculous power to heal his plague-ridden soldiers. The Gros piece was intended to portray Napoleon with the aura of divine kingship.

38. Marc Bloch, *The Royal Touch: Scrofula in England and France* trans. J. E. Anderson (London: Routledge and Paul Kegan; Montreal: McGill University Press, 1973). In de- picting Napoleon about to touch the wounded soldier, Gros undoubtedly tried to attribute the healing powers of the French kings to the Corsican ruler. Bonaparte's presence in the hospital also suggested Christ's powers to heal the poor, sick, and wounded, a reference that would have been obvious to a general audience.

39. Text beneath *Bonaparte touchant les pestiférés* (1835), Thiébault, Pellerin, Epinal.

40. Dumont, *La Vie et l'oeuvre de Jean-Charles Pellerin*, 48: In contrast with the soldierly interpretation of Napoleon during the July Monarchy, during the late Empire, Jean- Charles Pellerin did publish a number of portraits of the Imperial family that eulogized Napoleon as emperor. These included: *Napoléon comme l'empereur, Marie Louise comme l'empresse, Le Triomphe de Napoléon, Le Triomphe de Marie Lou- ise, La Naissance et le baptême du roi de Rome, L'Union de la France et de l'Autriche, La Famille Impériale,* and *L'Entrée à la Moscowa* see also Perrout, *Les Images d'Epinal*, 38. Unfortu- nately, many of these Imperial prints done by Pellerin have been lost, such as *L'Empereur monté à cheval, Napoléon comme général républicain,* and *Le Sacre de Napoléon.*

41. Musée des Arts et Traditions Populaires, Bois de Boulogne, Paris. The five engravings done by Jean-Baptiste Debret were printed by Allemand on the rue St. Jacques in Paris. The artisan executed almost precise copies of five Debret engravings. These included: *Napoleon and the Mother of the Grenadier* (1834), *Napoleon at the Camp of Boulogne* (1835), *Valor and Humanity* (1830), *Honor to the Courageous Wounded* (1835), and *Sire, This Coat Is Worth the Cross* (n.d.). In Georgin's version of *Honor to the Courageous Unfortunate,* only the addition of the tricolor flag distinguishes the popu- lar print from the Debret original.

42. Textual commentary beneath *Napoléon et la mère du grenadier* (1834), Georgin, Pellerin, Epinal. "Ma bonne

vieille, vous aurez votre fils bientôt et en attendant, je vous fais une pension de 600 francs à prendre sur ma cassette particulière."

43. Maurice Choury, *Les Grognards de Napoléon* (Paris: Perrin, 1968), 70.

44. Though this print was not signed by Georgin, the composition suggests either the inspiration or direction of the master craftsman. The positioning of the Little Corporal in *The Eve before the Battle of Austerlitz* is very similar to Georgin's rendition of Bonaparte in *Napoleon Wounded at Ratisbonne.* The weeping figure of the soldier in the right foreground also resembles the grieving soldier in the left foreground of Georgin's *Tomb of Napoleon I.*

45. Baroness Eleanor Anne Steuben, born Trollé, was a portrait painter and engraver. She was a student of her husband, Charles Steuben, and Robert Lefevre. Born in Paris 25 December 1788, she exhibited in the Salons of 1827 and 1835. Steuben died in Paris, December 1869.

46. For an incisive analysis of religious and political meanings associated with the iconographic history of Na- poleon as the Little Corporal or *L'Homme du peuple,* see Mar- rinan, *Painting Politics for Louis-Philippe,* 146–50.

47. Rosenblum, *Transformations in Late-Eighteenth- Century Art,* 9, 146–91. The linear and repetitive style used by popular wood-block engravers was comparable to the formal presentation found in military engravings from the Imperial period. Like the Imperial artist, the Pellerin arti- sans used flat linear blocks to map out the battle campaign, and gradations of size to portray the historical narrative.

48. Susan Locke Siegfried, "Naked History: The Rheto- ric of Military Painting in Postrevolutionary France," *Art Bulletin,* 75, no. 2 (June 1993): 235. When Napoleon came into power in 1800, he promoted military themes in the Salon and commissioned artists to execute military art as a principal theme during the Empire.

49. Carl Vernet, *Campagnes des français sous le consulat et l'empire* (Paris: Michel de l'Ormeraie, 1979). Note how Vernet's layered compositional pattern is often repeated by Georgin in his descriptions of battle, although he consis- tently draws attention to Napoleon's leadership and hero- ism by enlarging his figure in the foreground of the design.

50. Engravings done by Edmund Bovinet and François Couchés Fils, in Pierre François Tissot, *Trophées des armées françaises de 1792 à 1815,* 7 vols (Paris: Lefuel, 1819–21) fur- nished the inspiration for at least nine compositions by Georgin. The Bovinet et Couché Fils engravings were prob- ably not originals, but copied from numerous military en- gravings produced during the First Empire.

51. This interpretation was influenced by the perceptive analysis done by Edith Mauriange in "Sources d'inspiration de François Georgin pour quelques estampes de l'épopée Napoléonienne," in *L'Art populaire de la France de l'Est* (Paris: 1969): 367–83.

52. Ibid., 383.

53. Ibid., 367–83. In her analysis, Edith Mauriange demonstrates an indisputable correspondence between nine Bovinet et Couché Fils military engravings and the same scenes done by François Georgin. These include: *The Battle and Passage over the Lodi Bridge, The Battle of Rivoli, The Passage over Mount St. Bernard, The Taking of Alexandria, The Battle of Marengo, The Battle of Austerlitz, The Battle of Iena, The Battle of Moscow,* and *The Battle of Lutzen.*

54. The Pellerin editor drew the explanatory legend from newspapers, reports, or Napoleon's own renditions of his campaigns found in the *Bulletins of the Great Army.* In

some instances, the editor selected the text for the military prints from commentaries for the lithographic illustrations found in Tissot's *Trophées des armées françaises de 1792 à 1815.*

55. Although most of Charlet's lithographic work on Napoleon and the Imperial armies was done during the Restoration, Charlet also designed an important series of lithographs that were used for a famous edition of the *Mémorial for St. Helena,* published in 1841.

56. Auguste Bry, *Raffet: Sa Vie et ses oeuvres* (Paris: E. Dentu, 1861), 20.

57. Edmund Bénézit, *Dictionnaire critique et documentaire des peintres, sculpteurs, déssinateurs, et graveurs* (Paris: Librairie Grund, 1976), 8:579.

58. Bry, *Raffet: Sa Vie et ses oeuvres,* 19; Dubreton, *Le Culte de Napoléon,* 404–5. At the same time, Raffet paid careful attention to accuracy in his depiction of historical events, costumes, and themes from the revolutionary and Imperial epochs.

59. Illustrations for the preceding text were taken from *Raffet,* vol. 8 (Paris: Gihaut Frères, 1832). This volume had originally been printed by the same editors in 1829. Each of the prints—*Ils grognait et le suivaient toujours, Vive l'empereur, Bautzen, nuit de 20 mai, 1813, Mon Empereur c'est la plus cuite*—emphasizes Napoleon's sense of mutuality with his men. This edition is presently located in the *iconothéque* at the Musée des Arts et Traditions Populaires.

60. Though *Le Debarkation de Napoléon* was not signed by Georgin, the portrait of the Little Corporal is strikingly similar to several compositions attributed to the Epinal craftsman, such as *La Colonne, Napoléon blessé à Ratisbonne,* and *Napoléon à Ste. Hélène.*

61. Terdiman, *Discourse/Counter-Discourse,* 139–97. For further discussion on the development of lithography as a graphic language that took issue with the social and political prerogatives of the July Monarchy, see Terdiman's discussion of Philippon and Daumier.

## CHAPTER 4. ST. NAPOLEON

1. Several other printing houses in the Northeast that printed Napoleonic art at the same time as the Pellerin firm included Lacour et Cie in Nancy (1830–35) and Deckherr Brothers in Montbéliard, where a few prints on Napoleon were designed from 1820 to 1830. From 1838 to 1848, Dembour et Gangel in Metz continued to produce Napoleonic themes with the assistance of several craftsmen trained in the Pellerin atelier.

2. Dépôt Légal (1820–48), 8T11–12, Archives Départementales des Vosges.

3. Dumont, *Les Maîtres graveurs populaires,* 59. In 1831, 20 percent of the Pellerin inventory was about Napoleon; in 1832, 40 percent; in 1833, 66 percent; in 1834, 100 percent; and in 1835, 80 percent of Pellerin's stock dealt with bonapartist themes.

4. Bollème, *La Bible bleue,* 17–18: While anonymous pamphlets published in the Blue Library were often derived from educated chansons and medieval romanciers, regional printers transformed *savante* or educated editions into simplified and shortened texts that were more accessible to the reading skills of petit bourgeois and artisan customers. Although over 1,000 texts could be in circulation at any one time, an inventory of some 450 titles (and subjects) remained relatively stable over a period of almost three centuries.

5. Dumont, *Les Maîtres graveurs populaires,* 53.

6. Dumont, *La Vie et l'oeuvre de Jean-Charles Pellerin,* 48.

7. Dumont, *Les Maîtres graveurs populaires,* 54.

8. Edward Berenson, *Populist Religion and Left-Wing Politics in France* (Princeton: Princeton University Press, 1984), 69.

9. Bollème, *La Bibliothèque bleue.* Even after the heat of Reformation and Counter-Reformation politics had subsided, commercial editors and engravers continued to produce devotional prints and pamphlets that created a steady popular demand from the sixteenth through the nineteenth centuries.

10. David Freedberg, *The Power of Images: Studies in the History and Theory of Response* (Chicago: University of Chicago Press, 1989), 174. From the fifteenth century on, imitation became an essential aspect of devotion, by encouraging an empathetic connection and subsequent identification with the experiences and behavior of the saintly figure.

11. *La Vie du grand St. Hubert* (Troyes: Baudot), Bibliothèque Bleue 920, Bibliothèque municipale de Troyes.

12. *La Vie de St. Antoine* (Troyes: Pierre Garnier, 1738), Bibliothèque Bleue 246, Bibliothèque Municipale de Troyes.

13. *La Vie de Napoléon* (Arcis: Blondel, 1832), Bibliothèque Bleue 1010, Bibliothèque Municipale de Troyes. During the July Monarchy, several editions of this text on the military career of Napoleon were added to the existing inventory of inexpensive pamphlets from the Blue Library. The publishing of this edition and of subsequent editions of this text confirmed the increased interest in political history among provincial customers during the Orleanist regime.

14. Text beneath *Napoléon à Arcis-sur-Aube* (1835), Georgin, Pellerin. Archives Départementales des Vosges, "Enveloppé dans les tourbillons d'une charge de cavalerie, il ne se dégagea qu'en mettant l'epée à la main."

15. Text beneath *La Bataille d'Iena* (1834), Georgin, Pellerin. Archives Départementales des Vosges. "Présent partout, l'Empereur dirigeait toutes les opérations.

16. Text beneath *La Bataille de Marengo* (1834), Georgin, Pellerin. Archives Départmentales des Vosges. "'Français,' s'écrie-t-il, 'C'est avoir fait trop de pas en arrière; le moment est venu de faire un pas en avant.'"

17. André Latreille, *Le Catechisme impériale de 1806* (Paris: Editions du Cerf, 1935), 80, "Nous devons en particulier à Napoléon I notre empereur, l'amour, le respect, l'obeissance, la fidelité, le service militaire, les tributs ordonnés, pour la conservation et la défense de l'empire et son trône; nous lui devons encore des prières ferventes pour son salut et pour la prospérité spirituelle et temporelle de l'État."

18. Hippolyte Delehaye, S.J., "La Légende de St. Napoléon," Excerpt from *Mélanges de l'histoire,* Belgium, Cabinet des Estampes, Bibliothèque Nationale, 81–88. Bonaparte accepted some rather specious research done by French clerics on the history of "Neopolis," taken from a document written by Hieronymous. According to Delehaye, the names of cities and states could easily have been confused; moreover, the translation from Greek to Latin was probably inexact. Nonetheless, the French government used such material as the basis for St. Napoleon's sanctification in 1803 and inclusion in the French liturgical calendar.

19. Ibid., 2, 28. In the year XI of Thermidor (1802), Bonaparte issued a decree that designated the feast day of St. Napoleon on 15 August.

20. *St. Napoleon,* RD2, Cabinet des Estampes, Bibliothèque Nationale, Paris. The first print of St. Napoleon done by Pellerin was taken from an illustration done by

the printer Glenmarc (ca. 1800), rue St. Jacques in Paris. The Glenmarc print shows Napoleon dressed as a Roman warrior holding the palm branch of martyrdom with a shield and spear on the ground.

21. Text from *St. Napoléon, Galerie Religieuse*, Georgin, Pellerin, 1842: "O Dieu, fort et puissant, protecteur des armées qui combattent en votre nom pour le maintien de votre église, faites que les exemples et les instruction que nous a laissés le glorieux saint Napoléon, nous fassent triompher des ennemis qui tenteraient de nous troubler dans le tranquille exercice de vos saints mystères, et qui chercheraient à diminuer la foi des fidèles que vous daignez éclairer et protéger, Par N.S. Jésus-Christ. Ainsi soit-il."

22. Dépôt légale, 8T 10–12, Archives Départementales des Vosges, Epinal. It is apparent that Pellerin submitted designs of St. Napoleon for authorization during the First Empire, July Monarchy, and Second Empire. The few facsimiles that remain from the July Monarchy and Second Empire are presently located at the Musée Départementale d'Art Ancien et Contemporain in Epinal, at the Cabinet des Estampes, Bibliothèque Nationale, and the Musée des Arts et Traditions Populaires in Paris. The celebration of St. Napoleon and his feast day was renewed by Louis-Napoleon Bonaparte during the Second Empire.

23. Philippe, "Jean-Charles Pellerin poursuivi pour vente d'images séditieuses (1816)" 17:1–15, 97–107. Though Pellerin did not indicate the proposed publication of St. Napoleon at police headquarters, he nevertheless continued to market such images during the Restoration. Evidence shows that prints of St. Napoleon done by Pellerin were confiscated from book dealers in 1816 and several peddlers' packs in 1816 and 1817.

24. Dubreton, *Le Culte de Napoléon*, 243.

25. "Colportage" 1815, I Z5 4, Archives Départementales des Vosges.

26. "Colportage" 1816, I Z5 6, Archives Départementales des Vosges.

27. "Colportage" 1820, I Z5 18, Archives Départementales des Vosges.

28. Sauvigny, *The Bourbon Restoration*, 302: On 5 October 1814, an ordinance was passed that allowed bishops to open an ecclesiastical school in each department. Observances of the Sabbath and holy days were made mandatory by the government; the Concordat of Napoleon with the church in 1802 was also abrogated and replaced by the previous Concordat.

29. Ibid., 317–18.

30. Philippe, "Jean-Charles Pellerin poursuivi pour ventes d'images séditieuses," 1–15.

31. Jean Jacques Darmon, *le Colportage de librairie en France sous le Second Empire* (Paris: Plon, 1972), 28: Booksellers had to apply for an urban license while peddlers were required to obtain a passport from local police authorities to travel either locally or from department to department.

32. L'Abbé Pierfitte, "Chamagne, les Chamagnons," *Bulletin mensuel de la société d'archéologie Lorraine* 12 (1903), 280–83. Pierfitte maintained that itinerant marketing developed due to the paucity of tillable land. Because of the very poor siliceous soil, the agricultural base of the village was limited to the growth of wheat, oats, and buckwheat. Since half of the land in the commune was a forest area (655 hectares), sheep farmers had few and meager fields for pasture. During my own interview on 7 August 1982 with M. Jean Cargamel, former mayor of Chamagne, he indicated that the name of the town was derived from two words

meaning "field of onions," referring to the poverty of the rocky soil.

33. Henri-Jean Martin, "The Bibliothèque Bleue: Literature for the Masses in the Ancien Regime," *Publishing History* 3 (1978): 87.

34. Charles Charton and M. Ravignat, *Revue pittoresque, historique et statistique des Vosges* (Epinal: Ponton fils, 1841), 21.

35. Jacquelyne LeSueur, "La Crise des imprimeurs," in *La Littérature de colportage*, ed. André Malraux (Reims: Maison de la culture, 1979, 1–5.

36. Pierfitte, "Chamagne, les Chamagnons," 282: Lay teachers, imbued with new faith in rationalism and progress during the Third Republic, were anxious to dispel myths and superstitious practices perpetrated by nomadic peddlers.

37. Albert Demard, *Un Homme et son terroir: Une Évocation de la vie rurale d'autrefois* ed. Joel Cuenot and Jean-Christophe Denard. (Tours: Mame, 1980), 5.

38. Jacques Choux, "Notice sur une boîte de colporteur," *Gazette des Beaux Arts* 122, no. 45 (December 1980): 209–13. St. Hubert was known in the Lorraine for his powers of healing and for protecting his devotees from natural disasters to crops and animals as well as to their families.

39. Material for this section was derived, in part, from an exposition catalog entitled *Les Colporteurs de Chamagne: Étude de leurs passeports (1824–61)*, put together by an elementary school in Chamagne and published by the Inspection Academique des Vosges, CDDP des Vosges, in 1990. The students prepared several statistical studies based on some 460 passports of peddlers from the early-nineteenth century that were issued from Chamagne. I provided further statistical work using the information secured by the students plus data from 2,000 unclassified passport stubs that were located in the Archives of Chamagne.

40. Archives de Chamagne, unclassified passports (1824–40). Normally, the women who registered for passports as peddlers were from fifteen to twenty-four years of age, and had not given birth or begun the more demanding chores of raising a family. Most men who registered for passports ranged from thirty to fifty years of age, suggesting they became peddlers to support the needs of their families.

41. My estimate of one-sixth of the population is a shade lower than Jacquelyne LeSueur's; she contends that one-fourth of the population from Chamagne were peddlers. Jacquelyne LeSueur, "Une Figure populaire en Lorraine au siècle dernier: 'Le Colporteur' ou 'Chamagnon,'" *Bulletin de la société des études locales dans l'enseignement publique* 36 (1969): 29–39: But my estimate does not include local peddlers, who did not always apply for passports.

42. Jacquelyne LeSueur, "Le Nouveau Visage du 'Chamagnon' ou la fin d'un mythe," *Bulletin de la société Lorraine des études locales dans l'enseignement publique* 51–52 (1976): 19–20. LeSueur contends that peddling became a more lucrative enterprise due to a crisis in the printing industry between 1827 and 1832. During this period printers in the Vosges endeavored to expand their sales of popular pamphlets and art into the countryside using traveling peddlers. Though passports for peddling did increase noticeably after the July Revolution. I would also attribute the increase of peddling to the release of press censorship during the first five years of the July Monarchy.

43. *Les Colporteurs de Chamagne; Étude de leurs passeports, 1824–1861*, 25–26: According to some 460 passports, ped-

dlers traveled primarily in the northern, northeastern, and northwestern regions of France. But a few also passed through southern France, including the cities of Avignon, Montpellier, Toulouse, and Bordeaux.

44. Berenson, *Populist Religion and Left-Wing Politics in France*, 69. Peasants and artisans formed the majority of Pellerin's customers: "the rural middle class was not large enough to account for more than a fraction of the ten million items sold annually."

45. Mistler, Blaudez, and Jacquemin, *Epinal et l'imagerie populaire*, 134. This evidence is corroborated in *L'Imagerie Messine, 1838–1871: Exposition d'images conservées aux Archives Départementales de la Moselle* (Metz: Direction des Services d'Archives de la Moselle, 1987), 238.

46. Information taken from my interview with the former mayor of Chamagne, M. Jean Cargamel, on 2 July 1982.

47. During the early-nineteenth century, religious and parareligious customs were still deeply embedded in the cultural fabric of provincial societies. But because of the dearth of primary material (memoirs, letters, or immediate witness accounts), it is difficult to ascertain precisely how lower-class and marginal groups in regional France received and appropriated Napoleonic texts and images. At best, we can approach provincial attitudes and practices through a discrete study of secondary sources that describes or illustrates how popular texts and images were used by lower-class groups. In addition to witness accounts and secondary representations, it will also be important to investigate devotional customs and practices associated with religious art as a way to ascertain how Napoleonic prints may have functioned in the provincial household.

48. Mistler, Blaudez, Jacquemin, *Epinal et l'imagerie Populaire*, 136.

49. Berenson, *Populist Religion and Left-Wing Politics in France*, 60–61.

50. Gazin, "Moeurs, traditions, légendes dans le département des Vosges" 4:554: Pilgrimages to a favorite saint were still very popular in the Vosges during the nineteenth century. At Jeuxey, near Epinal, on 28 August farmers, in particular, celebrated the feast day of St. Guérin. Residents of the Vosges believed that St. Guérin would protect animals who had eaten "blessed bread."

51. Duchartre and Saulnier, *L'Imagerie Populaire*, 56; See also Berenson, *Populist Religion and Left-Wing Politics in France*, 61. Rural dwellers increased devotional practices and pilgrimages to shrines and representations of St. Roch during the cholera epidemic that occurred in France during the early 1830s. Other than remonstrances for immoral conduct, the Catholic church could provide few solutions or comfort to parishioners who experienced the ravages of the plague.

52. Michel Vovelle and Didier Lancien, *Iconographie et histoire des mentalités* (Paris: Centre National de la recherche scientifique, 1979), 11: Often a chapel or grotto in the countryside was a devotional place for the local saint or deity responsible for the health and protection of the community. Recent discoveries of land chapels throughout Alsace-Lorraine corroborate the practice of ritual pilgrimages to sacred and para-Christian shrines in the rural Northeast. According to Vovelle and Lancien, "The forest chapel continued pagan forms of worship where the community regenerated itself."

53. Judith Devlin, *The Superstitious Mind: French Peasants and the Supernatural in the Nineteenth Century* (New Haven and London: Yale University Press, 1987), 40: Devlin explains how people in the countryside were not as concerned with questions of piety as they were with desires to satisfy their immediate needs through religious rituals and magical practices.

54. Ibid., 25, 60. Devlin concludes that "the popular God was a child of the 'petits gens,' [little people] a God who punished the arrogant rich and who helped the poor, who appeared to the miserable and charged them with important tasks, who arranged miraculous reversals of fortune; a God who offered protection in life and solace in death."

55. Ibid., 61: Religion, like fairy tales and magic, was a way for the poor to re-create a world that would favor their own particular needs and concerns. Through physical contact or proximity to relics, images, and statues, believers felt they could gain access to, or appropriate the supernatural powers ascribed to a particular saint. Devlin added that most commoners who participated in such "sacred" rituals did not necessarily believe in an automatic response to each appeal, but that the ritual itself functioned as a sort of cathartic exercise and relief from natural uncertainties.

56. Freedberg, *The Power of Images*, 437–38: Through his study of audience response to religious art, David Freedberg puts the traditional separation between art and reality, sign and signified into question. "Instead then of seeing disjunctions, the time has come to see the picture and sculpture as more continuous with whatever we call reality than we have been accustomed to, and to reintegrate figuration and imitation into reality (or into our experience of reality.)"

57. Ibid., 436–37: Through his study of the viewer's response to art, Freedberg puts the traditional disparity between art and reality into question. "This is not to argue for a revision of the philosophical and ontological view; it is to propose that we will only come to understand response if we acknowledge more fully the ways in which the disjunction lapses when we stand in the presence of images. However much we may strive to do so, we can never entirely extract ourselves from our sense of the signified in the sign."

58. E. M. Laumann, *Le Retour des cendres* (Paris: H. Daragon, 1904), 43.

59. Jules Dechamps, *Sur la légende de Napoléon* (Paris: Librarie Ancienne Honoré Champion, 1931), 97: Dubreton maintains that "people perceived Napoleon as a hero and medieval saint toward whom the popular soul responded with waves of enthusiasm and religious devotion."

60. Victor Auger, *L'Empereur* (Paris: Jules d'Agneau, 1853), 1: "Dans chaque chaumière de France se trouvent un Christ noirçi, une vierge de plâtre, une image de Geneviève de Brabant . . . enfin un grossier portrait de l'empereur-debout sur la colonne, plus souvent calme sur un cheval fougueux."

61. Henri Houssaye quoted in Armand Dayot, *Napoléon raconté par l'image d'après les sculpteurs, les graveurs, et les peintres* (Paris: Librairie Hachette, 1895), 18–121.

62. Honoré de Balzac, *The Country Doctor*, trans. Ellen Marriage (London: J. M. Dent and Sons, 1961), Maurice Descotes, *La Légende de Napoléon, et les écrivains français du dix-neuvième siècle* (Paris: Lettres moderne, 1967) 227, 238, 260–61. Balzac apparently derived his inspiration from the memoirs and oral tales of several veterans from the Imperial wars whom the author contacted. In addition to the resources of these veterans, Balzac was certainly influenced by Parisian theater, pamphlet serials, and prints that dra-

matized the adventures of Imperial soldiers. According to Descotes, Goguelot, the former lieutenant in *The Country Doctor*, represented a recognized "type" who lived outside of civil society while maintaining allegiance to the emperor and to a particular code of military honor.

63. Balzac, *The Country Doctor*, 191.

64. Ibid. 199.

65. Ibid. 201.

66. M. Agulhon, "Le Problème de la culture populaire en France autour de 1848," *Romantisme* 9–10 (spring 1975): 64–72. According to Agulhon, many songs were devised by local artisans and artists for village funerals or festivities.

67. Charles Nisard, "Jésus et Napoléon," in *Des chansons populaire chez les français: Essai historique*, vol. 2, *Sur la chanson des rues contemporaines* (Paris: Buffet, 1867), 152.

68. Victor Hugo, "Ode à la colonne," in *Oeuvres Poétiques* (Paris Pierre Albouy, 1964), 1:825–830. In his "Ode to the Column," written 9 October 1830, several days after the Chamber of Deputies refused to authorize the return of Napoleon's ashes to France, Hugo wrote this extensive poem to vent his frustration and anger with the new Orleanist government. Hugo felt that Bonaparte deserved a monumental interment beneath the Vendôme column, "Dans ce puissant Paris qui fermente et bouillonne." (Within this powerful Paris which ferments and bubbles.)

69. During the initial years of the Orleanist regime, bonapartists experienced repeated setbacks and obstructions from a government that took an increasingly defensive stance toward any sort of dynastic threat to the French throne, be it from carlist or bonapartist contenders. The government's determination to bar any member of the Bonaparte family from France in a law passed on 10 April 1832 appeared to mark an unavoidable debacle for political bonapartism. The death of Napoleon's son and designated heir on July 22, 1832, moreover, spelled a temporary halt to the dynastic aspirations of bonapartist groups in Orleanist France.

70. Anita Schorsch, *Mourning Becomes America* (Harrisburg, Penn.: William Penn Memorial Museum, 1976), 1. In Europe, the mourning picture reflected neoclassical fashion during the late-eighteenth and early-nineteenth centuries. Upper-class tastes in mourning art eventually filtered down to less well heeled provincial groups in the form of wood block prints, memorial cards, and commemorative images.

71. Ibid., 1.

72. *Le Convoi funebre* (1835) constitutes another of the few Napoleonic prints done in Georgin's style, but not formally signed by the master craftsman. The representation of the sun, for example, corresponds precisely to several prints attributed to Georgin, such as *The Apotheosis* (1834) and the cover for the *Almanac of the People* (1833).

73. Text beneath *Le Convoi funèbre de Napoléon* (1835): "C'est là que repose le Vainqueur des Rois, le Dominateur des Nations, l'Homme qui a rempli l'Univers de son nom et de la gloire des Français."

74. In the Epinal illustration for *Napoléon sur la colonne* (1833), Georgin monumentalized the figure of the Little Corporal taken from a lithograph by Laumann entitled *L'Arrivée de Napoléon au pied de la colonnee* (1833), QB1, collection da Vinck, Cabinet des Estampes, Bibliothèque Nationale, Paris.

75. Lyrics for a popular song to be sung to the tune of *Mt. St. John* surround Georgin's illustration of the Little Corporal mounted atop the Vendôme column. Subsequent stanzas describe not only Bonaparte's fame but also his suffering when separated from his wife and son.

76. Lyrics from a poem to be sung to the tune of *La Victoire en chantant*. The composer (or composers) of both poems that frame *Napoléon sur la colonne* is anonymous.

77. From the two prints he signed, it is apparent that Thiébault worked for Pellerin very briefly, from 1832–1834 before returning to the printing house Desfeuilles et Cie in Nancy.

78. In this instance, Napoleon does not wear the overcoat of the Little Corporal, but the accoutrements of "colonel" with the bicorne hat and sword of Austerlitz. The officer's uniform with the unadorned hat also represented *le petit caporal*.

79. Text beneath *Sire ce linceul vaut bien la croix* (1837), Pellerin, Epinal. "Le grenadier, qui se sentait mortellement blessé, répondit à l'Empereur: 'Sire, le linceul que je viens de reçevoir vaut bien la croix.' et il expira enveloppé dans le manteau Impérial . . . l'Empereur fit relever le grenadier, qui était un soldat de l'armée d'Egypte, et ordonna qu'il fût enterré dans son manteau." Though Georgin did not sign this print, it is interesting to note that after the artisan's death in 1862, he was buried in the infantryman's coat worn by his mentor, Réveillé, in the Russian campaign.

## CHAPTER 5. ORLEANIST CO-OPTATION AND BONAPARTIST BROADSIDES

1. Marrinan, *Painting Politics for Louis-Philippe*, 160: According to Marrinan, Louis-Philippe "tried to alter its [the Little Corporal's] social signification by institutionalizing it as a symbol of past military glory." That is, the king attempted to neutralize potentially seditious aspects of the image while holding on to its power.

2. Driskel, *As Befits a Legend*, 35. According to Lamartine's speech in the Chambers on 26 May 1840, the Place Vendôme was not a suitable location for Napoleon's ashes because the openness of the surrounding area could encourage seditious demonstrations or bonapartist rallies.

3. Maureen Meister, "To All the Glories of France: The Versailles of Louis-Philippe," in *All the Banners Wave: Art in the Romantic Era, 1792–1851* (Providence, R.I.: Brown University Press, 1982), 21: Louis-Philippe used his personal funds to reconstruct Versailles to house a series of paintings that he commissioned to display French military heroism and glory as well as his own political formula for a *juste milieu* of peace and moderation under the law.

4. Claire Constans, *Versailles: La Galerie des Batailles* (Paris: Les Editions Khayat, 1990), 13–46: While some of the subjects the king selected were paintings commissioned by the emperor himself, such as Jacques-Louis-David's *Sacre*, Baron Antoine Gros's *The Battle of Aboukir*, and François Gérard's *Battle of Austerlitz*, most themes were requested from contemporary artists such as Ary and Henry Scheffer, Charles Steuben, Eugene Delacroix, Jean Alaux, and the king's favorite painter, Horace Vernet.

5. Meister, "To All the Glories of France," 21–26.

6. Walter R. Herscher, "Evoking the Eagle: The July Monarchy's Use of Napoleonic Imagery" (Ph.D. diss., Marquette University, 1992), 232–34: In principle, artwork commissioned for the Arch of Triumph (1836) was allegedly designed to celebrate the glorious feats of the Revolutionary and Imperial armies. However, two out of the four high-relief designs, Antoine Etex's *Resistance* and *Peace*, empha-

sized the defeat of Napoleon's armies and the salutary reinstatement of peace in 1815. Etex's interpretations thus corresponded more closely to the Orleanist government's efforts to tread a path of moderation and compromise in French foreign affairs.

7. Marrinan, *Painting Politics for Louis-Philippe,* 177: Since Louis-Napoleon Bonaparte had tried to execute his coup at Strasbourg only a few months prior to the Salon opening, the painting was probably deemed to be politically provocative.

8. Neil McWilliams, "David D'Angers and the Pantheon Commission: Politics and Public Works under the July Monarchy," *Art History* 5, no. 4 (December 1982): 430–36: Despite the government's request in the spring of 1837 to change the design by removing some of its more contentious figures, such as Rousseau and Voltaire, and by erasing military references to Bonaparte, republican d'Angers refused to modify his design. Although the relief was not destroyed, as many had expected, the monument was not unveiled on 29 July 1837 to celebrate the July Revolution. It was covered by a tarpaulin for almost a month until the republican press threatened that unless the monument was unveiled, lithographed images of the relief would be made available to the public.

9. Herscher, "Evoking the Eagle," 251: While the mural portrays great personages in the history of the church and state, there is no trace of any Bourbon king after Louis XIII. Louis-Philippe was descended from Louis XIII's younger son Philippe, the Duke of Orleans.

10. Marrinan, *Painting Politics for Louis-Philippe,* 142–47.

11. Ibid., 150: My study of republican politics and propaganda in the Vosges concurs with Michael Marrinan's description of the republican-bonapartist coalition that developed in the capital during the early years of the July Monarchy. Representations of the Little Corporal thus furnished a rallying point for republican-bonapartist contenders in both Paris and northeastern France.

12. Gabriel Perreux, *Aux Temps des sociétés sécrètes* (Paris: Hachette, 1946), 9: La Société des Amis du Peuple, in particular, denounced the snobbery of the bourgeoisie and pointed out the misery of the working classes. In addition to issues of economic justice, the organization was also committed to helping the working classes find access to basic literacy skills.

13. Marrinan, *Painting Politics for Louis-Philippe,* 147, 150; Perreux, *Aux Temps des sociétés sécrètes,* 19: The working classes wanted greater access to public power, but they also were committed to avenge France's humiliation in 1815. The same desire for military revenge pervaded the countryside, where commoners were disappointed that French armies had not crossed the Rhine again to chastise the German despots.

14. Paul-Marie Pierre Thureau-Dangin, *Histoire de la Monarchie de Juillet* (Paris: Plon, 1914), 2: 26–27: At the beginning of his reign, Louis-Philippe was determined to avoid any major dispute with the Quadruple Alliance, which had defeated Bonaparte in 1815. Through nonintervention in Spain and avoidance of any threatening alliances with liberal England, the king tried to court France's former enemies Austria, Prussia, and Russia.

15. Ibid., 2: 358: The debate over war and peace was resolved in October 1832, when the king and his ministry made a definite decision to avoid further armed confrontations in Belguim, Poland, or Italy.

16. Girard, *Les Libéraux français,* 37.

17. Perreux, *Aux Temps des sociétés sécrètes,* 347–48: Between 1834 and 1835, the republican press had been suppressed throughout France and by October 1835, every Parisian newspaper had been closed down, including the politically abrasive *National* and incendiary *Tribune des départements,* which was reproduced in many provincial towns and cities.

18. Thureau-Dangin, *La Monarchie de juillet* 2:442: According to historian Thureau-Dangin, by 1836 "la révolution est contenue, les émeutes écrasées, les clubs fermés, les sociétés secrètes dissoutes, la presse réprimée, la sécurité rétablie. Le gouvernement a reconquis sa force matérielle et une partie de son autorité morale; le crédit public est restauré, le commerce et l'industrie jouissent d'une prospérité sans précédent." [the revolution was contained, insurrections quelled, (dissident political) clubs closed, secret societies dissolved, the (dissident) press put down, and security reestablished. The government has reconquered its material strength, and to some degree, its moral authority; public credit was restored, (and) commerce and industry enjoyed a prosperity without precedent.]

19. Jean Baylot, *La Voie substituée* (Lièges: Éditions Borp, 1968), 256: When Masonic members became disenchanted with the reactionary policies of the Orleanist government, lodges tended to become a camouflage for other political movements that extended from republicanism to communism in the spirit of Cabet and Blanqui, to utopian doctrines influenced by the St. Simonians, Fourier, and Proud'hon.

20. Bossu, *Les Origines de la franc-maçonnerie dans les Vosges,* 29–31.

21. Aide-toi, le ciel-t'aidera was originally a liberal republican organization founded in 1827 to effect liberal reforms in the government through the electoral process. The *Sentinelle of the Vosges* advertised and solicited membership for what had become an aggressive republican organization during the early years of the July Monarchy.

22. Jean Bossu, *Quelques francs-maçons d'autrefois* (Epinal: Imprimerie Cooperative, 1960), 26: Les Droits de l'Homme was a liberal republican organization, founded in 1830, that encouraged legal process as a way to entertain political reform, while the more radical and sometimes violent Société des Amis du Peuple advocated social and economic reforms that favored the working classes. In 1832, Les Droits de l'Homme merged with Les Amis du Peuple, creating a much larger underground republican organization in Paris and the provinces that divided itself into sections of twenty or less persons to avoid political censure.

23. Freemason files, FM2 231 II, Département des Vosges, Salle des Manuscrits, Bibliothèque Nationale, Paris: "l'imprimeur Pellerin fils et l'ancien officier Pierre-Germain Vadet, qui, tous deux s'associèrent pour la gloire de notre imagerie."

24. Dumont, *Les Maîtres graveurs populaires,* 63. Though done with the style and flair of the master craftsman, the series of military portraits entitled *Les Gloires nationales* was not signed by Georgin.

25. Jean Chevalier and Alian Ghëerbrant, *Dictionnaire des symboles* (Paris: Robert Laffont, 1969), 12–16: For the Greeks, the laurel wreath that celebrated military victories and athletic contests was a symbol for immortality associated with the elusive Daphne and her predatory suitor Apollo.

26. As in most wood-block copies, the engraver reverses the direction of Napoleon's attention and semiprofile to the viewer's right instead of left, with his left rather than right hand tucked beneath a distinguished vest.

27. Jules Boucher, *La Symbolique maçonique* (Paris: Dervy-livres, 1948–85), 98, 101: While three columns supported the temple, two pillars marked the entrance for the initiate.

28. Seal for La Parfaite Union, found in Freemason file, FMP2 231 II, Epinal, Vosges, Salle des Manuscrits, Bibliothèque Nationale, Paris.

29. Boucher, *La Symbolique maçonnique*, 90.

30. Ibid., 223–34: The burning star meant that the initiate had reached the second stage of initiation.

31. Ibid., 234: "[l'étoile] c'est pour signifier l'homme libre, affranchi de l'authorité des dogmes de Dieu, n'acceptant pas d'autres lorsque celle de la raison et d'autres connaissances que celle de la science et de la science matérialiste."

32. Société d'Émulation dans les Vosges, P17 3, Archives Départementales des Vosges. In addition to his participation in La Parfaite Union, Nicholas Pellerin belonged to a sister organization called Société d'Émulation dans les Vosges that was organized in 1825 to further science, agriculture, and education by encouraging the practical resourcefulness of entrepreneurs in the department of the Vosges. The Société d'Émulation promised to recognize and reward individual businessmen who discovered engineering solutions to agricultural, industrial, or educational problems in the region.

33. Text from *L'Apothéose de Napoléon* (1834), Georgin, Thiébault, Pellerin, Epinal: "Aucun des grands hommes de toutes les époques et de tous les âges peuvent-ils être mis en parallèle avec l'Homme du XIX siècle? C'est au Créateur de l'Empire que la France doit ses lois, ses monuments, et sa gloire. Il l'a conduite au Temple de l'Immortalité."

34. George Levitine, *Girodet-Trioson: An Iconographical Study* (New York: Garland, 1978) 173–74: The Pellerin version of the *Apotheosis* was clearly derived from a painting done in 1802 entitled *The Ghosts of French Heroes Killed Serving the Nation during the War of Liberation* by Anne-Louis Girodet-Trioson. The emperor commissioned the work to commemorate officers and soldiers from Napoleon's armies recently deceased. Girodet rendered the painting of Ossian welcoming the heroes of the republican armies to celebrate the Treaty of Lunéville on 9 February 1801, which established peace between France, Austria, and Prussia. But Girodet's painting was also an obvious eulogy to French supremacy in Continental Europe.

35. Pilbeam, *The Revolution of 1830 in France*, 153–54: A national defense association was established in Metz, just to the north of Epinal, in February 1831, entitled Union des Départements de l'Est pour la Défense de la Patrie to solicit money, weapons, and securities for an imminent war on the eastern border. By the spring of 1831, a related organization called Association Nationale pour la Défense du Territoire, created in Metz, spread to Paris and to sixty departments throughout France.

36. Bossu, *Quelques francs-maçons d'autrefois*, 31: Most of the brothers who signed the manifesto for the Association later joined Vadet as editors for the controversial republican newspaper the *Sentinelle des Vosges*, later printed by Pellerin. These included: Brothers Adam, Dutac, Deblaye, Génin, Mougin, Beaurain, Guilgot, N. Clement, Turck, and the notorious carbonari leader Mathieu d'Epinal.

37. Gilles Durand, "La Vie politique dans le département des Vosges de 1830 à 1840 (Thesis, University of Nancy II, France, 1972), 49: Because the Association Nationale was centered in Paris, and its leaders were known to be contentious republicans such as Carrel, Salverte, and Béranger, the local administration tried to squelch its activities in the spring of 1831 by forbidding soldiers in active service to become members.

38. Pilbeam, *The 1830 Revolution in France*, 156.

39. Pierre-Germain Vadet to the prefect of Epinal, 24 November 1832, 8M14, Archives Départementales des Vosges. In his letter to the police chief, Vadet includes excerpts from a legitimist conspirator: "Je désire, Monsieur, que ce reseignement soit utile, non à la conservation du gouvernement actuel (car je suis entièrement de l'avis de ceux qui pensent que toutes les promesses de juillet n'ont pas été tenues) mais au maintien du Trône populaire dont j'en espère la réalisation, lorsque la marche rétrograde aura reçu un mouvement contraire."

40. Ibid. "Monsieur, le Préfet, Mon attachement au Trône national établi par la souveraineté du peuple en 1830 me porte à vous donner encore confidentiellement communication de la demande qui nous est faite d'une ville de la Bretagne sous la date du 20 de ce mois, d'estampes relatives à Henry V et à la Duchesse de Berry."

41. Prefect of the Vosges to the minister of interior, 26 November 1832, 8M14, Archives Départementales des Vosges. "M. Vadet a refusé de se charger de cette commande comme de la précédente, mais il a cru en même temps qu'il serait utile que le gouvernement fût informé de ce fait et c'est dans ce but qu'il me l'a communiqué." [M. Vadet refused to respond to this order as well as to to the preceding one, but he believed it would be useful for the government to be informed of this information and this is the reason that he told me about it.]

42. Text beneath *Chacun son metier* (1835), Georgin, Pellerin: "Il traverse la France, presque toujours porté en triomphe sur les bras de ses soldats. Partout la population l'accourut sur les routes pour le voir et le saluer par des cris d'allégresse et d'espérance."

43. Legend beneath *Chacun son metier* (1835), Georgin, Epinal: "Sire, excusez de la liberté. C'est que voyez-vous, je vous aime beau. . . . Quand vous êtes parti, et que j'eus vu les Bourbons prendre votre place, je m'ai trouvée très vexée. Maintenant que vous voilà—je vais vous dire ce qu'il faut que vous fassiez pour que la même chose n'arrive plus." Napoleon replied to the vegetable seller, "Ma bonne femme, chacun son métier. Mêlez-voux de vos affaires, vendez vos légumes, soignez vos chous et vos carrotes. Laissez-moi le soin de la politique, et tout ira pour le mieux s'il [sic] chacun fait ce qu'il doit.'"

44. The legend below the Pellerin illustration at first seems quite ingenuous. Note, however, the condescending tone of Napoleon's response to the peasant woman. The incident could be a parody of Napoleon's treatment of Mme de Staël, and his annoyance with her attempt to become involved in French politics during the Imperial regime. Her political and literary audacity meant she was repeatedly prohibited from living in Paris and was eventually exiled to her father's estate in Switzerland.

45. *Annuaire Départementale des Vosges, 1830–1842*, 11 vols., JPL 726, Archives Départementales des Vosges. The commander of the Vosges and Meurthe et Moselle was stationed in Nancy.

46. Ibid., vols. 1831–42. In 1830, the Vosges furnished 1,002 recruits for the Orleanist army; in 1831, 1,006; in 1832, 1,008; in 1835, 1,018; in 1836, 1,657; in 1839, 1067; in 1840, 1,045.

47. Ibid., vols. 1835–40. The garrison began to house one regiment per year after 1835, indicating additional pre-

cautions added after several attempted uprisings against the government in the Vosges.

48. Ibid., vol. 1835, 81–88: In addition to physical infirmities, candidates for the military were examined for their level of literacy. (i.e., those who could read; those who could write; those who could read and write). Total illiteracy—inability to read or write—were grounds for dismissal from the army. For example, in the total class for 1834 of 4,500, 2,905 had some degree of literacy, while 928 could neither read nor write. The army encouraged local cantons to take more responsibility for the education of young people in order to prepare them for military service.

49. Prefect, Henri Simeon to the minister of interior, Montalivet, 2 March 1831, 8 bis M4, Archives Départementales des Vosges.

50. Minister of interior, the Duke de Broglie, to Prefect Simeon on 20 August 1832, 8M 184, Archives Départementales des Vosges.

51. Perrout, *Les Images d'Epinal*, 65: According to René Perrout, Nicholas Pellerin was: "Un bourgeois simple, paisible et considéré, l'homme qui s'avance dans la vie d'un pas tranquille et sûr. Il était régulier, méthodique, et tenace . . . élevé dans l'imprimerie, il en savait les secrets . . . ce fut son oeuvre ininterrompue de transformer et moderniser d'outillage, d'améliorer les procédés." [A simple bourgeois, moderate and considerate, a man who advanced in life with a steady and sure pace. He was reliable, methodical, and tenacious. Being raised in the printing business, he knew its secrets. His ceaseless work (of art) was to transform and modernize the (firm's) equipment, and to improve its proceeds.]

52. Prefect of Epinal to the minister of interior, 22 October 1832, 9bis M, Archives Départementales des Vosges: "C'est Pellerin qui se charge désormais de la publication [of the *Sentinelle*]. Ce conseiller municipal d'Epinal ne s'est engagé . . . probablement qu'à des conditions qui mettront ses intérêts à couvert et qui laisseront un droit de surveillance sur la rédaction de cette feuille." [It is Pellerin who henceforth takes charge of the publication (of the Sentinelle). This municipal councilor from Epinal probably only took on this task for reasons that will indirectly benefit his own affairs and that will permit some editorial control over this paper.]

53. This announcement may have quieted the authorities, but Turck soon returned to the editorial board of the *Sentinelle* using the nom de plume Le Solitaire des Vosges.

54. Bossu, *Les Origines de la franc-maçonnerie dans les Vosges*, 31: According to Masonic historian Bossu, "Les lois de la charbonnerie sont une transposition sur le plan politique de la maçonnerie tout court." [The laws of the carbonari are simply a transposition of Free masonry into the political sphere.]

55. Durand, "La Vie politique dans le département des Vosges," 45–46.

56. See Masonic membership lists for 1786–1829, FM 2 231 II, Epinal, Vosges, Salle des Manuscrits, Bibliothèque Nationale, Paris.

57. Bossu, *Les Origines de la franc-maçonneirie dans les Vosges*, 25–27.

58. Durand, "La Vie politique dans le département des Vosges." After an exhaustive study of the electoral and representative list from the Vosges, Durand reached this most telling conclusion.

59. Though the Georgin print was undoubtedly inspired by a painting done by Charles Steuben for the Salon of 1831 (engraving by Pierre-Marie Jazet), the message in the Pellerin legend is more politically didactic than the romantic metaphor of the exiled leader being welcomed back by his former troops.

60. Text beneath the illustration for *Le Retour de l'île d'Elbe* (1833), Georgin, Pellerin: "L'empereur, instruit que le peuple, en France, avait perdu tous ses droits acquis par vingt-cinq ans de combats et de victoires, et que l'armée était attaquée dans sa gloire, résolut de faire changer cet état des choses et de rétablir le trône Impérial."

61. Text beneath *Le Retour d'île d'Elbe*: "Le trône des Bourbons est illégitime, parce qu'il n'a pas été élevé par la volonté du peuple. . . . 'Oui, *Vous êtes la Grande Nation.*'" Note: By 1833, the government had refused to change the electoral law that required a 500 franc tax minimum for a political candidate and a 200 franc minimum for the right to suffrage. Essentially, this limited parliamentary candidates to members of the financial aristocracy or wealthy notables, and the electorate to a limited group of propertied elite and civil servants who could afford the tax franchise.

62. Legend beneath *Le Retour de l'île d'Elbe*: "Les paysans, instruits de son arrivée accouraient de tous côtés, et manifestaient leurs sentimens [sic] avec la plus grande énergie. Des populations entières se pressaient sur son passage."

63. Text beneath *Le Retour d'île d'Elbe*: "Les soldats arrâchaient leurs cocardes et la larme à l'oeil, ils prenaient avec enthousiasme la cocarde tricolore, 'il y a longtemps que nous vous attendions' disaient tous ces braves gens à l'Empereur. 'Vous voilà enfin arrivé pour délivrer la France de l'insolence de la noblesse, des prétentions des prêtres et de la honte du joug de l'étranger.'"

64. Editorial, *Sentinelle des Vosges*, no. 177, November 1832, 1.

65. Editorial, *Sentinelle des Vosges*, no. 145, 11 July 1832, 1.

66. Editorial, *Sentinelle des Vosges*, no. 198, 15 January 1833: "La noblesse est née du pouvoir absolu; c'est un de ses enfants le plus monstrueux; C'est celui auquel il a dévolu les titres, les dignités, les privilèges, le pouvoir à l'exclusion et au mépris de tous les autres associés."

67. Editorial, *Sentinelle des Vosges*, no. 192, 26 December 1832, 2.

68. Ibid., "Comme les doctrinaires ne sont séparés des légitimistes purs que par des nuances très légères."

69. Editorial, *Sentinelle des Vosges*, no. 179, 10 November 1832, 1–2.

70. *Sentinelle des Vosges*, no. 175, 27 October 1832, 3.

71. *Sentinelle des Vosges*, no. 181, 17 November 1832, 3.

72. Editorial, *Sentinelle des Vosges*, no. 174, 24 October 1832, 1: "Alternativement, Bourbonien ou Napoléonien, attaché à tous les partis, vainqueurs, monomanie du pouvoir, idolâtre de titres et de dignités."

73. Editorial, *Sentinelle des Vosges*, no. 197, 12 January 1833, 3.

74. *Sentinelle des Vosges*, no. 176, 31 October 1832, 1: "On nous, joue, nous le répétons, nous sommes joués et peut-être trahis."

75. Ibid. This was the second paper published by Pellerin: "La guerre donc! Puisqu'elle entraînera forcement toutes nos nullités diplomatiques dans une chute inévitable."

76. Editorial, *Sentinelle des Vosges*, no. 130, 19 May 1832, 3: "Tout soldat est citoyen et tout citoyen devient soldat."

77. *Sentinelle des Vosges*, no. 175, 1832, 2: "Il fût un temps, temps de glorieux souvenirs où le soldat français ne connaissait pas ce commandement 'en arrière, marche.'"

The editor continues, "Dites vieux guerriers, soldats de la république et de l'empire, vous qui vainqueurs avez mesuré de votre regarde intrépide la hauteur des pyramides."

78. While French troops had moved into Belgium in the fall and winter of 1832, and had successfully taken over the garrison of Anvers from the Dutch, Louis-Philippe withdrew French soldiers in the spring of 1833, leaving Belgium prey to the ambitions of Holland and Prussia. After Russia invaded Poland in September 1831, France also refused to intervene militarily to protect her former ally.

79. Editorial, *Sentinelle des Vosges*, no. 191, 22 December 1832, 1.

80. Legend beneath *The Battle of Lutzen* (1833), Georgin, Pellerin: "Jamais l'empereur ne s'était montré plus audacieux: il semblait avoir établi son quartier-général au foyer même du danger. Il vit tout périr autour de lui. . . . 'Allez à Cracovie, et dites que j'ai gagné la bataille.' "

81. Text for the Parisian print *Le Nouveau Pont d'Arcole,"* (The New Bridge of Arcole) chez Cereghetti, Qb1, M 110798, "Histoire de France," Collection da Vinck, 28 July 1830, Cabinet des estampes, Bibliothèque Nationale de France: "Mes amis, si je meurs, souvenez-vous que je me nomme Arcole."

82. Text beneath *Passage du Pont d'Arcole* (1833), Georgin, Pellerin. "Grenadiers, qu'est devenue votre ancienne valeur? N'êtres-vous donc plus les vainqueurs de Lodi, et ne suivez-vous pas votre général? à ses mots, chaque soldat, honteux de l'hésitation commune répond par des cris de 'Vive la liberté!' "

83. Durand, "La Vie politique dans le département des Vosges," 89–91. In addition to penalizing the paper repeatedly for slander against the government, the local authorities in Epinal attacked the editors Turck and Gerbaut of the *Sentinelle* for professional misconduct in their former professions, respectively as doctor and notary.

84. Prefect Baron Henri Simeon to the minister of interior, 3 September 1833, 8M 184, Archives Départementales des Vosges: According to the police chief, the closure of the republican newspaper *la Sentinelle des Vosges* the preceding spring had averted serious political troubles in the region.

85. Bossu, *Les Origines de la franc-maçonnerie dans les Vosges*, 24.

86. Léopold Turck, *Almanach du peuple, 1833*, Special Collections, Bibliothèque Municipale de Nancy, 72. At the end of each almanac, there was usually a dialogue between Père Simon, a peddler and advocate of the farmer, with fictional characters who were critical of the poor. For example, in the almanac for 1833, a bourgeois condemns the people for laziness and lack of resourcefulness. Simon reproves the speaker by explaining the effect of government tax abuse on the subsistence farmer.

87. Athanassoglou-Kallmyer, "Sad Cincinnatus," 83.

88. Text on the cover of the *Almanach du peuple pour l'année bissextil 1832*, Pellerin, Special Collections, Bibliothèque Municipal de Nancy: "Tous les hommes sont égaux devant Dieu; Ils doivent l'être, et, en France, ils ne le sont pas encore devant la loi."

89. Perreux, "Aux Temps des sociétés secrètes," 326–27.

90. Legend beneath the *Bataille de Marengo* (1834), Georgin, Pellerin, Epinal: "Français s'écrie-t-il, c'est avoir fait trop de pas en arrière; le moment est venu de faire un pas en avant. Souvenez-vous que mon habitude est de coucher sur le champ de bataille." From Tissot, *Trophées des armées françaises* 4:68. The textual commentaries for the illustrations in the Tissot book were edited versions or excerpts

from the "Bulletins de la Grande Armée" written by Napoleon to his soldiers. For the original "Bulletins," See Alexandre Goujon, *Bulletins officiels de la Grande Armée* (Paris, 1821).

91. Text beneath *Passage du pont d'Arcole*: "le second bataillon en tête, et suivie par tous les bataillons de grenadiers, elle s'avance au pas de charge et aux cris de 'Vive la République!' " [The second battalion in front, followed by all the battalions of grenadiers [the army] charges forward with shouts of 'Long live the Republic.']

92. H. A. C. Collingham and R. S. Alexander, *The July Monarchy: A Political History of France, 1830–1848*, (London and New York: Longman, 1988) 159–60: During the outbreak of violence in Lyon (April 1834), revolts also occurred in Clermont-Ferrand, Grenoble, Chalons-sur-Saône, Vienne, and Lunéville, just to the north of Epinal. On 12 and 13 April, while violence was occurring in the capital and in Lunéville, groups of officers associated with the garrisons in Epinal and Nancy attempted to organize a military coup against the government. But the coup was discovered and instigators put in prison as St. Pélagie in Paris.

93. Ibid., 161–62: Out of the original two thousand who were indicted, 59 were Lyonaise and 42 Parisiens.

94. While *Sentinelle* editors Turck and Gerbaut were arrested and then released after the April insurrections, only Mathieu, notorious leader of Les Amis du Peuple from Epinal and instigator of the military insurrection at Lunéville, was convicted for life of conspiracy against the government and imprisoned until 1837, when he was put on probation for life.

95. Legend beneath *Le Débarquement de Napoléon* (1835), Pellerin, Epinal: "Le premier mars, à trois heures de l'aprésmidi la flottille de l'île d'Elbe entre dans le golfe de Juan, quitte le pavillon blanc parsemé d'abeilles, et reprend la cocarde tricolore aux cris de 'Vive la France! Vivent les Français!"

96. Legend beneath *Le Débarquement de Napoleon*: "'Grenadiers, dit-il, alors, nous allons en France, nous allons à Paris!' Les grenadiers l'auraient suivi partout."

97. Legend beneath *L'Entrée de Napoléon à Grenoble* (1835), Georgin, Pellerin, Epinal: "Dès qu'il fut à portée, il arrête ses grenadiers, et seul s'avança d'un air calme. Les soldats de Grenoble se préparaient à faire feu, mais lui découvrant sa poitrine et les fixent avec fierté: 'C'est moi—leur dit-il, reconnaissez-moi! S'il en est parmi vous qui veuille tuer son empereur, il le peut—son heure est venue.' "

98. Excerpt from the legend for *L'Entrée de Napoléon à Grenoble*: "Tant de confiance les vainquît, et ils coururent embrasser ceux qu'ils voulaient combattre. La multitude brisa les portes . . . et courut faire hommage à Napoléon qui fit son entrée dans la ville, à dix heures du soir."

99. "Cris et placards séditieux" (1834–35), BB18 1225, Archives Nationales, Paris.

100. "Cris et placards séditieux" (1836–37), BB18 1240–47, Archives Nationales, Paris.

101. Collingham and Alexander, *The July Monarchy*, 166.

102. "Debate on the Censorship Law of 1835," *Archives Parlementaires, 1800–1860*, no. 2 (Paris: Dupont, 1899), 98: 537: "Le but de la lois . . . c'est de tuer la mauvaise presse, la presse anarchique, républicaine, royaliste . . . ou pour mieux dire, la presse hostile."

103. Ibid., 257–59.

104. Prefect of Epinal to the minister of interior, March 1836, 8T 36, Archives Départementales des Vosges.

105. While it is clear that veteran Pierre-Germain Vadet maintained a passionate allegiance to the person and mem-

ory of Napoleon Bonaparte, Nicholas Pellerin, raised in a liberal Masonic household, appeared to support this venture only so long as bonapartist representations appeared to endorse the republican cause.

106. Dépôt légale, 8T12, Archives Départementales des Vosges, Epinal. In 1832, Pellerin requested authorization for four new Napoleonic designs in 1831 and 20,000 copies; in 1832 for four new designs and 20,000 copies; for sixteen designs in 1833 with 80,000 copies; five new themes in 1834 for 25,000 prints; sixteen new themes in 1835 for 55,000 prints; and seven Napoleonic themes in 1836 for 180,000 copies.

107. To increase the longevity of his wood-block designs, Pellerin cast many of his compositions in a steel mold (stereotyping) that included the image and the textual commentary.

108. Information for the Metz images found in *L'Imagerie Messine, 1838–1871*. For Deckherr Brothers of Montbéliard see *"Catalogue raisonné de l'oeuvre des Deckherr de Montbéliard"* (Montbéliard: Archives de Montbéliard, n.d.).

## Epilogue

1. Driskel, *As Befits a Legend*, 42–58: A bitter conflict over the location of the tomb had preceded the selection of the Invalides. Some members of the government commission felt that Napoleon should rest with the other kings of France, in the Basilica of St. Denis, or with the heroes of the French Revolution, in the Pantheon. The Vendôme column was the preference of veteran soldiers and democrats who wanted Napoleon's tomb to be open and accessible to the people, while more conservative groups felt that the Madeleine Church or the hill at Chaillot was an appropriate site for Napoleon's remains.

2. Jean Tulard, "Le Retour des cendres," in *Les Lieux de mémoires* (Paris: La Nation, 1986), 2:102.

3. Victor Hugo, *Choses vues: Souvenirs, journaux, cahiers, 1830–1846*, ed. Hubert Juin (Paris: Gallimard, 1972), 1:192.

4. Driskel, *As Befits a Legend*, 25–26.

5. Ibid., 31–32.

6. Hugo, *Choses vues*, 199: "On a laissé dans l'ombre tout ce qui eût été trop grand ou trop touchant. On a dérobé le réel et la grandiose sous des enveloppes plus ou moins splendides; on a escamoté le cortège impérial dans le cortège militaire; on a escamoté l'armée dans la garde nationale; on a escamoté les chambres dans les Invalides; on a escamoté le cercueil dans le cénotaphe." [They (the government) screened off anything that might be too remarkable or moving. They disguised what was genuine and majestic with an exterior that seemed lavish. They avoided an Imperial funeral with a military cortege; they eluded the army with the national guard; They circumvented the Chambers (lower house of parliament) with the Invalides (home for veterans); they pilfered the coffin and (instead erected) a cenotaph.]

7. The five prints included: *Exhumation des cendres de Napoléon, Char funèbre de Napoléon, Translation des cendres de Napoléon aux Invalides, Napoléon aux Invalides,* and *Intérieure de l'église des Invalides transformé en chapelle ardente pour les restes mortelles de l'empereur Napoléon.* The Pellerin woodcuts, such as *Translations des cendres de Napoléon* were obviously copies of Parisian engravings, such as the Guérard lithograph showing the *Arrival of the Ashes of Napoleon I in Paris.*

8. *Tribune Vosgienne: Journal des intérêts de tous,* edited by Pellerin (June 1848–November 1848), special collections, Bibliothèque Municipale de Nancy. In the newspaper that Pellerin published and edited from April to November 1848, the *Tribune Vosgienne,* the printer maintained a very firm republican position that promoted liberal freedoms, representative government, and institutional reforms through electoral process. The editorials reveal that Pellerin was a proponent of the entrepreneurial bourgeoisie who believed in family, property, and public order as the basis for a productive society. It is not surprising then, that after the June Days, Pellerin came out very strongly against working-class demonstrations and supported Cavaignac and not Louis-Napoleon in the elections of 1848. Because of his republican predisposition, Pellerin feared the imminent revival of another despotic system under Louis-Napoleon Bonaparte.

9. The description for the pilgrimage to Dijon was taken from a pamphlet by M. J. Trullard, *Souvenirs de l'inauguration du monument érigé à Napoléon en Bourgogne, 1847* (Dijon: Guasco-Jobard, 1847).

10. Louis-de Bousses de Fourcaud, *François Rude, sculpteur: Ses oeuvres et son temps, 1784–1855* (Paris: Librairie de l'art ancien et moderne, 1904), 300–301: In addition to a contingent of 300 veteran soldiers from Dijon, artillery troops from Beaune and d'Auxonne, plus the local national guard and gendarmerie, more than 10,000 peasants came to witness the inauguration of the statue. According to François Rude and Claud Noisot in a pamphlet entitled "Notice sur le monument élévé à Napoléon à Fixin (Côte d'Or)" (Dijon: Imprimerie Loireau-Feuchot, 1847), 22, that evening, more than 20,000 people (including both middle class and peasants) celebrated the event with dances and games.

11. Ibid., 292: When Captain Noisot met François Rude at the celebration for the Return of Ashes, he invited the artist to come to Fixin, where the veteran had purchased property for a shrine to Napoleon. Fourcaud cites an excerpt from *Journal de la Côte d'Or, Courrier de la Côte d'Or,* and *le Spectateur,* 19 and 21 September 1847, where Noisot lamented the lack of any satisfactory representation of his beloved Napoleon: "Comprenez-vous, mon cher Rude, dit-il brusquement, qu'il n'y ait pas, dans mon pays, un tableau, une figure, un monument, qui rappel à mes yeux mon empereur." [Do you understand, my dear Rude, he said abruptly," that in my country we don't have a painting, a portrait, or a monument that reminds me of my emperor.] At that time the tomb of the Invalides had not been completed, and no statue of the emperor graced the famous basilica.

12. Trullard, *Souvenirs de l'inauguration du monument érigé à Napoléon,* 6: Trullard described the pilgrim's approach to the shrine: "On se dirige vers un côteau-rapide, couverts des rochers, nu jusqu'au sommet, sorte de Calvaire, mais auquel se lient le Mont de Oliviers et le Jardin de la Résurrection." [One makes one's way toward a sharply rising hillside, covered with rocks, stark to the summit, a sort of Calvary, but that connects the Mount of Olives and the Garden of the Resurrection.]

13. Dressed as a cavalryman, Napoleon wore the most characteristic accoutrements of the Little Corporal: the bicorne hat from Eylau, his greatcoat from the Battle of Marengo, and the sword from Iena.

14. Fourcaud, *François Rude et son temps,* 296–97. Beneath the shadow of his coat the artist placed Napoleon's

bicorne hat and his famous sword. Bonaparte wears a civic crown of leaves etched with Napoleon's conquests in Italy, including Rivoli, Lodi, Campo-Formio, and Arcole.

15. Trullard, *Souvenirs de l'inauguration du monument érigé à Napoléon*, 24, 38.

16. Ibid., 27: "La Nuit arriva, et après un feu d'artifice, la foule, emportant dans son coeur et dans son imagination la représentation de la figure de Napoléon, se répandit sur toutes les routes en chantant la Marseillaise, des odes de Béranger, et d'autres hymnes nationaux."

17. Frank Bowman, *French Romanticism: Intertextual and Interdisciplinary Readings* (Baltimore: Johns Hopkins University Press, 1990), 34–61: Bowman points out how Napoleon was treated as a type of Logos figure or messiah by illuminist and evadist writers in the 1840s. During this period, the writings of Wronski, Adam Mickiewicz, and André Towiansky described the messianic impact of Napoleon on French history for a more selective audience. But some of these messianic ideas were translated by Etienne Cabet and A. L. Constant into a revolutionary doctrine for artisans and working classes. The Dijon pilgrimage demonstrates, moreover, how the representation of a deified Napoleon was not simply the idiosyncratic dream of a veteran soldier but was also a vision that inspired provincial residents during the latter years of the July Monarchy.

18. Dubreton, *Le Culte de Napoléon*, 406: Notably, no officials from the Orleanist government were in attendance at the unveiling of the statue; rather, the shrine was a demonstration of the devotion of veteran soldiers, such as Noisot, as well as residents from regional France.

19. Ménager, *Les Napoléon du Peuple*, 89: Louis-Napoleon Bonaparte also continued to write short treatises such as *La Question des sucres* to protect the domestic sugar industry and short articles in the *Guetteur de Saint Quentin* and the *Progrès du Pas-du-Calais* from 1842 to 1845 that criticized corruption, privilege, and patronage in the Orleanist government.

20. Tudesq, *L'Élection présidentielle de Louis-Napoléon Bonaparte*, 253: Tudesq includes a table of electoral results for the entire nation. Urban (bourgeois) areas tended to vote for Cavaignac and rural areas for Louis-Napoleon Bonaparte. For example, the department of the Vosges gave Bonaparte an 82 percent vote, and the neighboring Haute Marne, 88 percent, while the adjacent department of the Aube gave the emperor's nephew a 92 percent majority.

# Select Bibliography

## Primary Sources

### Archival

Archives de Chamagne. Chamagne, France.

Archives Départementales des Vosges. Epinal, France.

Archives Municipales de Bordeaux. Bordeaux, France.

Archives Nationales. Paris, France.

Bibliothèque Municipale de Nancy. Nancy, France.

Bibliothèque Municipale de Troyes. Troyes, France.

Biliothèque Nationale de France. Paris, France.

Personal Collection, *Sentinelle des Vosges* (1831–32). Jean-Goery Janot. Epinal, France.

### Museum

Cabinet des Estampes, Bilbiothèque Nationale de France. Paris, France.

Collection de l'Imagerie d'Epinal. Archives Départementales des Vosges. Epinal, France.

Fondation-Dosne Thiers, Bibliothèque Thiers de Paris. Paris, France.

Hagley Museum and Library. Wilmington, Delaware.

Musée de l'Armée, Hotel National des Invalides. Paris, France.

Musée des Arts et Traditions Populaires. Bois de Boulogne, France.

Musée Départementale d'Art Ancien et Contemporain. Epinal, France.

Winterthur Museum and Library. Wilmington, Delaware.

## Published Sources

Adhémar, Jean. *Imagerie populaire française.* Milan: Electra, 1968.

Agulhon, Maurice. *Pénitents et francs-maçons de l'ancienne Provence.* Paris: Fayard, 1968.

———. "Le Problème de la culture populaire en France autour de 1848." *Romantisme* 9–10 (spring 1975): 64–72.

———. *The Republican Experiment, 1848–1852.* Translated by Janet Lloyd. Cambridge and London: Cambridge University Press, 1983.

Agulhon, Maurice, Gabriel Desert, and Robert Specklin. "Attitudes politiques." In *La France rurale,* vol. 3, edited by Georges Duby, 143–75. Paris: Editions du Seuil, 1976.

Albouy, P. *Mythes et mythologies dans la littérature française.* Paris: Armand Colin, 1969.

Alexander, R. S. *Bonapartism and the Revolutionary Tradition in France: The Fédérés of 1815.* Cambridge: Cambridge University Press, 1991.

Allen, James Smith. *Popular French Romanticism: Authors, Readers, and Books in the Nineteenth Century.* Syracuse, N.Y.: Syracuse University Press, 1981.

*Annuaire Départementale des Vosges 1830–1840.* 11 vols, Epinal: Archives Départementales des Vosges.

Antommarchi, F. *Les Derniers Moments de Napoléon, 1819–1821.* Paris, 1825.

Ardèche, P. M. Laurent de. *Histoire de l'empereur Napoléon.* Illustrated by Horace Vernet. Paris: J. J. Dubochet et Cie, 1859.

Ariès, Philippe. "L'Histoire des mentalités." In *La Nouvelle histoire,* edited by Jacques Le Goff, Roger Chartier, and Jacques Revel. Paris: CEPL, 1978.

———. "La Religion populaire et reformes religieuses." *Maison Dieu* 122 (1975): 84–97.

Aron, Jean Paul, Paul Dumont, and E. Le Roy Ladurie. *Anthropologie d'un conscript français.* Paris: Mouton, 1972.

Assier, Alexandre. *La Bibliothèque bleue depuis Jean Oudot premier jusqu'à M. Baudot, 1600–1869.* Paris: Champion libraire, 1874.

Athanassoglou-Kallmyer, Nina Maria. *Eugene Delacroix: Prints, Politics, and Satire, 1814–1822.* New Haven: Yale University Press, 1991.

———. "Sad Cincinnatus: 'Le Soldat Laboreur' as an Image of the Napoleonic Veteran after the Empire." *Arts Magazine* 60 (May 1986): 65–77.

Aubrey, Octave. *Napoléon.* Paris: Flammarion, 1936.

Auger, Victor. *L'Empereur.* Paris: Jules d'Agneau, 1853.

Aynaud, Adolphe. "L'Imagier inconnu de Metz [Jean Wëndling]." In *Le Vieux Papier,* 1–11. Paris, 1954.

———. "Notes sur l'imagerie de Nancy." In *Le Vieux Papier,* 1–7. Paris, 1957.

———. "Les Thiébaults, graveurs nanciens." In *Le Vieux Papier,* 1–8. Paris, 1955.

Balzac de, Honoré. *The Country Doctor.* Translated by Ellen Marriage. London: J. M. Dent and Sons, 1961.

————. *Les Paysans*. Paris: Gallimard, 1975.

Barberis, Pierre. "Napoléon: Structures et signification d'un mythe littéaraire." *Revue d'histoire littéraire de la France*, 5–6 (1970): 1031–58.

Barbier, Pierre, and France Vernillat. *Histoire de France par les chansons*. Paris: Gallimard, 1958.

Barrès, Jean-Baptiste. *Memoirs of a Napoleonic Officer*. Edited by Maurice Barrès, translated by Bernard Miell. London: Greenhill Books, 1988.

Baylot, Jean. *La Voie substituée*. Lièges: Editions Borp, 1968.

Beauroy, Jacques, Marc Bertrand, and Edward Gargan, eds. *The Wolf and the Lamb: Popular Culture in France*. Paris: Anima Libri, 1976.

Beauterne, M. de. *Conversations religieuses de Napoléon*. Paris: Lacy, 1840.

Becquevort, Raymond. *Les Colporteurs d'Arconsat au dix-neuvième siécle*. Clermont Ferrand: Auvergne, 1975.

Bénézit, Edmund. *Dictionnaire critique et documentaire des peintres, sculpteurs, dessinateurs et graveurs*. Vols. 2 and 8. Paris: Librairie Grund, 1976.

Benjamin, Walter. *Illuminations*. New York: Harcourt, Brace, and World, 1968.

Beraldi, Henri. *Raffet, peintre national*. Paris: Librairie illustrée, St. Joseph, 1982.

Béranger, Pierre-Jean de. *Oeuvres complètes*. Vols 1–3. Paris: Fournier, 1834–37.

————. Oeuvres complètes. Vols. 1–2, Paris: Perrotin, 1858.

Bercé, Yves-Marie. *Fête et révolte: Des Mentalitées populaires du seizième au dix-huitième siècles*. Paris: Hachette, 1976.

Berenson, Edward. *Populist Religion and Left-Wing Politics in France, 1830–1852*. Princeton: Princeton University Press, 1984.

Bergeron, Louis. *L'Episode Napoléonien*. Paris: Editions du Seuil, 1972.

Bertrand, Henri Gratien. *Cahiers de Sainte Hélène*. Paris: Paul Fleuriot de Langle, 1959.

Bertrand, Louis. *Histoire de Napoléon*. Paris: Marne, 1969.

Besson, Elisabeth. "Les Colporteurs de l'Oisans au dix-neuvième siècle." In *Le Monde Alpin et Rhodanien-revue régionale d'ethnologie*. Grenoble: Musée Dauphinois, 1975.

*La Bibliothèque bleue*. Univesita di Bari, Roma e Ferrara, Facolta di Lingue,; Facolta dei Magistero. Paris: Bari/Nizet, 1981.

Bloch, Marc. *The Royal Touch: Scrofula in England and France*. Translated by J. E. Anderson. London: Routledge and Paul Kegan; Montreal: McGill University Press, 1973.

Bluche, Frédéric. *Le Bonapartisme*. Paris: Presses universitaires de France, 1981.

Boime, Albert. *Art in the Age of Bonapartism, 1800–1815*. Chicago and London: University of Chicago Press, 1991.

————. *Hollow Icons: The Politics of Sculpture in Nineteenth-Century France*. Kent, Ohio, and London: Kent State University Press, 1987.

Bois, Paul. *Les Paysans de l'Ouest*. Paris: Flammarion, 1971.

Bollème, Geneviève. *Les Almanachs populaires au dix-septième et dix-huitième siècles*. Paris: Le Haye, 1969.

————. *La Bible bleue*. Paris: Flammarion, 1975.

————. *La Bibliothèque bleue: La Littérature populaire en France du seizième au dix-neuvième siècle*. Paris: Julliard, 1971.

————. "Littérature populaire et littérature de colportage au dix-huitième siècle." in *Livre et société dans la France du dix-huitième siècle*, 61–91. Paris: Mouton et Cie, 1965.

Bonnet, Serge. *Prières secrètes des français*. Paris: Les Editions du Cerf, 1976.

Bossu, Jean. *Les Débuts de la franc-maçonnerie dans les Vosges*. Epinal: Imprimerie coopérative, 1972.

————. *Les Origines de la Franc-Maçonnerie dans les Vosges Deuxième Parite, 1804–1847*. St. Die: Thouvenin, 1953.

————. *Quelques francs-maçons d'autrefois*. Epinal: Imprimerie Cooperative, 1960.

Bouchard, Gérard. *Le Village immobile: Sénnély en Sologne au dix-huitième siècle*. Paris: Librairie Plon, 1972.

Boucher, Jules. *La Symbolique maçonnique*. Paris: Dervy-Livres, 1948–85.

Bourgogne, Adrian Jean Baptiste François. *Memoirs of Sergeant Bourgogne, 1812–1813*. Edited by Paul Cottin. New York: Doubleday and McClure, 1899.

Bourguignon, Jean. *Le Retour des cendres, 1840*. Paris: Plon, 1941.

Bourrienne, *Mémoires de Bourrienne, Ministre d'état sur Napoléon*. 10 vols. Paris: Advocat, 1830.

Bowman, Frank Paul. *French Romanticism: Intertextual and Interdisciplinary Readings*. Baltimore: Johns Hopkins University Press, 1990.

————. "Napoléon et le Christ." In *Le Christ romantique*. Geneva: Librairie Droz, 1973.

————. "Napoléon et le Christ." *Europe* 222 (April 1969): 82–105.

Brettell, Richard R. *French Salon Artists, 1800–1900*. New York: H. N. Abrams, 1987.

Brochon, Pierre. *Béranger et son temps*. Paris: Editions sociales, 1961.

————. *La Chanson sociale de Béranger à Brassens*. Paris: Les Editions ouvrières, 1961.

————. *Le Livre de colportage en France depuis le seizième siècle: Sa Littérature, ses lectures*. Paris: Grund, 1954.

Bry, Auguste. *Raffet: Sa Vie et ses oeuvres*. Paris: E. Dentu, 1861.

Burns, Michael. *Rural Society and French Politics: Boulangism and the Dreyfus Affair*. Princeton: Princeton University Press, 1984.

Las Cases, Comte Emmanuel Dieudonné de. *Mémorial de Sainte Hélène*. Illustrations by Charlet. Paris: E. Bourdin, 1842.

————. *Mémorial de Sainte Hélène*. Vols 1 and 2. Paris: Laffont, 1981.

———— *Mémorial de Sainte-Hélène: Journal de la vie privée et des conversations de l'empereur Napoléon à Ste. Hélène*. London: Colburn, 1823.

Montholon, Bertrand, Las Cases, Gourgaud. *Napoléon à Sainte Hélène: Textes, préfaces, choisis et commentés*. Edited by Jean Tulard. Paris: Robert Laffont, 1981.

*Catalogue raisonné de l'oeuvre des Deckherr de Montbéliard*. Montbéliard: Archives de Montbéliard.

Certeau Michel de. *L'Écriture de l'histoire*. Paris: Gallimard, 1975.

Champfleury, [Jules-François Felix Husson] *Histoire de l'imagerie populaire*. Paris: E. Dentu, 1879.

———. *Henry Monnier: Sa Vie et son oeuvre.* Paris: Dentu, 1879.

Chartier, Roger. *Cultural History: Between Practices and Representations.* Translated by Lydia G.Cochrane. Ithaca: Cornell University Press, 1988.

———. "Culture as Appropriation: Popular Cultural Uses in Early Modern France." In *Understanding Popular Culture.* Edited by Steven Kaplan. Berlin, New York, Amsterdam: Mouton, 1984.

———. *Figures de la gueuserie.* Paris: Montalba, 1982.

———. *Practiques de la Lecture.* Paris: Editions Rivages, 1985.

Charton, Charles. *Annuaire administratif et statistique des Vosges pour 1834.* Epinal: Imprimeur de la Préfecture, 1834.

———. "Histoire Vosgienne: Souvenirs de 1814 à 1848." *extraite des Annales de la Société d'Emulation des Vosges.* Vol. 4. Epinal: Giley, Collot, 1870–74.

———. *Les Vosges pittoresque et historique.* Mirecourt: Chassel, 1862.

Charton, Charles, and H. Lepage. *Le Département des Vosges, statistique, historique, et administrative.* Epinal: Gérard, Gley, 1845.

Charton, Charles, and M. Ravignat. *Revue pittoresque, historique, et statistique des Vosges.* Epinal: Ponton fils, 1841.

Chateauvieux, F. J. Lullin de. *Manuscrit venu de Sainte Hélène d'une manière inconnue.* Edited by Jean Rumilly. Paris: Horizons de France, 1947.

———. *Manuscrit venue de Sainte Hélène d'une manière inconnue* Paris: Gallimard, 1974.

Chevalier, Jean, and Alain Ghëerbrant. *Dictionnaire des symboles.* Paris: Robert Laffont, 1969.

Cholvy, Gérard. "Le Catholicisme populaire en France au dix-neuvième siècle." In *Le Christianisme populaire,* edited by Bernard Plongeron and Robert Pannet. Paris: Musée des Arts et Traditions Populaires, 1977.

———. "Réalités de la religion populaire dans la France contemporaine du dix-neuvième au vingtième siècles." In *La Religion populaire.* Edited by Bernard Plongeron. Paris: Editions Beauchesne, 1976.

Choury, Maurice. *Les Grognards de Napoléon.* Paris: Librairie academique Perrin, 1968.

Choux, Jacques. "Notice sur une boîte de colporteur." *Gazette des Beaux Arts* 122, no. 45 (Decmeber 1980): 209–13.

Clark, Timothy J. *The Absolute Bourgeois: Artists and Politics in France, 1848–1851.* Greenwich, Conn.: New York Graphic Society, 1973.

Collingham, H. A. C., and R. S. Alexander. *The July Monarchy: A Political History of France, 1830–1848.* London and New York: Longman, 1988.

*Les Colporteurs de Chamagne:* Etude de leurs passeports (1824–1861). Inspection Academique des Vosges, C.D.D.P. des Vosges, 1990.

Constans, Claire. *Versailles: La Galerie des Batailles.* Paris: Les Editions Khayat, 1990.

Corbin, Alain. *Archaisme et modernité en Limousin au dix-neuvième siècle.* 2 vols. Paris: Marçel Rivière et Cie, 1975.

Courtas, Raymond, and François Isambert. "Ethnologues et sociologues aux prises avec la notion de populaire." *La Maison Dieu* 122 (1975): 20–42.

Crow, Thomas. *Painters and Public Life in Eighteenth-Century Paris.* New Haven: Yale University Press, 1985.

Crubellier, Michel. *Histoire culturelle de la France du dix-neuvième au vingtième siècles.* Paris: A. Colin, 1974.

Cuisenier, Jean. *French Folk Art.* Tokyo and San Francisco: Kodansha Intl., 1977.

Dansette, A. *Sainte Hélène, terre d'exile, 1821–1840.* Paris: Hachette, 1971.

Darmon, Jean-Jacques. *Le Colportage de librairie en France sous le Second Empire.* Paris: Plon, 1972.

Davis, Natalie Zemon. *Society and Culture in Early Modern France.* Paris and Stanford, Calif.: Stanford University Press, 1975.

Dayot, Armand. *Napoléon raconté par l'image d'après les sculpteurs, les graveurs, et les peintres.* Paris: Librairie Hachette, 1895.

"Debate on the Censorship Law of 1835." *Archives Parlementaires, 1800–1860.* 98, no. 2. Paris: Dupont, 1899.

Dechamps, Jules. *Sur la légende de Napoléon.* Paris: Librairie Ancienne Honoré Champion, 1931.

Delehaye, Hippolyte, S.J. "La Légende de Saint Napoléon." In *Mélanges de l'histoire.* Belgium, n.d.

Demard, Albert, Joel Cuenot, and Jean Christophe Demard, eds. *Un Homme et son terroir: Une Évocation de la vie rurale d'autrefois.* Tours: Mame, 1980.

Descaves, Lucien. *L'Humble Georgin: L'Imagier d'Epinal.* Paris: Firmin-Didot et Cie, 1932.

Descotes, Maurice. *La Légende de Napoléon et les écrivains français du dix-neuvième siècle.* Paris: Lettres modernes, 1967.

Devigné, Roger. *La Légendaire des provinces françaises.* Paris: Horizons de France, 1950.

Devlin, Judith. *The Superstitious Mind: French Peasants and the Supernatural in the Nineteenth Century.* New Haven and London: Yale University Press, 1987.

Driskel, Michael. *As Befits a Legend: Building a Tomb for Napoleon, 1840–1861.* Kent, Ohio, and London: Kent State University Press, 1993.

Drujon, Fernand. *Catalogue d'ouvrages, écrits, et dessins poursuivis, supprimés, ou condamnés depuis le 21 Octobre, 1814 jusqu' au 13 juillet, 1877.* Paris: Edouard Rouvèyre, 1879.

Dubreton, Jean Lucas. *Le Culte de Napoléon, 1815–1848.* Paris: Editions Albin Michel, 1960.

DuChartre, Pierre Louis, and René Saulnier. *L'Imagerie populaire.* Paris: Librairie de France, 1925.

Dumont, Jean-Marie. *Les Maîtres graveurs populaires, 1800–1850.* Epinal: L'Imagerie Pellerin, 1965.

———. *La Vie et l'oeuvre de Jean-Charles Pellerin, 1756–1836.* Epinal: l'Imagerie Pellerin, 1956.

Durand, Gilles. "La Vie politique dans le département des Vosges de 1830 à 1840." Thesis, Université de Nancy II, France, 1972.

Espinouse, Mme de Coriolis. *Le Tyran, les alliés, et le roi.* Paris: Le Normant, 1814.

Farwell, Beatrice. *The Charged Image: French Lithographic Caricature, 1816–1848.* Santa Barbara, Calif.: Santa Barbara Museum of Art, 1989.

———. *The Cult of Images: Baudelaire and the Nineteenth-Century Media Explosion.* University of California, Santa Barbara Museum of Art, 1977.

———. *French Popular Lithographic Imagery, 1815–1870.* 12 vols. Chicago: University of Chicago Press, 1981.

Faucher, Jean-André. *Les Francs-maçons et le pouvoir: De la révolution à nos jours.* Paris: A. Perrin, 1986.

Fisher, H. A. L. *Le Bonapartism.* Oxford: Clarendon Press, 1908.

Fleuret, Fernand. *Cartouche et Mandrin d'après les livrets de colportage avec images populaires.* Paris: Librairie de Paris, 1932.

Foucart, Bruno. "Les Salons sous le consulat." *Revue de l'institute Napoléon* 13 (1969): 113–19.

Fourcaud, Louis de Bousses de. *François Rude, sculpteur: Ses Oeuvres et son temps, 1784–1855.* Paris: Librairie de l'art ancien et modern, 1904.

Fournel, Victor. *Les Cris de Paris.* Paris: Didot et Cie, 1888.

Freedberg, David. *The Power of Images: Studies in the History and Theory of Response.* Chicago: University of Chicago Press, 1989.

Frénilly, Baron de. *Souvenirs du Baron de Frénilly, pair de France.* Paris: Plon, 1908.

Friedlaender, Walter. "Napoleon as Roi Thaumaturge." *Journal of the Wärburg and Courtauld Institutes* 4 (1940–41): 129–41.

Furet, Francois, and Jacques Ozouf. *Lire et écrire.* Paris: Les Éditions de minuit, 1977.

*Galerie militaire de Napoléon.* Paris: Panckoucke, 1821.

Garnier, J. M. *Histoire de l'imagerie populaire et des cartes à jouer à Chartres.* Paris: Garnier, 1869.

Garnier, Nicole, and Maxine Préaud. *Catalogue complète de l'imagerie d'Epinal.* Paris: Réunion des musées nationaux, Bibliothèque Nationale de France, 1996.

Gazin, Edgar. "Moeurs, traditions, légendes dans le département des Vosges." in *Le Département des Vosges.* Vol. 4. Edited by Léon Louis. Epinal, 1889.

Gennep, Arnold Van. *La Formation des légendes.* Paris: Ernest Flammarion, 1910.

———. *Les Rites de passage.* Paris: Librairie critique, Emile Nourry, 1909.

Ginzberg, Carlo. *Le Fromage et les vers (l'univers d'un meunier).* Paris: Flammarion, 1980.

Girard, Louis. *Les Libéraux français, 1814–1875.* Paris: Aubier, 1985.

Godechot, Jacques Léon. *Napoléon.* Paris: Éditions Albin Michel, 1969.

Godechot, Jacques, Beatrice Hyslop, and David Dowd. *The Napoleonic Era in Europe.* New York: Holt, Rinehart and Winston, 1971.

Goldstein, Robert Justin. *Censorship of Political Caricature in Nineteenth-Century France.* Kent, Ohio: Kent State University Press, 1989.

———. *Political Censorship of the Arts and the Press in Nineteenth-Century Europe.* Basingstoke, Hampshire: Macmillan, 1989.

Gonnard, Philippe. *Les Origines de la légende Napoléonienne.* Paris: Calmann-Lévy, 1907.

Goujon, Alexandre, ed. *Bulletins officiels de la Grande Armée.* Vols. 1–4. Paris, 1820–21.

Gourgaud, Général Gaspard. *Sainte Hélène, journal inédit, 1815–1818.* Paris: E. Flammarion, 1899.

———. *Talks of Napoleon at Saint Helena with General Baron Gourgaud.* Chicago: A. C. McClurg, 1903.

Graham, John. *Lavater's Essays on Physiognomy: A Study in the History of Ideas.* Berne, Frankfurt, and Las Vegas: Peter Lang, 1979.

Guérard, Albert L. *Napoleon III.* Cambridge: Harvard University Press, 1943.

———. *Reflections on the Napoleonic Legend.* London: T. Fisher Unwin, 1924.

Harris, Elizabeth M. *The Art of Pochoir.* Washington, D.C.: Smithsonian Catalogue, National Museum of American History and Technology, 1977.

Hébrard, Jean. "Ecole et alphabetisation au dix-neuvième siècle: Approche psycho-pédagogique." *Annales économies, sociétés, civilisations* 1 (1980): 66–80.

Hélias, Pierre. *Les Contes Bretons.* Chateaulin: J. Le Doré, 1965.

Hélot, René. *La Bibliothèque bleue en Normandie.* Rouen: Albert Laisne, 1928.

Herscher, Walter R. "Evoking the Eagle: The July Monarchy's Use of Napoleonic Imagery." Ph.D. diss., Marquette University, 1992.

Hind, Arthur Mayger. *An Introduction to the History of the Woodcut.* Boston and New York: Houghton Mifflin, 1935.

Hinzelin, A. *À messieurs les membres de la commission de colportage.* Nancy, France: Hinzelin, 1858.

Hugo, Victor. *Choses vues: Souvenirs, journaux, cahiers, 1830–1846.* Edited by Hubert Juin. Paris: Gallimard, 1972.

———. *Oeuvres poetiques.* 2 vols. Paris: Pierre Albouy, 1964.

Hunt, Lynn Avery. *The New Cultural History: Essays.* Berkeley and Los Angeles: University of California Press, 1989.

———. *Politics, Culture and Class in the French Revolution.* Berkeley and Los Angeles: University of California Press, 1982.

*Iconographie et histoire des mentalités.* Paris: Éditions de CNRS, 1979.

*L'Imagerie Messine, 1838–1871: Exposition d'images conservées aux Archives Départementales de la Moselle.* Metz: Direction des Services d'Archives de la Moselle, 1987.

*Les Intermédiaires culturels.* Acte du colloque du centre méridional d'histoire sociale des mentalités et des cultures. Provence: Université de Provence, 1978.

Judt, Toni. *Socialism in Provence, 1871–1914.* New York and Cambridge: Cambridge University Press, 1979.

Julia, Dominique, Jacques Revel, and Michel de Certeau. "La Beauté de la mort." In *La Culture au pluriel.* Paris: Christian Bourgeois, 1980.

Jullian, Philippe. *The Orientalists: European Painters of Eastern Scenes.* Oxford: Phaidon, 1977.

Ladurie, Emmanuel Le Roy. *Les Paysans du Languedoc.* Paris: Mouton, 1966.

Junot Mme (Duchess d'Abrantes) *Memoirs of the Emperor Napoleon, from Ajaccio to Waterloo.* London: Walter Dunno, 1838.

Latreille, André. *Le Catechisme impériale de 1806.* Paris: Editions du Cerf, 1935.

———. *L'Église Catholique et la révolution française.* Vol. 2. Paris: Editions du Cerf, 1970.

Laumann, E. M. *Le Retour des cendres.* Paris: H. Daragon, 1904.

Lebey, André. *Louis-Napoléon Bonaparte et la révolution de 1848.* Paris: Librairie Vuven, 1905.

LeClerc, Marie Dominique, "Les Avatars de Griséldis." *Marvels and Tales,* 5, no. 2 (1991): 200–234.

Lefebvre, Georges. *Napoléon.* Paris: Presses universitaires de France, 1947.

Le Goff, Jacques, and Pierre Nora. *Faire de l'histoire.* Paris: Gallimard, 1974.

Lerch Dominique. *Imagerie et société: L'Imagerie Wentzel de Wissenbourg au dix-neuvième siècle.* Strasbourg: Librairie Istra, 1982.

————. *Imagerie populaire en Alsace et dans l'Est de la France.* Nancy, France: Presses universitaires de Nancy, 1992.

LeSueur, Jacquelyne. "La Crise des imprimeurs." In *La Littérature de colportage.* Edited by André Malraux. Reims: Maison de la culture, 1979. 1–5.

————. "La Diffusion et le vehicle des chansons-colporteurs et marchands-chanteurs dans les Vosges." *Bulletin de la société Philomatique Vosgienne* 96, no 73 (1970): 101–8.

————. "Une Figure populaire en Lorraine au siècle dernier: Le Colporteur ou Chamagnon." *Bulletin de la société des études locales dans l'enseignement publique* 36 (1969): 29–39.

————. "Le Nouveau visage du 'Chamagnon' ou la fin d'un mythe." *Bulletin de la société Lorraine des études locales dans l'enseignement publique,* 51–52. (1976): 19–20.

Levitine, George. *Girodet-Trioson: An Iconographical Study.* New York: Garland, 1978.

Ligou, Daniel. *Histoire des francs-maçons en France.* Toulouse: Privat, 1981.

————. *Histoire de la franc-maçonnerie dans l'état.* Edited by Albert Lantoine. Paris and Geneva: 1982.

Lotz, François. *Les petits soldats d'Alsace.* Strasbourg: Edition des dernières nouvelles d'Alsace, 1977.

Louis, Léon. *Le Département des Vosges.* Vol. 4. Epinal, 1889.

Lowenthal, Leo. *Literature, Popular Culture, and Society.* Englewood Cliffs, N.J.: Prentice-Hall, 1961.

Luria, Keith P. *Territories of Grace: Cultural Change in Seventeenth-Century Grenoble.* Berkeley and Los Angeles: University of California Press, 1991.

MacKensie, John. *Orientalism in the Arts.* Manchester and New York: Manchester University Press, 1995.

Macpherson, James, ed. *Fragments of Ancient Poetry Collected in the Highlands of Scotland.* Edinburgh, 1760.

Magraw, Roger. *France, 1815–1914.* Oxford: Oxford University Press, 1986.

Mandrou, Robert. *De la Culture populaire au dix-septième et dix-huitième siècles: La Bibliothèque bleue de Troyes.* Paris: Stock, 1964.

Marais, Jean-Luc. "Littérature et culture 'populaire' aux dix-septième et dix-huitième siècles." *Annales de Bretagne, et pays de l'Ouest* 87, no. 1 (March 1980).

Margadant, Ted. *French Peasants in Revolt: The Insurrection of 1851.* Princeton: Princeton University Press, 1979.

Marrinan, Michael. "Literal/Literary/'Lexi': History, Text, and Authority in Napoleonic Painting." *Word and Image* 7, no. 3 (July-September 1991): 177–99.

————. *Painting Politics for Louis-Philippe: Art and Ideology in Orleanist France.* New Haven and London: Yale University Press, 1988.

Martin, Henri-Jean. "The Bibliothèque Bleue: Literature for the Masses in the Ancien Regime." *Publishing History* 3 (1978): 70–102.

————. "Culture écrite et culture orale." *Journal des savants* (July-December 1975): 225–81.

Martin, Henri-Jean, and Roger Chartier. *Histoire de l'édition française.* Vol. 3, *Le Temps des éditeurs: du Romantisme à la Belle Epoque.* Paris: Promodis, 1985.

Martin, Marie-Madeleine. *Histoire de l'unité française: L'Idée de la patrie en France des origines à nos jours.* Paris: Presses universitaires de France, 1982.

Mauriange, Edith. "Sources d'inspiration de François Georgin pour quelques estampes de l'épopée Napoléonienne." In *L'Art populaire de la France de l'Est,* 367–83. Strasbourg: Librairie Istra, 1969.

May, Gita. *Stendhal and the Age of Napoleon.* New York: Columbia University Press, 1977.

Mazoyer, *Les Héros de la France ou apothéose des braves du dix-neuvième siècle.* Paris: J. M. Barret, 1835.

McAllister Johnson, W. *French Lithography: The Restoration Salons, 1817–1824.* Agnes Etherington Art Center, 1977.

McWilliams, Neil. "David D'Angers and the Pantheon Commission: Politics and Public Works under the July Monarchy." *Art History* 5, no. 4 (December 1982): 430–36.

Meister, Maureen. "To All the Glories of France: The Versailles of Louis-Philippe." In *All the Banners Wave: Art in the Romantic Era, 1792–1851.* Providence, R.I.: Brown University Press, 1982.

Mellon, Stanley. "The July Monarchy and the Napoleonic Myth." *Yale French Studies* 26 (fall-winter 1960–61): 70–78.

*Memoirs of Sergeant Bourgogne.* Edited by Paul Cottin. New York: Doubleday and McClure Co., 1899.

Ménager, Bernard. *Les Napoléon du peuple.* Paris: Aubier, 1988.

Merriman, John M. *The Agony of the Republic.* New Haven and London: Yale University Press, 1978.

Michelet, Jules, *The People.* Translated by C. Cooks. London: Longman, Brown, Green, Longmans, 1846.

————. *La Sorcière.* Paris: Garnier-Flammarion, 1966.

Miles, Margaret R. *Image as Insight: Understanding in Western Christianity and Secular Culture.* Boston: Beacon Press, 1985.

Mistler, Jean, ed. *Les Cahiers du Capitaine Coignet.* Paris: Librairie Hachette, 1968.

————, ed. *Lieutenant Chevalier: Souvenirs des guerres Napoléoniennes.* Paris: Librairie Hachette, 1970.

————, ed. *Napoléon et l'empire, 1769–1821.* Paris: Librairie Hachette, 1968.

Mistler, Jean, François Blaudez and André Jacquemin. *Epinal et l'imagerie populaire.* Paris: Librairie Hachette, 1961.

Monmarché, Marcel. "Une leçon de géographie sur les bouteilles." *Bulletin de la société archeologique historique et artistique du vieux papier* (1 July 1905): 244–51.

Monnier, Henri. *Vignettes pour les chansons de Béranger.* Paris: Fabré, 1873.

Montholon, Count Charles Jean-Tristan de. *History of the Captivity of Napoleon at Saint Helena.* London: H. Colburn, 1846–47.

Morin, Alfred, *Catalogue descriptif de la bibliothèque bleue à Troyes.* Geneva: Librairie Droz, 1974.

Moxey, Keith. "Hieronymus Bosch and the 'World Upside Down': The Case of the Garden of Earthly Delights." In *Visual Culture.* Edited by Norman Bryson, Michael Ann Holly, and Keith Moxey. Hanover and London: Wesleyan University Press, 1994.

——. *The Practice of Theory: Postructuralism, Cultural Politics, and Art History*. Ithaca and London: Cornell University Press, 1994.

Muller, Robert, and André Allix. *Les Colporteurs de l'Oisans*. Grenoble: Presse universitaire de Grenoble, 1979.

Nicolet, Claude. *L'idée Républicaine en Francé*. Paris: 1982.

——. "Essai sur le colportage de librairie." *Journal de la société de la morale chrétienne* 3(1855): 1–60.

——. *Des Chansons populaires chez les français: Essai historique*. Vol. 2, *Sur la chanson des rues contemporaines*. Paris: E. Dentu, 1867.

Nisard, Charles. *Des chansons populaires chez les anciens et chez les français: Essai historique*. 2 vols. Paris: Buffet, 1867.

——. *Histoire des livres populaires ou de la littérature du colportage depuis le quinzième siècle jusqu'à l'établissement de la commission d'examen des livres du colportage*. Paris: E. Dentu, 1864.

Okun, Henry. "Ossian in Painting." *Journal of the Wärburg and Courtauld Institutes* 30 (1967): 327–28.

O'Meara, Barry, E. *Napoléon en exile*. London: W. Simpkin and R. Marshall, 1822.

Panofsky, Erwin. *Studies in Iconology*. New York: Oxford University Press, 1939.

Perreux, Gabriel. *Les Conspirations de Louis-Napoléon Bonaparte*. Librairie Hachette, 1946.

——. *Aux Temps des sociétés sécrètes*. Paris: Libraire Hachette, 1946.

Perrout, René. *Les Images d'Epinal*. Pais: Paul Ollendorff, n.d.

Philippe, André. "Des affiches séditieuses apposées sur les murs d'Epinal." In *La Révolution dans les Vosges*, vol. 21, 126–34. Epinal: Société anonyme de l'imprimerie Fricotel, 1933.

——. "Colportage de fausses nouvelles." In *la Révolution dans les Vosges*, 19: 111–14. Epinal: Société anonyme d'imprimerie Fricotel, 1929.

——. "Les Débuts de l'imagerie populaire à Epinal: Les Images Napoléoniennes de Jean-Charles Pellerin, 1810–1815." In *L'art populaire de France*. Paris: Librairie Istra, 1929.

——. "Jean-Charles Pellerin poursuivi pour vente d'images séditieuses, 1816." In *La Révolution dans les Vosges*, 17: 1–15, 97–107. Epinal: Société anonyme de l'imprimerie Fricotel, 1927.

Pierfitte, L'Abbé. "Chamagne, les Chamagnons." *Bulletin mensuel de la société d'archéologie Lorraine* 12 (1903): 280–83.

Pilbeam, Pamela. *The Middle Classes in Europe, 1789–1914*. Macmillan, 1990.

——. *The 1830 Revolution in France*. New York: St. Martin's Press. 1991.

Pimenta, Robert. *La Propagande Bonapartiste en 1848*. Paris: Edouard Cornely et Cie, 1911.

Pinkney, David. *The French Revolution of 1830*. Princeton: Princeton University Press, 1972.

Poujol, G., and R. Labourie. *Les Cultures populaires*. Toulouse: Edouard Privat, 1979.

Pourrat, Claire Krafft. *Le Colporteur et la mercerie*. Paris: Denoël, 1982.

Price, Roger. *The French Second Republic*. Ithaca: Cornell University Press, 1972.

Putigny, Miot. *Putigny: Grognard d'empire*. Paris: Gallimard, 1950.

Puymege, Gérard de. *Chauvin: Le Soldat laboreur*. Paris: Gallimard, 1993.

*Raffet* (lithographs). Vol. 8. Paris: Gihaut frères, 1832.

Rémond, René. *Le Droite en France de la première restauration à nos jours*. Vol. 1. Paris: Aubier, Éditions Montaigne, 1968.

Rémusat, Charles de. *Mémoires de ma vie, enfance et jeunesse, 1797–1820*. Vol. 1. Paris: Librairie Plon, 1958.

Rémy, Eliane. "La Vie politique dans le département des Vosges, 1848–1860." Thesis, Université de Nancy II, France, 1982.

Rogger, Hans, and Eugen Weber. *The European Right: A Historical Profile*. Berkeley and Los Angeles: University of California Press, 1966.

Rosenblum, Robert. *Transformations in Late-Eighteenth-Century Art*. Princeton: Princeton University Press, 1969.

Roth, François. "Nation, armée, et politique à travers les images d'Epinal." *Annales de l'Est* 32, no. 3 (1980): 195–213.

Ravigo, Duc de. *Mémoires du Duc de Ravigo pour servir à l'histoire de l'empereur Napoléon*. Brussels: Voglet, 1828.

Rude, François, and Claud Noisot, *Notice sur le monument élévé à Napoléon à Fixin (Côte d'Or), publiée par la commission du banquet*. Dijon: Imprimerie Loireau-Feuchot, 1847.

Saff, Donald, and Deil Sacilotto. *The History and Process of Printmaking*. New York: Holt, Rinehart and Winston, 1978.

Saint-Esprit, Jérôme Catherine Delandine de. *Histoire de l'Empire, 1804–1814*. Paris: Debécourt 1843.

Saulnier, René. *Les Sources d'inspiration de l'imagerie populaire: Un Curieux exemple de copies successives*. Paris: Le Roux, 1948.

Sauvigny, Guillaume de Bertier de. *The Bourbon Restoration*. Translated by Lynn M. Case. Philadelphia: University of Pennsylvana Press, 1966.

Sauvy, Anne. "La Librairie Chalopin du colportage: Livres et livrets au début du 19ème." *Bulletin d'histoire moderne et contemporaine*: 95–140.

——. "Noël Gille dit la pistole." *Bulletin des bilbiothèques de France* 5 (1967): 177–90.

Schnapper, Antoine. *David*. New York: Alpine Fine Arts Collection, 1982.

Schorsch, Anita. *Mourning Becomes America*. Harrisburg, Penn.: William Penn Memorial Museum, 1976.

Sébillot, Paul, Louis Morin, and P. Ristelhuber. *Livres et images populaires*. Paris: Lechevalier, 1894.

Séguin, Jean Pierre. *Canards du siècle passé*. Paris: Pierre Horay, 1969.

——. "Un Texte peu connu sur 'la bilbiothèque bleue' et la littérature de colportage." *Musée des Arts et Traditions Populaires* 6, nos. 1–2 (1958): 74–75.

Siegfried, Susan Locke. "Naked History: The Rhetoric of Military Painting in Postrevolutionary France." *Art Bulletin* 75, no. 2 (June 1993): 235–58.

Spitzer, Alan. *The French Generation of 1820*. Princeton: Princeton University Press, 1987.

——. *Old Hatreds and Young Hopes*. Cambridge: Harvard University Press, 1971.

Stendhal. *Le Rouge et le noir*. Paris: Presses de la Renaissance, 1976.

———. *Vie de Napoléon*. Paris: Cercle du bibliophile, 1970.

Syntex, Dr. [William Comb] *Life of Napoleon: a poem in Fifteen Cantos*. London, 1817.

Terdiman, Richard. *Discourse/Counter-Discourse: The Theory and Practice of Symbolic Resistance in Nineteenth-Century France*. Ithaca and London: Cornell University Press, 1985.

Thiers. M. A. *Histoire du consulat et de l'empire*. 21 vols. Paris: Paulin-librairie, 1845–1861.

Thureau-Dangin, Paul Marie Pierre. *Histoire de la Monarchie de Juillet*. 7 vols. Paris: Plon, 1914.

Tickner, Lisa. *The Spectacle of Women: Imagery of the Suffrage Campaign, 1907–1914*. London: Chatto and Windus, 1987.

Tissot, Pierre François. *Histoire de Napoléon*. 7 vols. Paris: Delange-Taffin, 1833.

———. *Trophées des armées françaises de 1792 à 1815*. 4 vols. Paris: Lefuel, 1819–21.

Touchard, Jean. *La Gloire de Béranger*. 2 vols. Paris: Librairie Armand Colin, 1968.

Trullard, M. J. *La Résurrection de Napoléon*. Dijon: Guasco-Jobard, 1847.

———. *Souvenirs de l'inauguration du monument érigé à Napoléon en Bourgogne, 1847*. Dijon: Guasco-Jobard, 1847.

Tudesq, André-Jean. *L'Élection présidentielle de Louis-Napoléon Bonaparte*. Paris: Armand Colin, 1965.

———. "La Légende Napoléonienne en France en 1848." *Revue histoirque* 218 (1957): 64–85.

Tulard, Jean. *L'anti-Napoléon: La Légende noir de l'empereur*. Paris: René Julliard, 1965.

———. *L'Histoire de Napoléon par la peinture*. Paris: Belfond, 1991.

———. *Le Mythe de Napoléon*. Paris: Armand Colin, 1971.

———. *Napoleon: The Myth of the Savior*. Translated by Teresa Waugh. London: Weidenfeld and Nicolson, 1977.

———. "Le Retour des cendres." In *Les Lieux de mémoire*, Vol. 2. Paris: La Nation, 1986.

Turck, Léopold, *Almanach du Peuple*, Epinal: Pellerin, 1833.

Vaulabelle, Achille de. *Campagne et bataille de Waterloo*. Paris: Perrotin, 1845.

Vernet, Carl. *Campagnes des français sous le consulat et l'empire*. Paris: Michel de l'Ormeraie, 1979.

Vidalenc, Jean. *Les Demi-soldes*. Paris: Librairie Marcel Rivière et Cie, 1955.

———. *La Société française de 1815 à 1848: Le Peuple des campagnes*. Vol. 1. Paris: Rivière, 1969.

*Vie de St. Antoine*, Troyes: Pierre Garnier, 1738. Bibliothèque Bleue 246, Bibliothèque Municipale de Troyes.

*Vie de Napoléon*, Arcis: Blondel., 1832. Bilbiothèque Bleue 1010, Bibliothèque Municipale de Troyes.

*Vie Du grand St. Hubert*, Troyes, Baudot. Bibliothèque Bleue 920, Bibliothèque Municipale de Troyes.

Vigier, Philippe. *La Monarchie de juillet*. Paris: Presses universitaires de France, 1962.

——— *La Seconde République*. Paris: Presses universitaires de France, 1970

Vovelle, Michel. *Les Métamorphoses de la fête en provence de 1750 à 1820*. Paris: Aubier/Flammarion, 1976.

———. *Piété baroque et déchristianisation en provence au dix-huitième siècle*. Paris: Editions du Seuil, 1973.

———. "La Religion populaire: Problèmes et méthodes." *Le Monde Alpin et Rhodanian: Revue régionale d'ethnologie*. (April 1977).

Vovelle, Michel, and Didier Lancien. *Iconographie et histoire des mentalités*. Paris: Centre National de la recherche scientifique, 1979.

Vovelle, Michel, and Gaby Vovelle. *Vision de la mort et de l'au-delà en Provence*. Paris: Armand Colin, 1970.

Wechsler, Judith. *A Human Comedy: Physiognomy and Caricature in Nineteenth-Century Paris*. Chicago: University of Chicago Press, 1982.

Weill, Georges. *Histoire du parti républicain en France, 1814–1870*. Librairie Felix Alcan, 1928.

White, Harrison C., and Cynthia White. *Canvases and Careers*. New York: John Wiley and Sons, 1965.

Woloch, Isser. *The French Veteran from the Revolution to the Restoration*. Chapel Hill: University of North Carolina Press, 1979.

Wright, Gordon. *France in Modern Times*. Chicago: Rand McNally, 1974.

———. *Rural Revolution in France*. Stanford: Stanford University Press, 1964.

# Index